MW00812137

HOTEL CHELSEA

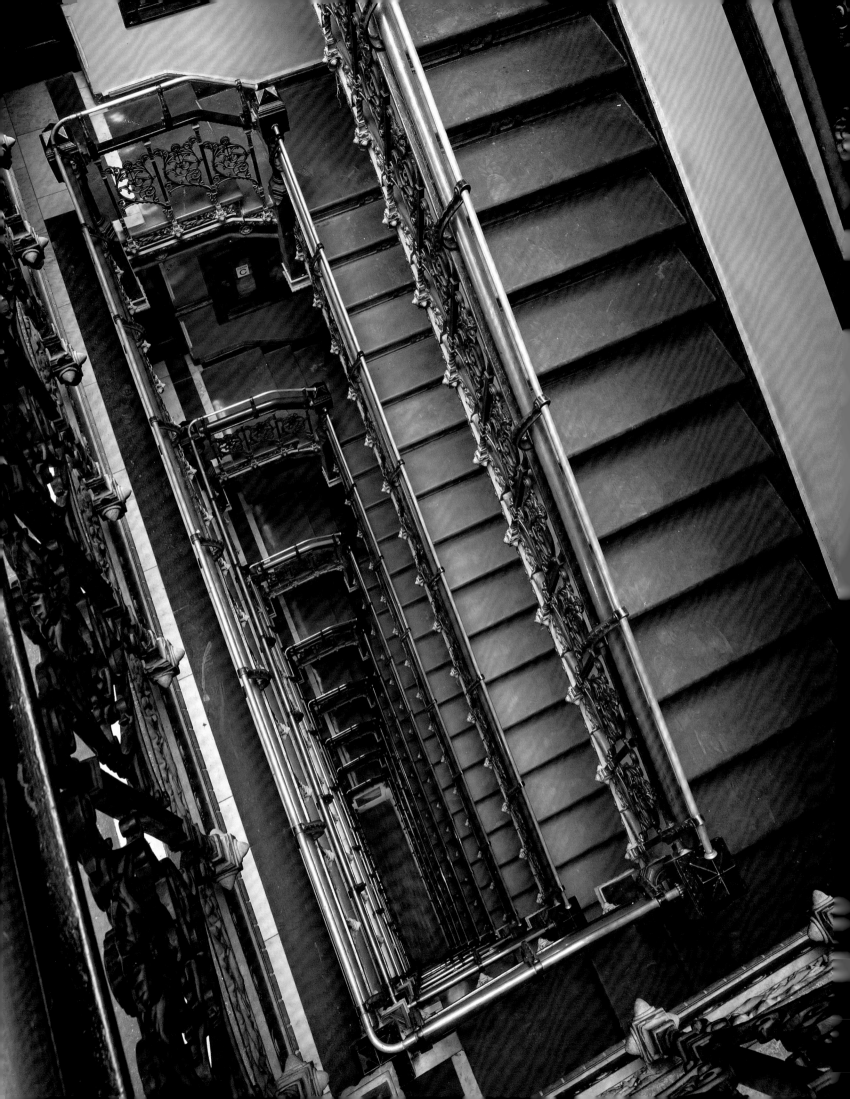

HOTEL CHELSEA

LIVING IN THE LAST BOHEMIAN HAVEN

PHOTOGRAPHS BY COLIN MILLER

TEXT BY RAY MOCK

FOREWORD BY GABY HOFFMANN AND ALEX AUDER

THE MONACELLI PRESS

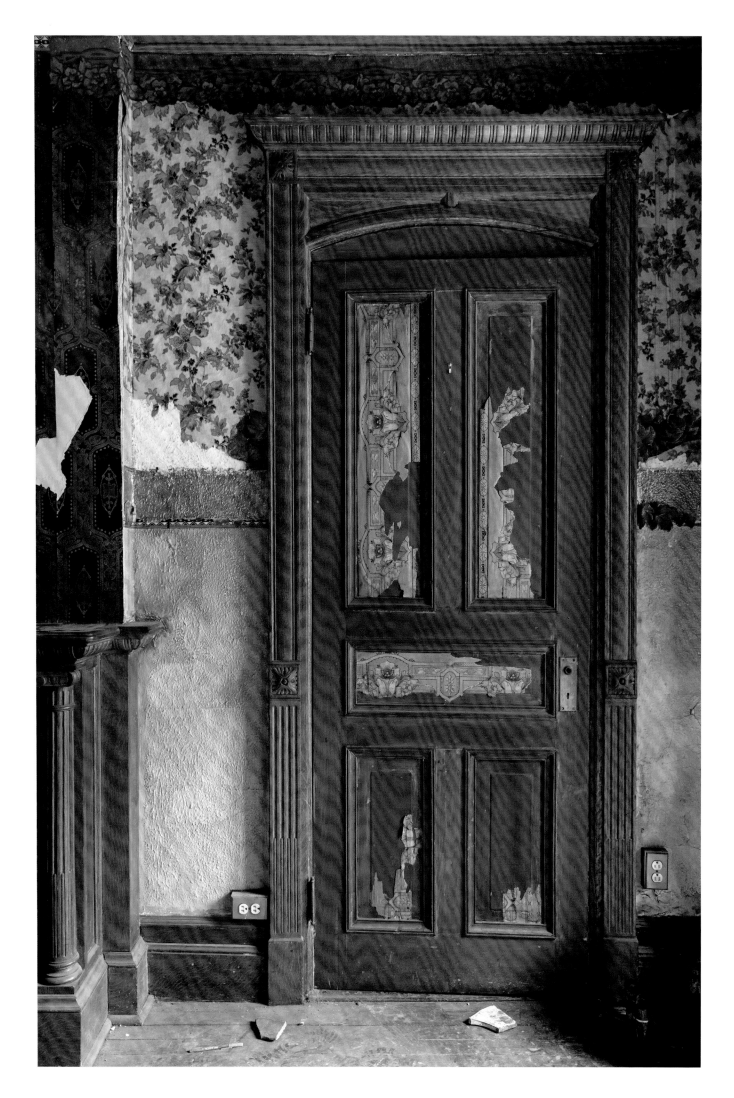

CONTENTS

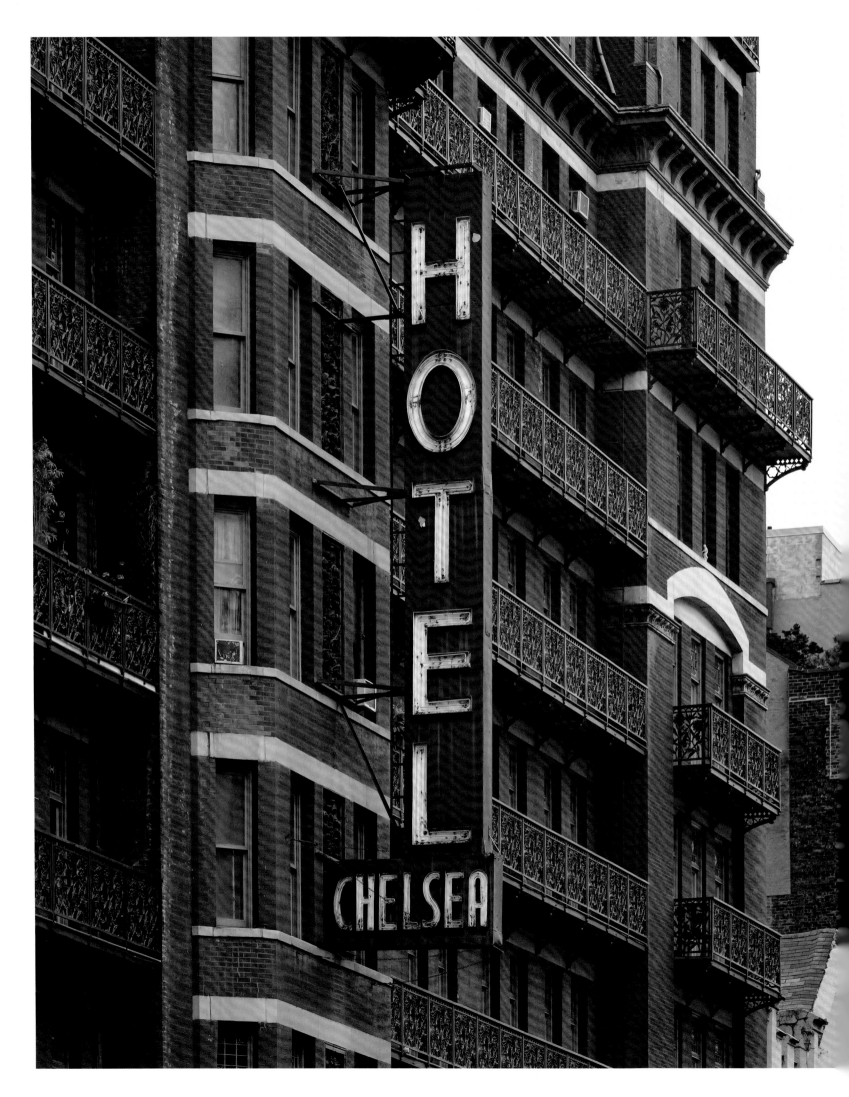

GABY HOFFMANN AND ALEX AUDER

FOREWORD

GABY: So some people are doing a book about residents at the Chelsea who are still living there through the construction and they asked me to write the foreword. I was just gonna say no cause I can hardly find time to write an email these days or how about a dream? Or that thing Rosy said about being brave and what it felt like when Lewis clapped with glee after Chris beatboxed for Rosy's dark disco tooth brushing session last night and if I'm gonna write anything do I wanna write the foreword to someone else's book about how bohemian the bohemians are and how cool it is that I was raised by an artist bohemian enough to live in the mecca of bohemianism and what a loss and oh the city and all those hideous chase banks and what about that old bum on the stoop I would chat with every day while eating my soggy éclair from the corner donut shop that is now a starbucks before I would go home to rollerblade down the halls and drop eggs off the balcony and—oh yeah they love it—step over that syringe in the back stairway while running upstairs to eat chicken and broccoli with Ruth and family cause mom "just can't take it anymore"—you know living on the postage stamp. And ahh those were the days and the fucking rich blah blah blah and if I'm gonna finally write about it all I will do it for my own book, film, or play, or eulogy, and then I thought you should do it cause you've already written so much and it's so good and then I thought I could interview you and then I thought we could just write emails like this one in the 5 minutes before the baby wakes. And then I would convince them that they're bohemian enough to let this be the foreword. What do you think? Ah there's that baby! xo

ALEX: You and I are forever bonded by our dead sibling, the Chelsea Hotel. We two are the rare few who really and truly grew up in the Chelsea Hotel and it takes a lot of intentional looking the other way when I hear about Chelsea stories from rich people who moved there in the 2000s because they CHOSE to live a "bohemian" lifestyle. As an adult, I had to give yoga classes to some of these characters IN the Chelsea Hotel, which I could no longer afford to live in even if I had wanted to, and finally I was forced out of NY altogether. That's the hard thing to explain. We didn't choose the Chelsea Hotel. We ended up there because Stanley didn't ask for a deposit or a lease. Mom always wanted to move out of our "postage stamp" of an apartment, but she just couldn't get it together for all of the reasons that drew her to the Chelsea in the first place. Yeah, we don't want to sound like bitter expats . . . and yet . . . we do have this love story to share. I loved the Chelsea so much. I loved waiting for you to come home to our little apartment the night you were born. Now

that I'm 48 and raising my kids in this neoliberal, helicopter-parenting world, I so often dig back into the memory banks to relive the freedom and community and uncanny surprises that waited for us in that lobby. I go through a somatic journey: through the lobby-I-know-like-the-back-of-my-hand, sneak into the sinister El Quijote bathrooms to tend to my recurring bloody nose, up to the first floor elevators if I don't feel like talking to Merle, and while I wait for the gold elevator I spit into the first-floor stairwell to see how it differed from spitting from the 7th floor. . . . Okay I gotta go . . . love you.

GABY: I was thinking about all the things I dropped from the 7th floor hallway down into that stairwell mouth that we treated as an incidental abyss, consequenceless, but was the foundation of our whole world — sucked candy, a note to no one, the spinach I didn't want to eat and yes a spittoon full of saliva. I love thinking about the El Quijote bathroom. Almost impossibly making it through the lobby before Stanley caught me to ask for rent or Bonnie barked my name from her station behind the front desk with a message from someone that I really don't want to get and then pushing through that heavy door into the musty gray entrance to the grand stairwell but then, instead of rising up into the sunlit center of it all, I move through that second set of doors into the dim romance of the restaurant and before anyone sees, slip into the warm, womblike, pink (pink right? I remember it feeling baroque, sort of parlor-esque from another era in Russia maybe) safe space, but I don't linger lest the waiters start to get aggressive. Ah Merle, now it seems so fun to get caught in the elevator with Merle doesn't it? Did you know that for the longest time I thought we had a portrait of Lee, her husband, in our apt and one day I told him so and he was shocked. "Yeah, you're smoking a cigar and it's on our mantel." "Your mantel?! I don't think so." When I saw mom and told her Lee didn't know we had a painting of him on our wall she laughed hysterically — "That's Castro!!!" Even though I was all but 8 I was ashamed — I should have known. I always say it was the ideal place to grow up in NYC as it essentially operated like a suburban cul-de-sac with all that freedom and community for kids. When Rosy goes down to Nancy's apartment to rewrite a page in *Frog and Toad are Friends* because it failed to explain where that button went and Nancy expertly adds a drawing of Toad slipping it into his pocket or when she asks me to leave her on the stoop with Jay and Niko while they drink beer and chain smoke so she can "chat with her friends alone," I feel like we've magically eked out a little of what we loved about growing up in the Chelsea. Fuck! Alternate side parking. love Xx

ALEX: Yeah, I love that Rosy gets to hang out on the stoop. God, I miss the filthy stoops of 23rd Street, where the drunks, bums, and OTB addicts hung out and chatted with us. When my coparenting friends get nervous about our kids running across the street to the playground by themselves, I have to refrain from rolling my eyes (I don't really refrain that much) and

going on and on about the hookers and drug dealers who watched over us in the Chelsea. When I was a teenager I could come home at any time of night, after dancing at Nell's, and be greeted by Jerry, the desk clerk who was there the night I was born and almost delivered on the lobby floor. Keys? Who needs 'em? How about when mom would tack a note to the front door — "At Vali's" — and though usually the seduction of our empty apartment was greater than visiting Vali, sometimes we would wander down and hang out for a few minutes in Vali's apartment, decorated with empty El Pico coffee cans and beaded curtains and stare at her face covered in curlicue tattoos and framed by fire-engine-red frizzy hair. Or "At Shirley's" and we'd find her lounging on Shirley Clarke's bed in her entirely black and white apartment that complemented her Felix the Cat collection. Or "At Ruth's" and oh yes we'd run up for a delicious meal cooked by mom's Israeli doppelganger in the apartment above ours, which mirrored the footprint of ours, but then expanded impossibly, little room after little room, with the outer hallways incorporated into the interior, because over the years they had broken down the walls of all the other adjacent hotel rooms and taken over the southeastern section of the 8th floor. Or "At Bettina's" . . . No, I wouldn't go down there. Too much to deal with . . . Okay Miko needs me to wipe his ass. . . .

GABY: Oh God I wish I'd said no to this foreword. Always trust my first instinct. Fuck me. All I want to do with this blunted brain, stoned and slow (ah so peaceful) from almost no sleep (Lewis just got 4 new teeth in two weeks and is now sick) — all I want to do is sit, half clothed, in the window seat, bathed in the breeze from off the park, and hocket with my baby: "da." "DA." "ya." "YA." "ma ma". "MAMA!!" back and forth, astonished by the bone-white tooth cutting up through his pink gums. Miraculous.

I resent that I have to go find the plug to my computer and fix my gaze elsewhere.

ALEX: Lewis reminds me so much of you as a baby. When I was 11 and mom brought you home to #710, on that snowy night, and placed you on the bed I shared with her. You had just been born a few hours before and mom refused to stay at the hospital. Ruth and Danny were there. I said you looked just like Mel Brooks and everyone laughed. But I was disappointed because you were so ugly to me. For the next year I paced the Chelsea halls at 1 AM, 2 AM, 3 AM, 4 AM, cajoling you back to sleep. Sometimes I'd jog up and down the central stairs, waiting for you to stop fussing and your body to go limp. Neighbors would be coming back from the clubs, from their late-night adventures, sweaty, with smeared eyeliner. "Hey, Alex, how's the baby doing?"

GABY: When I think of Vali in her apt or Shirley or Susanne Bartsch (or what was the name of our 7th-floor neighbor? "Shoot you with my shotgun!") in their respective apartments it seems like they built a natural habitat for themselves. Their neon-pink walls, coffee

cans, Felix the Cats, etc., created a sort of camouflage so they could vanish. Rather than those spaces, those loud echoes of how they presented, dressed, behaved, sharpening their identities, acting as an identity prison almost, maybe they actually liberated them? Maybe those ultra-curated spaces allowed their egos to dissolve into the cheetah print sofa, or pink beaded doorways, giving them greater access to their true selves beyond all that decoration and armor, not because it confirmed some idea of who they are but instead freed them from having to define themselves, so that they could be anything in those rooms? Ok we are off to see the Japanese tree peonies at the botanic gardens. xo

ALEX: Fuck, what was her name. . . . Sydney would know. The band was called Schizzo, or at least that's what I remember. The teal paint spilling out under the doorjamb. She'd rehearse that song in the hallway and you and I would secretly roll our eyes when we'd walk past. Another band, The Grunge, would rehearse on the 3rd floor. And Sydney and I, while we were babysitting you, would prank call them from the beige lobby phone. I'd put on a husky "male" voice, as I imagined the lead singer of The Grunge to sound, and call Schizzo's room: "Yo! You suck Schizzo!" Then sweet Schizzo with her high-pitched eastern European accent would say, "Fuck you! Who is this?" Then I'd call The Grunge's room and pretend to be Schizzo: "You don't have ze good manners!" We once opened the breaker box right next to the elevators and turned off The Grunge's electricity! Apparently the two bands got into a physical fight in the lobby over this. School bus coming, gotta go.

GABY: I remember spying on Schizzo rehearsing so we could imitate her later pulling out her invisible shotgun from her holster and shooting . . . who? Who was she shooting??

I went to the bookstore yesterday to get *Summer* (have you read *Spring* yet? Sooo good! Did you finish Book 6?) and there was a shiny new book on the shelves called *How to Do Nothing*. I had to take a glance. I wondered how her version of doing nothing compares to my own. From the little I browsed it seemed like a book trying to remind us of our humanity, amidst the raging capitalistic, productivity-obsessed, tech-driven society we live in. A "how to" for how to be connected to oneself and thus this human family and planet in a culture determined to alienate each of us from, not only one another, but ourselves so that we can become so dizzy, so blind, that the inverted value system created for profit can keep tricking us into undermining our well-being so we can support it . . . you know, the usual. I mean I imagine that is where she was headed I got interrupted and moved on — lord knows the last thing I need is a guide on doing nothing — I just need 6000 more pages of Karl Ove describing his thighs sticking to the hot car seat, his cigarette smoke wafting through his blooming garden, watching his children eat that sausage he just made and the tiny existential crisis that follows.

I'll have to go back and take a second look at that book before committing to this

statement but: I think we can locate the dysfunction, perversion, of this modern world in the way NOTHING is being defined by best-selling books. This was not a study on nihilism, but in fact just the opposite.

ALEX: I'm halfway through book 6 and I actually LOVE the Hitler stuff. A few people told me they skipped it, but I find it thoroughly absorbing. But it's hard to read these days — because it feels like doing . . . nothing . . . hahaha. And THAT's it! You've nailed it. That's what mom got famous for and what Warhol captured in his movies: the art of doing nothing. Now even nothing is being commodified. The "good old days" were filled with the delights of doing nothing. Our childhood was all about lounging in our apartment, in Ruth's, in Vali's, in Shirley's. . . . listening to the women talk. Doing nothing was a countercultural activity and now it's an app.

GABY: Yes mom raised us right with a healthy focus on the importance of doing "nothing" (of course not "being earnest" — her least favorite thing). We even had our regular congregation down the hall to chant and meditate with the Ganapati gang and do "nothing" intentionally, methodically.

I wonder what it does to each of us to keep conjuring the past. Not even idealize it, but to just keep reconjuring it for fun, aesthetic urges, clues, prescriptions, prognostications, explanation, illumination, vindication? Do you think it helps or harms our imagination for the future? Cause lord knows we need a radical new vision. I promised myself last time I was returning to live in NYC I would stop looking for the past and mourning the broken, corrupted, or just plain gone relics that I found or didn't. It helps to almost never go into Manhattan. Never walk through Soho or the Lower East side and pass what was once a gathering place, a watering hole, a holy site of so much communion with people who are gone, relationships that have gotten lost, a self that is slowly dissolving into something else.

ALEX: I know, I know, it's so hard to avoid nostalgia, to not be infected by it. You know the word means sickness, right? But it's a sweet sickness, a longing. That's what I feel when I catch a glimpse of the Chelsea from, say, a car window: a honey-sweet pit in my stomach. I went there a few months ago to get my hair cut. Now you have to enter next to the guitar shop, into some weird makeshift lobby. Merle was sitting in there. Seriously.

GABY: Yeah I did know that. For me it's more like getting punched in the gut. A Cat Power song came on at a store the other day and it shot me right back to 1998 and I almost doubled over. Right now it occurs to me that that "sickness" is fear of death. I wonder if cultures that have an intimate relationship with death, keep it close and even celebrate it, get nostalgic?

What if we had to go back and live in the Chelsea FOREVER? Whatever that is.

Love you x

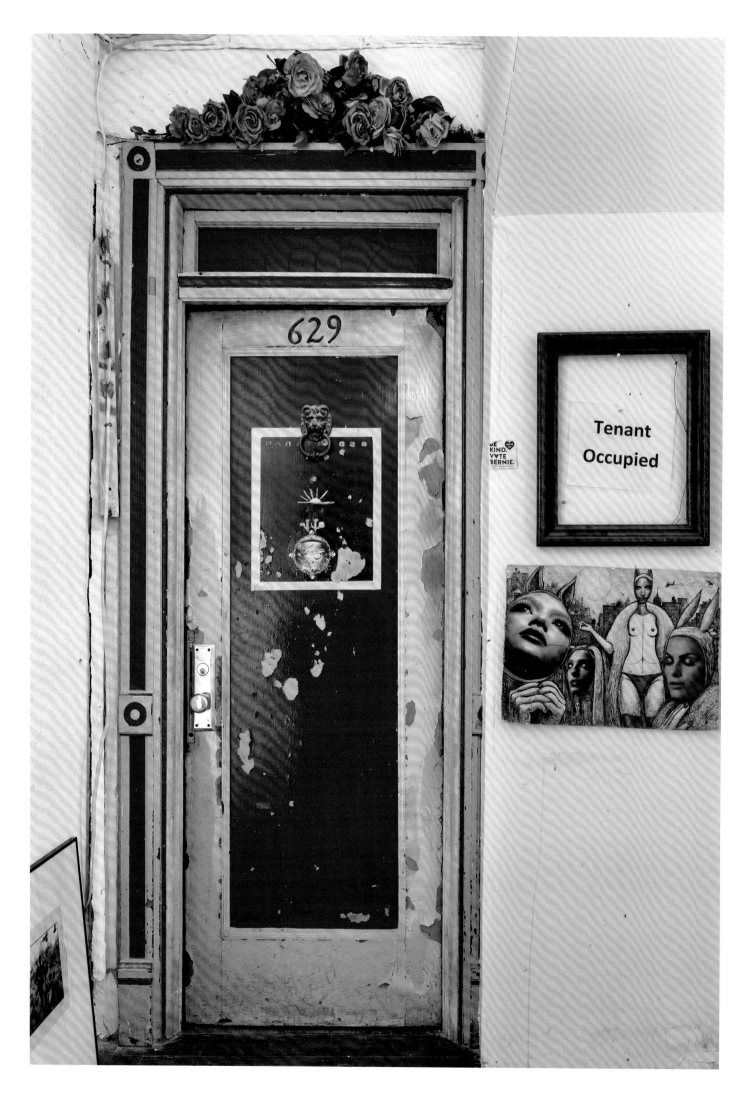

PHOTOGRAPHER'S NOTE

I N 2015 AN ARCHITECTURE FIRM APPROACHED ME to take some photographs of the renovations they'd made to the historic Hotel Chelsea after the building was sold out from under its longtime owner and manager Stanley Bard. What I found was that many of the hotel's original features had already been lost in the demolition of large swathes of the building. The Chelsea's ornate and beautiful red brick facade concealed the destruction that was taking place within the hotel. The photographs I made were forgettable, but when I looked down the iconic wrought iron staircase I saw something of the hotel's former glory. Several pieces of the tenants' artwork decorated the stairwell and amid the construction mess were visible signs of a vibrant community of residents who cared deeply for their home.

I had only a vague sense of the Chelsea then, primarily through the film *Sid and Nancy* and from living in New York on the edge of the punk scene. But I had friends who had a great appreciation for the hotel. I had actually been there once before: in the early 2000s, in my first years in New York City, I was invited to a birthday party at the Chelsea. My friend had rented a corner suite and invited his band and other friends (I'd been shooting the band for one of my first college projects, a kind of rite of passage for a young photographer) and at the hotel I drank and smoked and took pictures of my friends drinking and smoking. Like many before and after us, we'd gone to the Chelsea to capture something of the rock stars stumbling through the hallways and making music until the sun came up. For many decades, an aura of fame and creativity emanated from the hotel.

Struck by what I had seen during my architectural shoot at the Chelsea, I set out to get a full and complete look at it, to photograph the homes of the last remaining residents before they were renovated and the historic units were further sterilized. At that time the word was out that the Chelsea's demise was imminent; I had precious few months before it would all disappear. I started to learn more about the Chelsea and read books about its history. I brought on friend and documentarian Ray Mock to write and collaborate on the project. Though I wouldn't connect the dots until later, he was a member of the band I had shot some fifteen years earlier on the night I was first introduced to the Chelsea.

A sympathetic architect connected me with several of the residents and I began sending them letters with samples of my work. I sent pictures of monasteries and temples I had recently shot in Western Sichuan, China, seeing those photos as somehow akin to the

kind of bohemian sanctuaries I expected to find at the hotel. I wasn't wrong. I met Tony Notarberardino for the first time in 2015 and entering his apartment was like crossing into another dimension. In his living room, lit by dozens of candles, my wife and I were rapt as he told us about his life in the hotel and about the wild parties he'd thrown in his space. An absinthe decanter sat on the table and a large Buddha stood framed in an arched nook. His bedroom was painted in deep reds and ochers and decorated as a kind of burlesque netherworld. When we stepped from the hotel onto Twenty-Third Street it truly felt like we were reentering the normal plane of existence; the sounds of traffic suddenly returned and we found ourselves back in the real world. But Tony's home had created a distinct and powerful shift in my perception of the hotel and I began to form a deeper understanding of the worlds people carved out there: his apartment was not only an extension of his personality but a collection of the lives of those who had lived there before him. It was Australian artist Vali Myers who had painted the bedroom, which was later occupied by Dee Dee Ramone and his young wife, Barbara. The Chelsea is a collaboration across time, an accumulation of the marks so many have made on it. At least until now.

The renovation of the Chelsea has progressed slowly, very slowly. My initial concern about a quick reopening of the hotel was unfounded as the months stretched to four years. In the intervening time it has changed ownership twice and it's still unclear when the Chelsea will finally reopen. At the time of writing there is a Stop Work Order in place and multiple lawsuits are pending. In the midst of ongoing renovation there has been

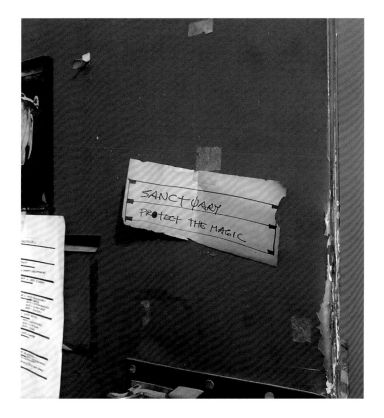

terrible destruction, but there have also been victories. The remaining tenants, many of them having formed a coalition, have claimed their rent stabilized status and may remain at the Chelsea. Things are changing, but they're not dying or dead, as I had originally speculated. No one would contend that a radical renovation like this can preserve everything, but many of the people who live at the Chelsea have found a way to stay there. And over time, the project evolved from a requiem to a celebration of what lives on at the Chelsea.

This project is about how creative people forge a place for themselves in the midst of turmoil. The photographs in this book capture a moment in this process and frame an instant of a city in constant transition. It would be false to claim that the Chelsea's history has been peaceful. But although gentrification and renovation have strained tenants' quality of life, these burdens have replaced an existence in which the front desk was protected by bulletproof glass and drug use proliferated within the hotel's walls. Despite the uniqueness of the hotel, its tenants tell a familiar narrative of life in a rapidly evolving city and increasingly exclusive real estate market. This book is about how a group of eccentric and varied personalities coexist and preserve the oral history of a rich and important part of New York City. The tenants have found a way to create and sustain a refuge where life and creativity have flourished. Gone are the times when those living alternative lifestyles could find shelter here for meager rents. The spaces that can accommodate artists who have yet to achieve broad success have long since moved far from the Chelsea. But those artists who found that here have persisted; they're still living creative and important lives.

On one of my last shoots for this book I met a great artist and tenant at the Chelsea, Bettina Grossman. Though she decided not to be part of the project, I noticed on her door as I was leaving, a small scrap of paper with the handwritten words "Sanctuary — Protect the Magic." I hope my work will help to preserve and share some of the magic of the Hotel Chelsea.

WHEN WE BEGAN TO DOCUMENT the remaining occupied apartments in the Hotel Chelsea in May of 2015, the best and the worst days already lay behind the famed building. We knew about the Hotel Chelsea and its history as a sanctuary for artists and creative people, but we had no idea what it was like to live there. We had heard about many of the famous people who had stayed there and the scandalous events that had unfolded in its rooms, but we didn't quite grasp just how important a role it played and continues to play in the lives of the countless artists, musicians, and writers who have quietly toiled in their rooms for many decades. As the hotel changed owners multiple times in recent years and we witnessed the conflict between the successive owners and tenants playing out, we wondered what exactly was at stake. What was left of the Hotel Chelsea's fabulous apartments and its community of artists and bohemians?

Built in 1883 as one of the first cooperative buildings in New York City and briefly among its tallest buildings, the Chelsea was under the ownership of David Bard, Joseph Gross, and Julius Krauss from 1942 and was managed by Bard. Comprising both residences and hotel rooms, it was already a storied haven for artists and writers by the time David Bard left the day-to-day management to his son Stanley in the early 1960s.

Under Stanley Bard's leadership, the hotel flourished as a magnet for leading figures in art, music, and literature, as well as for others wanting a quiet place to work. It became a cultural institution in New York and acquired a near-mythical, not entirely flattering reputation. The sordid side of its history has been thoroughly documented in numerous books and films, and a few notable anecdotes resurface in the pages of this book, recounted by firsthand witnesses. Its cultural significance, particularly during the 1960s and '70s, is hard to overstate.

But by the early 2000s, decay pervaded the building and serious allegations of financial mismanagement were levied against Stanley Bard. In 2007, Bard was ousted by the board of the Chelsea (which comprised descendants of the Bard, Gross, and Krauss families) and in October of 2010, after several interim managers failed to restore its financial health, the building was put up for sale. In May of the following year, it was acquired by the notorious developer Joseph Chetrit. For two years, during what was perhaps the darkest hour in the hotel's history, Chetrit tried unsuccessfully to empty the building of its remaining long-term tenants. Determined residents fought back and Chetrit eventually gave up his plans. The hotel has changed hands twice more since, and while the new owners have been more

amenable to the concerns of the dwindling number of residents — around sixty to seventy remain — ongoing construction in the building has profoundly affected their lives and work.

Under these conditions, shooting the building's apartments and talking to their inhabitants was not easy. As we were working on this project, some residents accepted an offer to have their unit renovated or to move into a different unit in the building. Scheduling was often challenging. In some cases we captured the old apartment, but conducted interviews up to two years later in a new, completely different apartment. Other apartments have barely changed since work in the building started. Some residents agreed to talk to us, but decided to move out before we had a chance to meet. A few refused to be involved with our project entirely.

Many of the remaining residents' stories revolve around the singular character of Stanley Bard. He was divisive: curator of artistic personalities, enabler and patron of struggling artists, and father figure to many — greedy landlord and negligent property owner to others. But no matter his failings, the Hotel Chelsea would not have been the same without him. Bard died in 2017, after witnessing the gradual undoing of his life's work. We never had a chance to meet him, but we were fortunate to catch a glimpse of his outsize personality through the eyes of those who knew him best.

We are eternally grateful to the residents who shared with us their stories and the stories of their homes and loved ones. We could not have imagined the worlds that opened up to us, for what emerged was not a story of decline or struggle, but a lesson about the importance of security and peace of mind for creative people to work and pursue their passions. Each door in the building, we found, harbors a promise of unimagined wonders.

What we discovered was not the Chelsea of the Beats, Janis Joplin, or Patti Smith, but a community of residents no less serious about their lives, their work, and their art who were determined to fight for their own well-being as well as the building's legacy. We found that the spirit of the Hotel Chelsea is still very much alive within its thick, famous walls. We found that there is an intangible quality to having a place like the Chelsea in New York, and that it is worth preserving, even as the building and the city are roiled by change. And we found that amid the chaos of demolition and construction, lawsuits and health hazards, there is still a hopeful willingness among the residents to embrace whatever the Chelsea may become.

Just like the rooms of the Hotel Chelsea, none of these stories are alike. Like the many layers of paint on the hotel's fireplaces and window frames, these stories became more interesting and varied with every new fact or anecdote we uncovered, and hinted at countless others beneath the surface. Some of them have been told before and many more have been lost in time. We hope that by sharing a few of them we can help to preserve a small part of the hotel's history and open a window to its future.

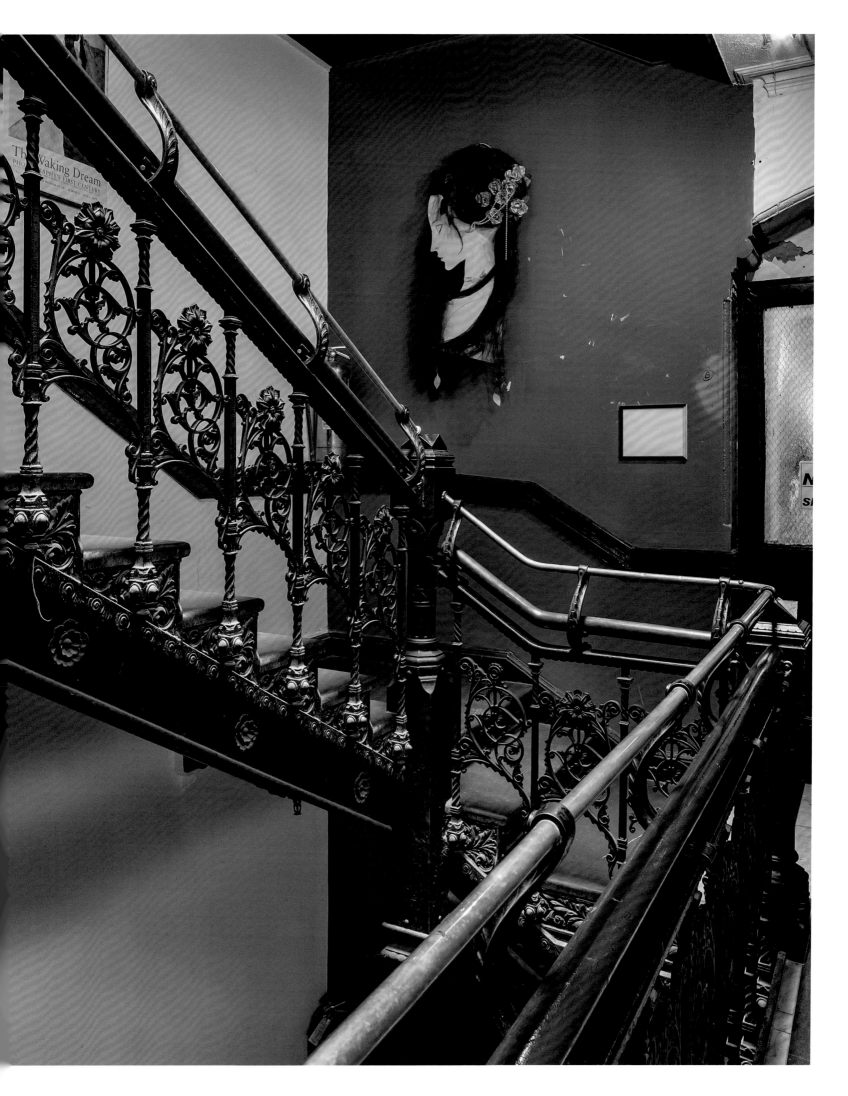

GOTHAM
COMEDY CLUB
NEW YORK CITY
.gothamcomedyclub.com
212-367-9000

222 West 23rd Street

OMNIBUILD CONSTRUCTION, INC.

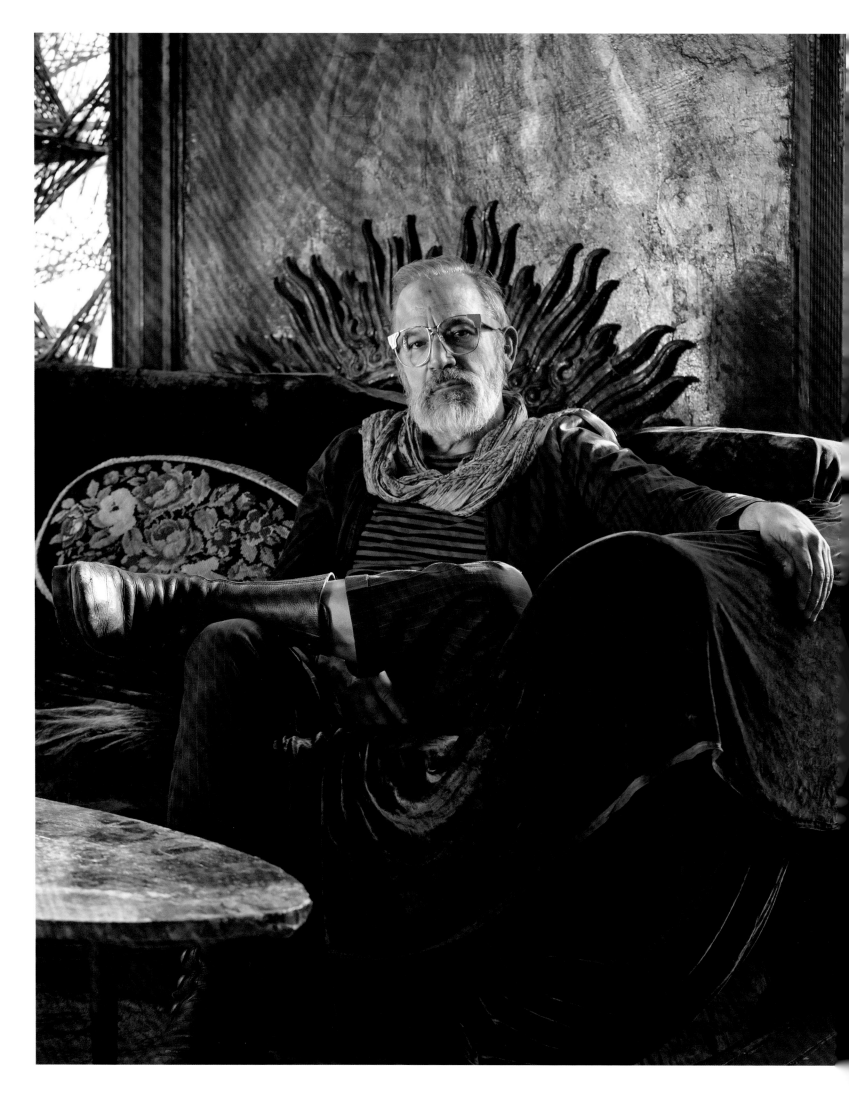

GERALD DeCOCK

HIGH ABOVE TWENTY-THIRD STREET, residents of the Hotel Chelsea's top floor have long enjoyed fantastic light and views of the city, thanks to large windows, southern exposures, and access to outdoor terraces. Gerald DeCock, a quick-talking Renaissance man, has lived in his rooftop studio since 1994. During that time, both his room and the roof outside his windows have undergone dramatic changes.

Unlike those among the hotel's residents who stumbled upon the Chelsea by chance, DeCock was familiar with the building and its legacy before he arrived at its doors. When he moved to New York in 1984, a friend gifted him photographer Claudio Edinger's book *Chelsea Hotel*, a captivating collection of black-and-white portraits of many of the hotel's residents and employees. Whether they were already famous or had merely followed an unusual path, in Edinger's photos the wildly individualistic inhabitants of the Chelsea unquestionably belonged to the building. DeCock was fascinated by the book, but once he settled into the city a few blocks north, he admits, he forgot about the hotel. "I never even walked into the lobby."

During a stint in Paris, where DeCock was working as a hairdresser in the fashion industry, he befriended a photographer who lived at the Chelsea and once back in New York he became a frequent visitor to the building. When a rooftop studio opened up, he jumped at the opportunity to live there, though not without first having to navigate manager Stanley Bard's unpredictable moods. "It was much smaller than I thought it would be for the money. I could barely afford it." To make it work, DeCock negotiated for the adjoining roof space as well. DeCock recalls, "He threw the lease at me and told me to get the fuck out of his office." Resigned, DeCock had left for a job in Anguilla when he heard that Bard was wondering whether he still wanted the apartment. At their second meeting, Bard was a different person. "Jekyll and Hyde," DeCock says.

DeCock signed the lease for October 1, 1994. When he went to get the key from Bard, he learned, to his dismay, that the room's occupant was unaware that he had to vacate. "It

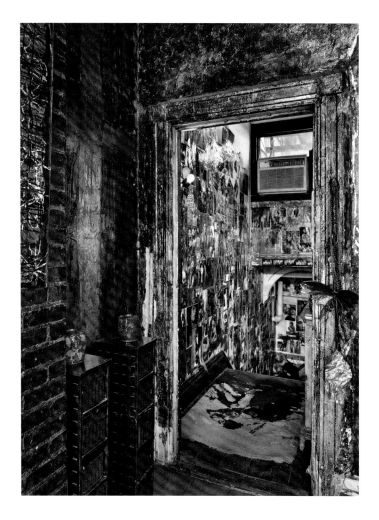

was Anthony Kiedis of the Red Hot Chili Peppers," says DeCock. "He'd been living here for two months." Bard promised he'd take care of it. He knocked on the door. "Kiedis answered," DeCock says, "and I remember — I don't know if I'm imagining this — but I remember him saying, 'Fuck off, I'm going to the Plaza!' He moved out by the end of the day." The episode foreshadowed DeCock's own tussles with Bard: Not long after, DeCock came home to find a film shoot — *Bed of Roses*, starring Christian Slater and Mary Stuart Masterson — sprawled across his terrace. Bard tried to assuage him, but DeCock wanted none of it. "They continued to build a set on the roof for another three weeks." Years later, on the last night of a trip to India, DeCock turned on the TV in his Mumbai hotel room to see the movie — and in it, his own terrace, covered in fake snow.

In DeCock's early days at the Chelsea, the hotel was still restless, its lobby, elevators, grand staircase, and hallways doubling as catwalks for transients and visitors. But inside its rooms, time moved at a different pace, as its residents burrowed in and their own desires and dreams manifested in the objects, colors, and living companions with which they surrounded themselves. Among the previous tenants of DeCock's studio (and the apartment at the bottom of his stairs, now a separate unit) were composer George Kleinsinger, his wife, and his menagerie of exotic animals. Kleinsinger, who, together with writer Paul Tripp, created the children's musical *Tubby the Tuba*, lived in the Chelsea until his death in 1982; his wife later moved to a different part of the building. "This apartment has a lot of animal energy," DeCock says. "He had a snake, he had a turtle. He seemed like a jolly guy. His spirit must be here. I've never seen him or seen ghosts, but this apartment has such a good vibe."

Once he had settled in, DeCock quickly set out to redecorate, turning his studio into one of the most visually arresting spaces in the building. He started with his brick walls.

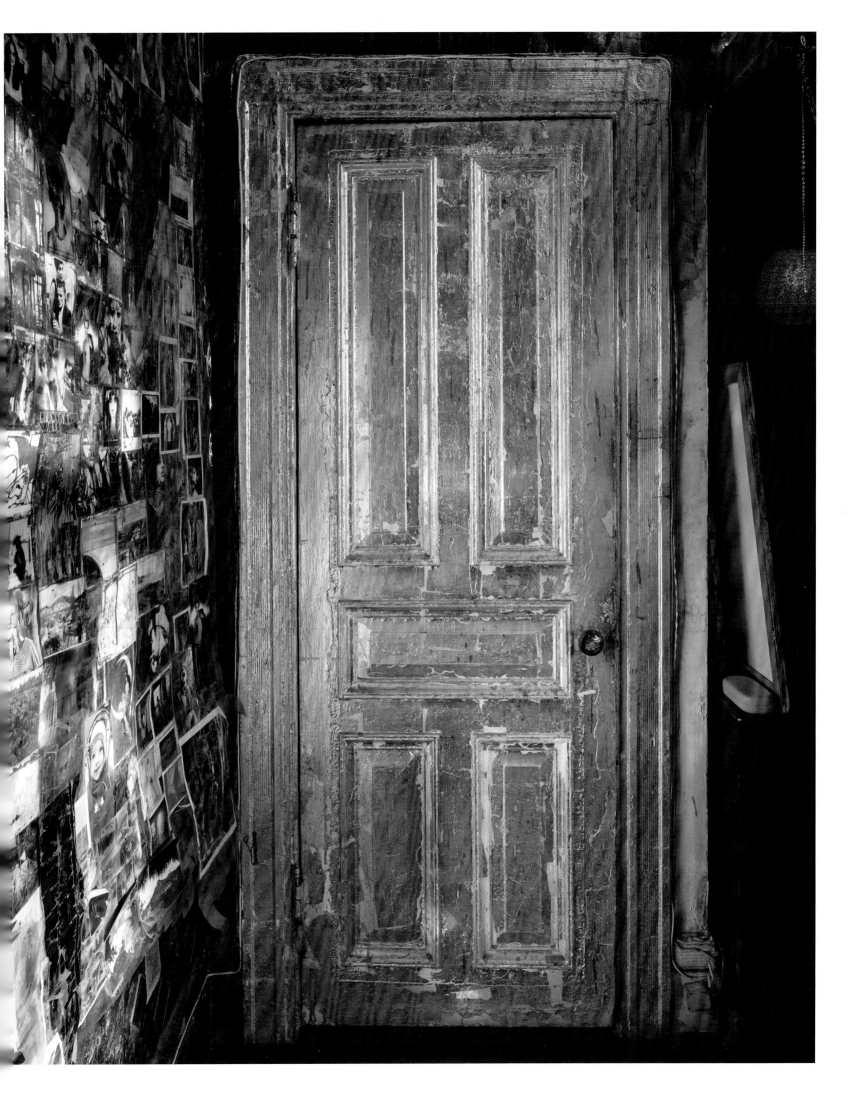

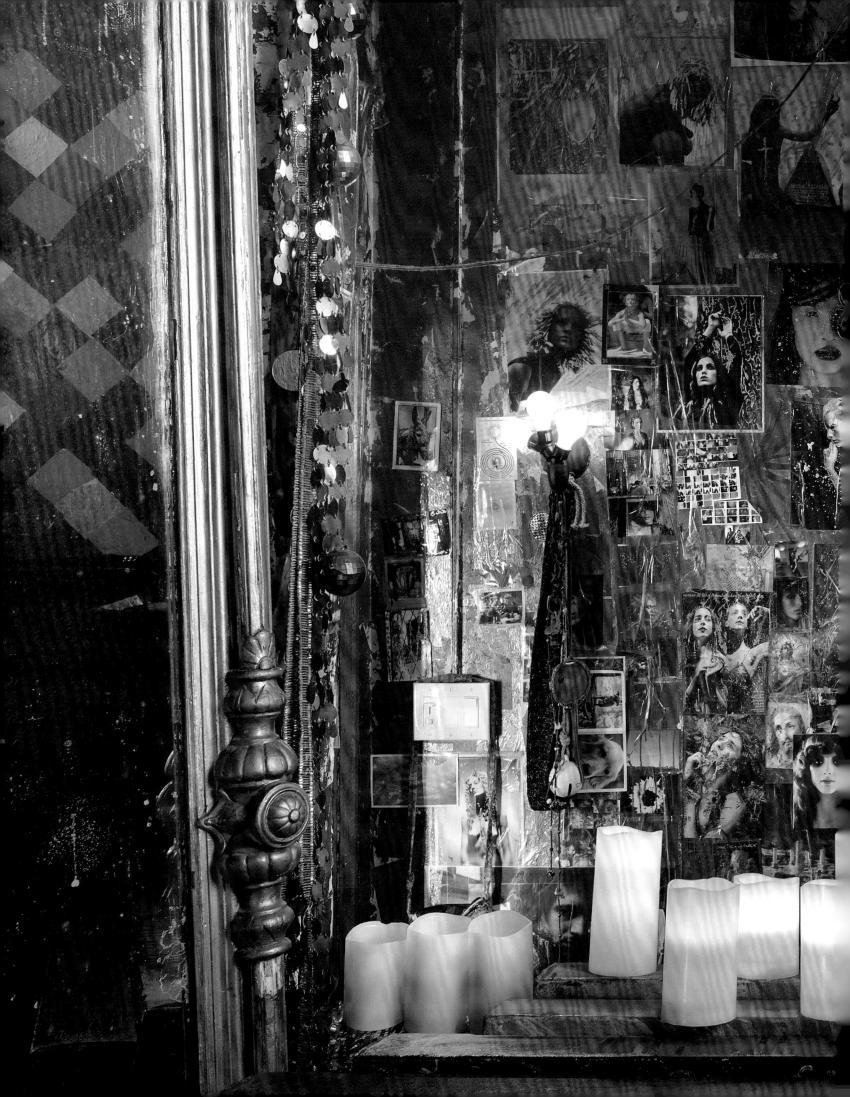

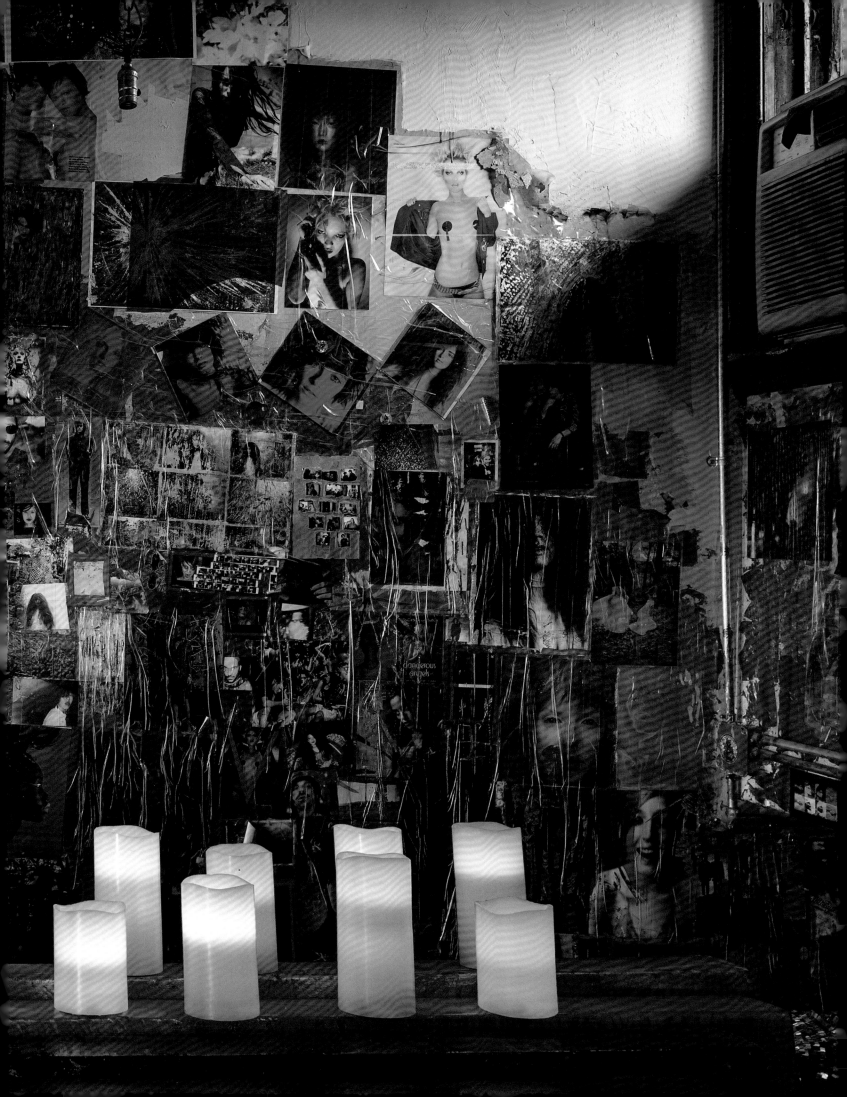

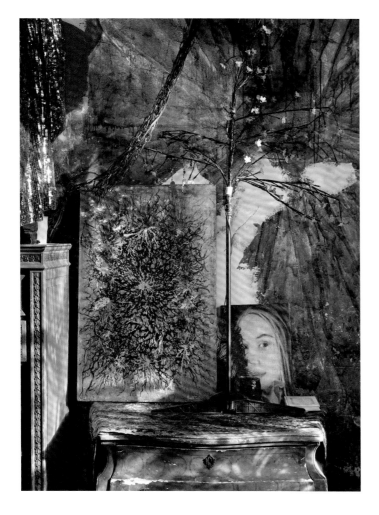

"I used gold, silver, and copper leaf." Once he had begun the process of transforming his space, he found that he couldn't stop. "I didn't really have a plan. I was possessed."

After entering from the tenth floor and climbing a narrow staircase, visitors to DeCock's studio step into a short hallway. To the right, the wall is plastered with a collage of photos decorated with smears of gold paint. Many are shots of stylish models. Others are more intimate, perhaps of friends or relatives, and more than a handful have been taken in this very room. All of the models have great hair. To the left, a doorway is taken up by chest-height painted canvases leaning against one another; their top edges, covered with candles, serve as a makeshift counter. Beyond is a small alcove — DeCock's kitchen-slash-dressing room — with a ladder leading to the roof. The efficiency of these overutilized spaces, drowning in color and imagery, is only matched by the grandiosity of the studio's main room, with its open plan and large windows.

DeCock is charming to begin with, but when he talks about the transformation of his space, he becomes even more animated. "I was super inspired by the purity of color and light and vividness," he says of a trip to India. "I was really into it. And into deep, rich jewel tones. I like things to be very, very vivid; I don't like black and white. And because my apartment is so sunny I wasn't afraid to paint my windows." He approaches decorating as he did painting, another one of his creative outlets. "When I was painting, I never said, Okay, I'm just going to use orange and yellow. I always ended up using every fucking color every time. I think the place tells you what it wants to be." Since the explosion of color on DeCock's walls delivers plenty of visual stimulation, he is selective about the objects in his home. His furniture is sparse, but striking. There is a chair in the shape of an open, gold-and-blue hand, as if a giant statue had come to life to dabble in finger-painting. One ceiling lamp appears to be made of large lily petals. His blue velvet couch creates a rich contrast

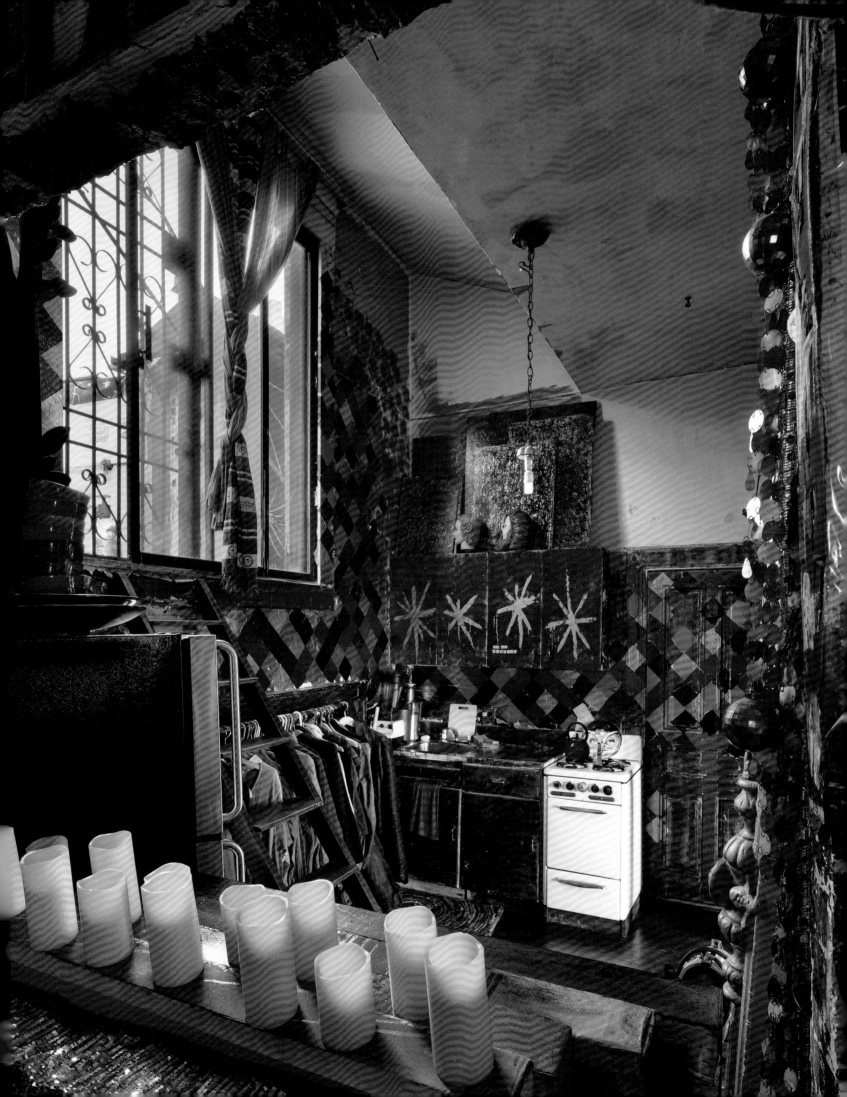

with the burnt orange wall behind it. But, like a painter's atelier or a dance floor, much of the room is open. Beads, on the other hand, are everywhere—as curtains, as a divider, and as a way to hide the ceiling fan. "They're all just plastic, nothing fancy," DeCock says. He had recognized their decorative potential while living in a previous apartment. During his first year at the Chelsea, he bought whatever strings of beads he could find in the neighborhood until he felt that he had enough. "I've spent a lot of time untangling beads."

As a creative project, decorating his apartment was as much a practical necessity as it was an extension of DeCock's many other interests. "I was always creative when I was a kid," he says. "I've been a hairdresser since I was sixteen years old and I love it, but I needed other creative outlets." His move to the Chelsea heralded a period of greater expressiveness and the hotel proved to be a bountiful environment for artistic collaboration, in part to explore his personal interests, but also as a response to the aesthetic constraints he encountered in his industry. He has chronicled these projects on his blog and website. "I did a project called Biblical Beauty. I shot thirty different people; one person in particular I shot fifteen times. Sometimes I would have a makeup artist, but usually I did everything myself. I styled and shot everything in less than two hours," DeCock says. He also collaborated on a series of photos with one of his neighbors on the roof, the filmmaker Sam Bassett. "I would use fabric to style with and we shot in my place or his place or on the roof or in his garden. We wanted to shoot at the same time every day and see how many different looks we could get. We did it for one year, twenty different subjects."

DeCock's apartment was prominently featured in two films, one-time Hotel Chelsea resident Ethan Hawke's *Chelsea Walls* and the indie *All that Glitters*, for which DeCock did production design and hair. In the film, a young woman awakes in the Chelsea, but no longer remembers who she is or how she got there. The residents of the hotel who were not famous, or creative, or had the means to abandon their inexpensive Chelsea digs have found themselves in the same state of desperate suspension. Some, in DeCock's words, "have lived here forever, but can't move anywhere else." Still, in DeCock's apartment the optimism of the old days is decidedly alive, and he is proud that it has served as a location for so many creative endeavors. If nothing else, he says, "I like that it's been documented." But does highly stylized documentation in photo shoots and films contribute to the mythology of the Chelsea as a bohemian wonderland that exists in a parallel universe from the rest of the city? "Yeah, absolutely," DeCock concedes, unbothered. "Smoke and mirrors, man!"

Smoke and mirrors—yet for decades the Chelsea really was a regular hangout for artists and celebrities, a place where something extraordinary could happen any day. DeCock met some of these better-known residents and visitors through his work. But he

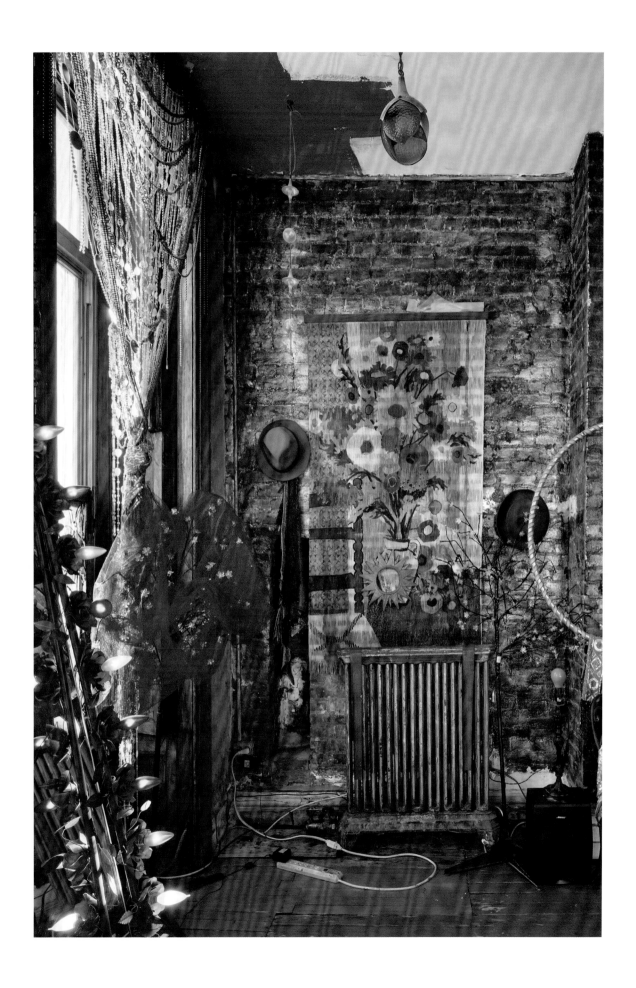

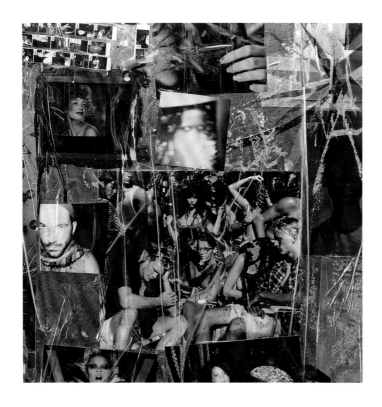

also became part of a community of long-term residents who cherished their privacy as much their freedom and who banded together when the building was sold and their future became uncertain. DeCock would ultimately side with those among the residents who did not support the same goals as the tenant association and who instead wanted to preserve their apartments as they were.

But while DeCock's apartment has remained mostly untouched, change came to the roof with an iron grip and swept away decades of lovingly cultivated greenery. Until just a few years ago, the hotel's roof was covered with lush vegetation. A painted all-seeing eye adorned a gable. The "pyramid"—the steeply pitched roof of a duplex that was at one time or another home to the musician Jobriath, filmmaker Shirley Clarke, and DeCock's friend Sam Bassett—towered above the gardens. For over a century, residents cultivated flowers, plants, herbs, and small trees, creating an oasis above the city. But, around 2009, when the hotel's new owner tried to beat the building and its remaining long-term residents into submission, DeCock remembers, "I came home and they were taking a chainsaw to my planters. They wouldn't even talk to me about it. They ripped off eighteen years worth of ivy." He rebuilt his garden, with the help of his friends, though he knew that he couldn't get too invested in it anymore. For years, most of the building's roof would be a barren construction site. DeCock retains a healthy level of skepticism, even though he accepts that the building has been swept up in an unstoppable wave of change that has engulfed much of the neighborhood and the city. "You can change your perspective and look at the beautiful things about it or move out," DeCock says.

But, for him, as for many others, it has become impossible to leave the hotel—he has joined the Chelsea tribe that Edinger documented years earlier. DeCock plans to one day collect all the art he and others have made in his apartment. He envisions a book, a gallery retrospective, and perhaps short films, roving series of images from his portrait projects. It's important to him to continue documenting his home and the creative work that is inextricably connected with it. But also, DeCock says with an excited gleam in his eyes, animated once again, "It could be kinda fun!"

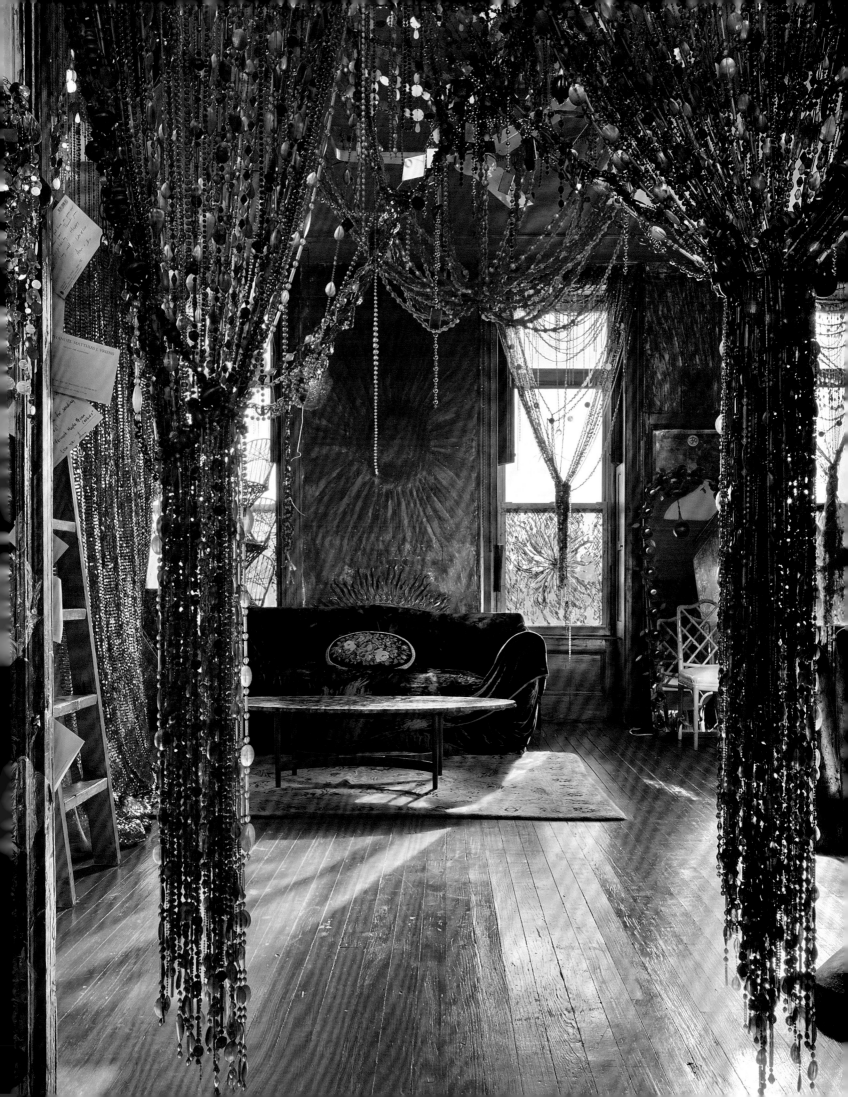

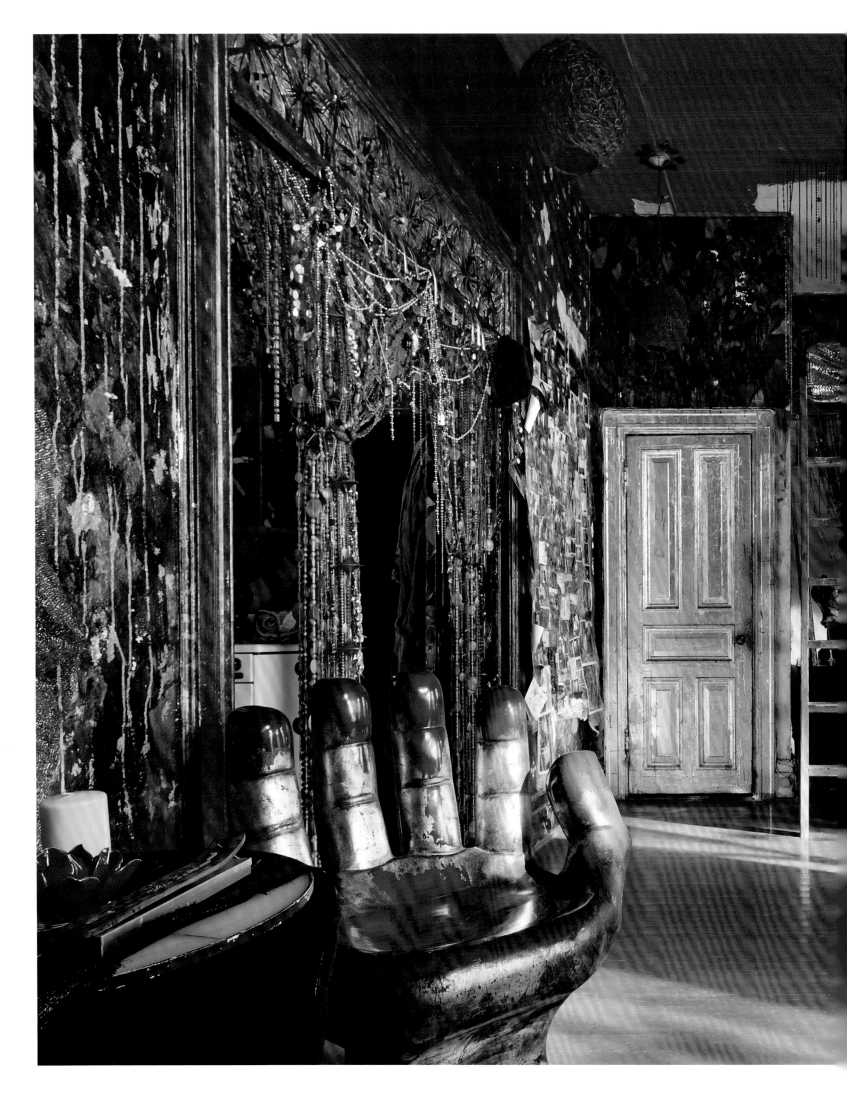

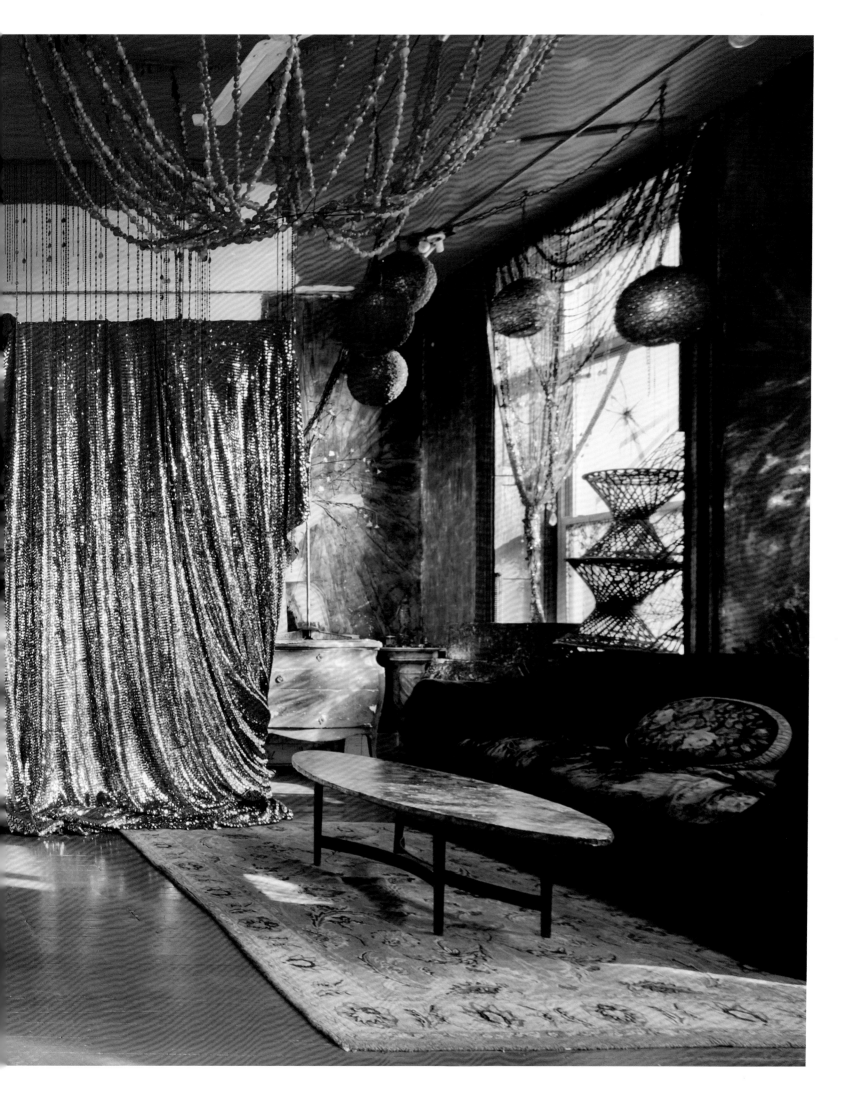

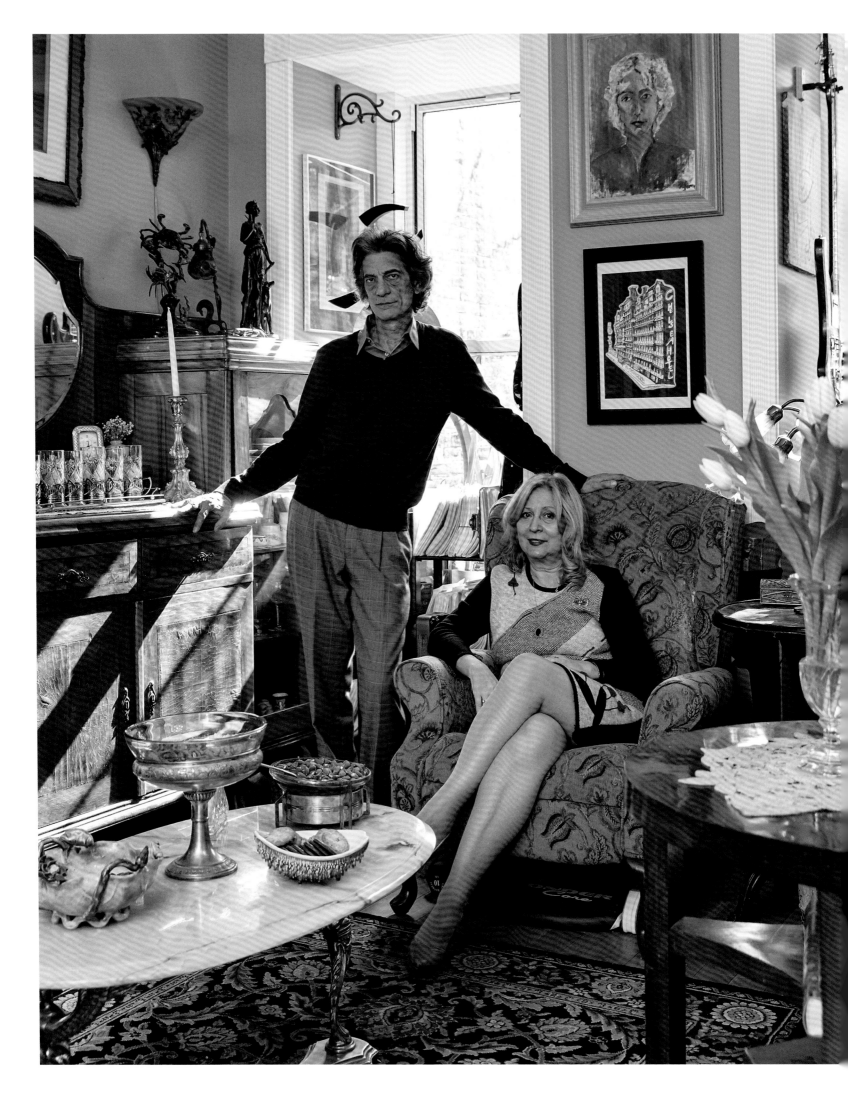

ZOE & NICHOLAS PAPPAS

Those craftsmen amain
Stretched out rope and chain,
Measured out the place,
Dug out the deep base,
Toiled day in, day out,
Raising walls about.
But whate'er they wrought,
At night came to naught.

— "Monastirea Argeşului"

'M PROUD THAT I DID THE RIGHT THING FOR EVERYBODY," says Zoe Pappas, head of the Chelsea Hotel's tenant association. By everybody, she means primarily the members of the association, those who came to her at all hours because they needed a document sent to their lawyer or a shoulder to cry on or reassurance that everything would be all right; after the Chelsea Hotel was sold to a developer, their future in the building was uncertain. But she also means everyone else who has benefited from her efforts, whether they agreed with what she did or not.

Sitting in her newly renovated apartment on the first floor, Pappas pulls no punches in her account of what has happened in the hotel in recent years, and particularly during the ownership tenure of the developer Joseph Chetrit, between 2011 and 2013. "During those two years, I slept between four and five hours maximum," she recalls in a distinct Romanian accent. "It hasn't been a pleasant experience."

Pappas's new apartment, a one-bedroom with a living room spacious enough to accommodate a grand piano, is an upgrade from room 214, the studio she inhabited before she opted to be relocated. The child of an artist mother and an economist father, Pappas was born Zoe Haretia Serac and grew up in a bourgeois home filled with music, art, and books. She and her husband, Nick, were finally able to recreate the nurturing environment

of Zoe's youth in their new home. Among the artworks on the walls are a few pieces by Pappas: delicate, impressionistic paintings based on Romanian folktales. "What do you see?" she asks, pointing at one of the abstract works, in which the shape of a woman is visible. It was inspired by "Monastirea Argeşului," the tale of Master Manole, a master mason tasked by the evil prince Radu with building a beautiful monastery. According to the legend, after construction stalls repeatedly, Manole unwittingly agrees to sacrifice his pregnant wife, burying her alive in the unfinished walls, in order to complete the building. Radu, jealous that the masons might build aneven bigger and more beautiful monastery than his if they are allowed to leave, traps them on the roof. Attempting to flee on wooden wings, the masons plummet to their deaths. "It's a very beautiful ballad," Pappas says. Perhaps the creative spirit that pervaded the hotel for many decades had to be sacrificed in order for the remaining tenants to preserve their homes.

Pappas immigrated to the United States as a political refugee in 1988, leaving her family and most of her belongings behind in Romania. She was determined to continue her professional career as an engineer in America and quickly found work in Los Angeles. From there Pappas came to New York in 1994 with her cocker spaniel, Beauty. A colleague had told her that the Chelsea was a haven for artistic personalities and, more importantly, that the hotel allowed dogs. "When I entered the Chelsea Hotel, I wanted to turn around and leave. It was awful," Pappas says. It reminded her of a bordello in a French surrealist movie, but she gave it a shot for the sake of her dog. Her first room was miserable. For months she harangued the manager, Stanley Bard, about upgrading her accommodation. He finally gave in when she threatened to leave and she moved into room 214, which had a big bay window and a kitchenette. It would be her home for the next twenty years.

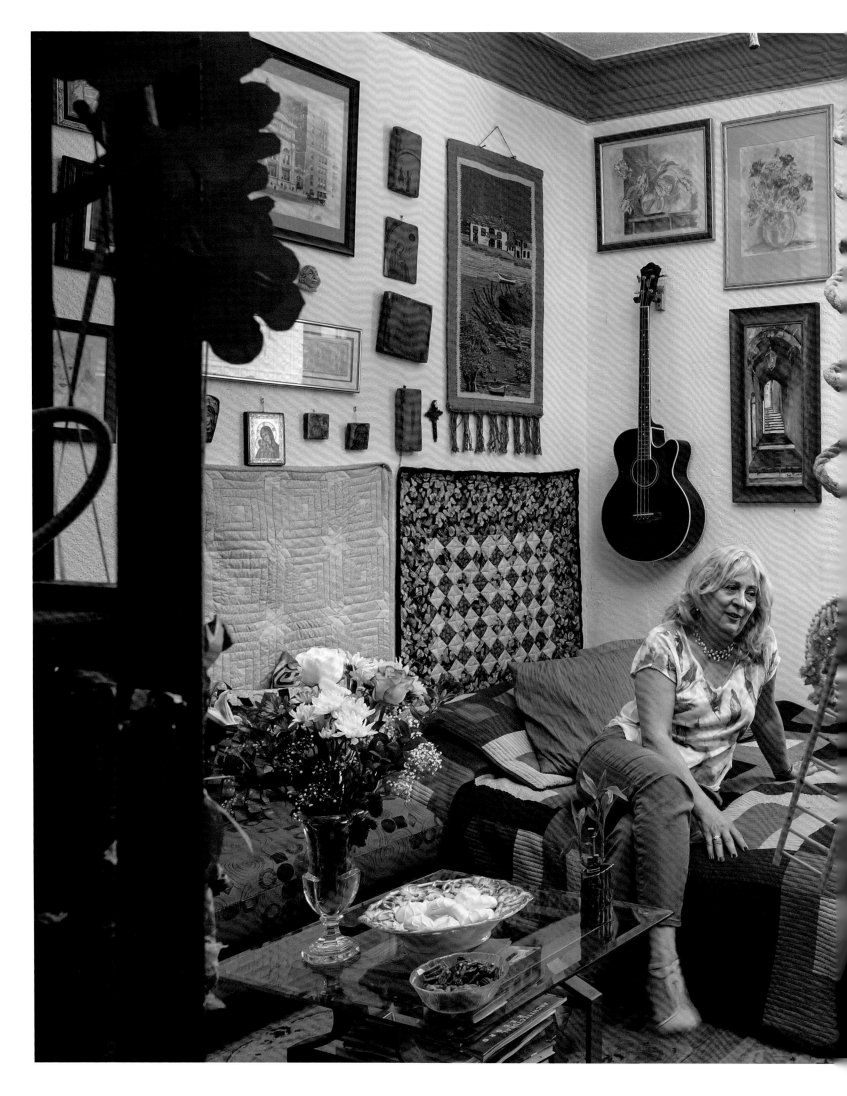

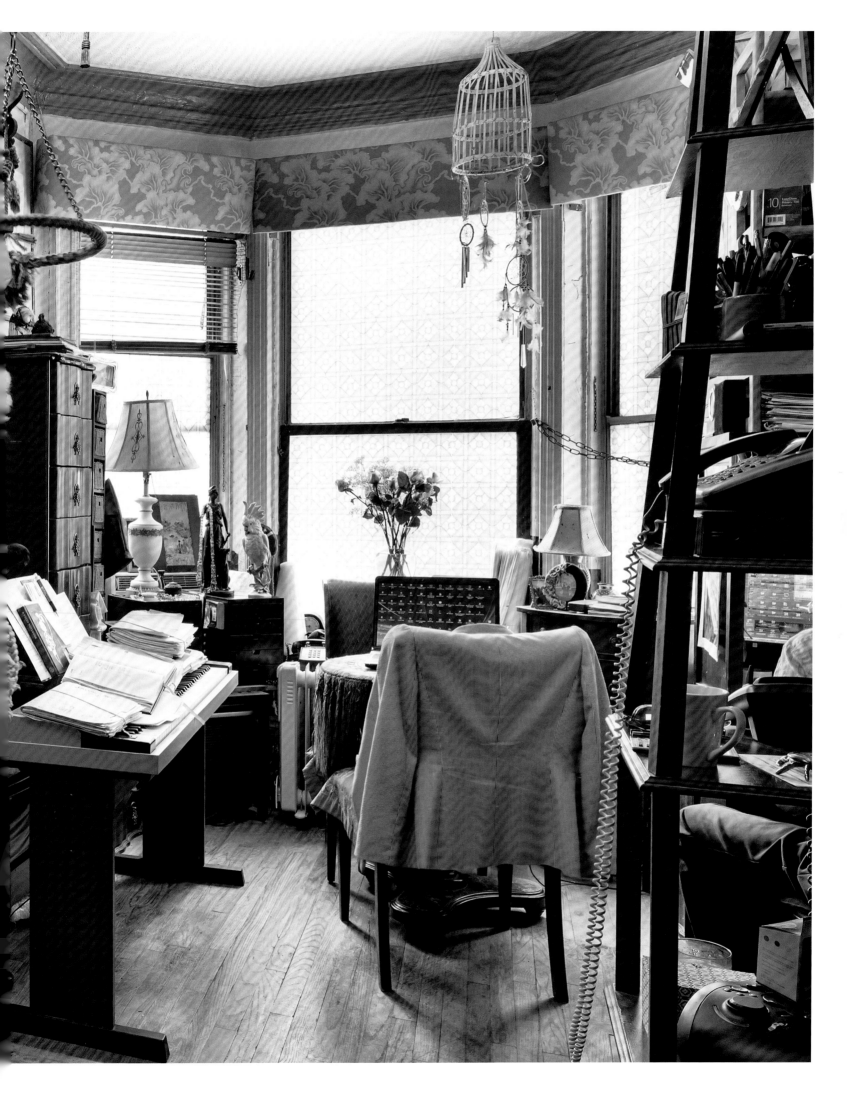

"My impression of Stanley was that he told you everything you wanted to hear. He tried to convince you that what's dirty is clean." The cockroaches in the bathrooms, the mice in the hallways? Bard never saw a single one. "I am aware that he helped a lot of people," she says, referring to the artists he allegedly let stay in exchange for artwork if they couldn't come up with rent, and she had a good relationship with him. But she wondered at the double life he appeared to live, indulging in bohemian fantasies in the hotel. "The Chelsea was like his beloved bride. It was an obsession and I don't know if it was healthy."

Pappas settled into life at the Chelsea. Fluent in five languages and conversational in several more, she was sometimes called down to the front desk to assist tourists. She got used to the presence of celebrity tenants and visitors, from RuPaul Charles and John F. Kennedy Jr. to writer Pete Hamill. She also made friends with some of her neighbors, accompanying Ruth Shomron on the piano — "She has a beautiful voice and a beautiful apartment" — and enjoying her conversations with the painter George Chemeche and the company of Mary Anne Rose, wife of the artist Herbert Gentry. She wasn't interested in what she calls the "drug culture" in the hotel. "I don't need to enhance my senses. I like to be very much in control of how I feel."

She met her husband, Nick Pappas, while on a project on Long Island. She was the structural engineer and he was the designated architect. They married in 1997. The following year, Nick Pappas started his own engineering business; his wife eventually joined him. Their two-person firm performs planning and zoning studies and works on renovations of residential and commercial properties. Among their specialties are landmarked buildings, including facade restorations, so Zoe Pappas was intimately familiar with the laws and regulations governing New York's buildings. There was perhaps no one better prepared than her to one day represent the tenants in the face of the destruction of the Chelsea Hotel.

In 2007, Stanley Bard was ousted by the board of the Chelsea Hotel after years of chronic mismanagement. Bard may have been obsessed with the Chelsea and a friend to many of its residents, but under his leadership the building gradually deteriorated. He invested little in maintenance or infrastructure improvements, while returning to his Central Park penthouse every night. "He paid himself very well," Pappas says. "He took the art and he did nothing to this building. If you love a building so much, you should show it some respect. That's the truth and it's disturbing."

Bard's ouster caused immediate anxiety among many of the tenants. Loose factions began to form as the number of evictions increased. When the hotel was put on the market in 2010, a group coalesced around Bard's son, David, who competed for ownership with a number of deep-pocketed investors. His supporters wanted things to return more or less to the way they had always been and rejected any wholesale changes to their living

arrangements. But Bard's bid was unsuccessful, and in 2011, Joseph Chetrit bought the building for a reported $80 million with the intention of emptying it of its long-term tenants and gut renovating. He didn't expect to meet much resistance.

The tenant association was formed on October 8, 2011, with Pappas as its president. Its primary purpose was survival: securing the rent-stabilized status for the hotel's long-term residents, some of whom had been there since the 1960s. "At that time, most of us didn't have a lease anymore, because Stanley wasn't interested in leases," Pappas said. Bard allegedly kept multiple sets of books and many records were lost. With invaluable guidance from the association's lawyers, Sam Himmelstein and Janet Calson (who passed away in 2017), Pappas took charge of the tenants' fight for the Chelsea.

As Chetrit set to work demolishing the building's interiors, his henchmen systematically intimidated and harassed the remaining tenants in order to force them out. Lead levels spiked, mold grew unabated, and the air quality reached dangerous levels. Valuable artwork that belonged to some of the tenants vanished from the hallways and the hotel's magnificent staircase. Cockroaches and rodents swarmed the building. Utilities were frequently turned off without notice. The industry term for these practices is "constructive eviction."

Pappas knew that in order to prevail against Chetrit, she had to keep the other tenants on a tight leash. "I told them the following: This is not a popularity contest. I don't need you to like me, but I need you to listen. We are not going to insult anybody. We are not going to use foul language." Any accusations of wrongdoing against Chetrit had to be backed up with photographic evidence or third-party assessments. And finally, "the moment anybody starts bickering and swearing, you are out. You're on your own."

At its height, 65 percent of the residents were part of the association. All they ultimately wanted was a clean, safe, and rent-stabilized home. But sentiments among the tenants were not unanimous. Some of David Bard's former supporters took matters into their own hands, unleashing a torrent of lawsuits to stop any work on the building. There was a third loose group made up of tenants who were primarily wary of making any changes to their own apartments that might compromise historical details. However, since none of the hotel's interiors were landmarked (interior landmark designations are very rare in New York City), it was unclear what constituted historical or original elements in a building that had seen many alterations since its construction in 1883. Nonetheless, this group of tenants held out without either joining the association or resorting to lawsuits, acquiescing only to minimal updates to their HVAC and electrical systems.

The efforts of the tenant association culminated in a rally in front of the Chelsea on May 6, 2012, that was attended by numerous city officials, including New York City Council Speaker Christine Quinn and Corey Johnson, her successor. "We were always

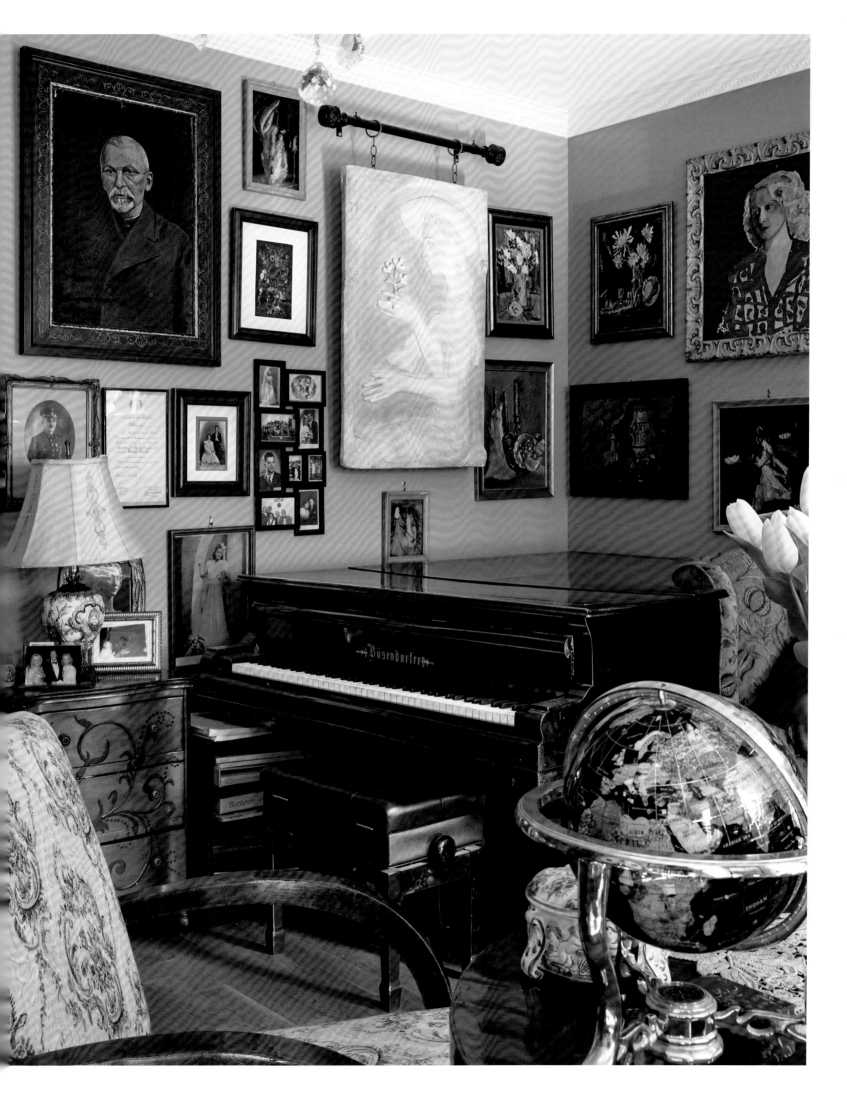

ahead of Chetrit," Pappas says proudly. She printed large posters with photos of the egregious conditions in the building and journalists were given tours of some of the afflicted rooms. The most pressing issue for Pappas was to ensure that their units would not be deregulated even if Chetrit invested a legally mandated minimum of capital into their upgrades. "That would have meant that nobody would have been left here. I said, 'Over my dead body!'"

Facing mounting costs and delays, Chetrit realized that he had lost. In 2013, he sold the building to hotelier Ed Scheetz, who already owned a minority stake. One of the first things Scheetz did after getting a three-page memo with issues requiring his attention from Pappas was to bring in pest control. According to Pappas, the exterminator caught two hundred and fifty mice on his first day in the building.

Ever since Chetrit's exit, the tenants have been able to sleep more easily, though some continued to vilify Pappas for working with the new owners (first Scheetz and most recently a group led by BD Hotels) to secure renovations, relocations, and buy-outs. As of the spring of 2019, ongoing lawsuits prevent work in the Chelsea from being completed. Pappas calls these lawsuits the work of a few "delusional, nasty people" whose goal is simply "to make the landlord waste as much money as possible."

She also has little sympathy for those who are reluctant to allow changes to their rooms. "The building doesn't belong to any of us. We are tenants," she says and adds, exasperated, "I've never seen so many people who do not believe in the legal system." Pappas remains focused on the tasks at hand in the unfinished building. Years of construction noise and dust, hostility from a few tenants, and the deaths of her two rainbow lorikeets from lead poisoning have not deterred her. "I don't regret anything."

After Master Manole falls to his death from the roof of the monastery he built, a beautiful well springs up in the spot where he perished. Perhaps one day the Hotel Chelsea will again become a well of inspiration and freedom for its residents, or perhaps new sanctuaries for artists will spring up in other parts of the city instead.

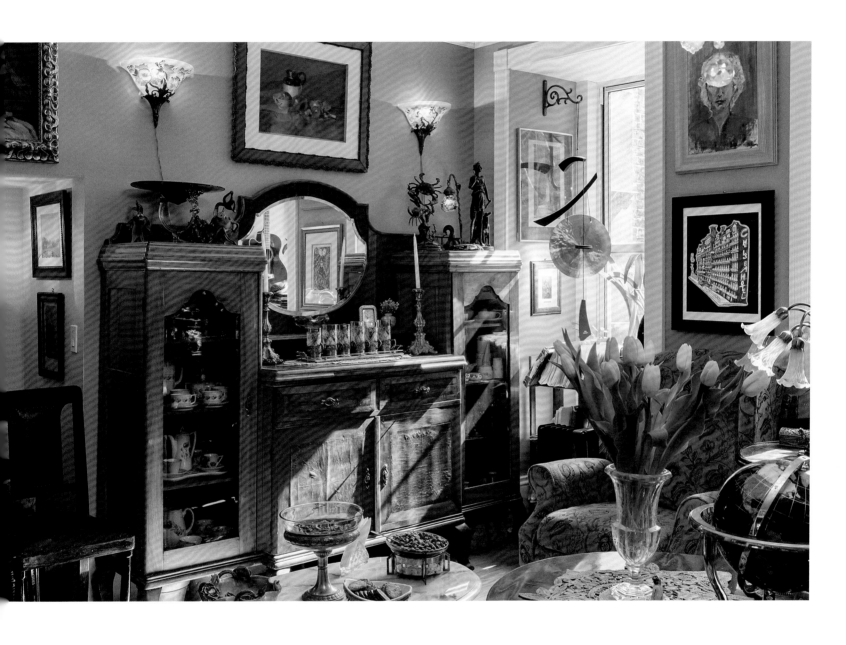

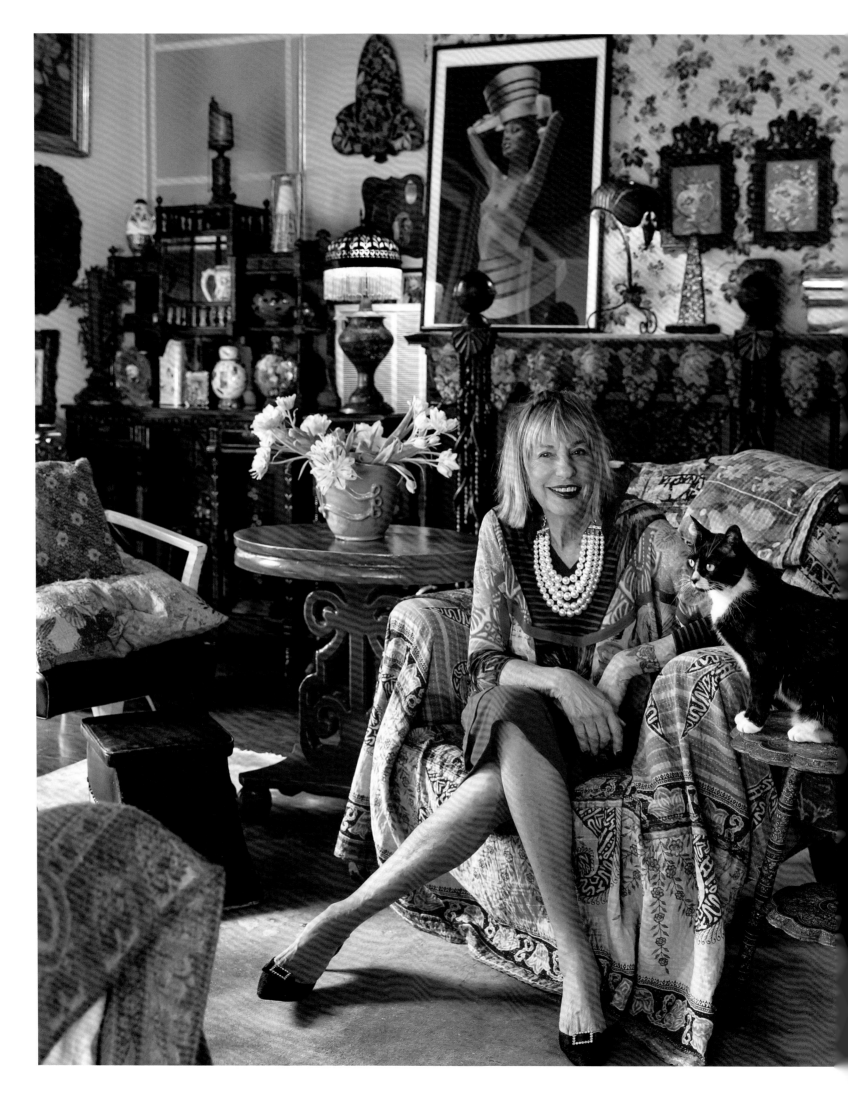

SUZANNE LIPSCHUTZ

S UZANNE LIPSCHUTZ LOVES TO START OVER IN NEW PLACES. It's no surprise that her new home in the Chelsea Hotel is still a work in progress; they always are. Lipschutz, an antiques dealer and wallpaper expert, has lived in and transformed many homes in locales from Palm Beach, Florida, to the Catskills. "I am so used to having to get rid of things," she says in a husky voice. She shows us an interior design book published in the 1980s that features one of her previous residences, a house in upstate New York. It's a riot of colors, with intricate wallpapers arranged in precise small and large pieces to cover every inch of wall space and even the floors. "This was my obsession," she says of her wallpapers and the mad decorating all-nighters she used to pull. "I was young and crazy and on drugs," she adds with a snicker.

Lipschutz moved into the Chelsea in the early 1990s. She was looking to downsize after her son, Luke, whom she raised in a succession of Greenwich Village apartments, went off to college. She was already quite familiar with the Chelsea and its residents. It was her scene. Stanley Bard gave her room 311, a one-bedroom toward the front of the building, with a small kitchen and a balcony. For the next two decades it would be her home and ultimate decorating project.

She immediately set to work transforming the space. "I spent about fifteen thousand dollars stripping the wood in that apartment," she says. At one point, all of her possessions were piled up in the middle of the rooms while a crew got to work removing twenty layers of paint from the fireplace, the windows, and the doorframes. She brought in marvelously detailed, custom-fitted aesthetic movement glass salvaged from doors from 1880 for her four transom windows. She had period-style furniture made for the kitchen, laid a glass-tile mosaic in the bathroom, and bought out a brownstone in Brooklyn just to get her hands on the wainscoting.

Then there was the wallpaper: exquisite period papers and borders selected to amplify the mood in every corner of the apartment. The small private hallway to her unit, which

she shared for years with her next-door neighbor, the actor Ethan Hawke, was covered in American Arts and Crafts wallpaper showing a lush forest scene. She later donated rolls of the same wallpaper to the Cooper Hewitt Smithsonian Design Museum. "It became this gem, this jewel box of an apartment."

Lipschutz fit right in at the Chelsea. "People think it's a weird place," she says. "It's really not." She was the owner of Secondhand Rose, an antique store she opened in 1964 that attracted an illustrious clientele, from Frank Serpico to John Lennon and Yoko Ono. The crowd at the Chelsea wasn't so different. "Everybody was creative in the building, so everybody did something amazing with their apartments," she remembers. As a result, no two rooms were the same and many of them were overflowing with art, music, and ideas. There was an immediate sense of community. "All my best friends lived here. We were all in each other's apartments all the time and everybody knew what was going on." If you found yourself sitting on the stairs crying, "there was always somebody to sit next to you."

Among her friends and neighbors was the family of the artist and director Julian Schnabel, whose daughter Stella would later live in her own room in the hotel. Lipschutz used to barter with Schnabel for artwork and one of the two Schnabel paintings she owns is a life-size portrait of her and her son in Montauk, painted on velvet. Upon her insistence, Luke and his wife, Glynis Cotton, eventually moved into an apartment on the ninth floor, and her twin grandchildren, Jude and Griffin, were born into the Chelsea and grew up there until the family needed more space. "That was the most fabulous time for me."

Right down the hall from her son and his family was the home of the poet and artist Rene Ricard and his partner, the photographer Rita Barros. "He used to read bedtime stories to my grandchildren every night. That was just magical, because Rene was this unbelievable intellect. There wasn't any subject Rene didn't really know. He was wonderful with children," Lipschutz recalls. Ricard died in 2014 from cancer. "Nobody knew he had a brain tumor. It was a horrible thing. He was crazy as could be, but a total genius and so much fun."

Lipschutz was also friends with the antiques dealer Alan Moss. It was he who inspired her to strip the wood in her room. "He had Viva's old apartment. It was huge." Viva, the actor and Andy Warhol protégée, had taken it upon herself to expand her footprint in the hotel when her daughter Gaby was born. "She literally broke through the plaster wall and took another apartment. Stanley hated her forever." Moss was later thrown out by the usually lenient manager for not paying rent, a notable achievement of a different sort.

In 1975, Lipschutz was renovating a former hotel in the Catskills and looking to replace some of its ornate wallpaper. She found thousands of rolls of it stored away at a

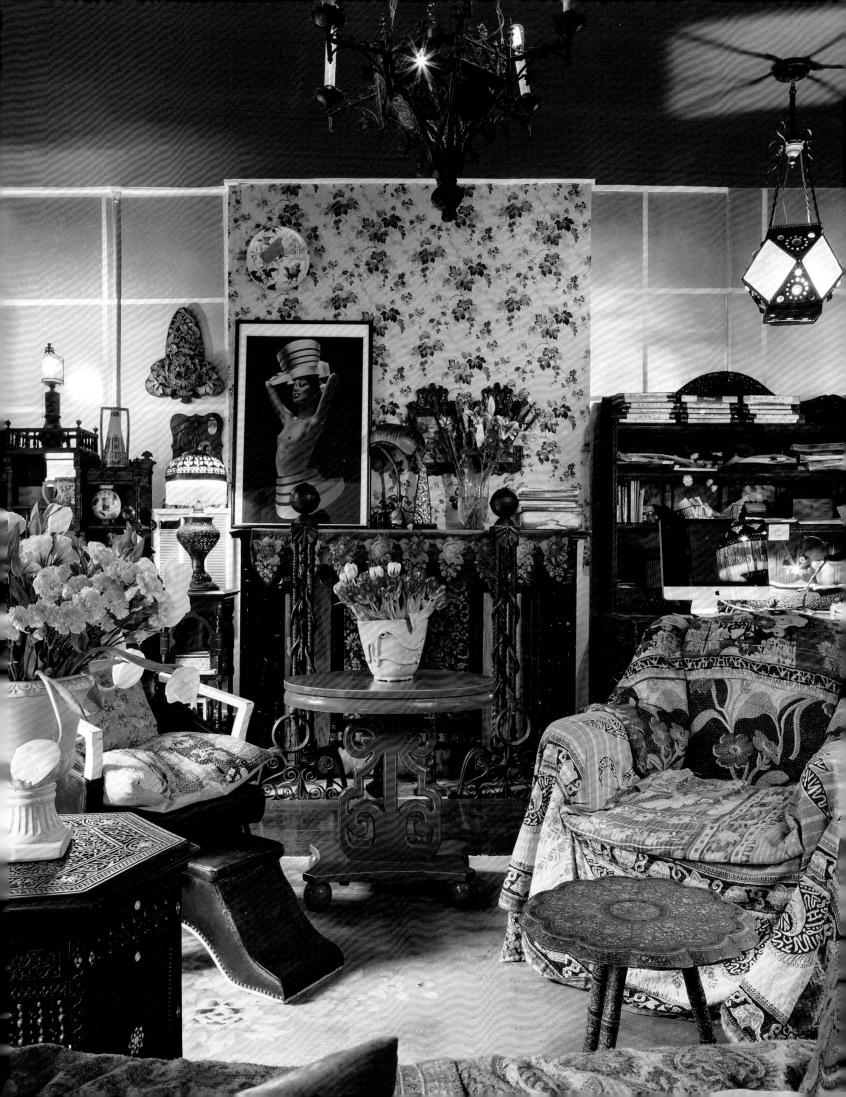

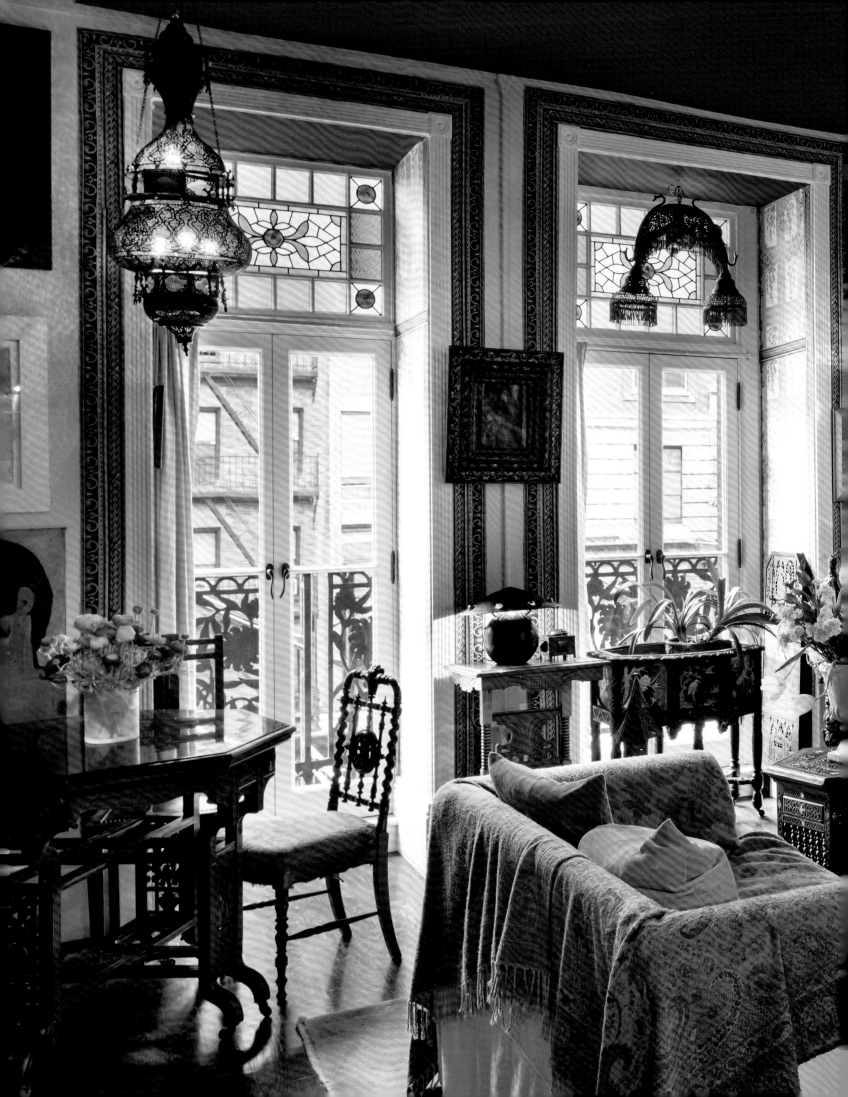

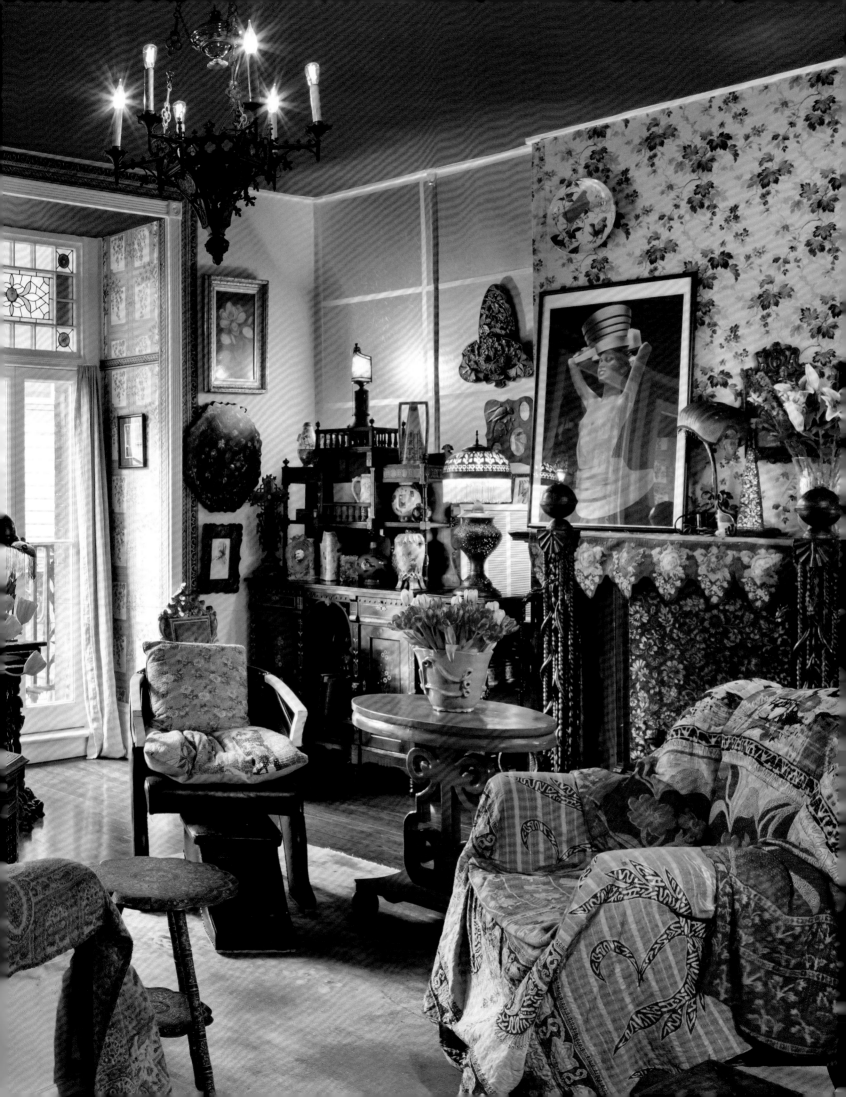

local hardware store. It was an epiphany that sent her on a scavenger hunt across the country. Old wallpaper "was sitting in every hardware store that was built before the 1930s," she discovered, tucked away in basements, storage rooms, and on the tops of shelves. "It would be a dollar a roll or a double roll and it was the most beautiful, hand-printed stuff you ever saw. So I started buying it." First she just used it for her own projects. Then, on a whim, she stocked some of it in her store. "It flew out, no matter what price I put on it." She became the go-to source for movies and TV productions with a period set design and soon enough "anytime you saw old wallpaper, it was mine."

"I went all over the world. There wasn't anywhere I wouldn't go to get wallpaper." So good was she at finding rare paper that nowadays there are few treasures left to unearth. "The great wallpaper has been gone for a while," she says. After closing her retail store a few years ago (she still maintains an online presence), she is now working on reducing her remaining inventory. "I've lost interest," she claims. Others have stepped in to supply the film and television industries with cheap reproductions. The idea seems downright offensive to her. "If I show you the paper you'll understand."

She fetches a book of samples and points out how one is made with vegetable dye and another printed on 1920s newsprint, because it was the cheapest option at the time. Yet another set of samples consists of black paper with delicate, crisp designs. But rather than using black paper, its manufacturer printed black ink on white paper and overprinted it with other colors. "They're so rich. I'm obsessed with them! Look at the colors!"

Then there's a wallpaper with a bold, yet oddly irregular geometric pattern reminiscent of pixelated flowers on vines that wouldn't be out of place in a contemporary New York City home. "This is a Wiener Werkstätte wallpaper that was printed in this country," Lipschutz tells us. The group of artisans from Vienna whose clean-lined, geometric style was a precursor to Bauhaus and Art Deco opened a branch in New York in 1922. "Look at them. This was your average poor person's kitchen wallpaper."

We let our hands run over the subtle bumps and creases in each paper sample, gently rubbing it between our fingertips to test its pliancy and thickness. Each feels different; each has its own story. "Amazing, isn't it?" Lipschutz says. "I love my papers. There's no reproducing them. They're handmade. They're alive. You reproduce that with a photo image, what have you got?"

Lipschutz was offered a bigger apartment, built out to her exact requirements, during Ed Scheetz's ownership tenure. She knew that her old room would need to be connected to the building's new heating, ventilation, and electrical systems, destroying much of her work on its interior, so she agreed to move. But she didn't let go of room 311 easily. "I was so upset when I left. I ripped paper down."

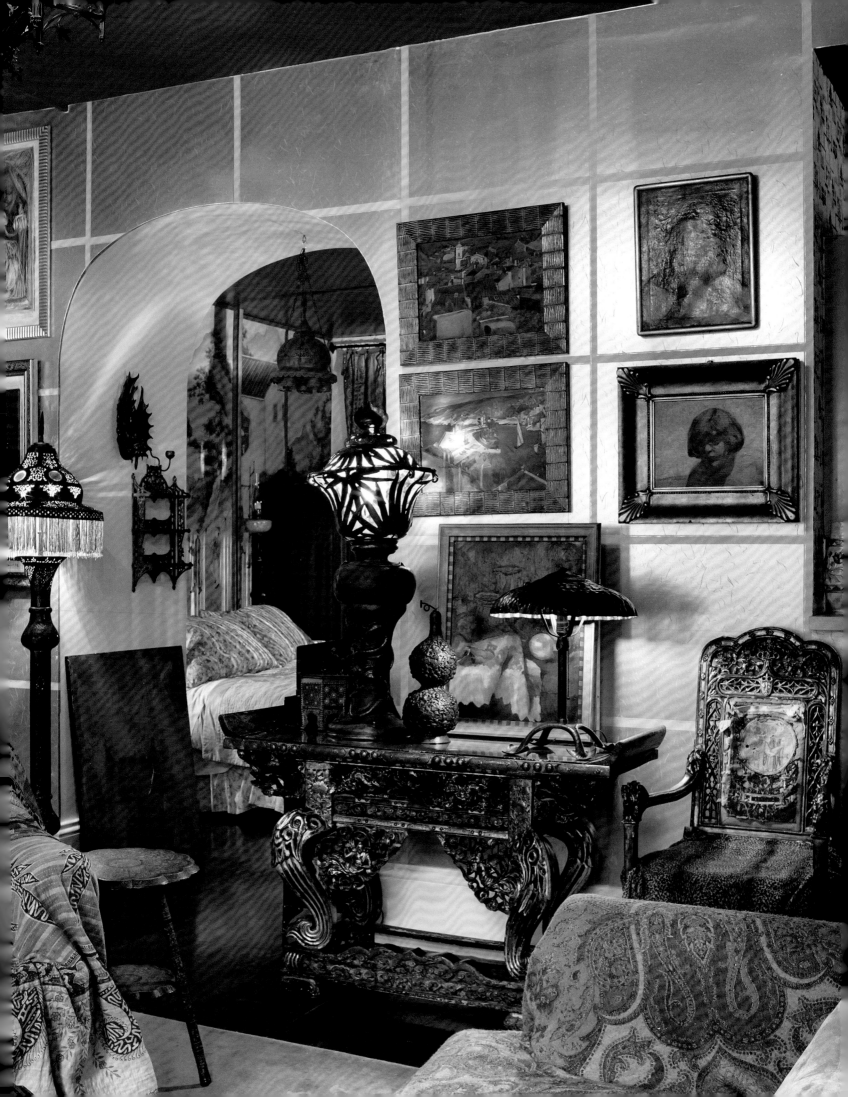

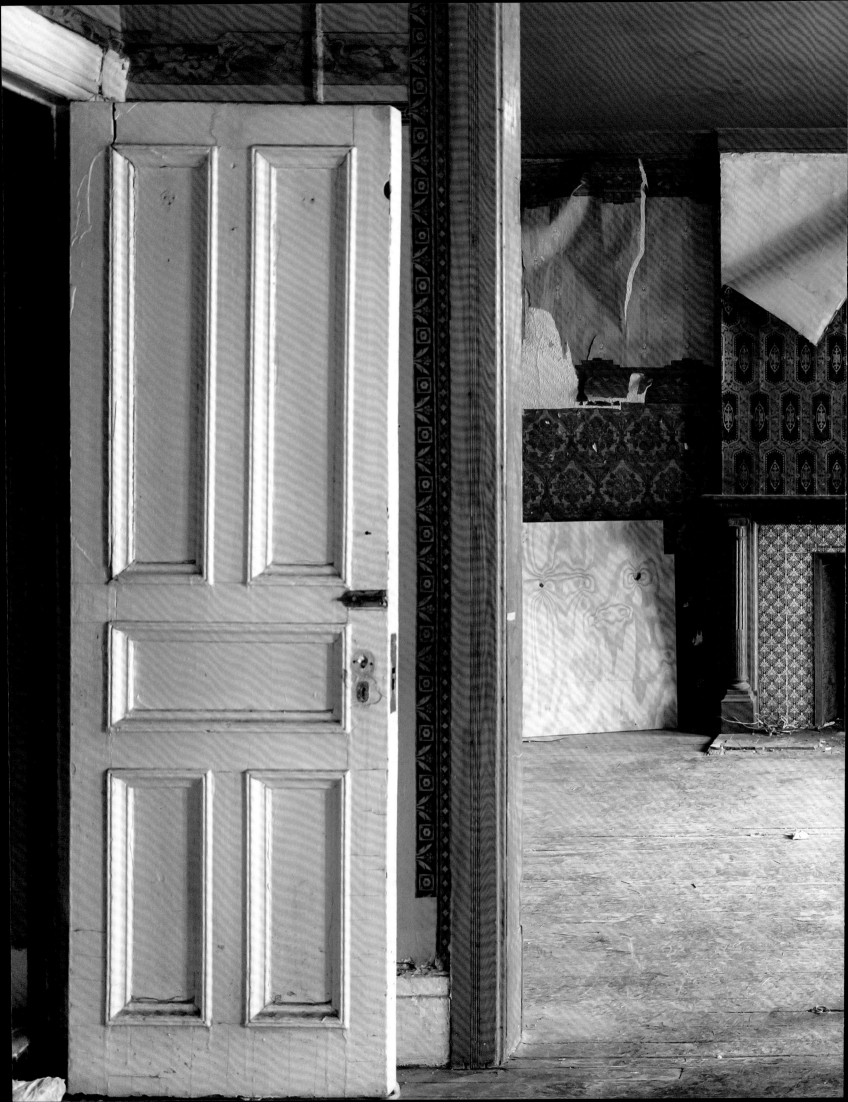

Of her new home, which she shares with her cat, Domino, Lipschutz says, "It's not done at all. When I'm in the mood I'll work on things," such as adding bits of wallpaper to the few remaining stretches of bare plaster wall (which she fought to retain) and sheetrock (which she hates). The ceiling is painted crimson, just as it was in part of her old apartment.

Schnabel's portrait of her and Luke leans against the wall in the hallway. Next to it on the back of a door is one of several Robert Loughlin paintings of his signature smoking brute that she owns. "Whenever Robert needed money, I got a painting, so they're everywhere." Also scattered throughout the apartment are works by George Condo, Donald Baechler, and William Wegman, among others. "Those were all trades. I could not afford to buy them." There is a photo of the playwright and onetime Chelsea Hotel resident Arthur Miller by Barros, which Lipschutz acquired at a fundraiser, and there are numerous impressionist-style paintings that she brought back from trips to Budapest. A pair of them hangs above an eighteenth-century altarpiece from Asia along with a few other paintings.

Her furniture, she says cheekily, consists of everything she didn't sell when she closed her store, though much of her inventory comes from room 311. An Anglo-Japanese étagère in one corner holds some of her ceramics and pottery collection as well as an elaborately detailed crucifix from Germany's Black Forest region. Across the room, a nineteenth-century Chinese case she acquired from an importer in Miami contains many more pots and vases, most of them Austrian, from the turn of the nineteenth century. Countless others populate the tops of shelves and the floor beneath chairs and side tables. She also brought her armadillo lamp; it sits prominently on the mantel of her fireplace.

Lipschutz's bedroom, which she refers to as "this sheetrock box in the middle of the room" was the only part of the apartment where the ceiling had to be lowered by more than a few inches. "I'm going to rip that ceiling down one day," she snarls. "It drives me crazy because it ruins the proportion of the room." The bedroom has an Asian theme, with late nineteenth-century paintings from China. At the foot of her bed sits a chair from the 1893 World's Fair in Chicago. The bedroom feels like a home within her home, a cozy refuge nested inside an Easter egg hidden inside a dollhouse, a product of change, yet refusing to let go of its soul.

It took almost nine months for the apartment to be built out to Lipschutz's wishes and a year and a half later it is still a work in progress. Even though Lipschutz misses her old room and the old Chelsea in general, she is glad for the extra space she got and the possibilities it offers. "I've tried to keep the place fairly sparse," she says nonchalantly. Looking at one of the remaining white walls she adds, "It will get done."

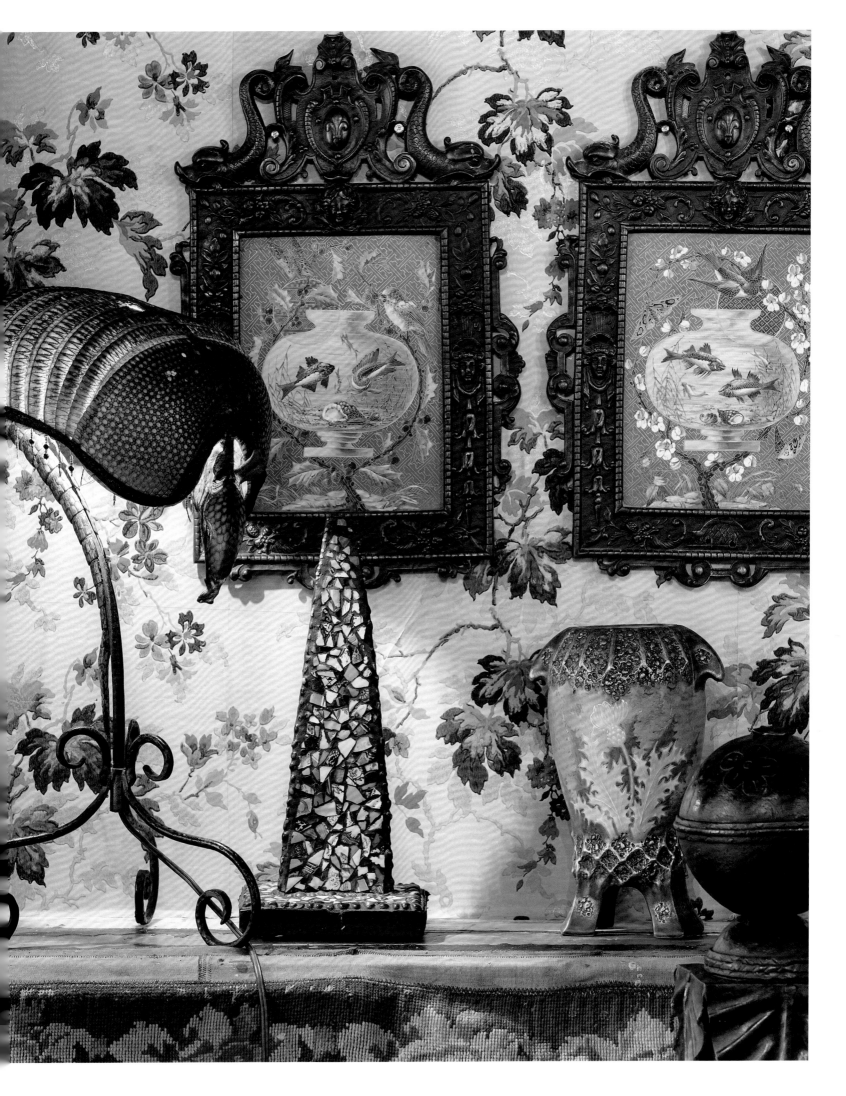

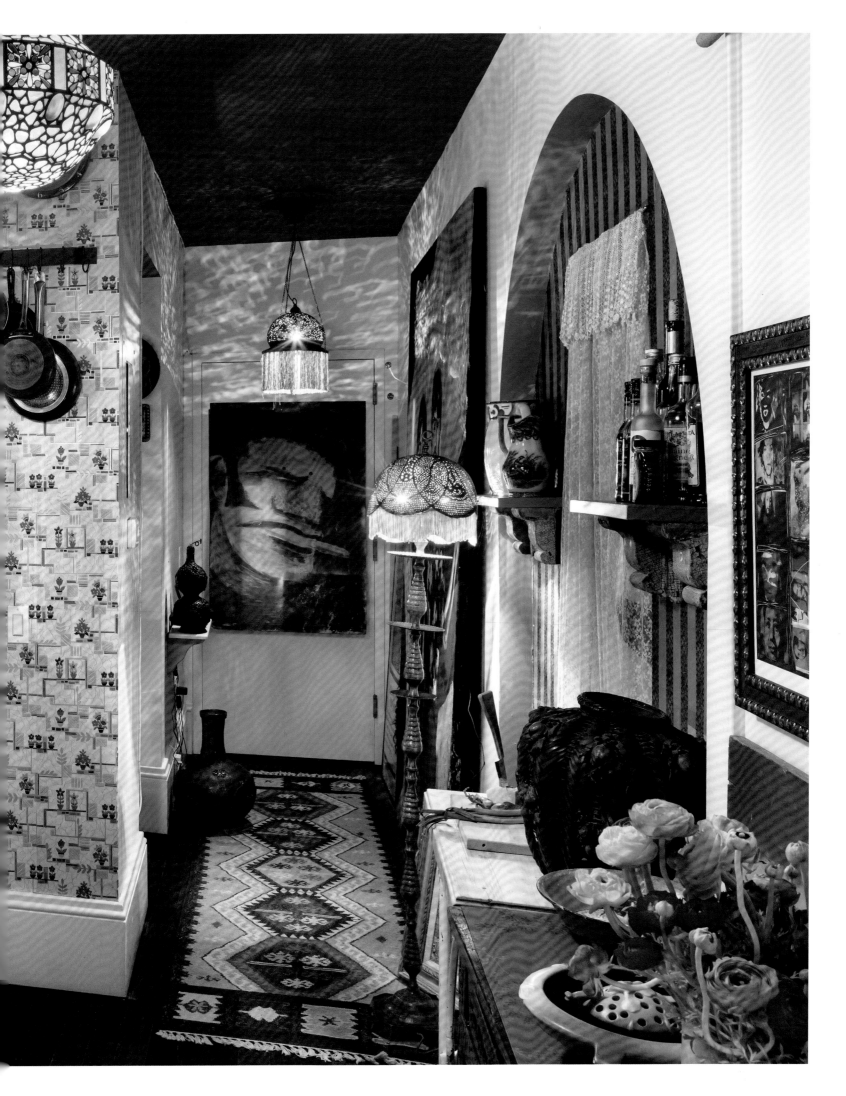

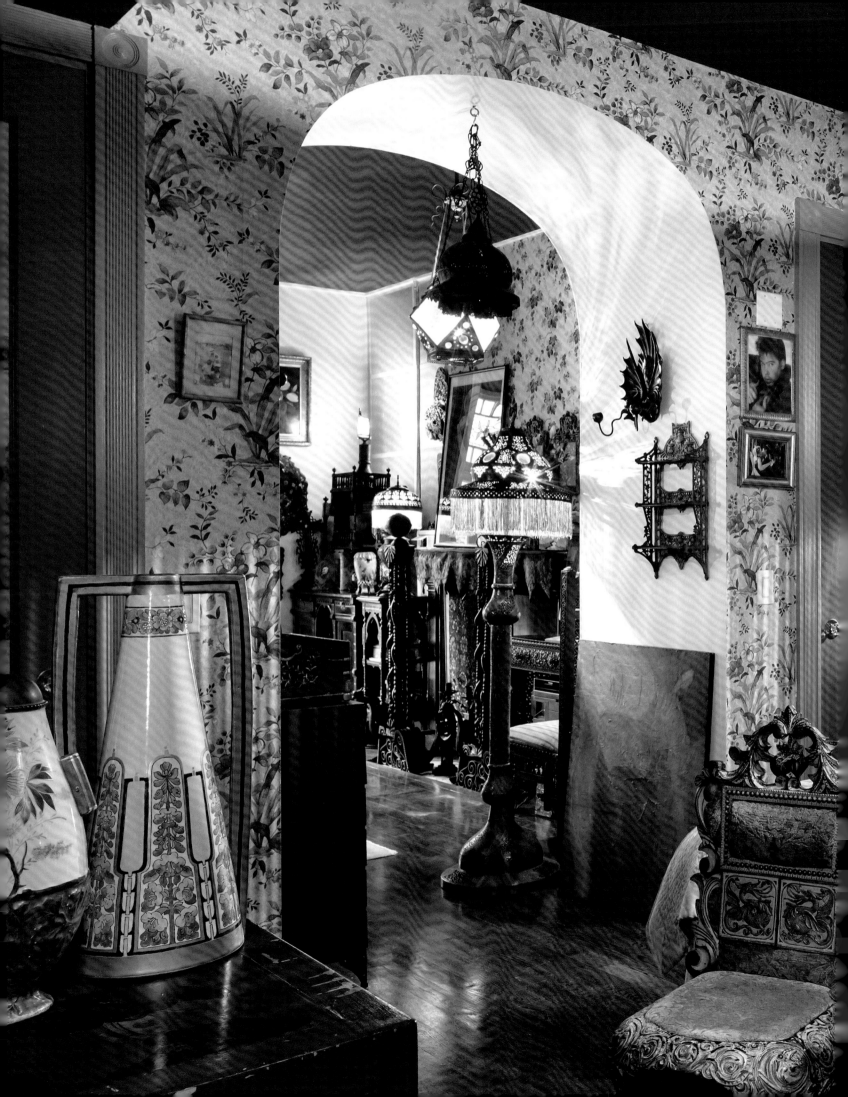

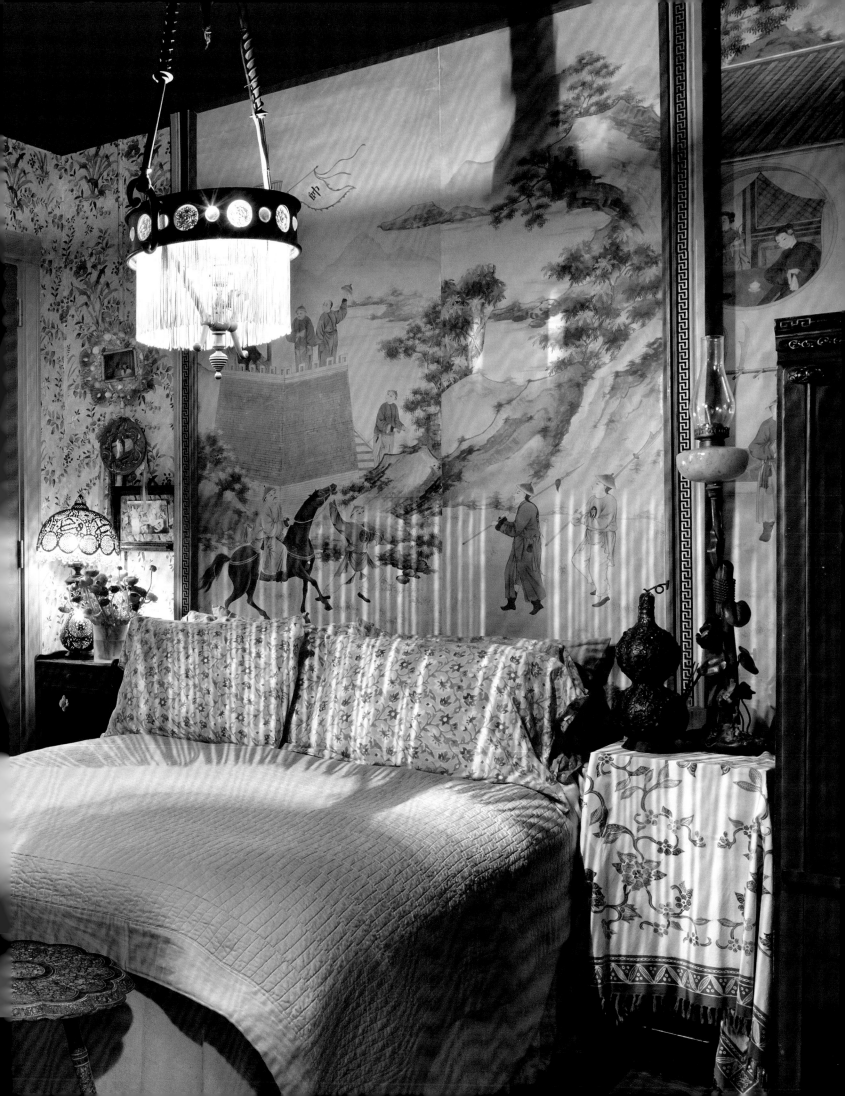

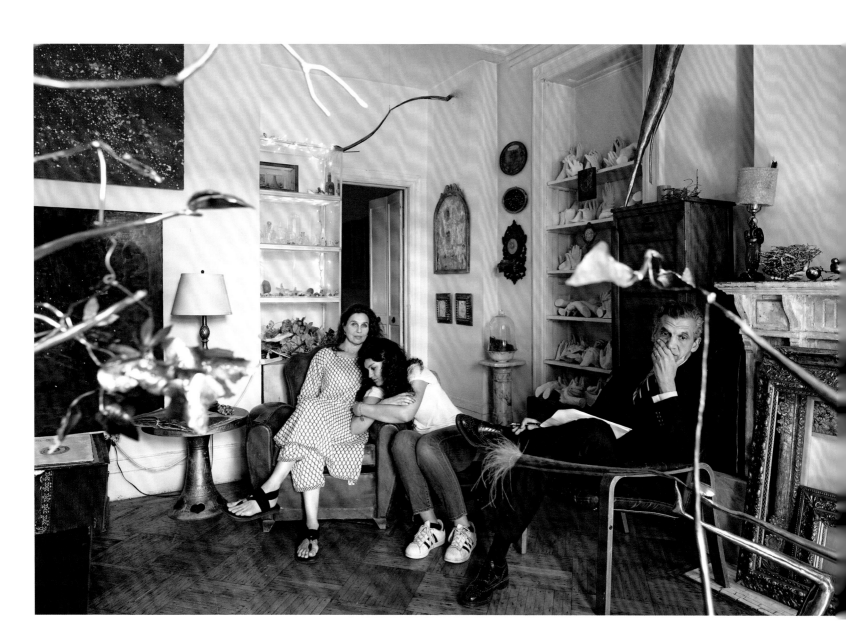

SHEILA BERGER & MICHAEL RIPS

ROOM 602 OF THE CHELSEA HOTEL, where the artist Sheila Berger and her husband, Michael Rips, the lawyer-turned-writer and executive director of the Art Students League, have lived for over twenty years and raised their daughter, Nicolaia, is destined for destruction. "This little inset, the floors, all of the detailing of the windows, the high ceilings. All of that will not exist," Berger remarks as we study photos of the old apartment while sitting in their new home on the same floor. Berger is wistful about the original wood floors, their parquet pattern stretching diagonally across the living room before a fireplace covered in chipped paint. "I loved that," Rips adds quietly.

As much as they cherished their old apartment, its appearance was never immutable. Berger and Rips have a penchant for reinventing their environment, keeping their home in a constant state of flux. When they were presented with the opportunity to design a renovated apartment from scratch (and escape the noise of the construction elevator situated right outside their daughter's bedroom window), they jumped at it, though not without agonizing over the decision. Their story is thus of two homes in the Chelsea, one with a history and the other with a future.

Berger, who worked as a model before becoming an artist, first noticed the Chelsea Hotel not long after she moved to the city in 1979. "I remember walking by, looking up, and seeing that wrought iron and the red building and thinking, I wish I could live here." The couple moved into the hotel in 1994, shortly after getting married. It proved to be a good fit for their respective sensibilities. Rips, who comes from a family of hoteliers, was accustomed to living in hotels, most recently the Regency. Berger was attracted to the creative spirit of the Chelsea. Over the next twenty-five years, they became close friends with other tenants and their families and raised their daughter among an assortment of unruly characters, some of whom appear in a memoir Nicolaia published about her childhood experiences, *Trying to Float*. Stanley Bard, whom the couple calls both a savvy businessman and an illusionist, was one of them. "He took this beautiful building and he created

this mystique about it," Rips says. Bard supported the Chelsea's resident artists even as he feuded with them over back rent. He may not have been interested in the essence of an artwork or the artistic process — "I never saw Stanley sit in front of a work of art and talk about it," Rips says — but Bard had what Rips calls "an appreciation of your essential seriousness." Berger, who was very close to Bard, recalls an episode involving the Capitan, one of the real-life characters in Nicolaia's book and a friend of the family, who was taking Bard to court for allegedly overcharging him on his rent: "They were both heading to court at the same time, getting ready to fight, and Stanley turned to the Capitan and said, 'You want to share a cab?'" "And off they go together," adds Rips.

Bard was also an indefatigable optimist when it came to selling the Chelsea. Rips recounts a time when the manager was showing them available rooms: "He'd say, 'Go to the Plaza! The bathrooms aren't as nice in the Plaza!'" even as the bathrooms at the Chelsea were falling apart and covered in mold. Bard's attempts at selling the hotel's vices as its virtues were infectious. "You get drawn into the nostalgia of the place and the more time you spend here, the more nostalgic you become, and at a certain point you become Stanley," Rips laughs.

Growing up in the Chelsea, Nicolaia was exposed to all of its extremes. Her parents' tight-knit circle of friends included the family of nightlife impresario Arthur Weinstein, whose daughter Dahlia was her babysitter, the artist Michele Zalopany, the Irish writer Joseph O'Neill and his wife, *Vogue* editor Sally Singer, and their upstairs neighbors, the actor Ethan Hawke and his daughter Maya, who is Nicolaia's age. She met Milos Forman, Arthur Miller, Larry Rivers, and Patti Smith, but she also met people like the late poet Rene Ricard, who was brilliant, but struggled with addiction. "It gave her an appreciation for the fragility of the artistic mind," her father says. "She grew up with people who are committed to the creation of art and I think she saw what a difficult life that is."

Nicolaia's memoir, which was published in 2016 and which grew out of a diary she kept, is a send-up of her favorite neighbors in the hotel and is filled with sharp prose, snappy dialogue, and the self-deprecating wit of an ugly duckling who is still trying to figure out just what kind of swan she'd like to become. Among the characters she introduces to her readers are Stormé, a gun-toting cross-dresser (aka Stormé DeLarverie, who, legend has it, threw the first punch against police at Stonewall); Mr. Crafty, a writer; and Uber-Crafty, a painter, who could frequently be found debating each other in the lobby; the Capitan, who ruins her princess party by strutting into her apartment in his underwear; and a lazy but lovable oaf who reads toddler-age Nicolaia his favorite adult books and who is probably an alcoholic. He is also her dad.

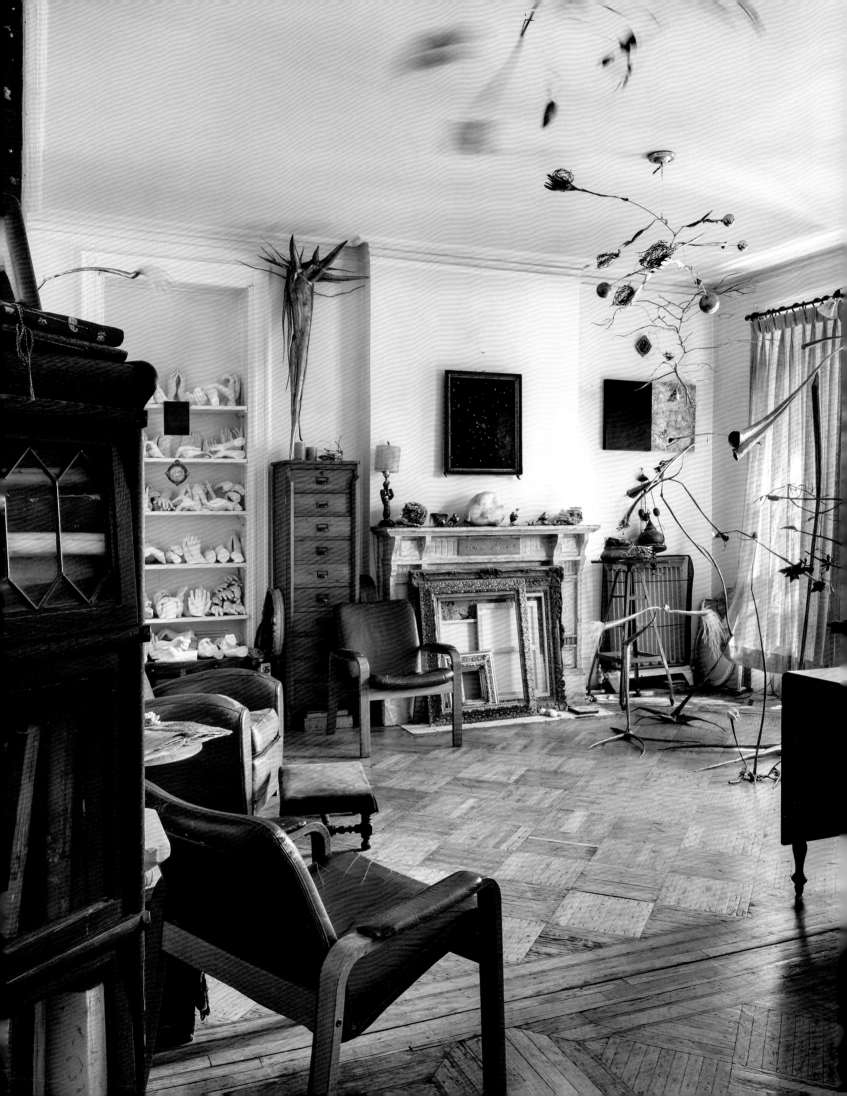

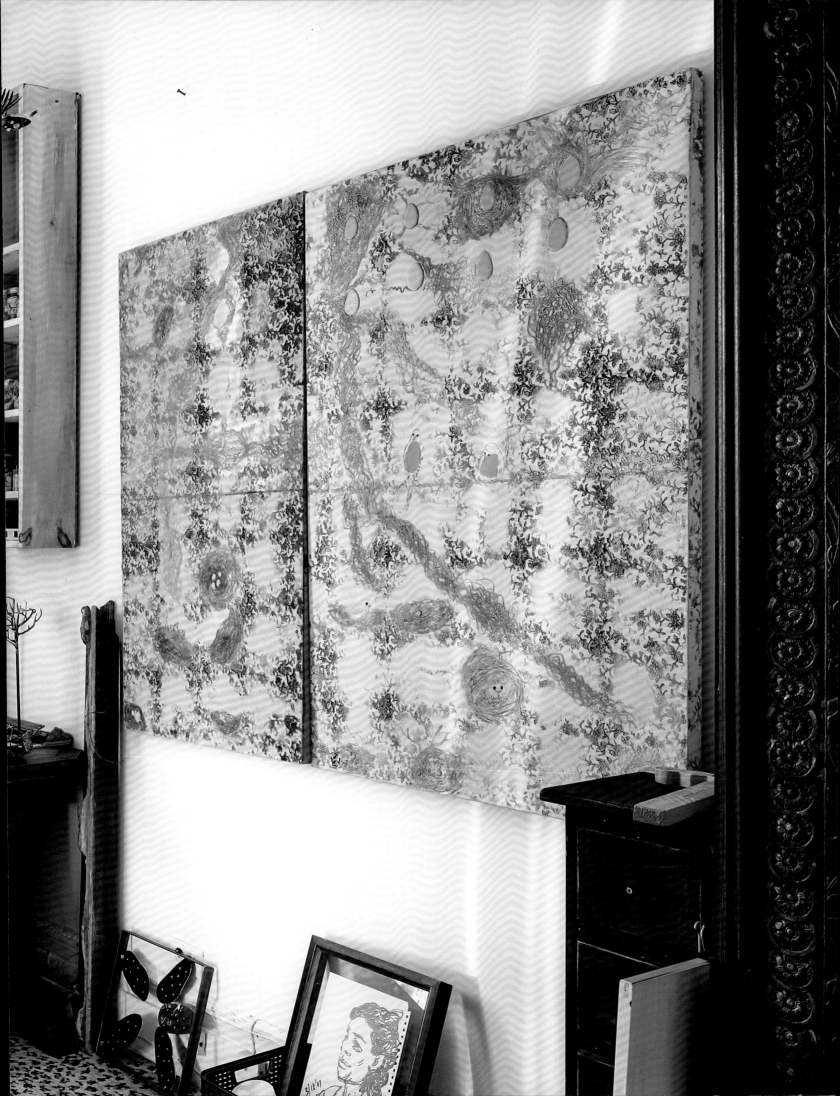

"It's a bit of an inside joke," Michael Rips says about his semifictional alter ego, which he helped create. He is every bit the espresso-loving dandy his daughter describes, but his professional achievements stand in stark contrast to the laissez-faire attitude of the bumbling bon vivant in her book. Rips gets a kick out of it. "When you read the introduction to her book, you were worried that you might not have a job the next day," Berger chimes in. "But you do like a good martini." Nicolaia's mother comes off a little better in her book; the most memorable image of her might be of the wildly dressed artist maniacally pedaling down Seventh Avenue, following Nicolaia's school bus on her bicycle.

Rips and Berger both say that their work has benefited from their living at the Chelsea. Rips wrote a screenplay with O'Neill and for a while shared a desk with the PEN/Faulkner prize-winning author. Berger says that just being at the Chelsea is an inspiration. "I don't know if it's the hotel that changes the artist or the artist that changes the hotel."

When the family's old apartment was photographed for this book, Berger was using it as a studio while the three decamped to the Upper West Side to escape the havoc in the hotel. Much of her work explores themes of nature and nesting. Many of her paintings — encaustics made by applying heat to layers of paint and wax — are from a series that chronicles the slow emergence of life from a bird's nest she found on a visit to her childhood home in St. Louis, Missouri. Her kinetic sculptures look like dark fairytale versions of Alexander Calder mobiles. From an image of hands holding an empty nest evolved another project: Berger began to cast hands. Dozens of them were neatly lined up on a shelf in the living room and Berger has recently returned to the idea with greater urgency, deciding to cast only women's hands. "What's happening politically right now is affecting me, no doubt about it," Berger says. Of her pairs of twisted, folded, stretched, bent, and clasped hands she says, "I think of each as a portrait."

Room 602 also still harbored vestiges of the family's life there, including a seventeenth-century, leather-embossed screen that the couple repurposed as closet doors, Nicolaia's writing on the wall of her former bedroom, and a stack of opulent House of Heydenryk frames that Michael Rips collected. An equally ornamented mirror frame from the old bathroom now holds a photograph by Cecil Beaton of a previous resident of their new apartment, the couturier Charles James, a favorite of Rips's mother. (Among the previous tenants in their old apartment was the musician and actor Vincent Gallo. "We know for sure he lived here because he wrote his name on the door. *Vincent Gallo lives here.*")

Michael Rips is a lifelong collector of art, artifacts, and interesting objects, which he finds at flea markets or acquires from antique dealers and auction houses. Rips, who says that he and his wife approach collecting "with a kind of Midwestern innocence and openness,"

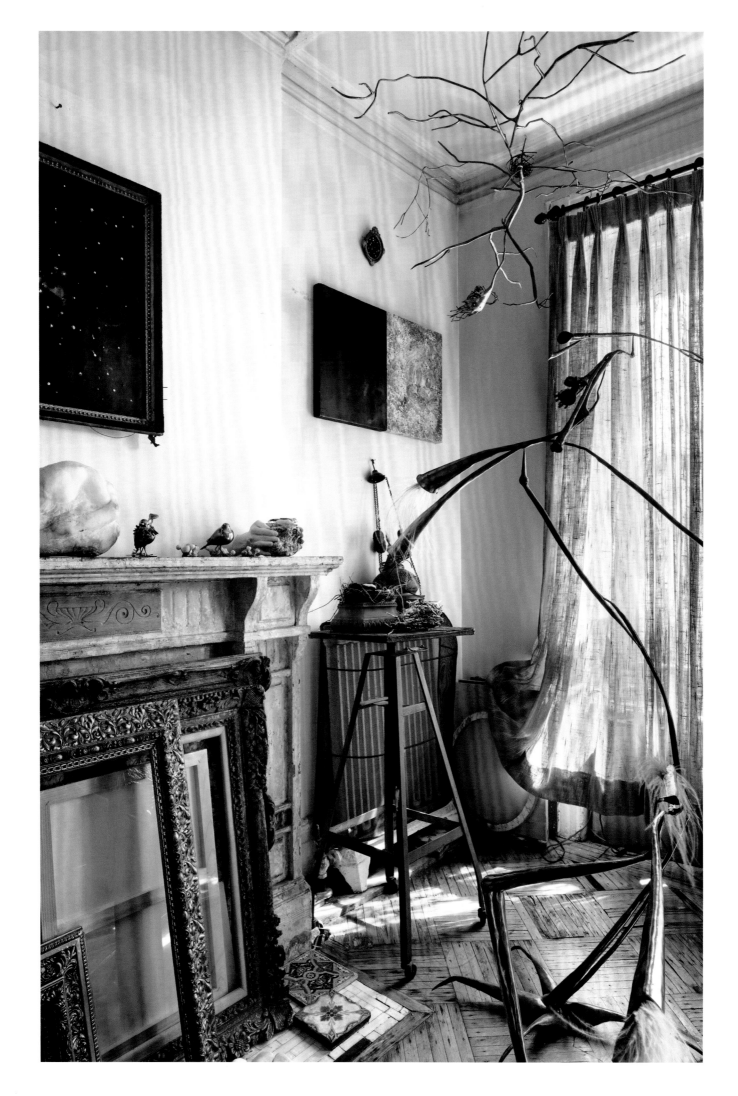

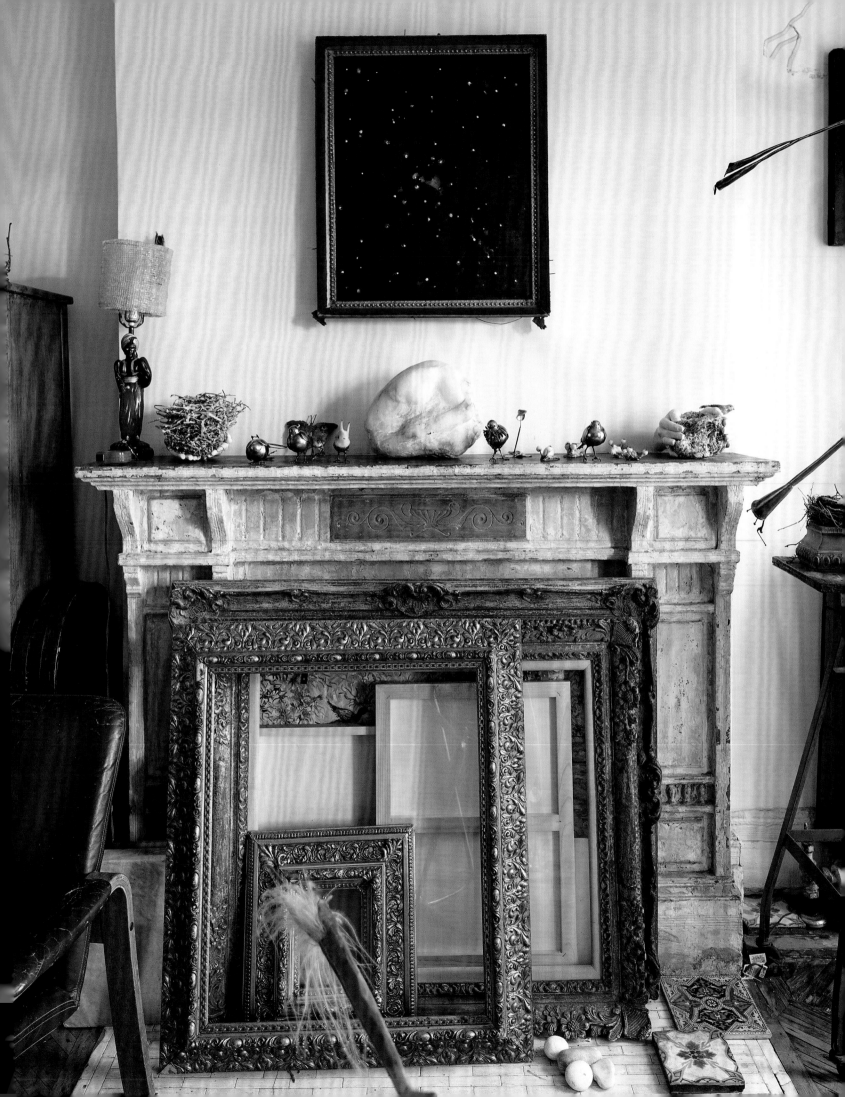

spends a lot of time thinking about what it means to be a collector. "There's a complex narrative to it," he says. He thinks of his environment as an ecosystem of objects and people that interact with and affect each other. "I've been collected by the objects," he says.

Most of his treasures are in storage, including a significant collection of African fetish objects, but over the years different waves of collectibles have washed through the old apartment. After Rips discovered a pile of American flags at a flea market, the apartment was covered in them. Around the same time, he amassed a collection of old shotguns. One night, an upstairs neighbor fell through a hole that opened up in their ceiling, prompting a visit from the Department of Buildings and the police. "It was my eight-year-old daughter who had the good sense to say, 'Is it okay that the police see these unregistered shotguns that are all over the apartment?'" They quickly removed them. Anyway, Rips says, you have to redecorate every once in a while. "I think the flags and shotguns overlapped with the bear rugs. We had rugs with heads on them. When you have drunken cocktail parties, people are always tripping over them, getting their feet caught on the mouths." The rugs went the way of the guns.

One wonders what wondrous transformations lie ahead for the family's newly built-out home. For now, the apartment has an almost stripped down, minimal look, with plenty of open floor space and relatively few, but impressive, paintings on its walls, including a large canvas by the painter David Salle, a friend of the couple, above their couch and another above the fireplace. The new apartment also retains a number of Berger's delicate sculptures and a few of her paintings. A diptych from her *Bird Show* series straddles a corner of the living room by the dining table. A number of other elements help prevent the apartment from looking like a generic New York rental, such as the original fireplace, and the windows in the couple's bedroom, which Berger salvaged from the hotel's basement and which date to the 1880s. "They were pristine."

Only a tiny fraction of Rips's collections has made it into the new apartment. Over the years he has donated some of it and the couple is thinking of buying a house outside the city in order to avoid the high cost of art storage in New York. Asked whether he has a game plan for his collections in the event of his untimely demise, the couple, sitting next to each other on the couch, both erupt in laughter, as if the punchline to yet another inside joke had been revealed. "Stay healthy!" Rips shouts as the two clasp hands, smiling at each other knowingly.

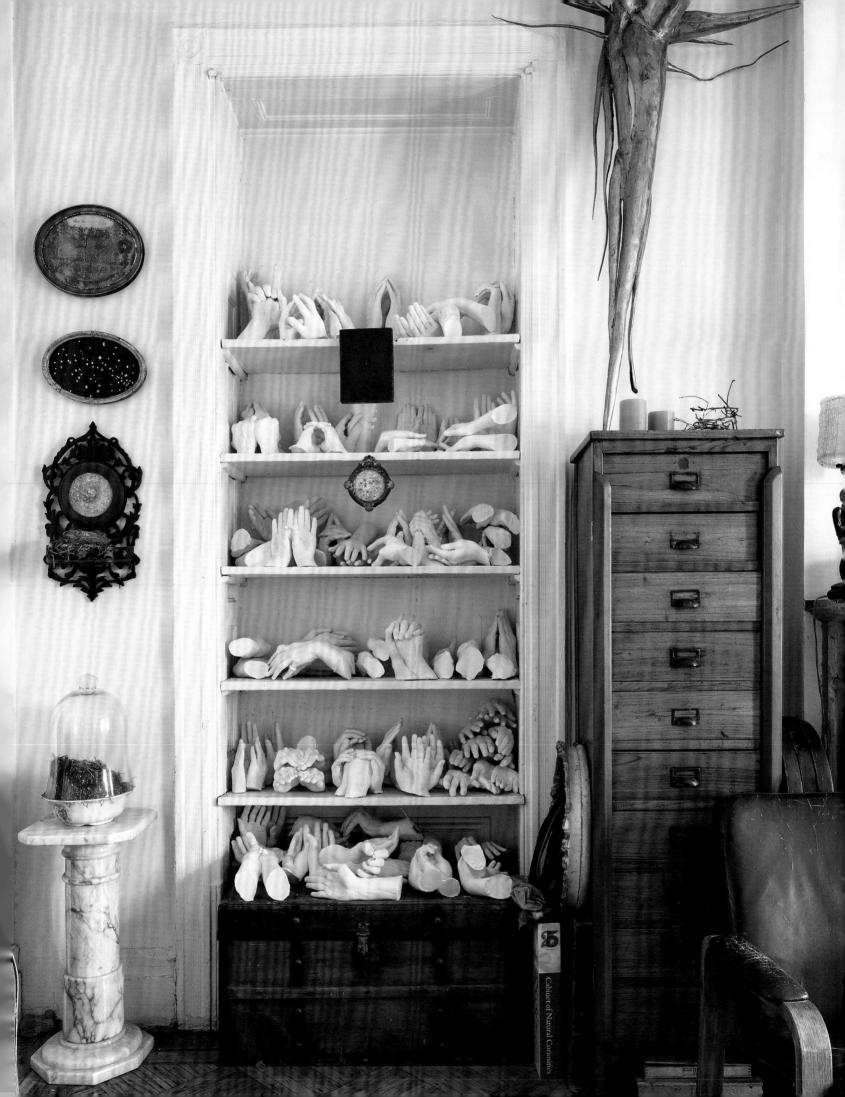

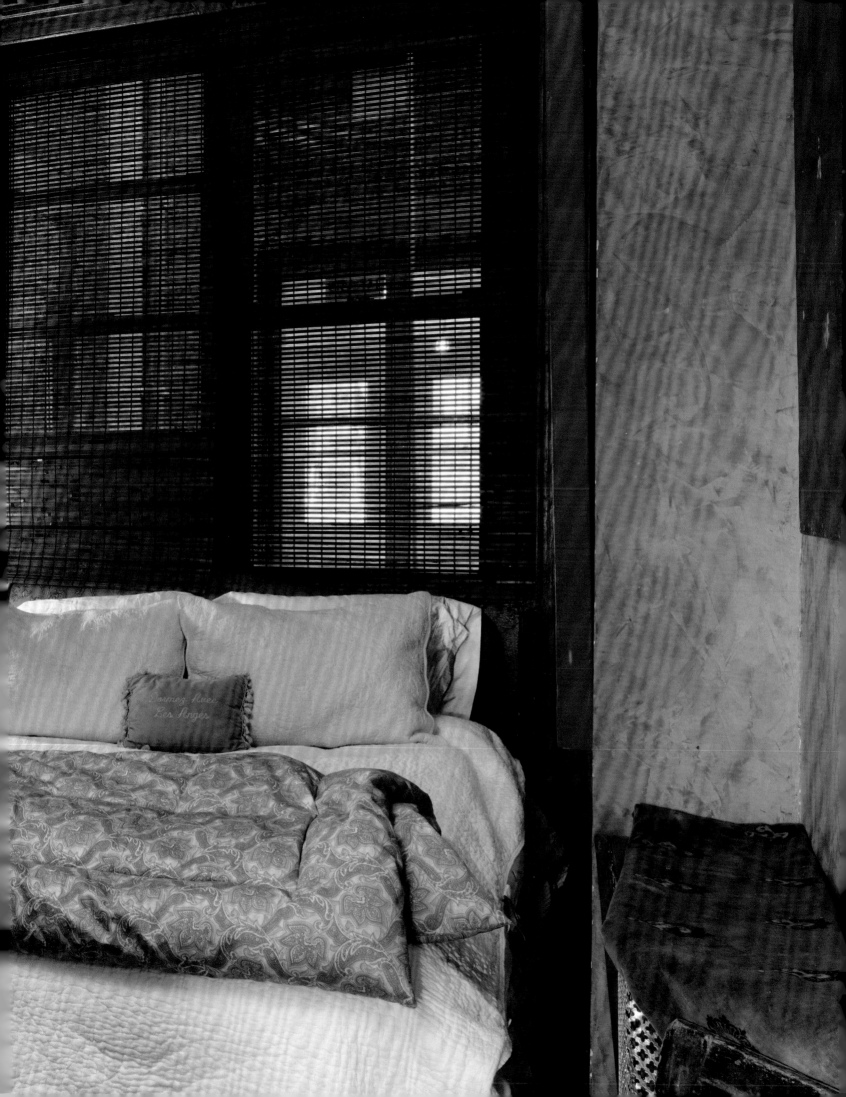

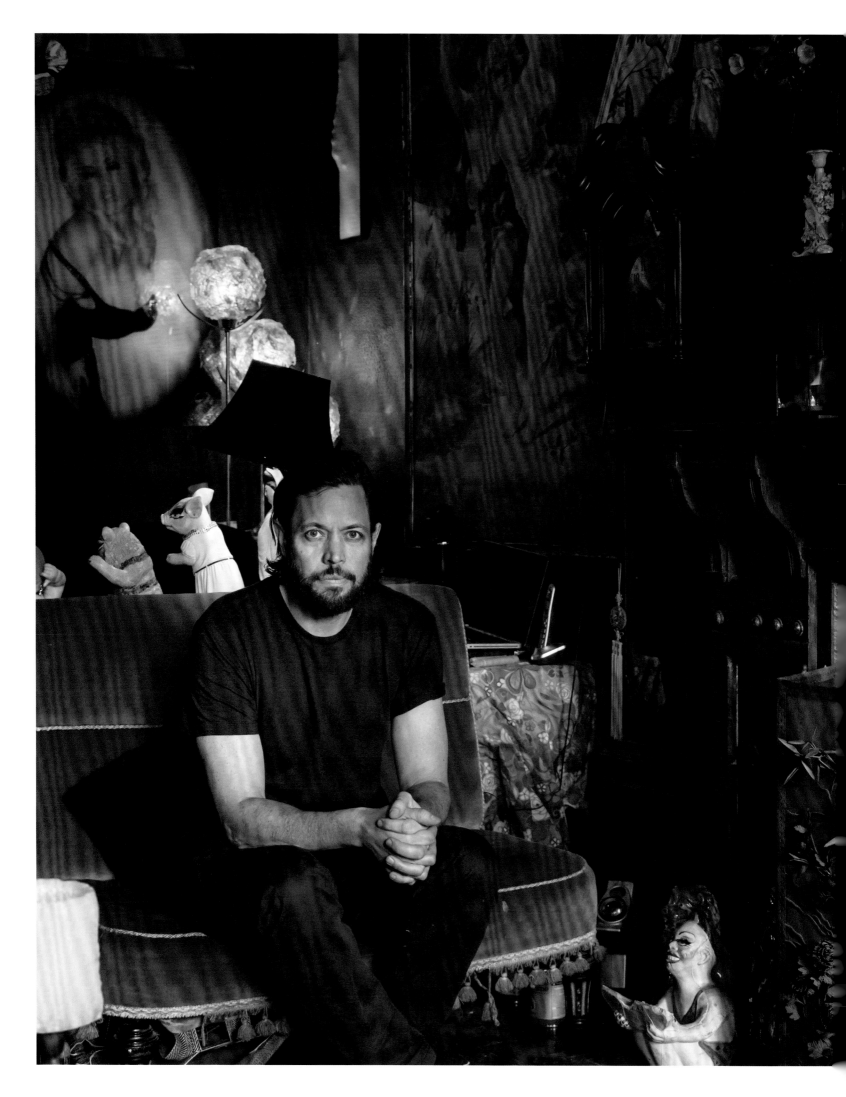

STEVE WILLIS

THE HOME OF STEVE WILLIS has a unique aura that reveals itself to visitors with quiet immediacy. A dark entranceway culminates in a shrine of sorts: an oil painting of a staid, bearded gentleman wearing heavy eye makeup and lipstick, gently illuminated by candles and a spectral cluster of lights that sit atop a delicate white cabinet. In the living room, the well-worn furniture and antique light fixtures appear to have been carefully placed within the space to create a stage for the numerous dolls, figurines, and busts that populate the room, all of which bear the same distinctive makeup as the portrait at the entrance. Similarly altered paintings and other colorful art fill the walls of the apartment.

One corner of the living room, dominated by a life-size, soft-focus photo of a voluptuous blonde woman, functions as a study. Framing either side of the fireplace mantel, which was painstakingly restored, are candelabra sconces adorned with metal flowers that are just the right kind of tacky. A tropical scene on an early twentieth-century theatrical backdrop that was procured from an upstate antique store dominates the opposite wall. The wondrous apartment evokes a mood somewhere between curiosity cabinet and oversize dollhouse.

Steve Willis has called his room on the fourth floor of the hotel (and later also its neighboring room) home since 1994. Willis has produced a number of TV shows and music documentaries and directed videos for the likes of Mary J. Blige and Patti LaBelle. He also produced and directed a documentary feature, *Wet Dreams*, about the fountains at the Bellagio hotel in Las Vegas and he has choreographed fountain shows in Las Vegas, Los Angeles, and Macau, China. His apartment at the Chelsea has served as a backdrop for his personal photography projects, for which his subjects frequently wear the same makeup as his dolls.

Willis first encountered the Hotel Chelsea while on a video shoot. At the time, he was unaware of the building's history and reputation and didn't know anyone who lived there. "I came here producing a Mariah Carey music video," he recalls. "Stanley asked if I

wanted an apartment." Willis lived in Los Angeles, but the idea of putting down roots in New York appealed to him, and he soon settled in the Chelsea. In the history of the hotel, the '90s are among its low points. Some rooms on the lower floors were de facto drug dens and strangers wandered into the building at all hours to score. "The front desk had bulletproof glass and you had to be buzzed in," Willis remembers. "This neighborhood was a no-man's-land." But he was undeterred. "It's really quiet in the building. The walls are thick. You can be loud; you feel like there's freedom to do whatever you want." He gradually began to transform his space, which was sparsely decorated and furnished when he arrived, adding and subtracting layers of paint and objects.

Amid the ups and downs of his career, Willis could count on Bard's support to be able to stay at the Chelsea. Being asked by Bard to become a resident "felt like a casting," Willis says. "He was trying to facilitate a place where artists can feel safe and live and do their thing. I was more than just welcome to be here. He was making sure that I stayed." Once, during a rough stretch, rent became too much for the young creative to shoulder on his own. Rather than show him the door, Bard encouraged him to expand his footprint in the building by annexing the adjacent smaller room. "He suggested I take over that apartment and get a roommate to supplement the cost. He really didn't want the people he chose to leave." It didn't hurt that Willis brought in the occasional celebrity. "You could tell he liked that. He was very aware of things that upped the cachet of the place."

By the time he moved in, Willis's room already had an illustrious history. "*Manhattan Murder Mystery* was filmed in this apartment," he says. Janis Joplin also stayed in the room, one of several she occupied for periods of time, and award-winning Broadway costume designer William Ivey Long lived there prior to Willis. But among its most famous residents were some of Willis's own former roommates, who occupied either one of his formerly separate hotel rooms, while Willis moved back and forth between them as needed. "A project that I've been thinking about for a while now is a film featuring all the people that have lived in this apartment," says Willis. "Everyone who lived here felt that during their time here, there was a profound change in their creative life." Rufus Wainwright wrote one of his most successful albums, *Poses*, while living in the small room. Dave Grohl from the Foo Fighters stayed in what is now Willis's main room when he was dating former Hole and Smashing Pumpkins bassist Melissa Auf der Maur. In an intimate video shot by Craig McDean, Auf der Maur and model-turned-songwriter Karen Elson perform an acoustic rendition of Danzig's "Devil's Plaything" while lounging on a couch in the room that was Joplin's.

Over time, Willis's roommates left their own marks on the apartment. One of his subletters, a big shot at Prada, gave the main room a clean, modern look. "When Melissa

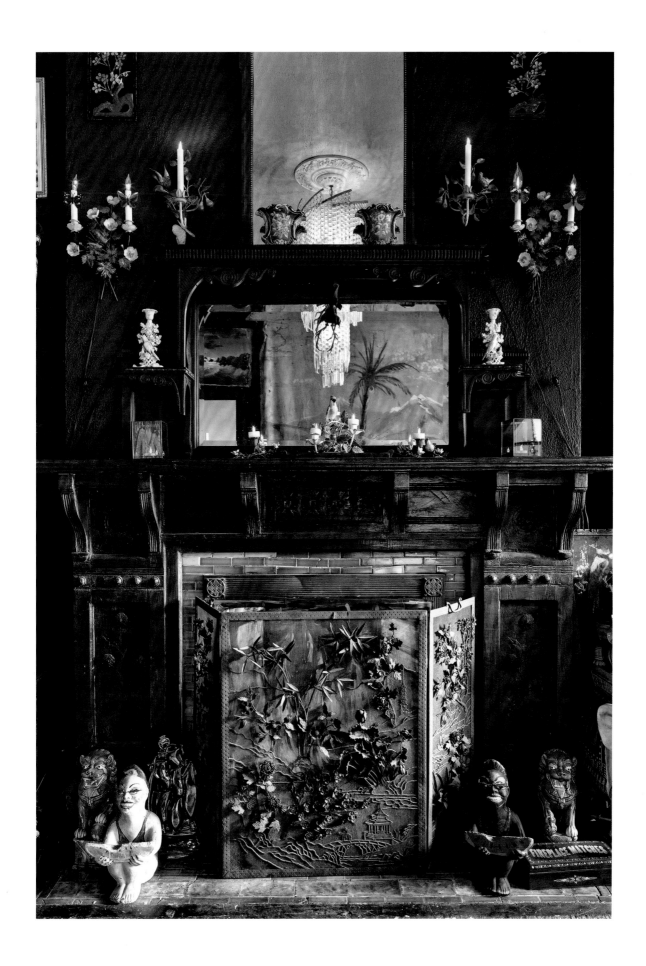

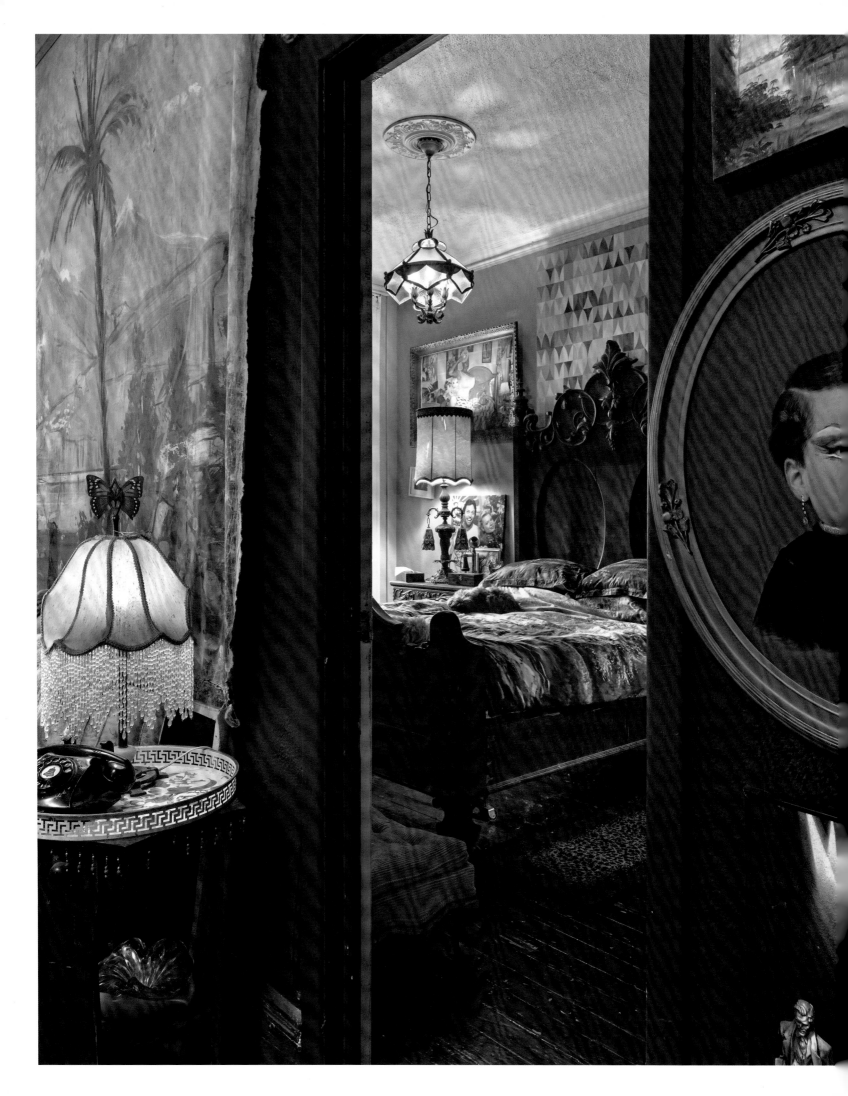

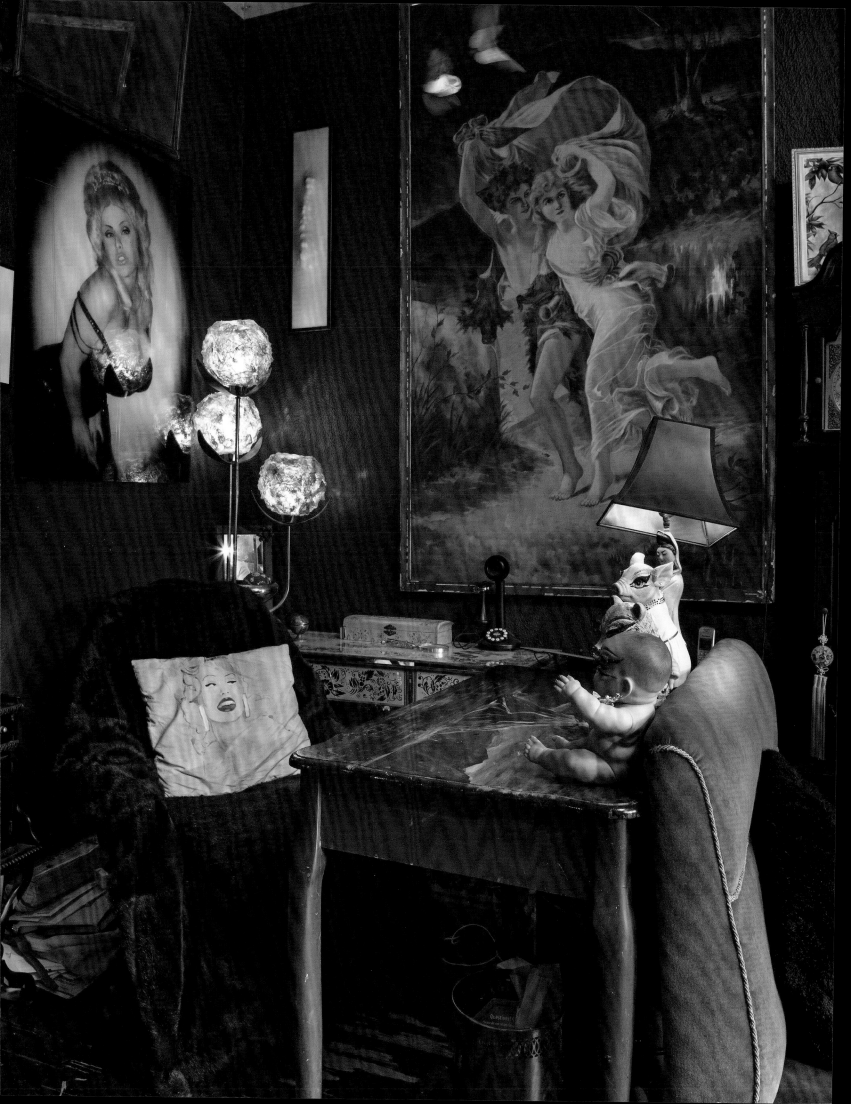

and Dave Grohl had lived here—they were a couple at the time—she'd spent a long time stenciling the walls with a Victorian-type pattern. It was gorgeous. That Prada guy painted over it and I almost killed him."

Willis ultimately tended toward a more vaudevillian style. His own artwork—the paintings, busts, and figurines wearing makeup—seem like natural additions to the environment Willis created. "It's something I've always been doing. I used to take magazines and go through with a pen and add makeup. I call them Glamour Eye." All are essentially found objects. A series of dioramas he has been working on represents a continuation of his own early ideas about how to create beauty.

Moving back and forth between his two rooms in order to accommodate his roommates forced Willis to constantly redesign the spaces. But since the building has been in various stages of demolition and redevelopment, he has felt an obligation to keep the basic elements of the apartment as they are, even if much within his own rooms is far from original. To Willis, the authenticity of his living space within the context of the Chelsea Hotel's history is derived not from the provenance of an object, given that very few apartments in the building have retained their original interior design elements. Instead, he values how stylistic changes or additions—"Different markers in time," Willis says—have frozen specific periods in place. "I feel strongly about this: cherishing the old patinas that developed over time." He points to the plywood patches on his floor. "They're part of the story. It's funny to me that that was Stanley's solution at one point, to patch the floor. It's not nice-looking, necessarily, but it's what makes this place unique. I've seen other apartments go through this transition, and they all feel like brand new apartments. It feels like you're not in the Chelsea anymore. There's nothing that remains that's old."

Age, Willis says, is a virtue that bestows significance upon the objects that surround him, as well as the building. That attitude has certainly not been shared by those seeking to extract greater returns from the Chelsea by turning it into something newer and more modern. But neither is it universally embraced among the hotel's remaining long-term tenants. Nonetheless, if there was a positive aspect to the turmoil surrounding the initial buyout and renovation plans for the building for Willis, it was that he met more of his neighbors. "The shit hit the fan and one of the funniest things that I wish I'd filmed was the first tenants meeting at the Hotel Chelsea," Willis remembers. "What could be worse than a bunch of angry tenants getting together? But it wasn't like that. I left thinking, There are so many cool people! I wish I'd known them longer." Willis banded together with a few like-minded neighbors who also had strong reservations about having their apartments gut-renovated, but did not join the tenant association. "It wasn't just about staying in the building for me," he says. "It was always about trying to preserve the building."

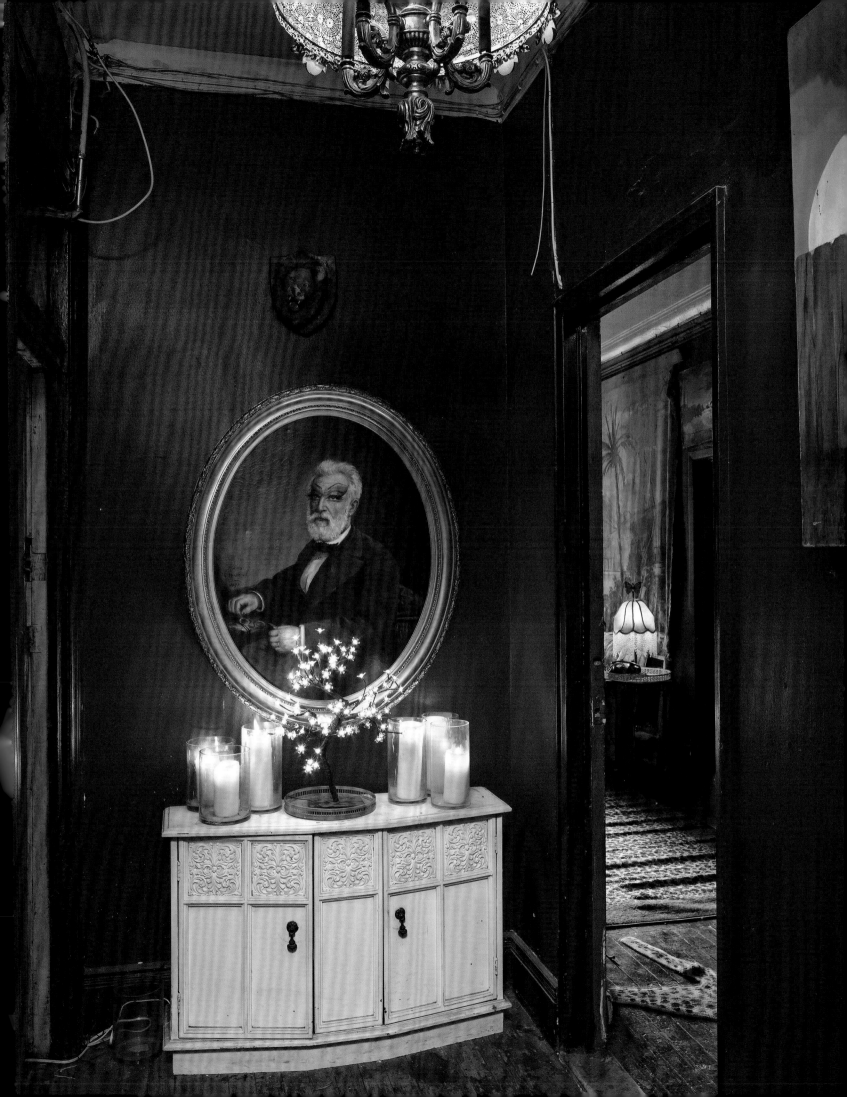

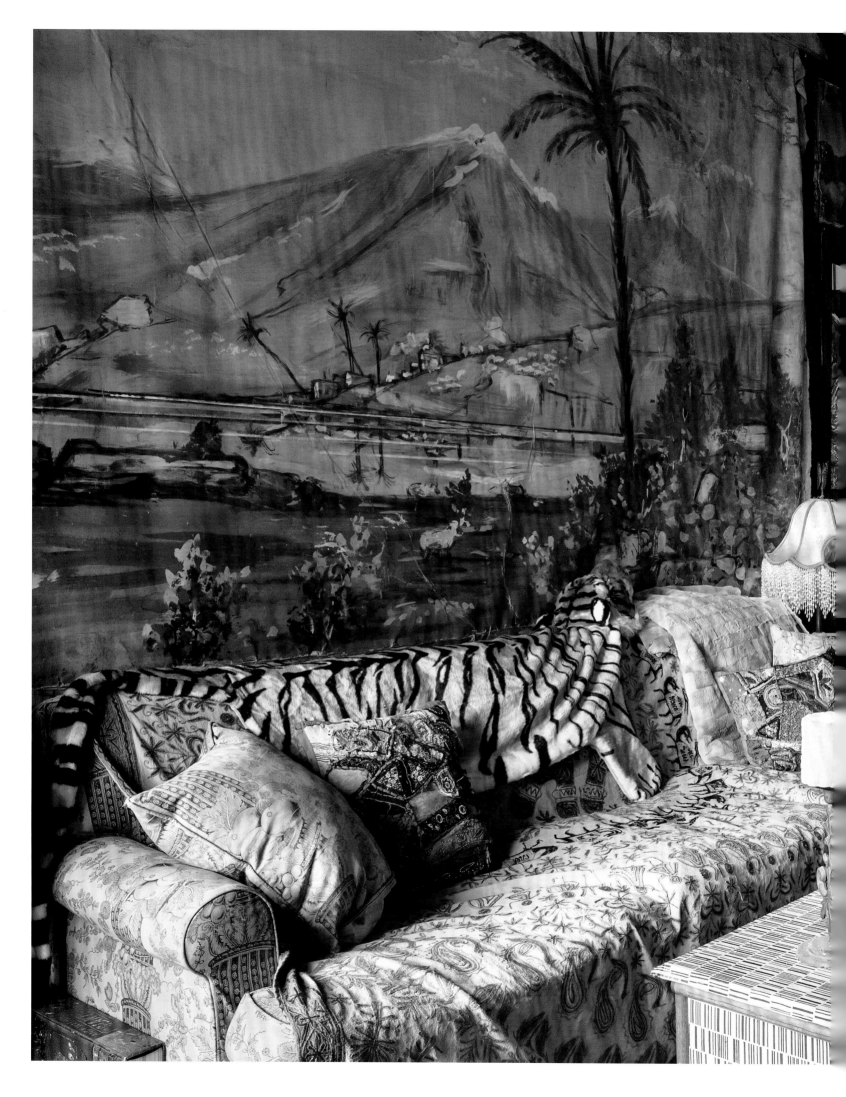

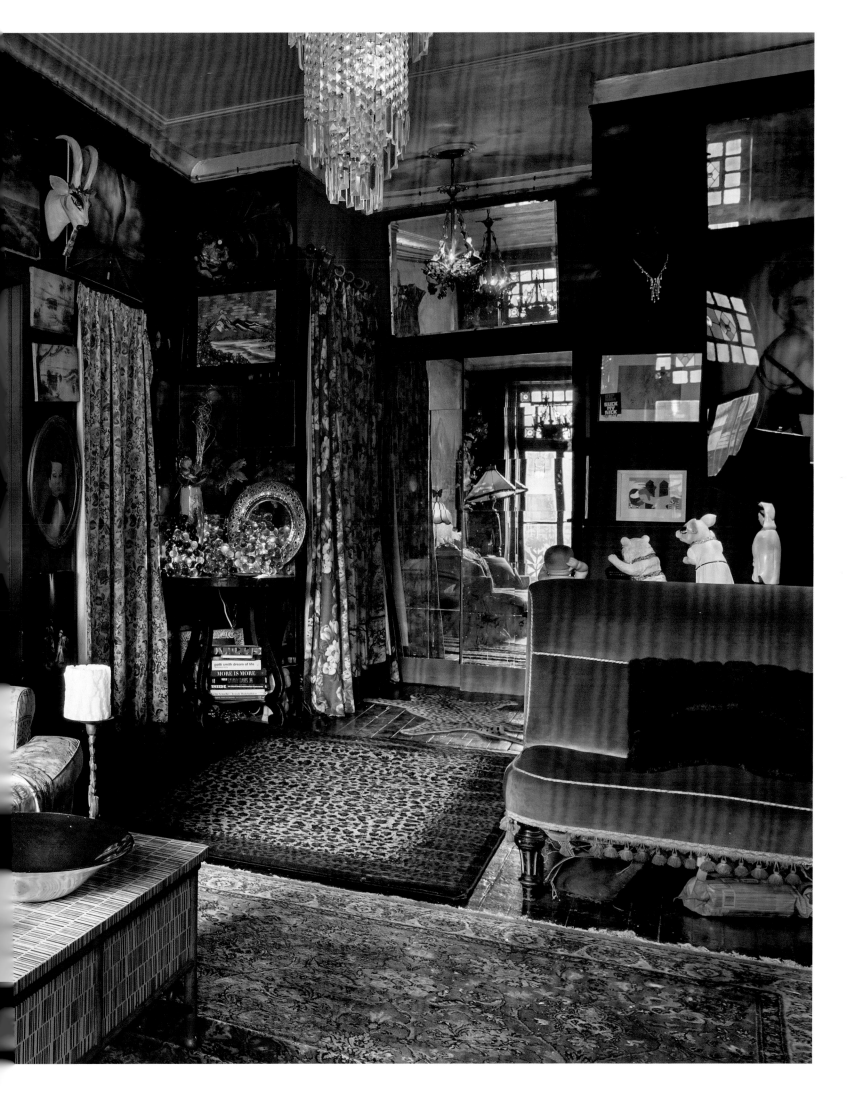

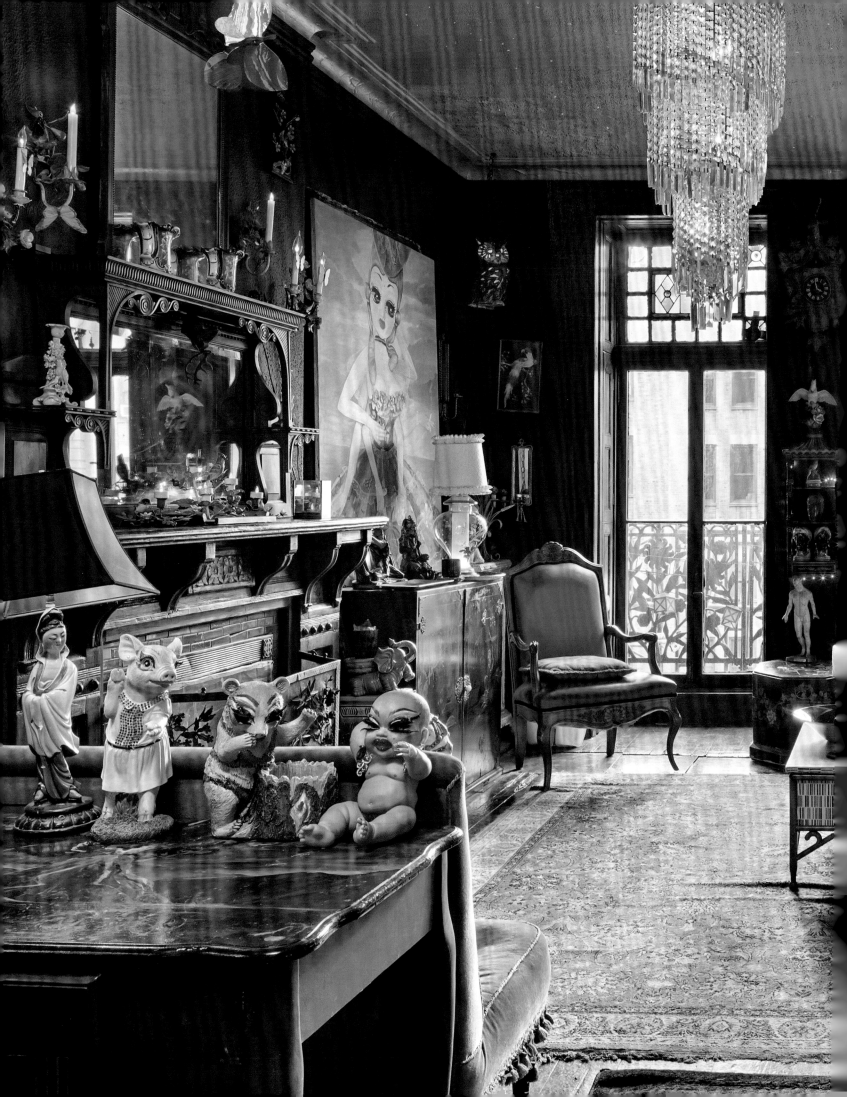

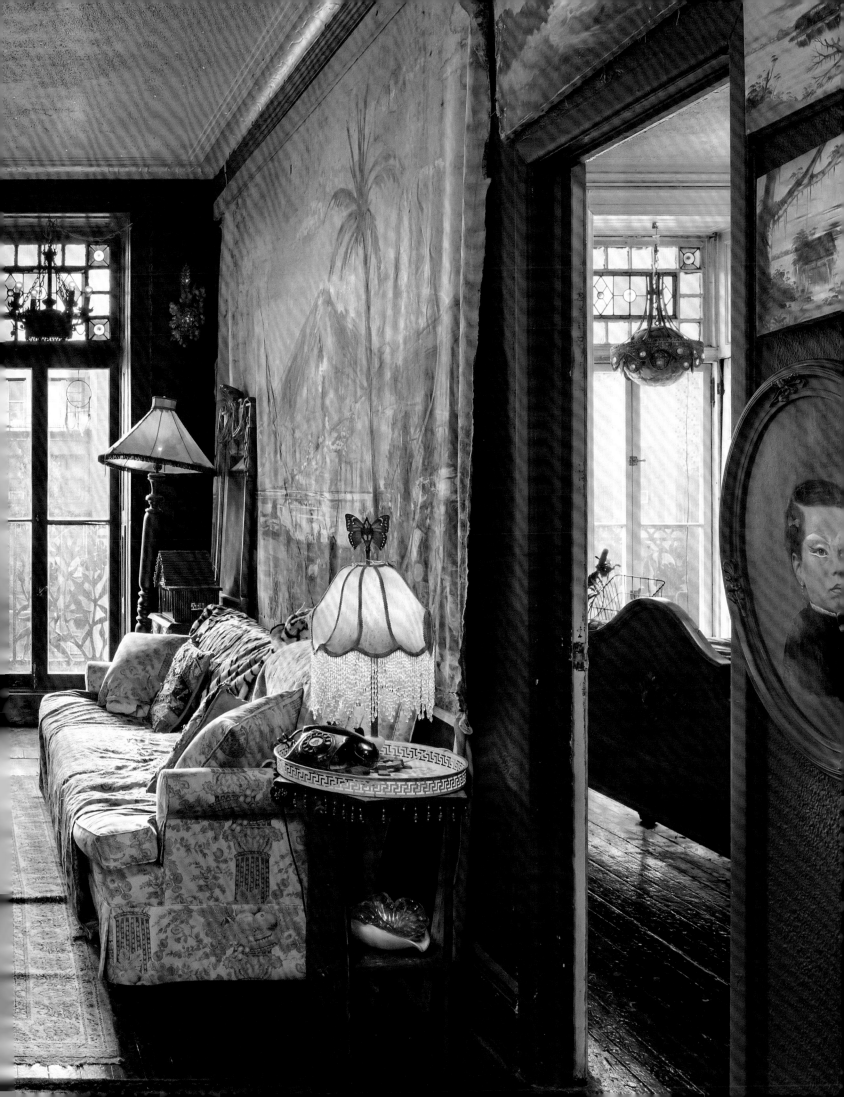

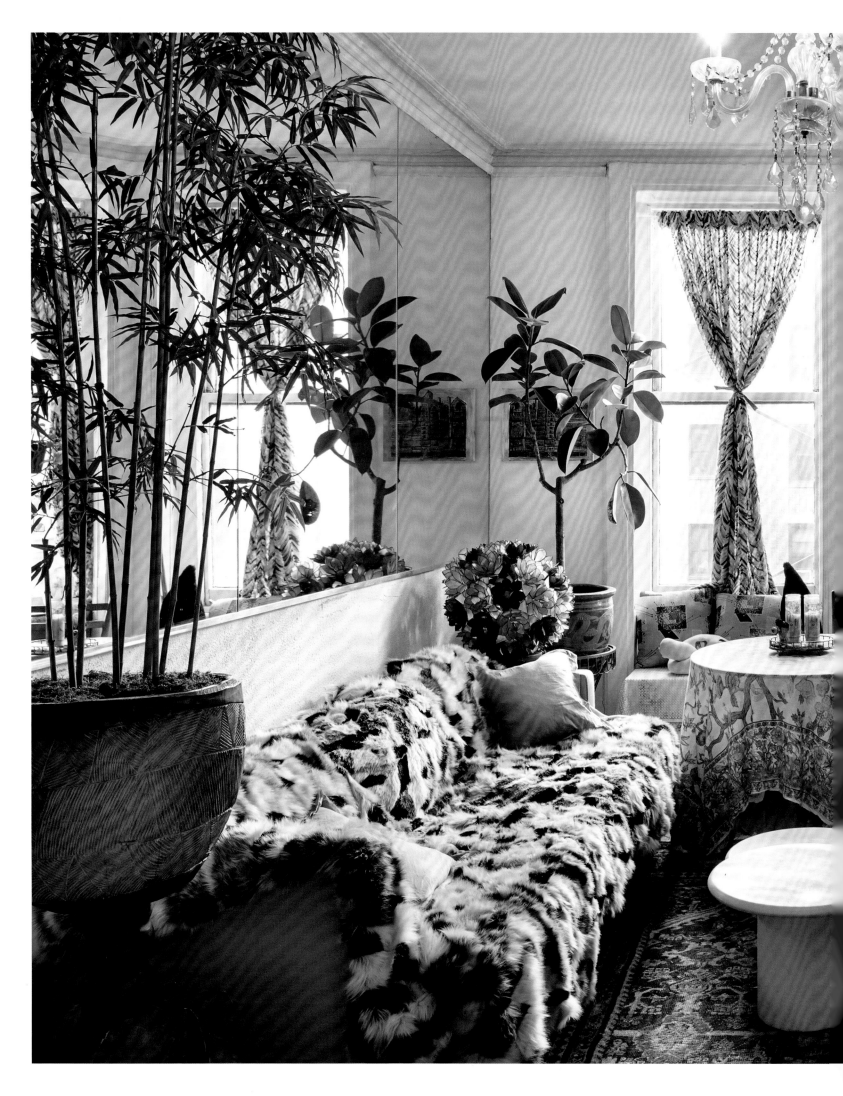

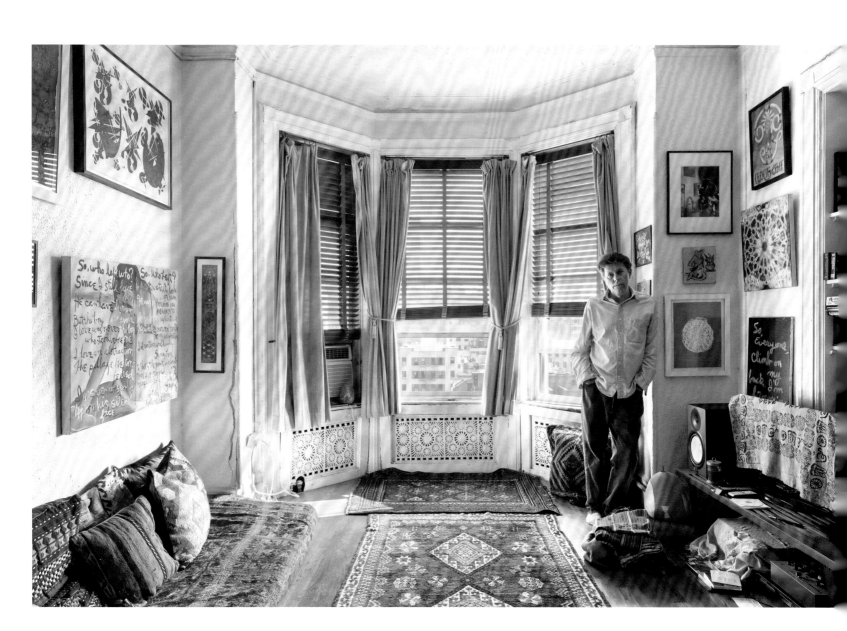

RAYMOND FOYE

I hope to god this is the last interview i do about the chelsea hotel," says Raymond Foye. "At this point it has entered the realm of pure mythology." As a curator and writer, Foye chronicles the past and makes it accessible to others, but he doesn't enjoy dwelling on it. "I don't like nostalgia. Every time I talk about somebody or something that happened, I'm somehow further away from it than I was before." Of course, few places in New York inspire more mythmaking than the Chelsea Hotel, and Foye has been in the thick of it for over four decades, living and working with some of the hotel's most legendary characters. Growing up in Lowell, Massachusetts, Foye got into philosophy, art, and poetry — particularly the Beats and their contemporaries — at an early age. During his first trip to New York, as a high school senior in 1974, he stopped by the Chelsea Hotel hoping to see his literary heroes (William S. Burroughs wrote much of *Naked Lunch* at the Chelsea in the 1950s, and Peter Orlovsky, Jack Kerouac, Allen Ginsberg, and Ginsberg's protégé Gregory Corso stayed at the hotel on and off through the '70s). "I was so naive. But then the first thing I saw was Corso smashing a pay phone in the lobby, screaming. It was perfect."

After high school, Foye bounced around for a few years, studying film at the School of the Art Institute of Chicago, moving to San Francisco's North Beach neighborhood — where he became friends with Corso, who lived there at the time — and then studying at the San Francisco Art Institute for a few semesters. But he kept returning to the Chelsea to hang out with its poet and artist residents, and in 1979 he got his own room. "I realized that people like that were going to be my teachers in life," he says.

"You would make connections really quickly," Foye says of living at the Chelsea. Everyone would hang out in the lobby, and a large, raucous group of tenants held regular communal candlelit dinners right in the ninth-floor hallway, to the bafflement of temporary hotel guests. Foye was introduced to "the magician of the hotel," Harry Smith, the filmmaker and groundbreaking musical anthropologist who compiled the *Anthology of American Folk Music*, by Peggy Biderman, Smith's assistant. "He had a room that was

packed to the ceiling with books, records, tarot cards, Mayan codices, Native American artifacts, fabric, baskets; he had collections of collections. He was making films and drinking a lot, smoking a lot of pot and taking a lot of psychedelics." If anyone epitomized the spirit of the Chelsea Hotel at the time, it was Smith, with his brilliant mind, erratic behavior, and complete disregard for material wealth.

During the 1970s, twenty dollars could buy a room at the Chelsea for the night. Some guests got even better deals. "When Gregory Corso needed a place to crash, when he was coming off drugs or something, he just grabbed a key from behind the front desk, went up and slept in a room. Sometimes Stanley would come in with guests to show them the room and he'd be sleeping in the bed," Foye recounts. "Stanley would just close the door." Bard, Foye says, "had a genuine love of artists and writers and creative people and it was like a salon to him. He was the curator of this hotel." If the hotel was a gallery, "every room was a different painting on the wall." If someone couldn't come up with rent, Bard grudgingly let it slip, at least for a while. When Harry Smith, one of Bard's favorites, decided to leave the increasingly unsafe and drug-ridden Chelsea for the Breslin in the late '70s, Bard was deeply upset, despite Smith owing him thousands of dollars in back rent. "Stanley called me down to his office and he was practically in tears," Foye remembers. "He said, 'What can we do to get him back?' He didn't care one bit about the money, he just couldn't stand the fact that Harry had left the hotel."

For Foye, who never wanted to be tied down to a place and didn't have a lease, the Chelsea was the perfect home base. As an editor for several avant-garde publishers, he benefited from the access the Chelsea gave him to some of the most cutting-edge voices in the country. In 1985, a friend, the painter Francesco Clemente, invited him along on a four-month trip to India. Upon their return, the two founded their own small press, Hanuman Books, which was based in the Chelsea and published fifty volumes of poetry, prose, and rare translations by an awe-inspiring list of artists and writers over the next ten years. Subsequently Foye became director of exhibitions and publications at Gagosian Gallery and then worked as an independent curator, writer, and publisher, once again benefiting from the many relationships he had forged at the Chelsea.

Foye's studio apartment on the eighth floor is the former home of the writer Christopher Cox, a good friend of Foye's who died in 1990. "We used to have dinner every Sunday night in his apartment with Virgil Thomson," he says. Foye filled the cozy room, which overlooks Twenty-Third Street, with books and a very personal selection of artwork by his friends and contemporaries. A large collage with painted and silkscreened elements by the artist Ouattara Watts hangs prominently above his bed. Jean-Michel Basquiat

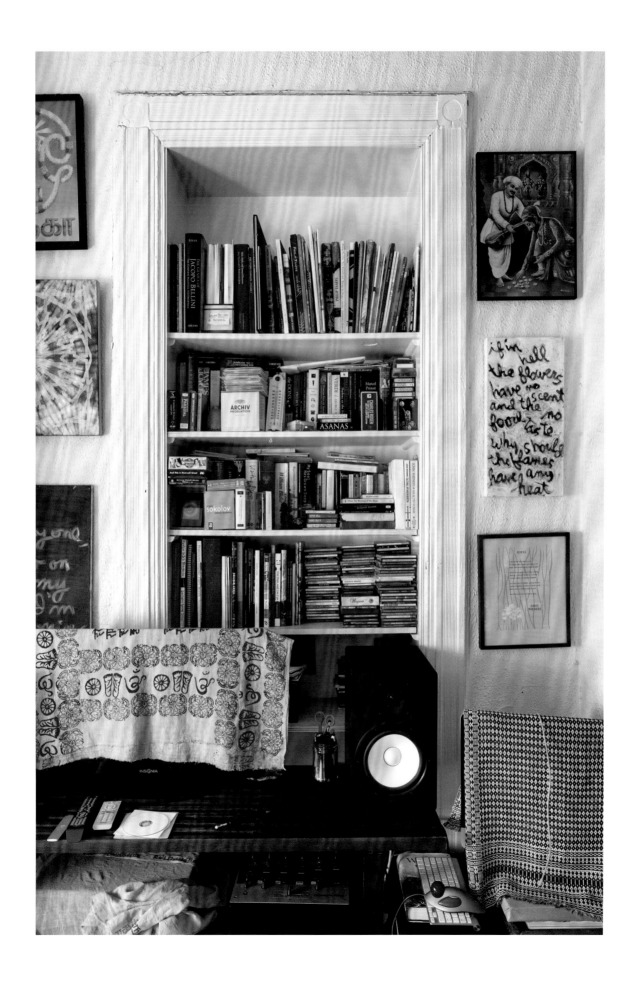

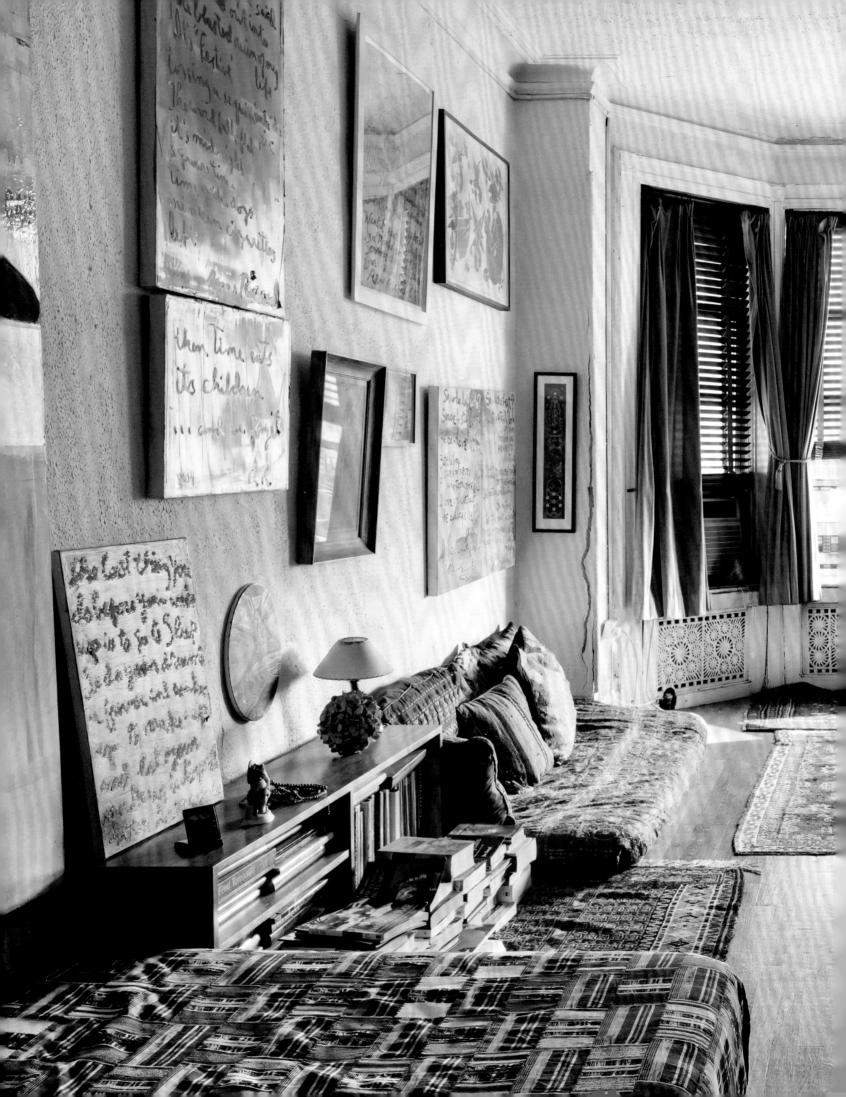

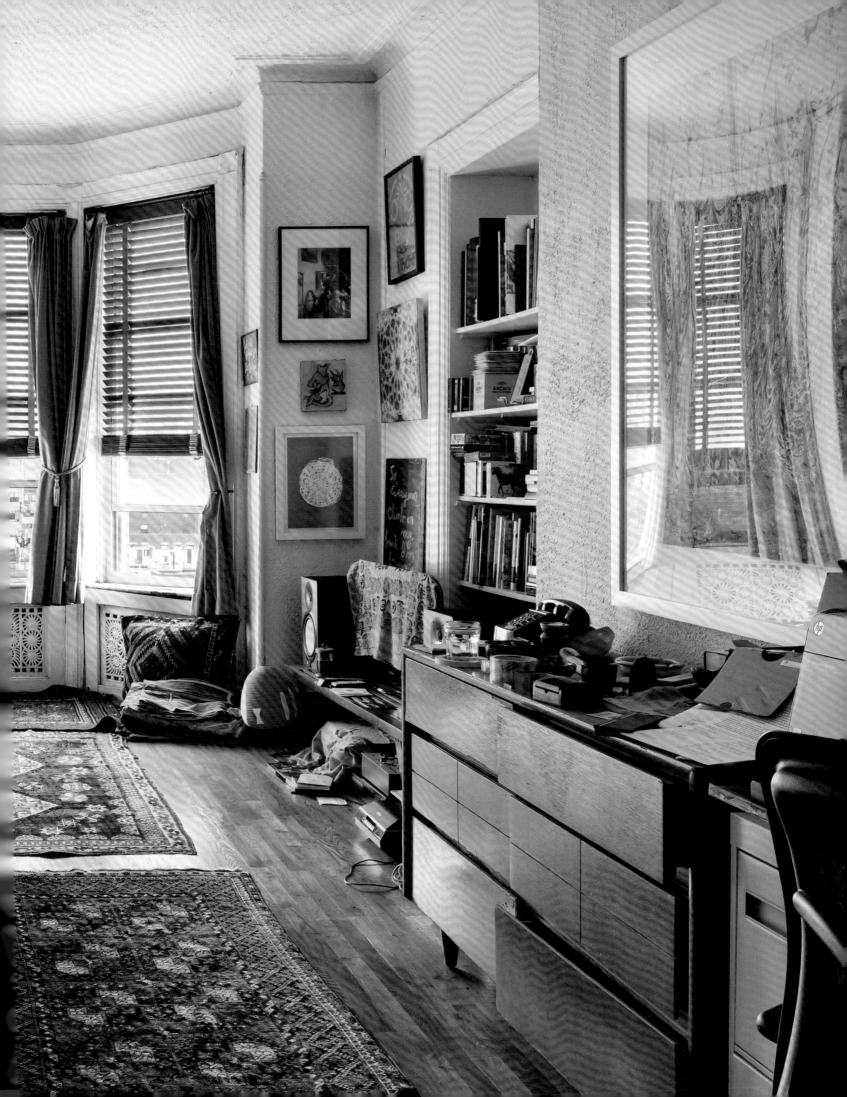

introduced Foye to Watts, who later organized the Ivorian painter's first show at Gagosian. A bookshelf set into an alcove is surrounded by smaller pieces, including a painting by Philip Taaffe, another current Chelsea Hotel resident. Foye, who has curated more than two dozen solo exhibitions of Taaffe's work, calls him "a dozen different artists in one person" and "probably the finest technician in contemporary art."

Among the artworks are examples of Indian lithographs from Foye's large collection, which he amassed during his repeat trips to the subcontinent. There's also a screen print by Henry Miller, a lithograph entitled *Tree of Life* by Harry Smith, a drawing by Terry Winters, another friend whose work Foye has curated, and a painting of UFOs attacking a subway car by an anonymous artist who used to sell his paintings at the subway station at Fourteenth Street and Eighth Avenue.

Interspersed throughout Foye's collection are half a dozen text-based works by another close friend, the poet Rene Ricard. Foye met him at Allen Ginsberg's apartment in 1978 and was immediately drawn to his wit and his vast knowledge of art and literature. The ups and downs of Ricard's life were fuelled by rampant drug use, but he had gained a measure of stability by the mid-'90s, when he moved into the Chelsea. There, he would be Foye's upstairs neighbor for twenty years until his death in 2014. Foye is Ricard's literary and artistic executor. Ricard's short and shrewd poems painted on found canvases are instantly recognizable among the other pieces in Foye's room. "Rene had a beautiful sense of color, light, drawing, and brushwork," Foye says.

Foye's apartment has since been renovated, but he has tried to restore its previous appearance as faithfully as possible to "keep a sense of that old vibe." Now in his early sixties, Foye looks younger and speaks calmly about the changes that have befallen the hotel and its residents. Citing the postmodern philosopher Jean Baudrillard, Foye muses that the hotel's new owners will sell "a facsimile of what they demolished back to people at very high prices." He tries not to be cynical about it and doesn't blame the new owners. "This is the world that we live in. They're just doing what they do. The problem is that artists are running out of real estate. There won't be some sixteen-year-old kid from Lowell coming to sleep on a sofa in the lobby."

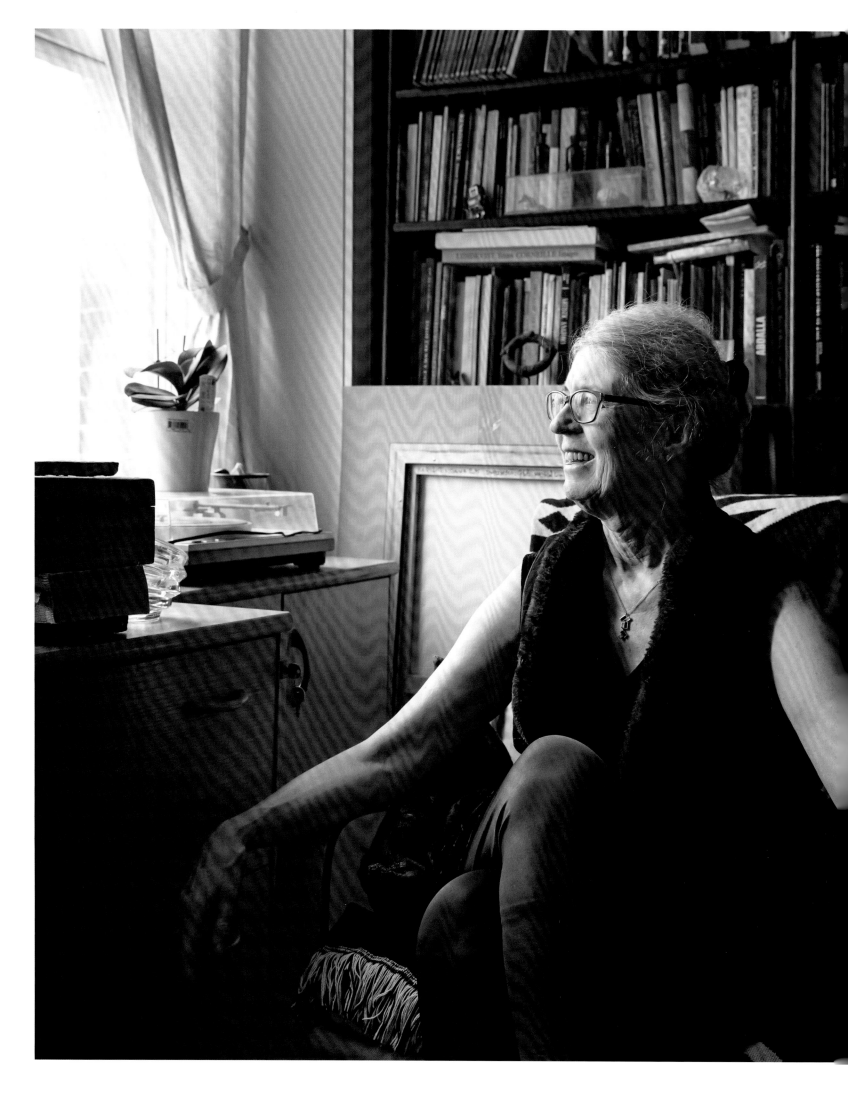

MARY ANNE ROSE

N 1976, THE ABSTRACT EXPRESSIONIST PAINTER HERBERT GENTRY began a four-year stay at the artist residence Cité internationale des arts in Paris. It wasn't his first time living in Paris. A World War II veteran from an artistic family, Gentry had split the decades since the end of the war between Paris, Copenhagen, Gothenburg, Stockholm, and New York, often maintaining a studio in more than one city in order to stay close to the international nexuses of the avant-garde and the art market. It was during this period in Paris, in 1978, that the recently divorced Gentry met an artist from California, Mary Anne Rose.

Rose had been invited to work at Cité and, once she met Gentry, quickly became swept up in his world. She was thirty years his junior, but this difference didn't seem to matter. "Luckily I was the oldest child and he was totally immature," she laughs. He had exhibited prolifically in Europe and the United States and had been a friend or student of countless major artists, musicians, and literary figures of the time. In the fall of 1978, Rose accompanied Gentry on a trip to New York for a gallery show. They stayed at the Hotel Chelsea, where since the early '70s Gentry had been a guest whenever he was in the city. He loved staying there. "It was 1970. He was African-American, and he was embraced there," Rose says.

During the four years after their first trip to New York together, the two commuted between their home in Paris and the Chelsea, staying for weeks or months at a time in order to work and attend art fairs and gallery shows. "My husband had to balance everything," Rose says. "There was no market for his work in Paris." But Gentry's work was well received in Sweden, where he was the first American artist to be honored with a retrospective at the Royal Swedish Academy of Arts, in 1975. He also found buyers for his work in New York, though he didn't show in the larger galleries. "They would say, 'There's no market,'" Rose says, but stops short of accusing anyone of prejudice. "It's complicated."

They stayed in different rooms in the hotel when they were in town. In 1982, Stanley Bard suggested that the couple, who eventually married, would be better off renting a room

long term. The social scene at the Chelsea to some extent mirrored their circle of friends and acquaintances from Europe. "Herb showed me a Chelsea that doesn't exist anymore," Rose recalls. She met some of the stalwarts of the "old Chelsea," including the composer Virgil Thomson and Mildred Baker, former assistant director and trustee of the Newark Museum, as well as many contemporaries of her husband and a host of younger artists. Gentry and Rose formed a friendship with the photographer Martine Barrat; Gentry loved the documentary photographs Barrat shot in the Bronx and Harlem, where he had grown up. Gentry's son from his first marriage, who was more into music, would hang out with the musician Tim Sullivan when he visited from Sweden. They also renewed some old friendships, such as with the artist Bernard Childs, whom Gentry had first met in Paris; his wife, Judith; the MacArthur Award–winning printmaker Robert Blackburn; and the artist Nicola L. "She knew my husband when she was a student at the Beaux-Arts in Paris in the '50s." Their neighbors at the Chelsea were their peers and as such they understood the ups and downs of their lifestyle; they knew when to work and when to celebrate. Gentry appreciated "the idea that no one is supposed to come to your room and just knock. You don't have to explain that to anyone in the building."

From 1980 onward, the couple, who shared their work spaces and occasionally exhibited together, also maintained a studio in Malmö, Sweden, and eventually became Swedish residents. During his final years, Rose says, Gentry received much better care from the Swedish government than he would have in the United States. He died in Stockholm in 2003. Nonetheless, she elected to leave Sweden, retreating to the Chelsea and her circle of friends in New York in order to manage her husband's estate. While there has been much greater interest in recent years in the work of African-American artists, Rose had to make great sacrifices to manage the estate. "I believe in it," she says. "All you can do is keep hustling and hope that it'll work out."

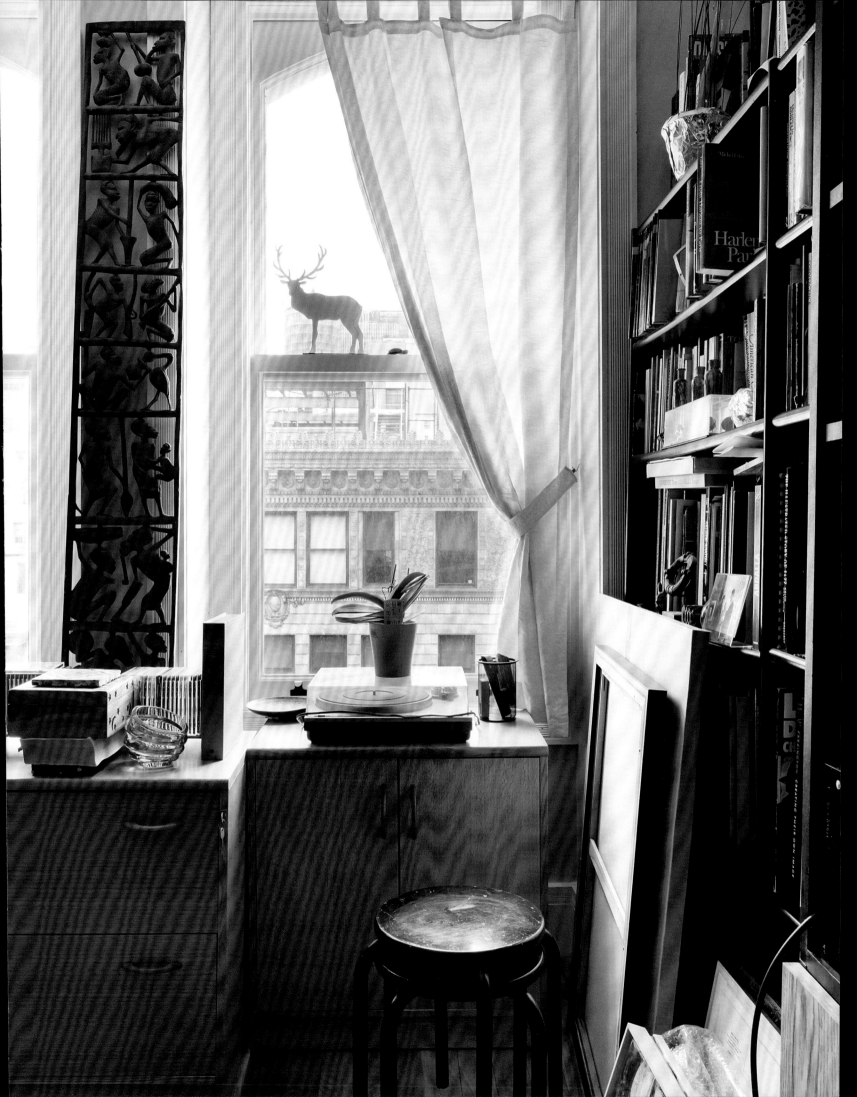

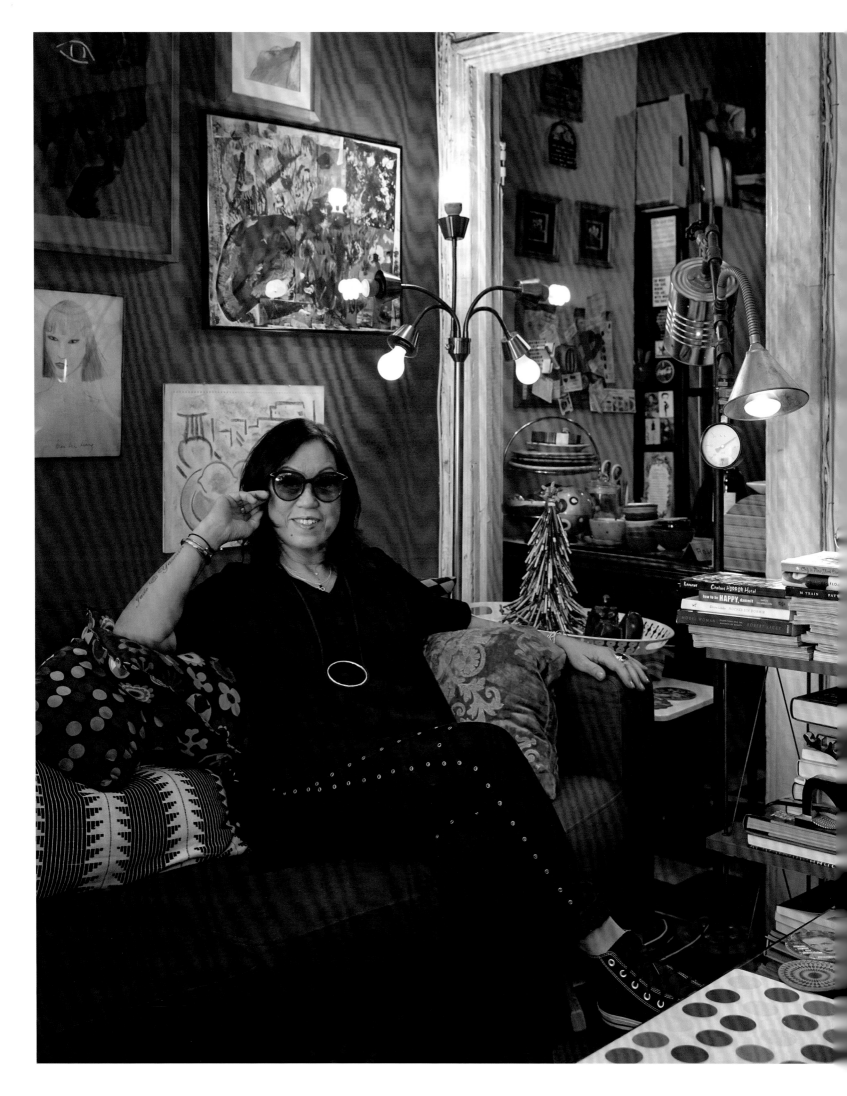

MAN-LAÏ

THE 1980S AND '90S ARE AN UNDERAPPRECIATED ERA in the history of the Hotel Chelsea. To some, this period is not worthy of much attention relative to the cultural significance in the preceding decades of the hotel and its notorious residents, the majority of whom had by then left, passed on, or simply receded from public view. But to those who moved into the building in the '80s, the experience could be just as unique and exhilarating as it was for those who came before.

One of these newcomers was Man-Laï, who goes by her first name and who grew up in Belgium and France and arrived at the Hotel Chelsea in 1980 via Spain. Man-Laï didn't know anything about the Chelsea before landing there, but she quickly learned what kind of place she had stumbled upon when she inquired about vacancies. "Can I have any pets? Can I bring the cat?" she remembers asking Jerry Weinstein, the front desk manager. "He said, 'Don't worry, on the tenth floor we have snakes and monkeys.'"

In the 1980s, the Chelsea was still a bubbling social hub. In the lobby there were gatherings of punks and drag queens, a resident who walked around carrying a snake, and another, known as the Wizard, who could be recognized by his pointy hat. "He had tarot cards and every morning when you went into the lobby you had to pick a card," Man-Laï remembers. There were frequent visits from cops, film and photo shoots at all times of the day and night, and the public screaming fits of residents like Viva, who complained angrily about the commotion. There were also celebrities. "You check in at the lobby in the morning and hear about Nina Hagen, then go outside and see a white limo and it was Valentino. And then later you would see Madonna." Famous residents and visitors were always treated with an unusual degree of normalcy at the Chelsea, even by jaded New York standards.

For Man-Laï, the Chelsea was a perfect match for her lifestyle: club girl at night, hardworking model during the day. She would often run into people she knew from Studio 54 at the hotel. "I'm a club girl. That's my generation," she says, her French accent still unmistakable. "It was disco, but it was also a whole philosophy. You had Calvin Klein,

Andy Warhol, Bianca Jagger. We were all actually doers. At this time I was doing photo shoots and music videos. Every night we were going to photo studios, and then from one place to another. Speakeasies, you name it. That's where I met Anna Sui and Steven Meisel. They were just starting. But everybody was working the next day. It was the culture. Having fun, going out, and working."

At the same time, the AIDS epidemic cast a stark shadow over New York City, and it didn't spare the tenants of the Chelsea or their friends. As Man-Laï recalls somberly, she would meet "artists, dancers, and a lot of pretty people" in the hotel, travel to Paris for a few months, and return to find that they had passed away.

Man-Laï's first room in the Chelsea was room 705. In 1987, she gave birth to twin girls, Jade and Yasmin, and took over adjoining rooms on the eighth floor. After a fire on the floor below, when the girls were three years old, she moved her family to the first floor opposite the infamous room 100, where Sex Pistols bassist Sid Vicious and his girlfriend, Nancy Spungen, lived briefly in 1978. Years later people still left votives to the couple in the hallway outside Man-Laï's door. "People were leaving candles and flowers," she recalls. Once, she says, she was on a bus, about to get off near the Chelsea, when she overheard two punk kids. "Those guys were pointing and screaming, 'This is where Sid killed Nancy!' I thought, Oh my God, this is my home!" According to Man-Laï, Stanley Bard was as protective of the reputation of the hotel as he was of his artist residents. That's why, she says, he eventually divided room 100 into two smaller rooms and removed the devotionalia to the ill-fated punk couple. "He didn't want people to talk about that."

Initially, the condition of the two-bedroom apartment she moved into with her twins, and which she still calls home today, was subpar. "Everything was painted black. One of the doors had a huge crack, like someone had karate-kicked it. And then it was sprayed with red paint that said Fuck You." For many years, her neighbors on the second floor were Dee Dee Ramone and his young wife, Barbara Zampini, with whom she became friendly. Man-Laï's children also quickly found companions in the hotel, joining the cohort of kids roaming the building. "This has been a great environment to be a single mother, bringing up those two girls," she says. Residents took turns watching one another's offspring, with occasional assistance from the staff, "from Stanley to the bell men." For children growing up in the Chelsea, the bohemian inclinations of its residents were utterly normal. "The only thing that my kids knew was that the guy next door was dressing like a lady," Man-Laï says. "He's a transvestite, no big deal." They never felt the need to question their neighbors' lifestyle choices. "It was pretty normal."

Over the years, Man-Laï's apartment came to reflect both her personality and her heritage. Her Belgian mother was an artist and gallery owner, while her Chinese father

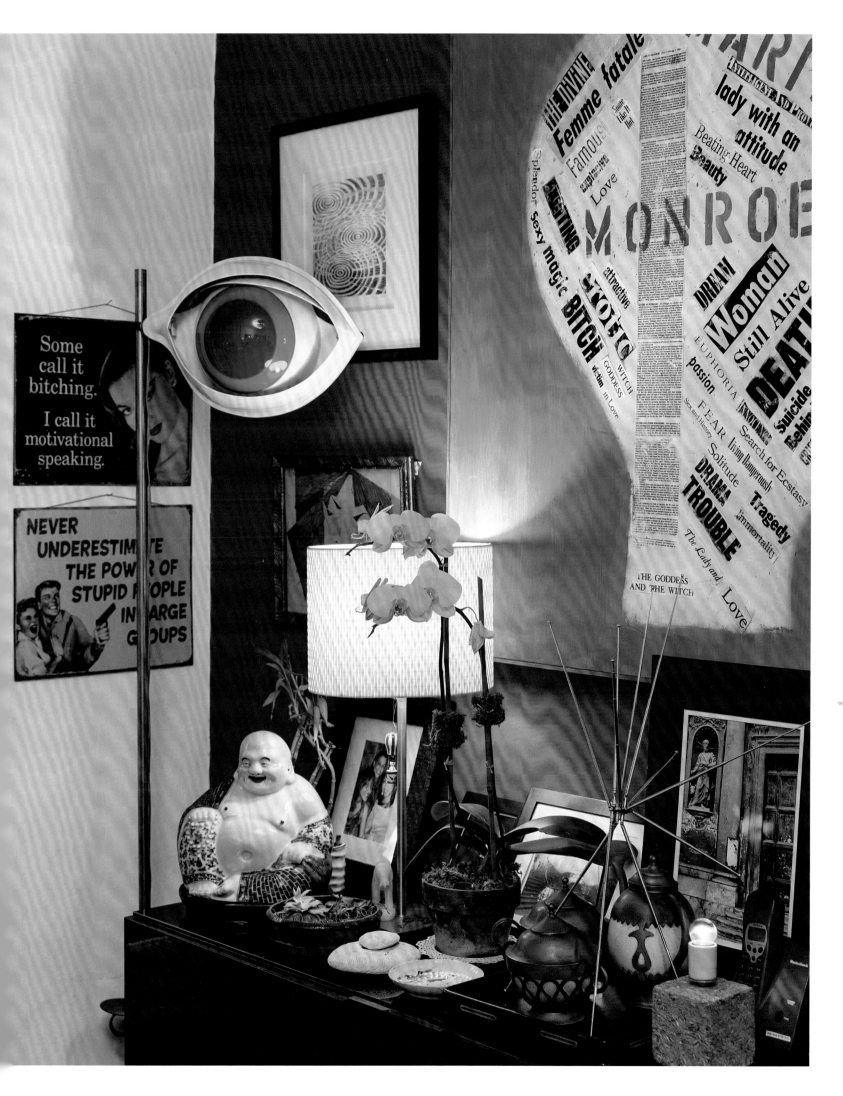

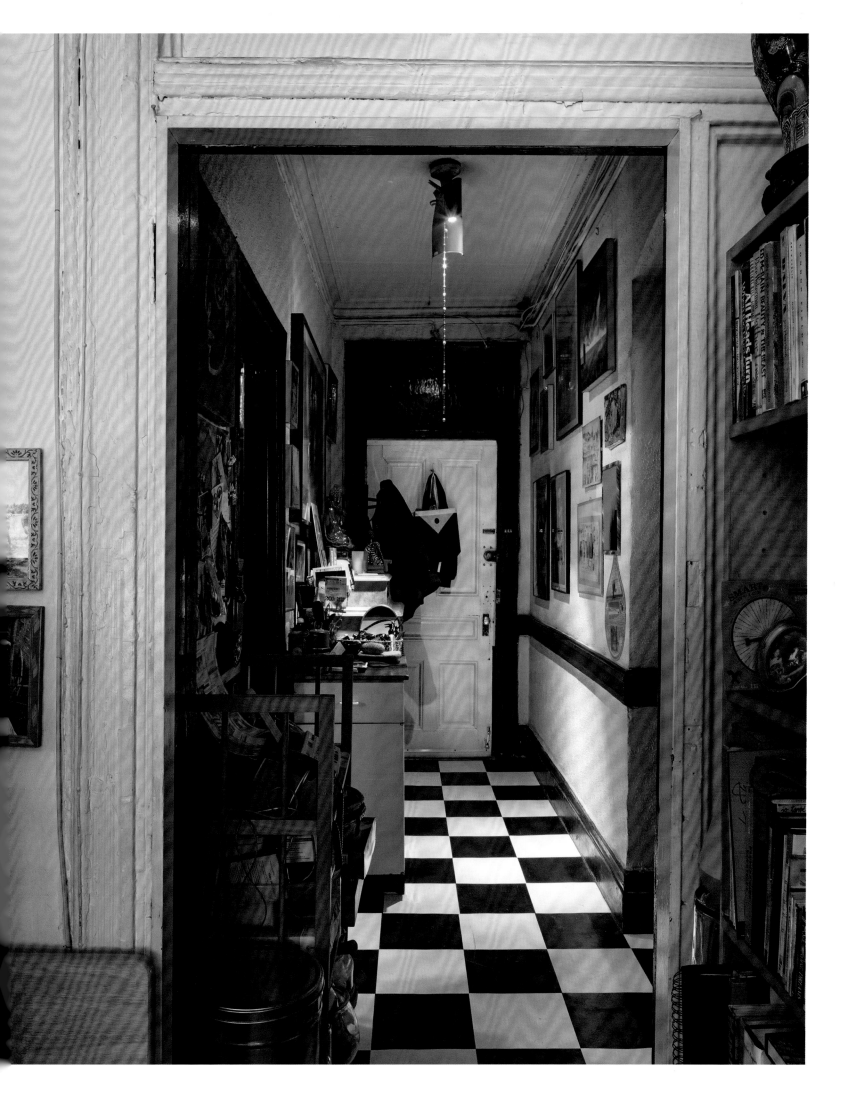

imported antiques, textiles, and stationery from China. He was also a prolific collector. Her father's fascination with objects rubbed off on Man-Laï; her apartment suffers no shortage of interesting and meaningful things. "I like to keep things because everything is a souvenir. Everything has a history, from my trips, from France." It doesn't help that the Chelsea neighborhood used to boast some of the city's best flea markets. "I grew up in a culture of flea markets with my mother in Belgium. That's why I need the Chelsea to give me another three rooms," she jokes. "I need to expand a little bit more."

In Man-Laï's home, the top of every flat surface—of every shelf, dresser, and side table, as well as the fireplace mantel—is covered in curiosities. In the living room, vases, lamps, Buddha statues, candles, plants, and countless trinkets happily mingle in a state of loosely choreographed chaos. Many follow an East Asian theme: A pair of lamps flanking the fire-place resemble Chinese take-out boxes. Another lamp looks like a miniature apothecary cabinet topped by two porcelain figurines wearing traditional Chinese garb. Similar figures peer from her bookshelf, where they are arranged in a neat scene amid tea lights, a teapot, a bronze palm tree, and an assortment of family photos, some recent and some many decades old.

In the living room, the fireplace and the wall opposite are painted a rusty red, giving the space a warm, earthy glow. Newly installed stained glass above the balcony doors evokes the hotel's original transom windows. But the most visually arresting piece in Man-Laï's apartment is a lamp in the shape of an eye. Like a large painting she hung nearby that features shades of green similar to the lamp's iris, it was made by the interdisciplinary artist, designer, and feminist Nicola L, a resident of the Hotel Chelsea since the 1970s and a longtime friend of hers. After she retired from modeling and founded her own event planning and strategic marketing company, she also helped promote the artist's shows.

Man-Laï's art collection consists largely of works given to her by friends or traded in lieu of compensation, including several portraits for which she modeled, and images of her with her daughters. To her, this artwork is intimately connected to her memories of the artists at various stages of her life in the Chelsea. "To live in a normal, plain place, on the Upper West Side or the Upper East Side, surrounded by normal things? No, I would stay in Europe. What's the point? I love New York, but it's basically the Chelsea that made me stay."

Man-Laï started growing tomatoes and herbs on her balcony shortly after she and her daughters moved in, taking full advantage of the luxury of the outdoor space. The balcony, with its ornate cast-iron railing, overlooks Twenty-Third Street from underneath the Hotel Chelsea sign. In addition to her gardening, it proved to be a great location for photo shoots, including the most memorable shoot: "The *Playboy* one," Man-Laï laughs.

If her lifestyle made the Chelsea a perfect fit in the beginning, it was the hotel's good vibes that kept her firmly planted there. As she puts it, the fact that the hotel has been quieter

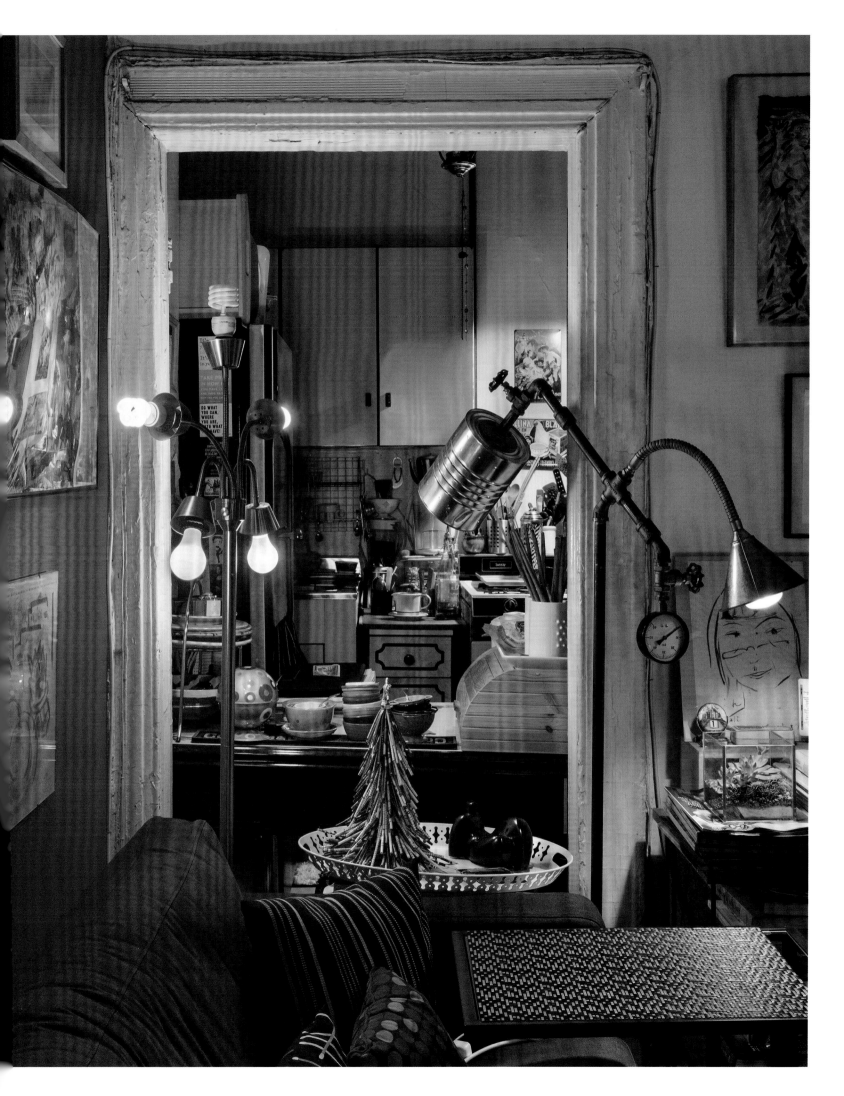

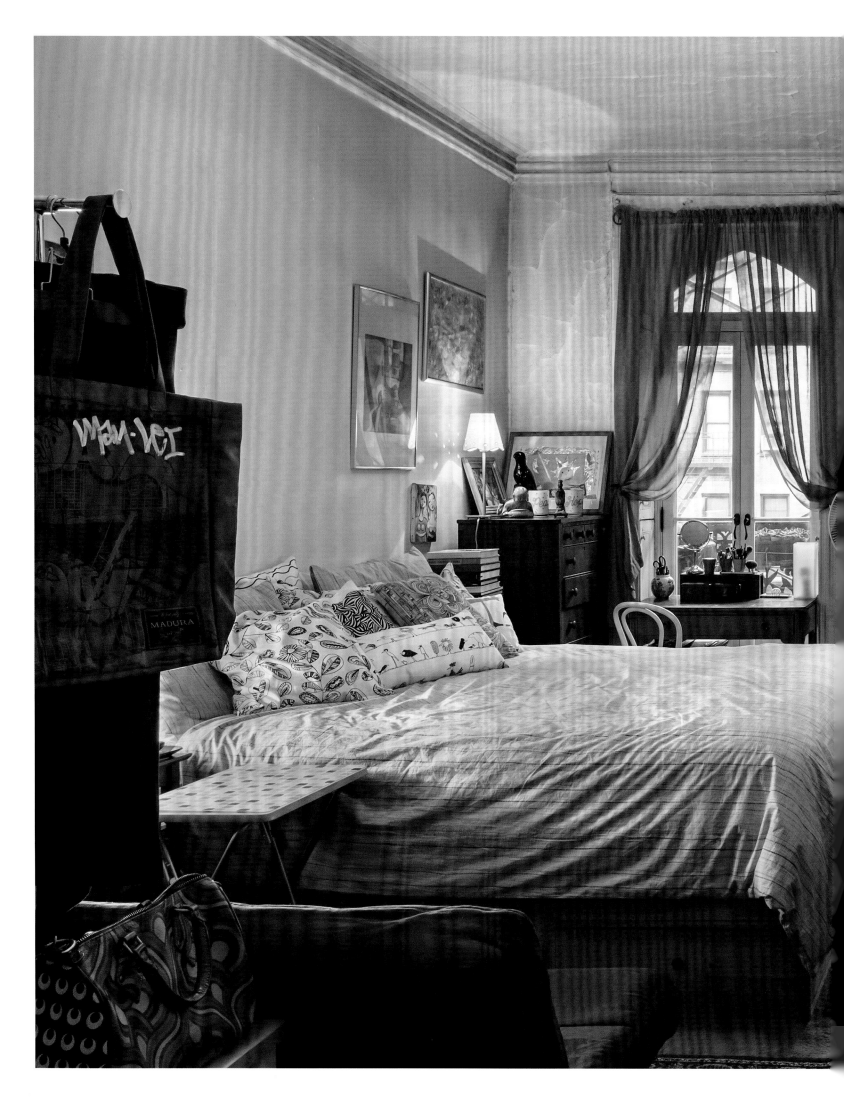

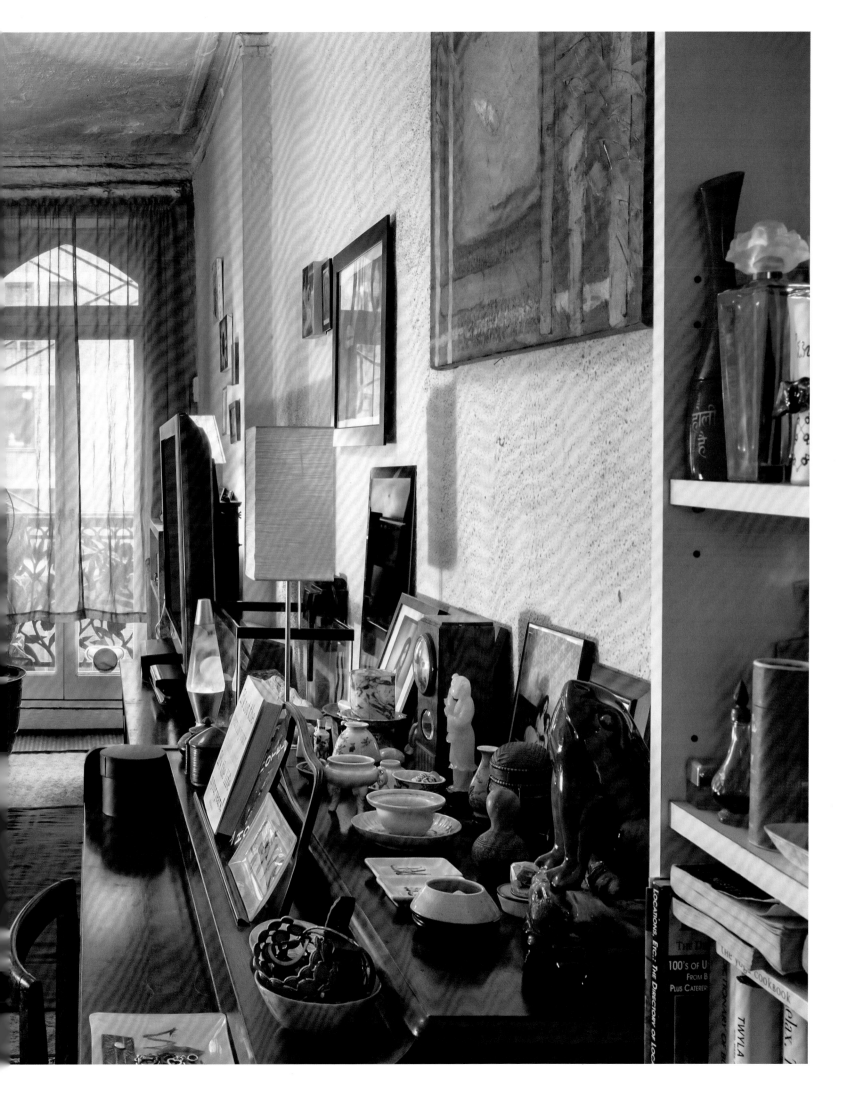

in recent years was not why she moved in, but it is why she stayed. "As soon as you come in you feel like it's home, it's protected, it's a positive energy in this totally dysfunctional world." If you feel safe, she says, you're better able to get in touch with yourself and thus to create art or music. As if that weren't enough, she also enjoys the company of benevolent spirits. "I don't believe in it, but I have a friend from France, she is a medium. She moved in here and she was all excited: 'This is really good! You have really friendly ghosts!'"

As the Chelsea transformed from cultural hub to, as some might say, a shadow of its former self, Man-Laï found herself in the role of caretaker and storyteller. For a while someone gave tours of the hotel, and when they found her at home, she would welcome the strangers and share some of her stories. She is now working on a memoir that spans her experiences, from immigrant club girl to entrepreneurial business owner. Her attachment to the building is as strong as ever, and like many she is wary of the changes happening around her, even as she tries to embrace them. A new heating system will replace the hotel's old radiators, but Man-Laï plans to hold on to hers nonetheless. "If you look down on the bottom it says 1890, the year that they were putting them in." She has been following the progress of the renovations closely and has observed the changes taking place in some of the empty sections of the building. "They are taking everything out," she says, dismayed. The old kitchens, the wallpaper, the woodwork — "They destroy everything. I saw a finished little room. The bathroom is not even a bathroom, you know, just the tiles on the floor and a glass wall, like in those new boutique hotels. That has nothing to do with the Chelsea. Nothing at all."

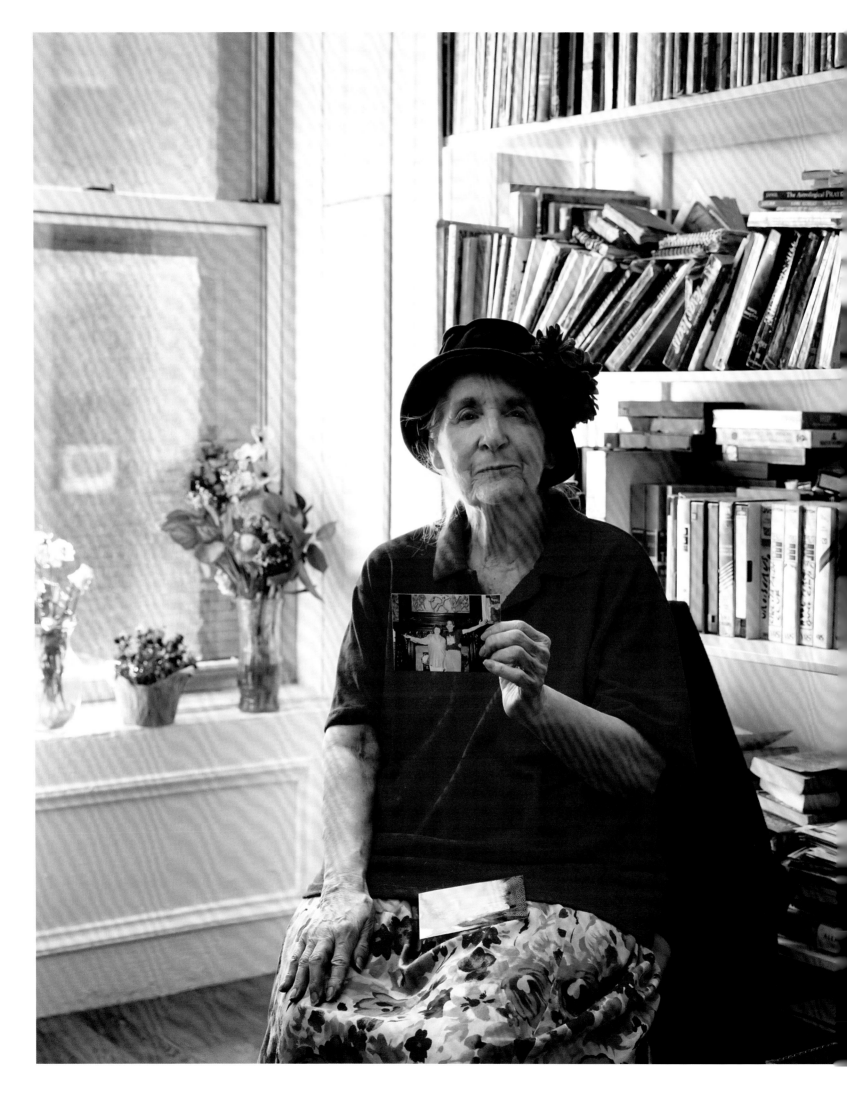

MERLE LISTER-LEVINE

NEW YORK IS A DEMANDING CITY. Some newcomers never find an anchor that tethers them to its social fabric and they end up leaving. "I anchored," says Merle Lister-Levine, who came to New York from her native Toronto, Canada, in 1962 as a twenty-three-year-old. "If I hadn't met my husband and if I didn't have my work, I might have not stayed."

Merle Lister met Leonard Levine, a native New Yorker from a Russian-Jewish family, through mutual friends the year she arrived. She came from an upper-class household with stringent social strictures. When after dating for a few months Leonard Levine asked her to move in with him, she said, "You mean marry me?" They wed the following year, and eventually her parents came to embrace their new son-in-law.

Having been introduced to dance as a child, Lister-Levine worked as a dancer and choreographer in New York and founded her own company in the 1970s. Later she would also teach dance at the Hudson Guild, a community center in the Chelsea neighborhood, where one of her students was a young woman named Caryn Johnson. "She came up to my class after school to dance. She had this great face. I said, 'What do you want to be when you grow up?' She said, 'A movie star.'" And that was just what she did, albeit under a different name — Whoopi Goldberg. Lister-Levine would eventually preside over the Hudson Guild's board.

Lister-Levine's husband was a lighting designer and stage manager at, among other theaters, La MaMa, where she had also worked in the '60s. They shared a spacious loft in Chelsea that they rented for $125 a month until their landlord forced them to leave. (A month later, the place burned down.) Leonard suggested they move to the Chelsea Hotel. In 1981 the couple rented room 717. The Chelsea would anchor Merle Lister-Levine even more strongly to the city.

For their first New Year's Eve in the Chelsea, Lister-Levine threw a party in her hallway. Her husband made a big paella and everybody was invited. "I bring people together," Lister-Levine likes to say. "That's what I do." At the Chelsea she quickly connected with

many of her neighbors, such as fellow choreographer Katherine Dunham and composer George Kleinsinger. Many still remember the performance entitled *Dance of the Spirits* that she organized in the staircase of the hotel on the occasion of its centennial in 1983. Her lead dancer portrayed a ghostly figure dressed all in white. Only later did she learn that the staircase and hallways of the hotel were supposedly haunted by a restless spirit named Paula who was said to wear a white gown. The performance added to both Paula's and Merle's legend. Lister-Levine says she frequently felt the presence of ghosts in the building. "I have that kind of consciousness. My husband went along with it. That's why I loved him dearly."

Lister-Levine also appreciated Stanley Bard, who she says was quirky, but very loyal to the people he liked. He also had a tendency to downplay any issues in the building. She recalls a time not long after she moved in: "We had had a fire on the sixth floor, and Stanley was showing the place." Bard didn't mention the blaze to the prospective tenants. "He said, 'We're renovating.'"

In 2000, Leonard Levine passed away. There was an outpouring of support for Lister-Levine, and in one way or another it has continued to this day, with helping hands never far away even as the building has emptied. In recent years she could often be found in the lobby, where she met friends and where her neighbors could easily drop in on her. A few years ago, she accepted an offer to relocate from her dilapidated studio to the first floor and she is grateful for the additional space and convenience. The only thing she misses is her large balcony.

Merle Lister-Levine believes that if she had not moved into the Chelsea, she would have ended up doing many of the same things she did. "I think you are who you are," she says. However, the Hotel Chelsea would not be the same without her.

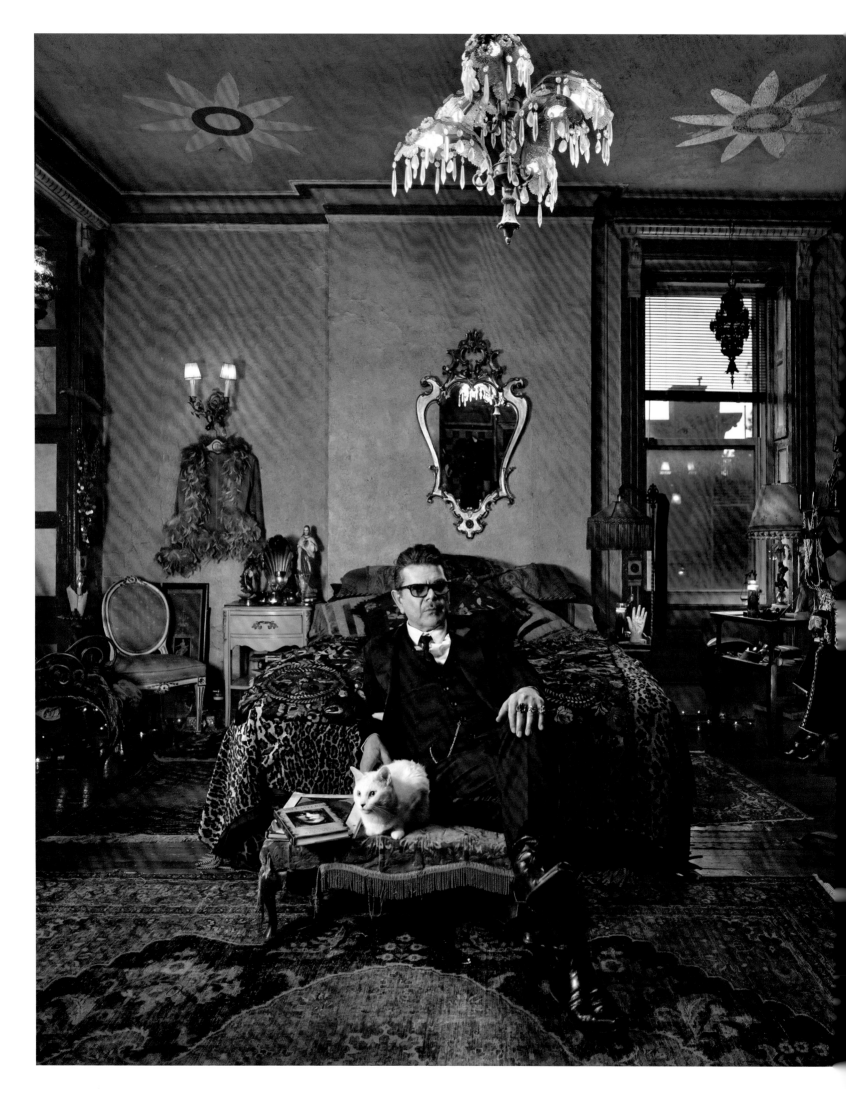

TONY NOTARBERARDINO

ony Notarberardino's apartment is one of the most visually arresting in the Chelsea Hotel. It consists of two rooms joined by a colorfully painted curved hallway. Both rooms are filled with Notarberardino's collection of wondrous objects, photographs, furniture, and garments, yet each has its own visual identity owing to the elaborate murals left behind by a previous tenant, the enigmatic artist Vali Myers, in what is now Notarberardino's bedroom.

It's early afternoon when we meet Notarberardino, but he hasn't had breakfast. He dons his scarf and fedora and we head to the Rail Line Diner at the corner of Twenty-Third Street and Ninth Avenue. On the way there, Notarberardino tells us about one of his latest projects, a neo-noir short film called *Erotic Dreams of the Chelsea Hotel*, which he wrote and codirected. Notarberardino is a photographer, and like others before him, he has found the hotel to be a rich source of inspiration and has branched out to filmmaking and cinematography in recent years. His film is his attempt to capture the cinematic atmosphere of the hotel.

An Australian from Melbourne who put in a few years in London and Paris, Notarberardino always knew that he would move to New York. When he arrived in 1994, a friend offered him a place to crash and gave him a phone number to call when he arrived. He dialed, expecting to hear his friend. Instead, a woman with a deep, husky voice answered: "Hello, Chelsea Hotel." "I hung up," Notarberardino says. "I thought I must have called the wrong number."

A second call cleared up the misunderstanding. "It was late at night. I walked in and immediately loved it. I felt like I had walked into a movie set." His friend already shared his tiny ninth-floor room with a few other people. Notarberardino realized that he would need to rent his own room if he didn't want to sleep on the floor. Undaunted and restless from the long flight, he decided to resolve the problem in the morning, put down his suitcase, and went out to party. He returned to the hotel around 6 a.m., hungover and tired, and looked for the manager. Stanley Bard was already in his office. "Stanley had a

way of sussing you out," he recalls. "He asked me a couple of questions and said, 'There's a room on the sixth floor that I think you're going to really like.' He walked me into that painted hallway and I thought, Where am I? This is fucking incredible!" Notarberardino was surprised to learn that the hallway (and a front room, which was occupied by another tenant) had been painted by a fellow Australian, Vali Myers, whose work he was familiar with from back home.

Then Bard showed him the back room, its windows opening to the city's west side and to Twenty-Third Street below. It was not in great shape, but Notarberardino could see the Chelsea Hotel sign, dramatically aglow in the early morning mist. He agreed to sign a lease for one month. Back in the office, Bard turned to him and said, "You're probably never going to leave this place, you know that?" he recalls. "I thought to myself, Yeah, right!"

A few months later, at a get-together in a room on the tenth floor, Notarberardino casually asked his host how much he paid in rent. The room fell silent. "What do you mean, pay rent? No one pays rent here. Just don't pay and wait," the man told him. That idea suited the photographer, who had yet to find steady work. "Sure enough, I didn't pay rent for almost two years," he admits. Stanley came asking for money periodically, but he never kicked him out. "He gave us all a hard time, but in a loving way." One moment he would threaten delinquent tenants with eviction, and the next he praised their work and inquired how he could help them. Notarberardino paid up eventually.

Back at his apartment, the photographer shows us the proof for a book of portraits of Chelsea Hotel tenants and guests, a project he started in 1997. There are celebrities, artists, writers, sex workers, and freaks, but also regular folks and blue-collar workers. "I didn't judge people with this project. Everyone was equal: the cleaner, the famous author, the famous musician." Character was more important than fame. He wanted to capture the essence of the hotel. The very last photo in the book is of Stanley Bard, who passed away just two weeks prior to our meeting with Notarberardino.

Working on his portraits opened up a new world to Notarberardino. "The artistic energy in the hotel pushed you to question a lot of things about yourself, your art, why you are there, and what you are doing with yourself," he says. At the Chelsea, he constantly met interesting and creative people and felt compelled to document them. All of the photos were shot with a large-format Toyo 8x10 in front of the same wall in his apartment. Once he was committed to these contraints, getting people into his room for their portrait became part of the challenge. He waited years to shoot some of his neighbors, ready to photograph them at a moment's notice if he could catch them, or if the staff tipped him off to a notable arrival. He worked on the book for seventeen years and estimates that he has

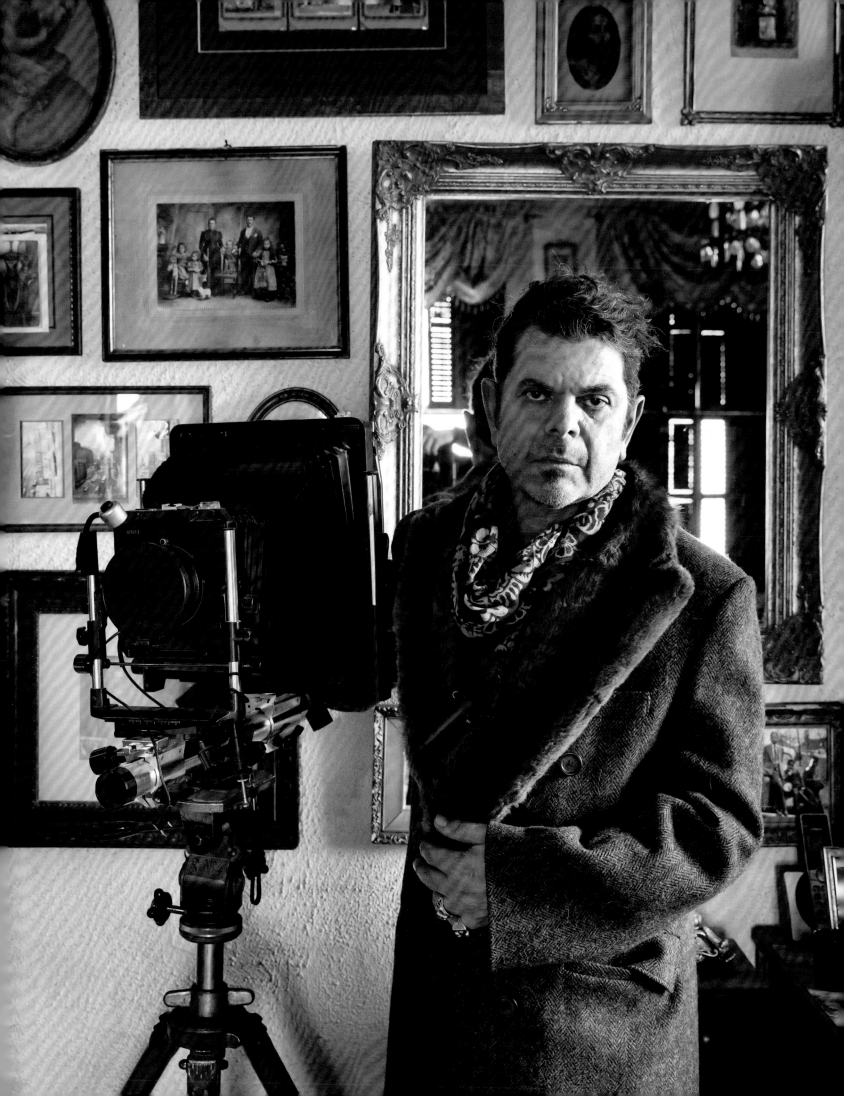

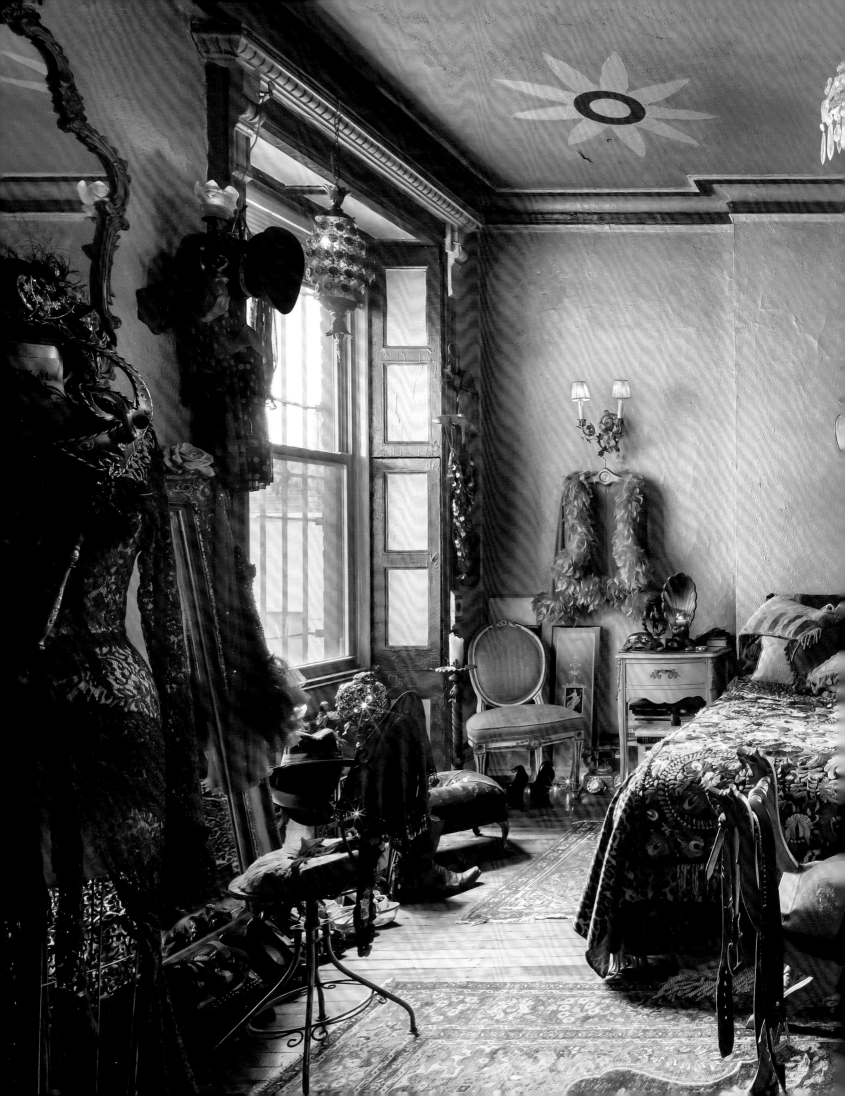

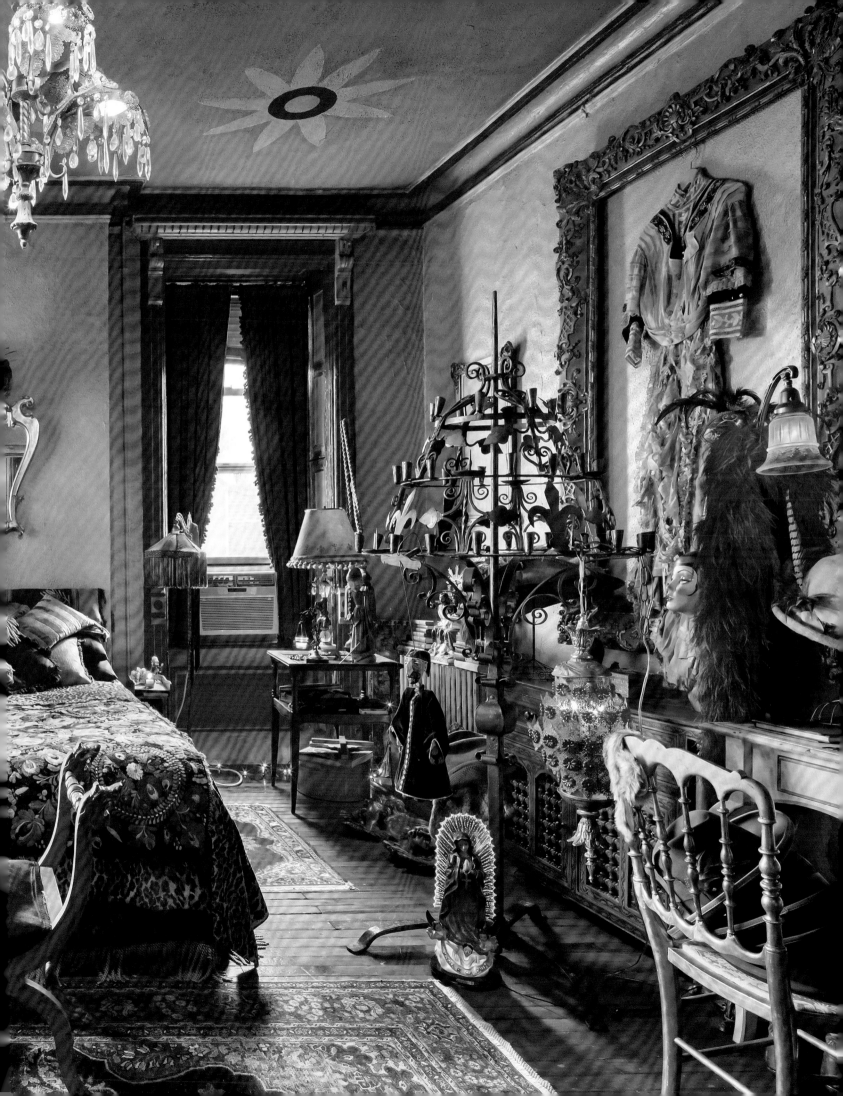

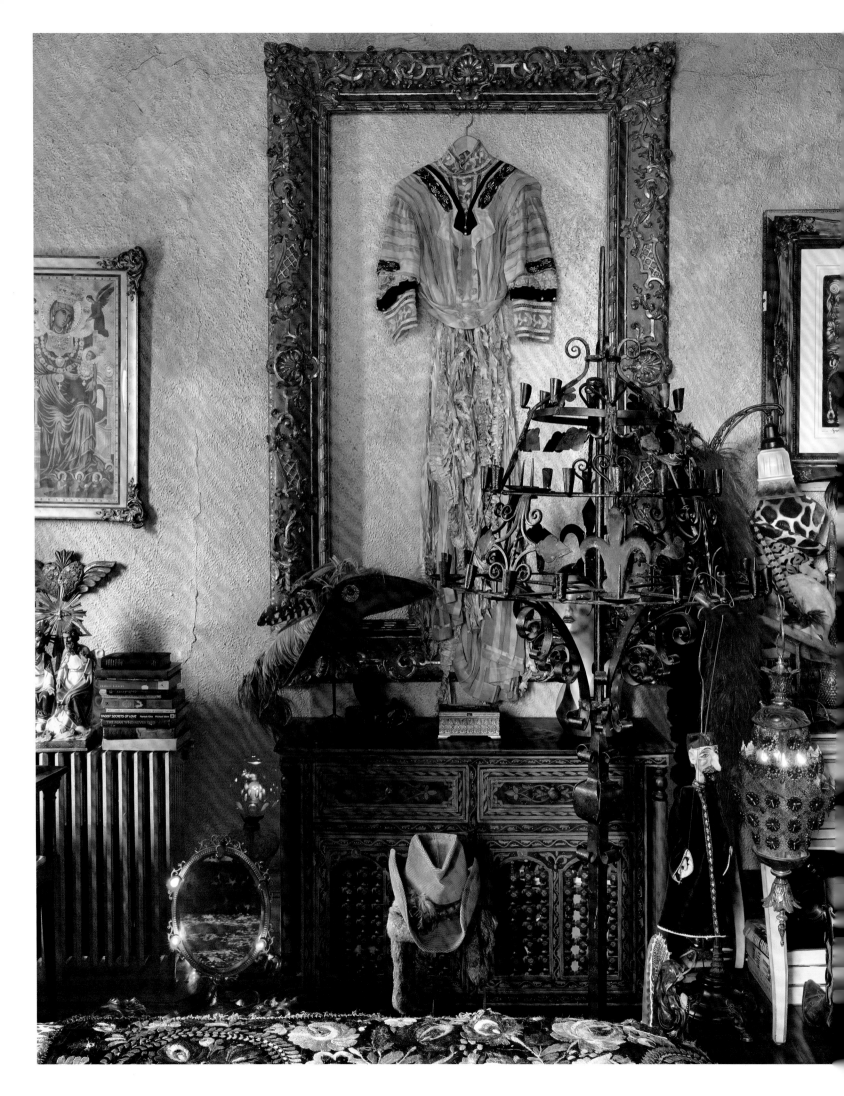

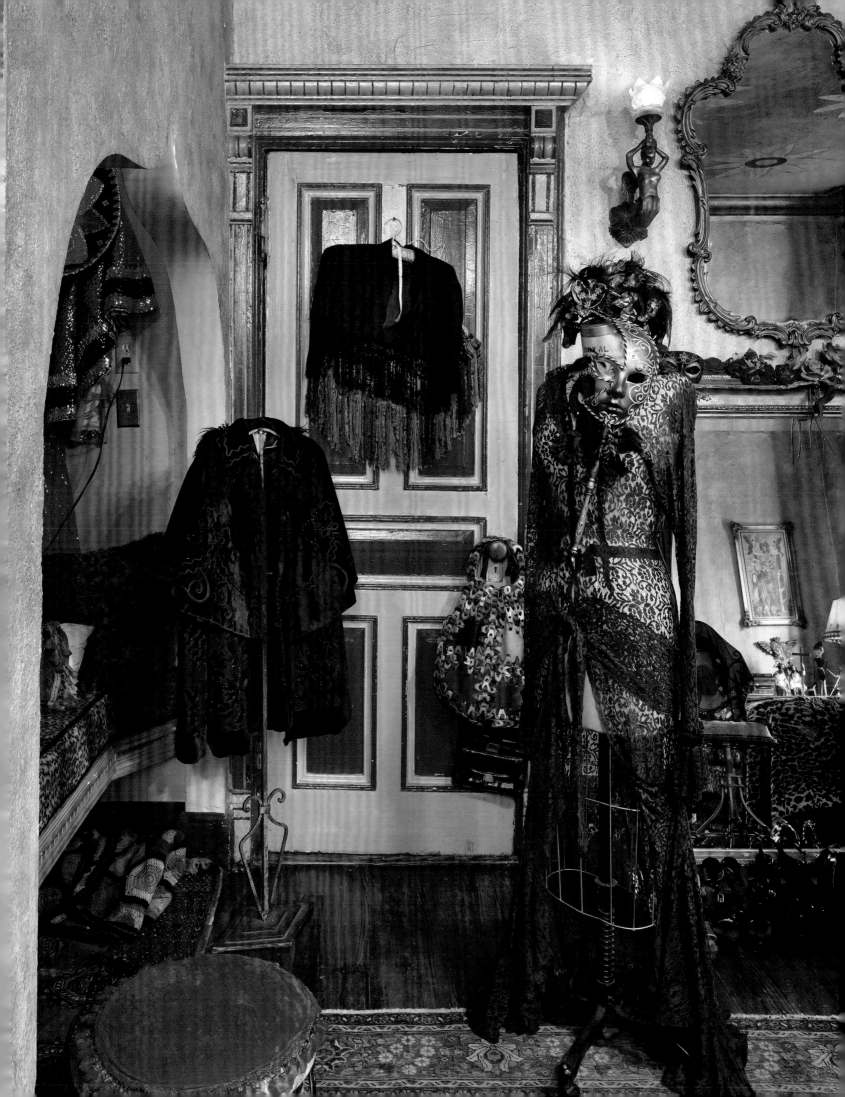

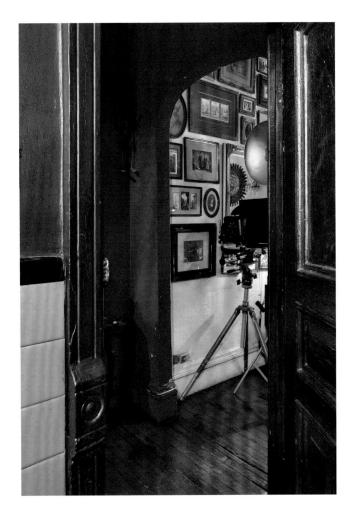

shot close to five hundred portraits; only a fraction made it into the book. The camera is still mounted on a tripod in the same spot where all of the photos were taken.

Notarberardino associates memorable moments and experiences with each photo he has taken, but a few stand out. One portrait is of Arthur C. Clarke, who, with Stanley Kubrick, cowrote the script for *2001: A Space Odyssey* while he was staying at the Chelsea Hotel in the 1960s. In 1999 Clarke returned to New York from his home in Sri Lanka for a medical visit and again stayed at the Chelsea. After Bard made the introduction, Notarberardino took Clarke's portrait and spent some time with him. "That was probably one of the greatest days I had here," Notarberardino recalls. "He was in a wheelchair. After we shot the portrait he wanted to see a few bookshops down on Eighth Avenue. I wheeled him down there and we spent a good part of the day together."

Another photo features his former neighbor Dee Dee Ramone, who lived in Vali Myers's old room for three years. "He was a paranoid fuck, a constant nightmare," Notarberardino says about the punk rocker, who was then in his sixties. Ramone's wife, Barbara, often threw him out, and Notarberardino would find him sleeping in their hallway. "I had to step over him to get to my front door." He offered up his couch. "He told me to fuck off. Then there was a knock on the door ten minutes later and he was standing there with his dog. Then I couldn't get rid of him. He stayed here for a week."

Getting a portrait of Ramone proved to be a challenge. Notarberardino finally cornered the musician on what would be his last day in the hotel. The photo in the book shows the wiry and heavily tattooed Ramone facing the camera at a slight angle, his chest puffed out and his head cocked back, staring defiantly into the lens. Notarberardino shot six sheets of film and Dee Dee left the same day for Los Angeles, where he would die a few years later, in 2002. Notarberardino never saw him again. A few months after Ramone's departure, he worked out a deal with Bard to take over his room. Then he set out to meet

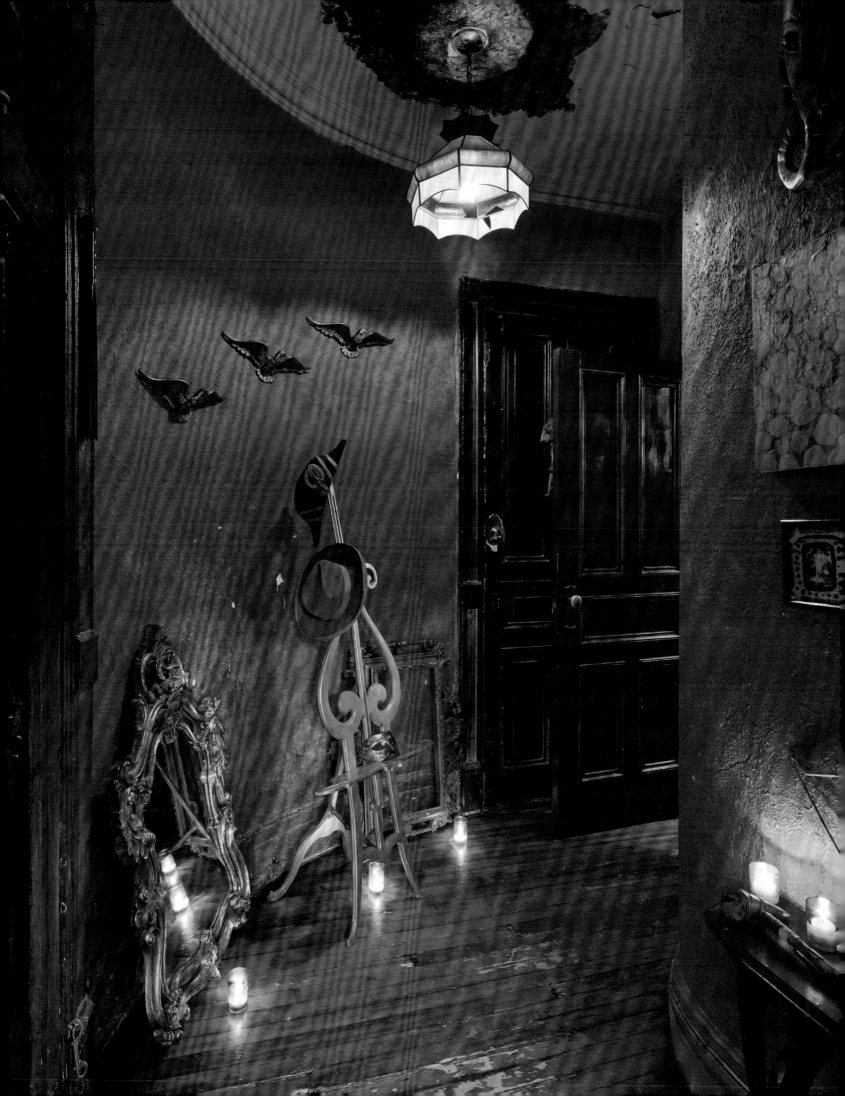

its earlier occupant, Vali Myers, or Vali, as everyone called her.

Vali was a wild spirit. Born in 1930 in Sydney, Australia, she developed a deep bond with nature and started drawing at an early age. She left home at nineteen to pursue a career as a dancer in Paris, but found that there was little work for her in war-torn Europe. Living a vagabond's life for the better part of the next decade, she experienced poverty, opium addiction, and harassment from the authorities. But the fiery redhead also bedazzled her contemporaries — among them Tennessee Williams, Jean Genet, Jean-Paul Sartre, and Jean Cocteau — with her skills as a dancer and with her drawings. Vali was the main subject of photographer Ed van der Elsken's 1956 book *Love on the Left Bank* and George Plimpton prominently featured her work in the *Paris Review* in 1958 (and again in 1975). In the late 1950s, she stumbled upon a remote valley in Positano, in Southern Italy, where she settled down, continued to work on her art, and eventually founded a nature reserve.

In the 1970s, Vali visited New York, and after the activist Abbie Hoffman introduced her to the Chelsea Hotel, she established an outpost there. She frequently welcomed visitors, including Salvador Dali, who encouraged her to exhibit her work. She also started tattooing and wore increasingly prominent markings on her own body, including on her hands, feet and face, which only served to make her appear more mysterious and fascinating. Patti Smith was instantly smitten with her when the two met at the Chelsea and had Myers tattoo a lightning bolt on her knee. In 1993, Vali returned to Australia for the first time in forty-three years to live in Melbourne, and in 2003 she died there, from cancer.

Vali turned her room at the Chelsea into a living art installation. She painted the walls and doors in rich, earthy yellows, reds, and browns, interspersed with checkerboard patterns, circus-tent stripes, and animal portraits. Even though the colors of Vali's wall paintings had faded or been painted over in some spots by the time Notarberardino moved in, it was still a magical place. He has changed little, turning his bedroom into what looks like a vaudevillian's dressing room, a mad hodgepodge of materials and artifacts that complement Vali's work.

While visiting Melbourne, where Vali had lived since her return, Notarberardino tracked her down. "I introduced myself and told her that I was living in her room. We became instant friends." He arranged for her to visit New York in order to take her photo in her old home, but her cancer diagnosis upset their plans. "I took the last portrait of Vali, two weeks before she died," he says. "She was one of the most original people I'd ever met. When I first took her room, I couldn't sleep in there. The energy was so intense. And it still is; I really believe it's built on some kind of vortex." Notarberardino says he felt the presence of spirits from the time he moved in. "I consciously set out to cleanse this space,"

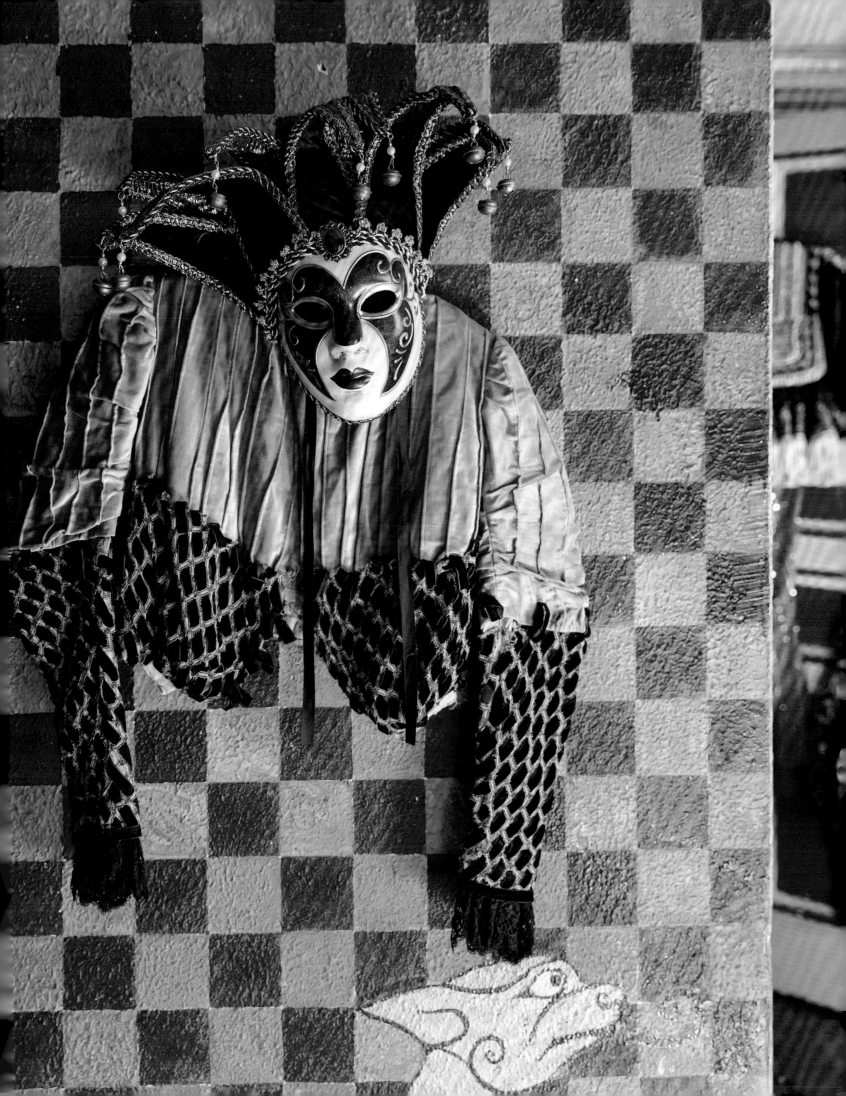

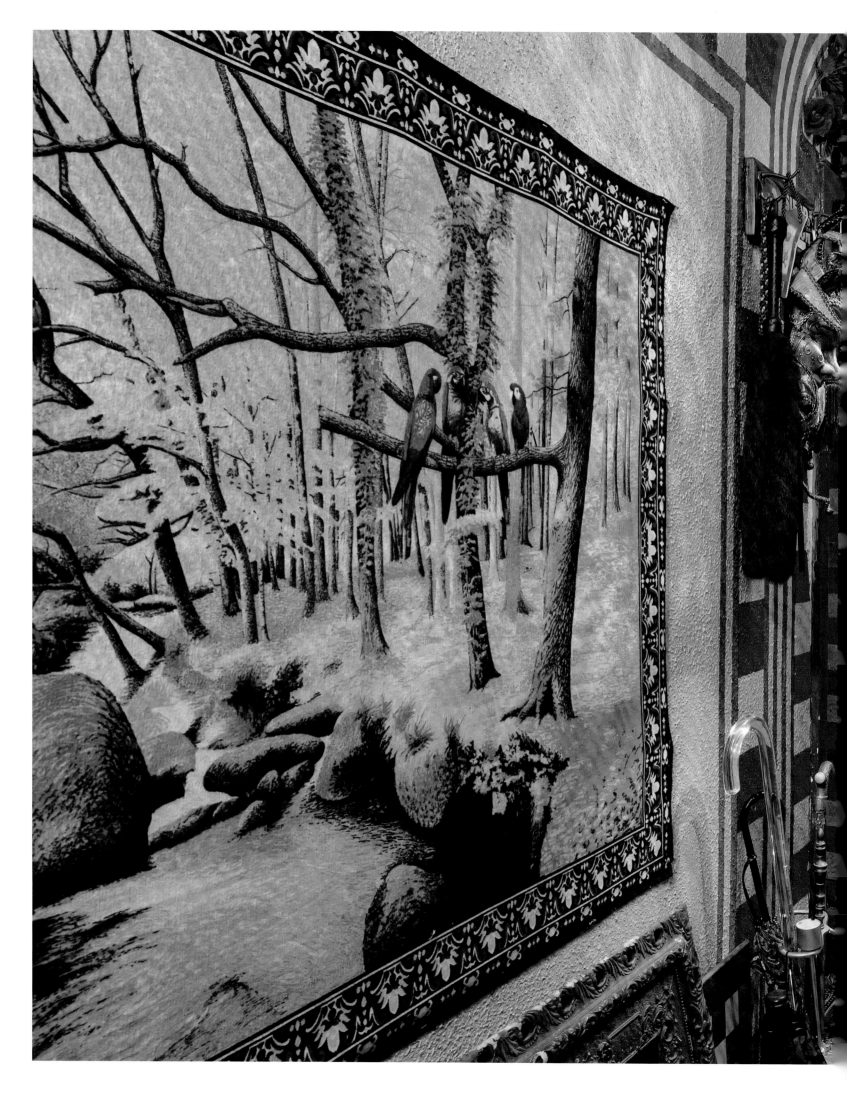

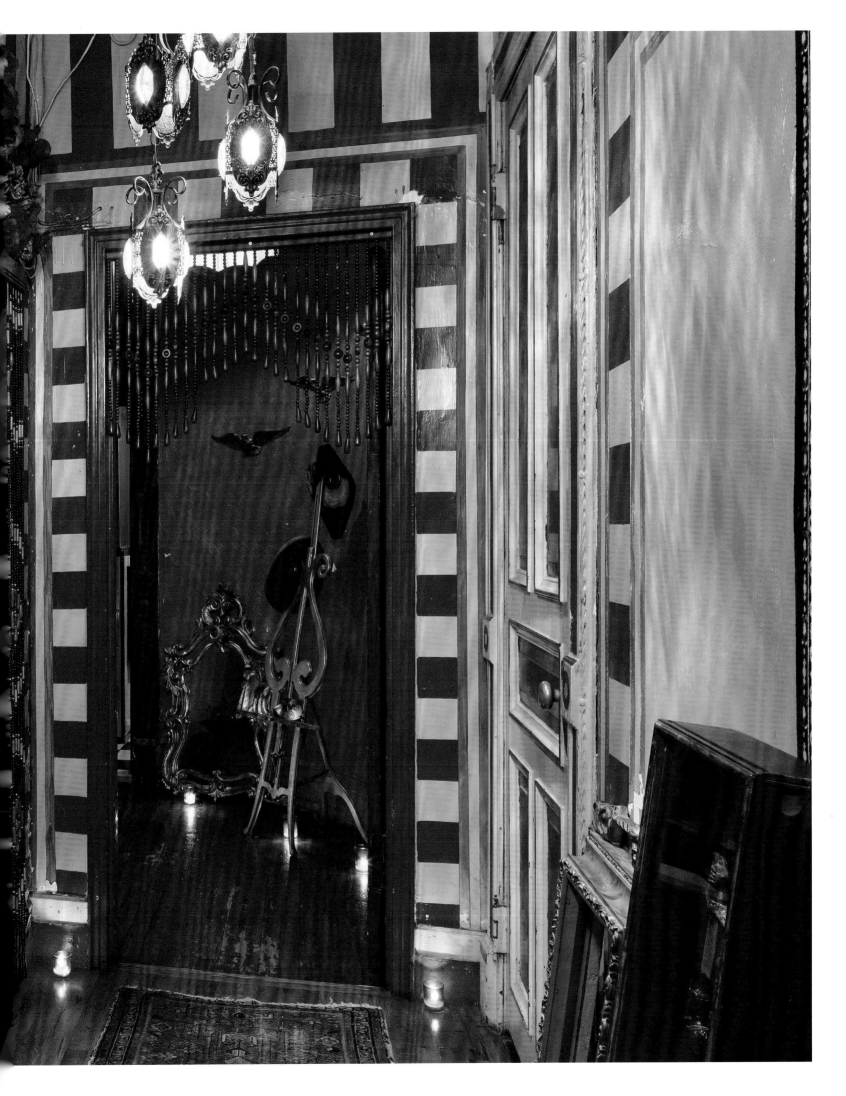

he says, "burning sage and doing cleansing ceremonies." Vali helped him harness this spiritual energy. "She was a real supreme, evolved witch," he says reverently. "She channeled a lot of that into her art, and she taught me how to channel it into my art."

Notarberardino has resisted offers to renovate his apartment and argues that his refusal to leave is an important act of resistance that will help preserve the hotel's history. "When the hotel reopens, people are going to want to see the original rooms," he ventures. "People want to come here and touch the wall that Jack Kerouac touched, they want that authenticity." If nothing else, the hotel might once again attract artists and musicians at the peaks of their careers. He's optimistic. "The Chelsea's bigger than anybody. It's going to outlive everybody."

Stanley Bard was right; there's no telling when or if Notarberardino will leave. "I've got my own sanctuary here."

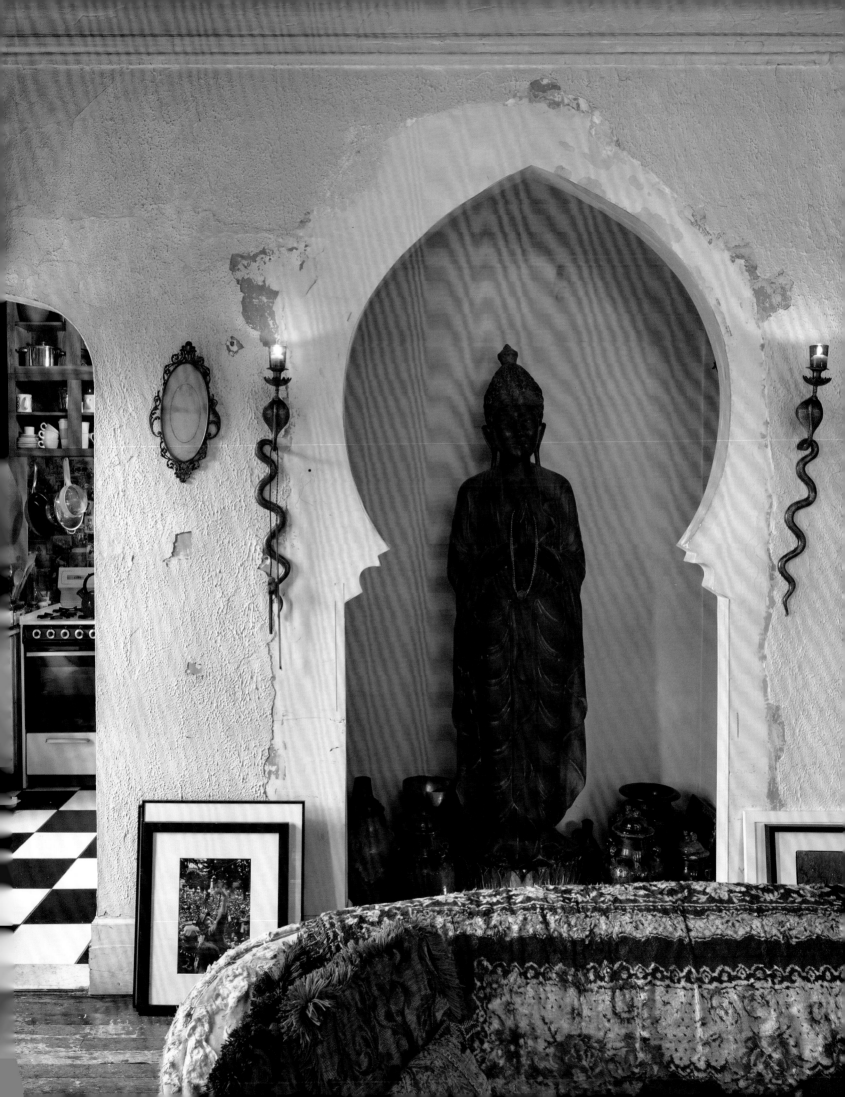

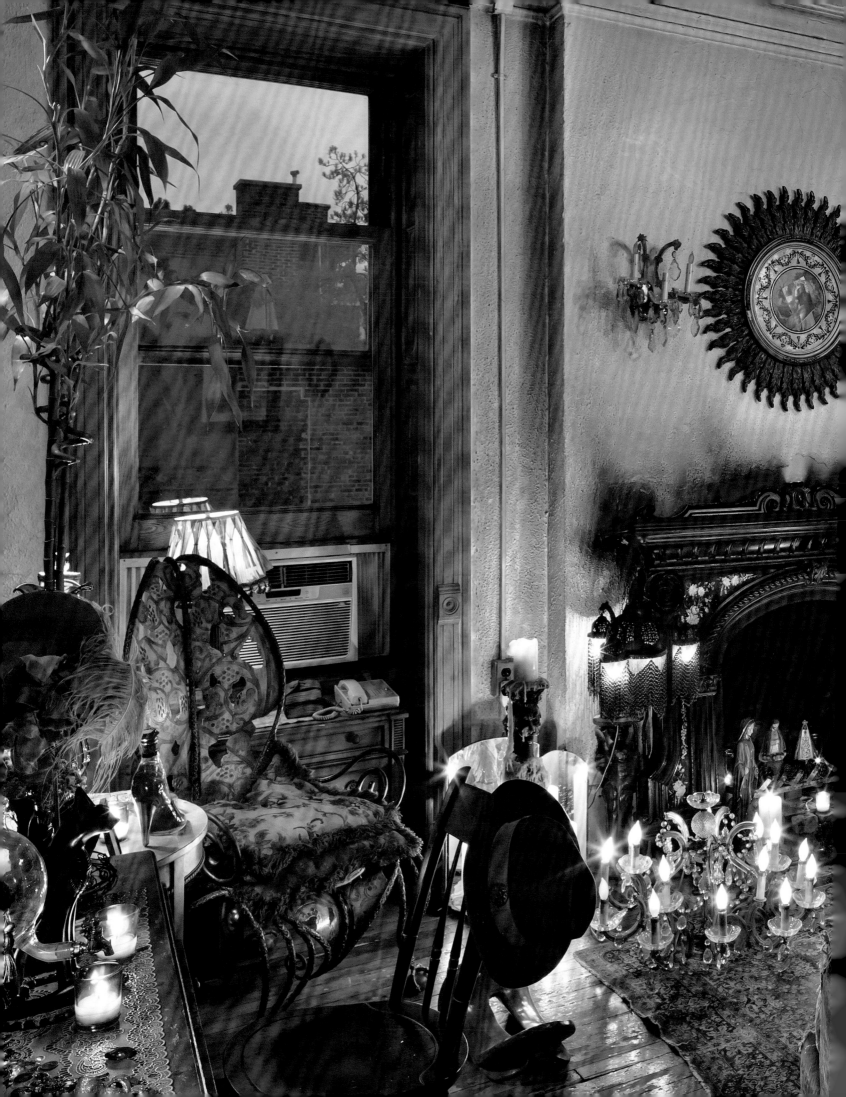

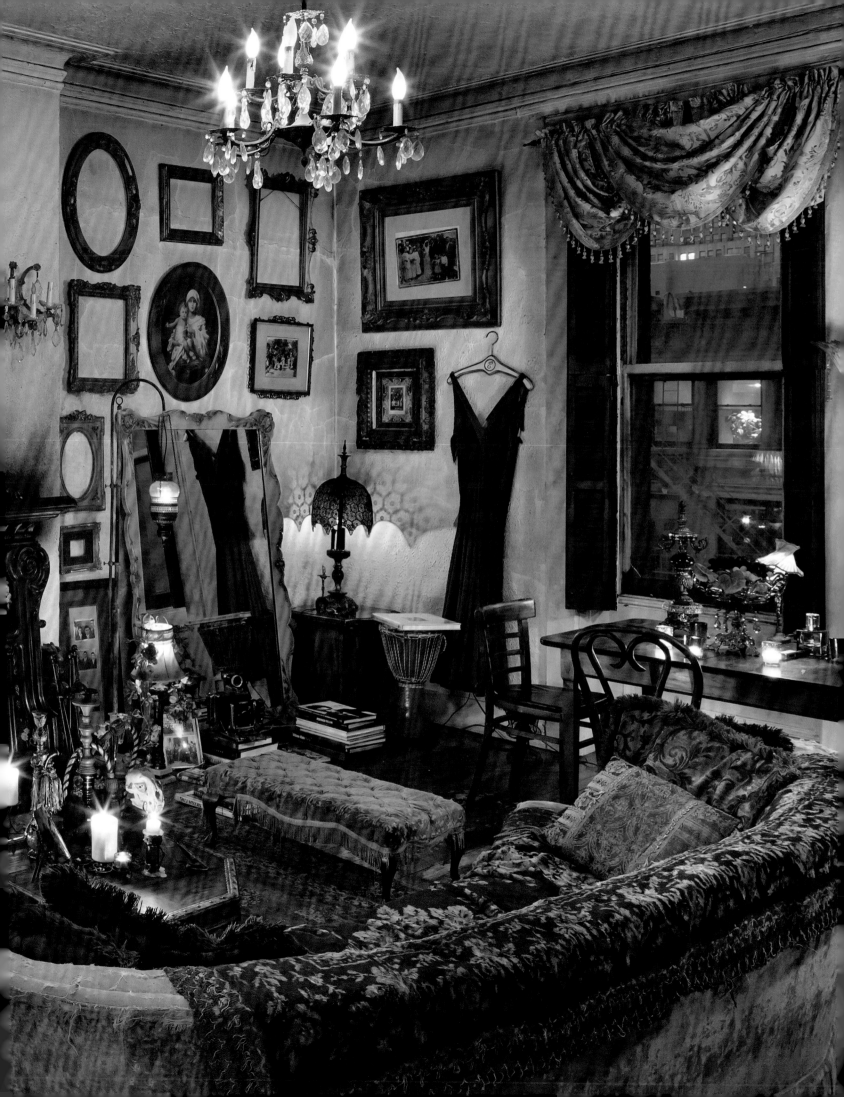

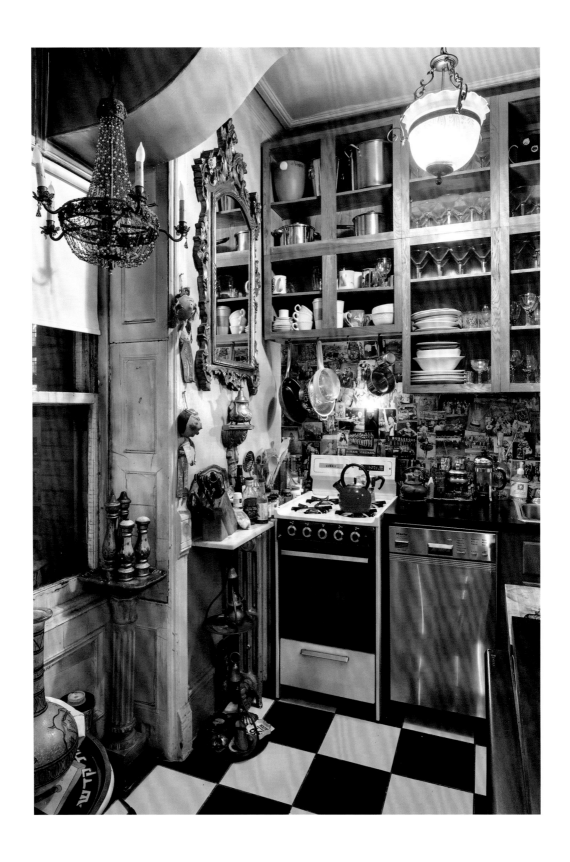

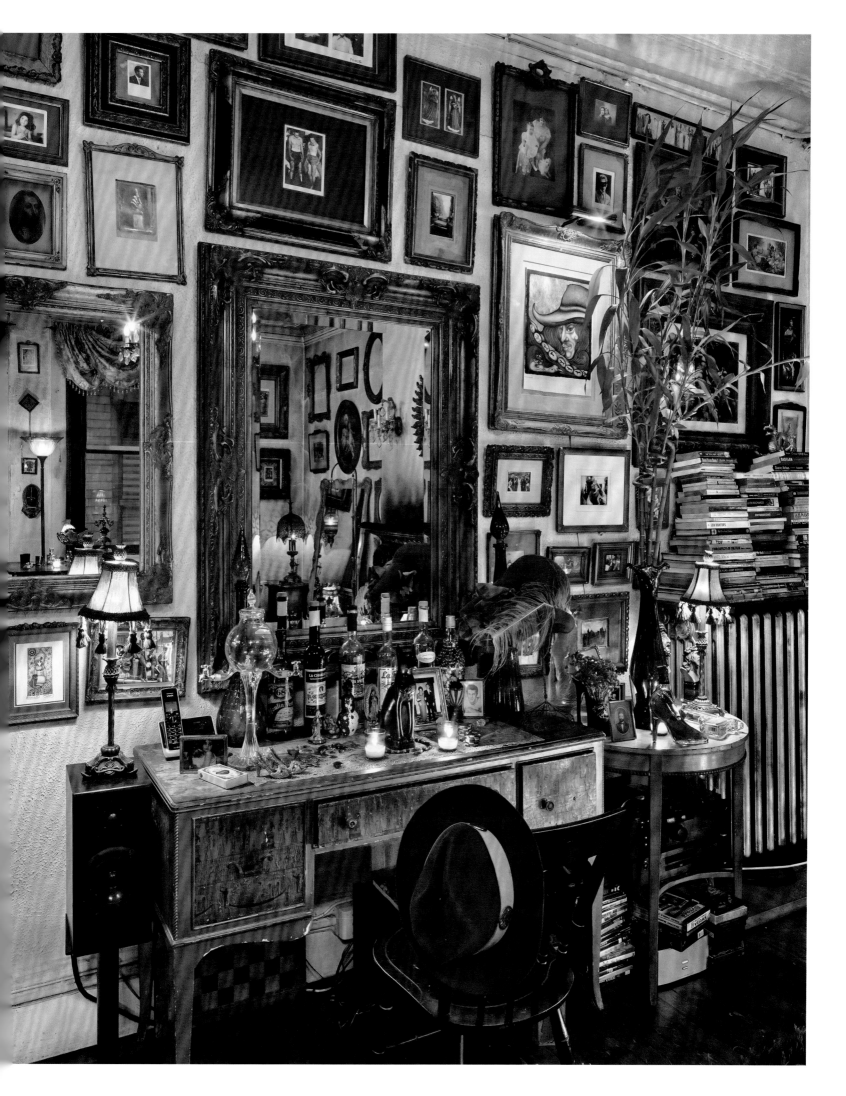

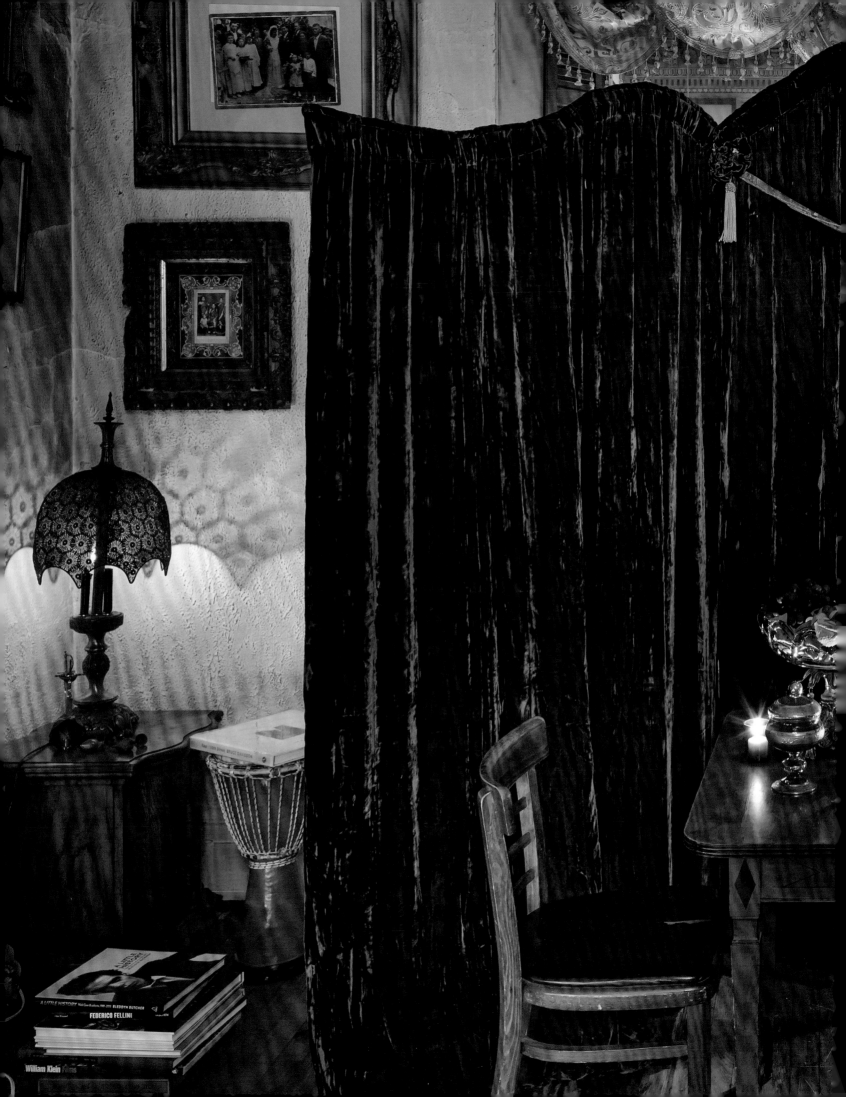

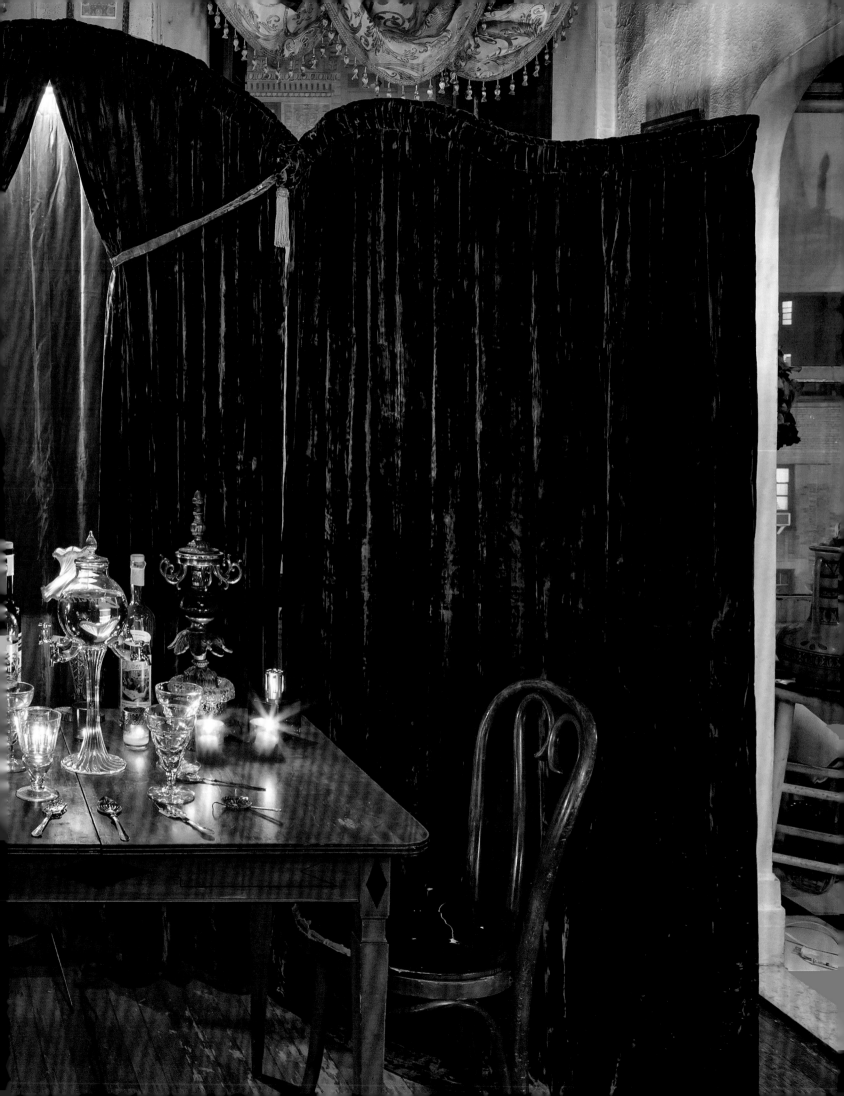

ZEV GREENFIELD

ZEV GREENFIELD GUESSES THAT HE WAS FIFTEEN YEARS OLD the first time he visited the Hotel Chelsea in the early '70s. He remembers seeing William S. Burroughs and Allen Ginsberg hanging out in the lobby and the poet Gregory Corso socializing and making the rounds in the hallways. To many teenagers, those names would not have meant much. But Greenfield had been raised in the theaters, art studios, and clubs of New York City and he was keenly aware of the significance of these literary giants.

Greenfield likes to wear a fedora. He is of slender stature and possessed with restless energy, perhaps an inheritance from his mother. In recalling his own and his family's story, he speaks in rapid half-sentences, but with the self-assurance of someone who's been through a lot and who nonetheless managed to thrive. From an early age, his mother, the artist and educator Rita Fecher, took him and his two brothers around town to meet artists and activists. Zev was her middle child. When his mother got a room for herself and another for Zev's younger brother, Avi, in the Chelsea Hotel in 1974, Zev was barely seventeen and already well acquainted with the building. At the time he lived with a girlfriend, but after the relationship ended he rented a room in the hotel as well. "We came to the Chelsea Hotel because we belonged here," he says. Fecher and her boys fit right in.

Rita Fecher grew up the youngest of four sisters in an orthodox Jewish family in New Jersey, was married at eighteen to a future rabbi, Murray Greenfield, and had three children by the time she was twenty-three. As her family's youngest child, she enjoyed more liberty than her older sisters, and her social and cultural interests ranged far beyond the confines of her conservative community. Marriage and motherhood didn't change that. "My mother was an artist and she would bring people home to the community that shared her interests in art and activism," Greenfield remembers. "My father had a little bit of a problem with this."

"My mother was very politically aware, and so we went on anti-war and civil rights marches, even when she was still married to my father. Later on, we started coming into New York City on weekends. We used to visit the League for Spiritual Discovery, which

was Timothy Leary's gathering on Perry and Hudson, where people used to come and take acid." Fecher was also involved with the Living Theatre, a traveling collective of radical activist performers, becoming close friends with its members and creating a large volume of drawings documenting its performances. Some nights, Fecher took her kids to the infamous restaurant and nightclub Max's Kansas City, which was Andy Warhol's scene at the time, or to catch shows at the Fillmore East. "This is from age nine or ten," Greenfield remembers. He adopted his mother's bohemian lifestyle and friends and soon struck out on his own. He grew his hair to his waist and became known as Zap from St. Mark's Place, where he could often be found. "I had an agreement with my mother that on non–school nights, as long as I told her where I was, I could stay out all night," he says. "I was hanging out with the rainbow people in crash pads."

As Fecher was increasingly drawn to the city, her marriage disintegrated. While his mother could sometimes feel more like a friend than a mom, Greenfield supported her choices. "My mother's favorite saying was, 'I was tired of living next to the garden of Eden, I wanted to live in it.'" In 1966 she divorced her husband and in the summer of 1968 she moved to the city. "She picked up and moved to New York City, to Greenwich Village, with three kids, on her own, without a job," Greenfield says. "It was a very brave and courageous thing."

Fecher went on to become an accomplished painter, illustrator, and printmaker. She took frequent inspiration from her immediate environment. To help pay the bills, she worked as a courtroom illustrator for many years. But her primary occupation and ultimately her calling was her work as an art educator, first in the South Bronx and later at Washington Irving High School in Manhattan. "Her real dream would have been just to be an artist. But she's always been an educator, so she was looking to find meaning and fulfillment."

When Fecher was working in the South Bronx in the late 1960s and early '70s, the area was deeply troubled socially and economically. Fecher dedicated herself to providing educational opportunities to children that many had already given up on. In order to make the daily reality of those caught up in gang rivalries more tangible for her fellow educators, Fecher started to film young gang members. She earned their trust and built mutual respect by taking their concerns seriously. Her footage formed the nucleus of what would later become the documentary *Flyin' Cut Sleeves* (1993), which she codirected with filmmaker and photographer Henry Chalfant.

Arriving at the Chelsea in 1974, Fecher persuaded Stanley Bard to rent her one of the top-floor apartments. Greenfield describes the vetting process: "You spoke to Stanley and

if he liked you, he showed you apartments. He'd always start by showing you his worst apartments and you'd say, No, no, no! Slowly you'd get to one that was acceptable." If Bard really liked a prospective tenant, he would direct them to one of the more desirable units. The energetic Fecher must have made quite an impression.

Her eleventh-floor apartment, which Greenfield now occupies with his wife, Jodi, and their two kids, has changed dramatically over the years. "My mother was an artist and recreated herself all the time," explains Greenfield. So her space changed along with her. In the early 1980s, after a fire destroyed much of the high-ceilinged main room, Fecher made some upgrades. Out of the destruction emerged a more livable space: Storage shelves above the kitchen were turned into a loft big enough to hold a bed and a few small pieces of furniture. Eventually, the ladder to the loft was replaced by stairs and the hatch to the roof—and its spacious rooftop garden—became a real door. As kids, Zev and Avi hung out on the roof. Occasionally one of their neighbors would hire them to help with gardening tasks. "We were like family. If you had a party, everybody who lived on the roof was invited, unless you were fighting with one of them. It was very much a community of artists; that was one of the beauties of the hotel."

Greenfield got into his fair share of trouble as a young man, but never strayed far from his mother's home. "The Chelsea Hotel was always a place I could come to and get my life back together. Stanley would rent me an apartment when nobody else would." While on a few occasions Bard came close to kicking him out for good—one episode involved Greenfield trying to walk out of the hotel with a television—he always welcomed him back eventually.

Since taking his first photography courses at the School of Visual Arts as a ten-year-old, Greenfield had taken pictures around New York and later in the Chelsea Hotel. Once he found his way back to SVA as a young adult, he realized that he was meant to be a photographer. For a while, Greenfield was plugged into the fledgling punk rock scene that was forming at his doorstep. He became friends with a few musicians, including the New York Dolls, Johnny Thunders, and a guy named Neon Leon, whose band he photographed around town. But Greenfield wasn't impressed with the scandalous Sid Vicious, perhaps because he'd grown up with the hardcore anarchists from the Living Theatre. "I knew him and knew to stay away from him. He went and knocked on my friend's door the night that shit happened and left blood on the door."

Greenfield finished his studies and worked in New York for a few years, drifting in and out of the Chelsea Hotel. In 1991, he followed his older brother, Haskel, an anthropological archeologist, to digs in Transylvania and the former Yugoslavia. "We were the first ones in Romania when the Iron Curtain came down. I was running his camps and doing

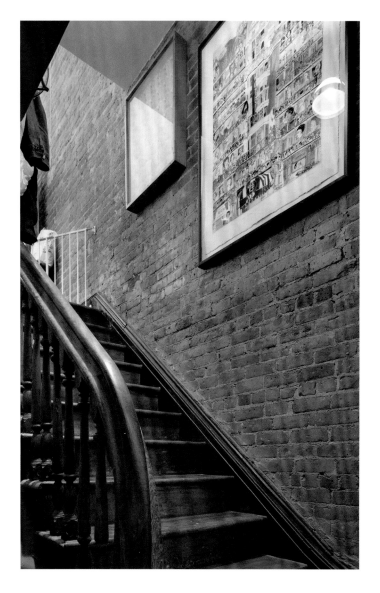

his photography in the field," says Greenfield. Subsequently, Greenfield received a grant to work in Israel. While there, he documented the old Central Bus Station in Tel Aviv. "Before they tore down this market place, it had streets with Bedouins and Ethiopians and Russians. Every street was dedicated to a different culture within Israel, you know? It was very fascinating."

His next destination was even farther afield from New York and the Chelsea, and this time he thought he might never return. "I met a woman and I moved to South Africa and I married her," Greenfield recounts. The marriage didn't last, but Greenfield immersed himself in the study of local customs, which opened him up to the possibilities in documenting wedding ceremonies. "I wanted to use it as a window to photograph different cultures. I got to photograph ceremonial events such as Zulu weddings, Christian weddings, and Jewish weddings, Muslim weddings and Indian weddings."

Greenfield found himself back in New York in 1996, uncertain what to do next. At the time, wedding photography followed cookie-cutter practices. "Everybody wanted me to get a Hasselblad and every single wedding was exactly the same." By chance he met Terry Gruber, who was building his reputation on a more photojournalistic, artistic, and candid approach to wedding photography and whose agency represented a handful of photographers. His style was right up Greenfield's alley, and today he still shoots for Gruber Photographers. In addition, he started his own film production company, taking a similar approach to documenting events, and has worked as a filmmaker and producer on a variety of high-profile projects.

The Chelsea Hotel has been Greenfield's center of gravity since his return to New York. When his mother became ill, he moved back in to care for her. She passed away in 2003 at the age of sixty-nine. Greenfield's two lively children are, at present, the Chelsea Hotel's youngest residents. The apartment was renovated to his requirements. Modern finishes, such as the new kitchen nook and floors and a tinted window screen in the upstairs sleeping loft are paired with the apartment's older features, such as the exposed brick wall that leads from the bottom of the curved entrance staircase all the way up to the cast-iron fireplace, and the tall, south-facing windows that flood the room with light.

While the apartment bears little resemblance to the room his mother moved into nearly fifty years earlier, memories of her enter quickly into conversation. "We used to have parties every year in honor of her birthday, because she always celebrated her birthday with a party on that weekend and there were hundreds of people on the roof," Greenfield remembers. They were raucous affairs, with a crowd as diverse as the city, "people from gang presidents to doctors, lawyers, to her students, to all the artists, to my religious relatives. They would all come together for her here. We carried on the tradition until about 2011 or 2012," when construction on the rooftop made it impossible. "We will again some day. We will have big parties up here again, hopefully!"

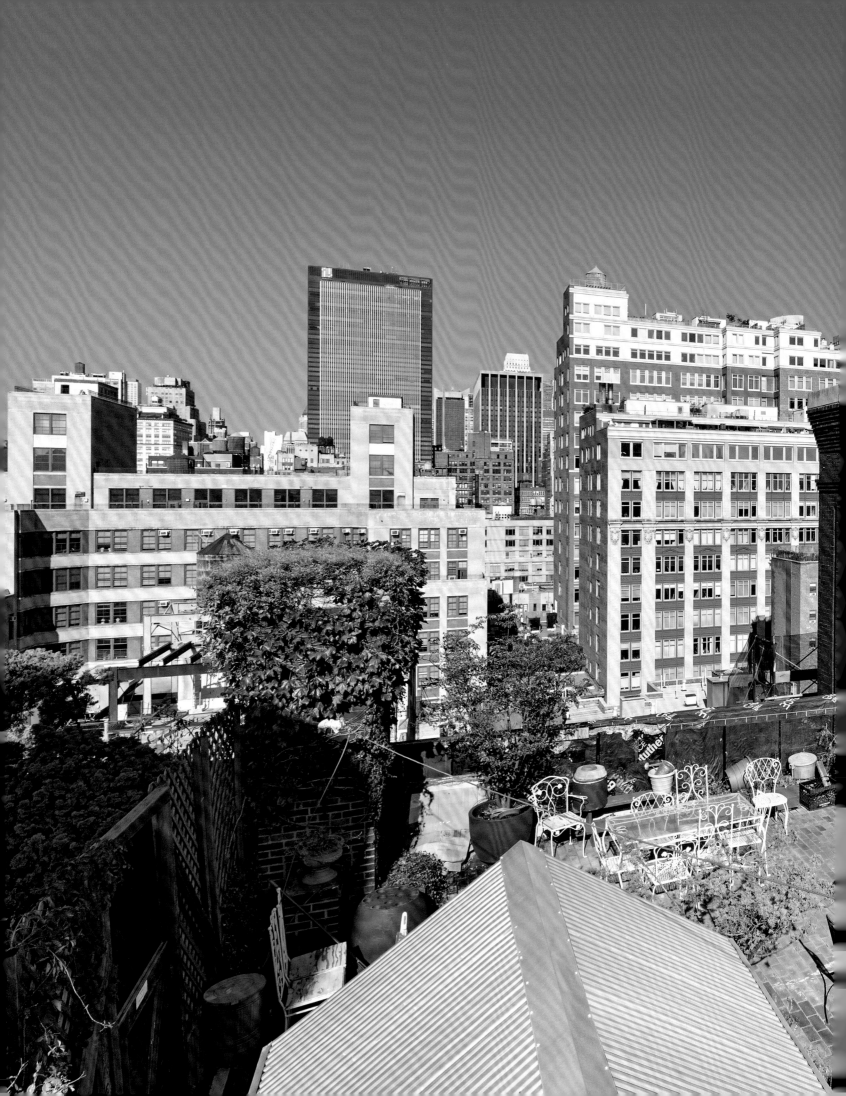

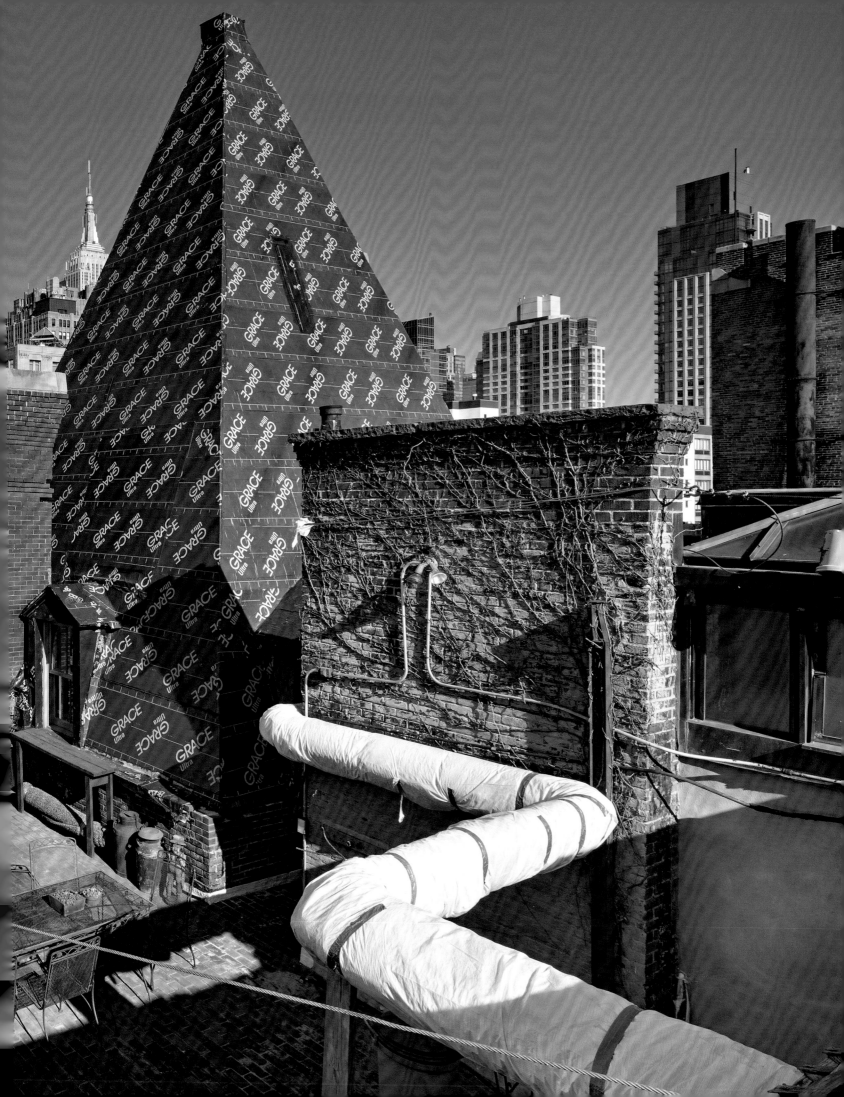

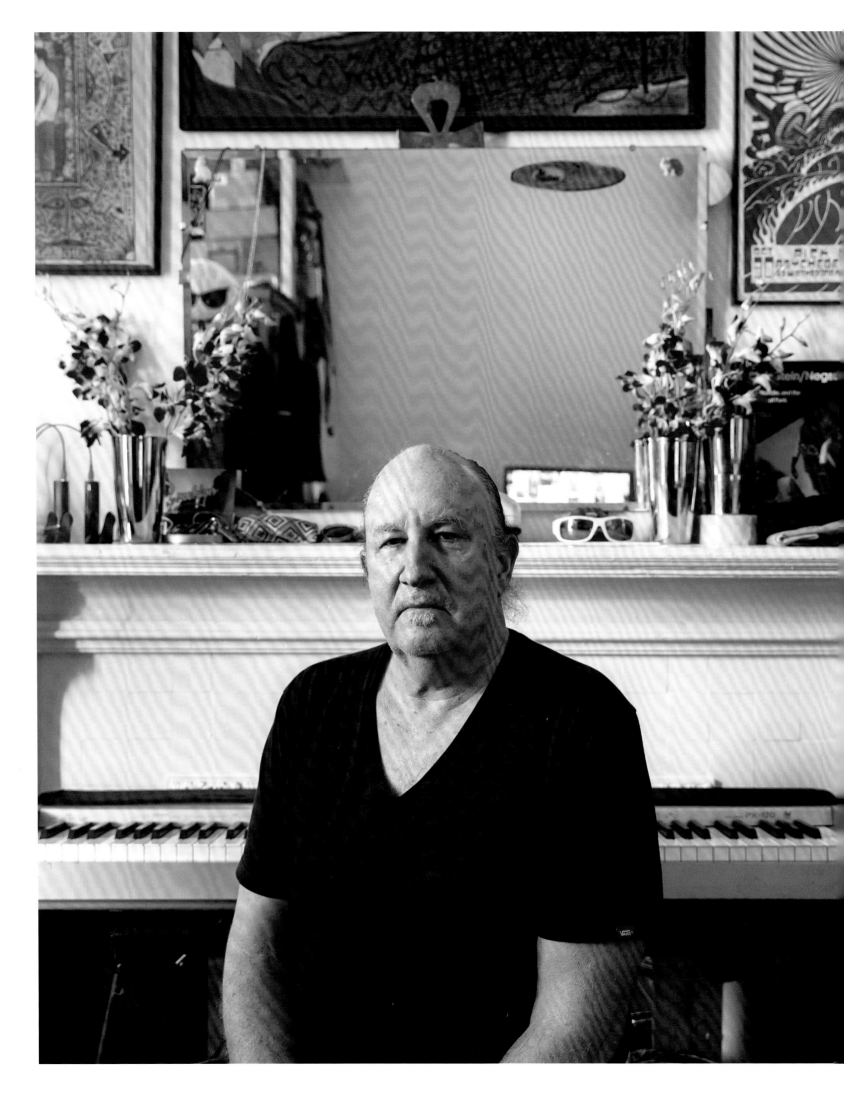

TIM SULLIVAN

WHEN TIM SULLIVAN FIRST VISITED THE CHELSEA HOTEL in 1979 he was underwhelmed. He arrived in New York a sun-bleached young man with multiple tricks up his sleeve: he had a scholarship to the Joffrey Ballet School, but had grown up in California a third-generation surfer, which also got him into playing surf rock. He was hanging out in the city with his older brother, Chip, who suggested that they visit the famous hotel. "I wasn't impressed," Sullivan recalls. "The lobby had a weird, creepy kind of vibe." He would occasionally visit the building with a girlfriend, but it wasn't until a few years later, after he had given up ballet for good to focus on music, that he rented his first room.

"I was in a rockabilly band and I was living down on Cornelia Street with my girl-friend." After the two broke up, he needed a place to stay. "I moved into the lead singer's loft over on Twenty-Eighth Street," Sullivan recalls. That was in 1982. "We were over there for about three weeks and then we got thrown out. He used to live in the Chelsea through the '60s and '70s. So we moved in here in the middle of the night, into room 522. There were four of us in the band." Tempers flared and before he knew it Sullivan had switched rooms several times (and done a stint at the Arlington across the street) before settling in his current room.

His life quickly became entangled in the social fabric of the building. "The '80s and '90s were a pretty wild time!" he remembers. Other hotels, such as Hotel 17, were known for their social scene, but no other place was quite like the Chelsea and its unique mix of characters. "You had everything! You had transsexuals, you had strippers, you had prosti-tutes, you had your classic pimps with a harem of girls. At least two murders. Quite a few suicides. Total insanity." He made friends with the resident Beats and was awed by their brilliance. He also stumbled into a job right downstairs that turned out to be a perfect fit.

Sullivan knew a street performer who went by the name Tex Saliva and was a longtime resident of the hotel. Saliva also worked at Dan's Chelsea Guitars, which occupied one of

the building's retail spaces (and has since changed owners and moved into a smaller store-front in the building). "He was working in there as a security guard. One day he said to me, 'Hey, I gotta run upstairs for a second. Will you do my job for me while I'm gone?' He never came back." So Sullivan was offered the job and ended up running the store for much of the next ten years. He woke up just in time to open up in the morning, sell instruments, meet other musicians, and hear their stories. "Everybody would come through," he says. The Red Hot Chili Peppers, Patti Smith, former Rolling Stones guitarist Mick Taylor, Country Joe McDonald, a "world-famous flamenco guitar player," with whom he discussed the similarities between surf rock and flamenco chord progressions, and Blondie. "Chris Stein and all those guys would come into the store and I would end up talking to them for three or four hours. I became almost like the social register."

Among all of Sullivan's fellow musicians, one neighbor, the late Dee Dee Ramone, occupies a special place. "I was probably one of his closest friends," Sullivan says. When he first met the Ramones bassist he was put off. Ramone was a fan of Sullivan's band, The Supertones, formed in 1988, and he wanted to meet Sullivan. "I said, 'I don't want anything to do with you!' because I knew he was a junkie. Later on we became good friends, when he was clean and sober." But Ramone's moods could be as caustic as his music. Sullivan once found Ramone talking to a female journalist in the lobby. When Sullivan exchanged a few flirtatious words with her, Ramone erupted in a fit of jealousy. But, Sullivan adds, "he'd always come back and apologize."

Sullivan also became Ramone's musical collaborator and appeared on the song "Please Kill Me" from the 1997 release *Ain't It Fun*. Sullivan recounts that Ramone came to him looking for help with the recording, so Sullivan agreed to play the organ. Ramone insisted on singing and playing the guitar, with his wife, Barbara, on bass. "He could barely play. He was not a very good musician. She couldn't play the bass at all," Sullivan sighs, the perfectionist side of him still dissatisfied with the result. "We did one take." But the song turned out just fine for Ramone's fans and inspired the title of the eponymous book recounting the history of New York's punk rock scene. "It's not a fast song, it's almost a dirge. He sings it brilliant," Sullivan relents. The Supertones remain an active fixture in the city's surf rock scene, where Sullivan is known as El Fez after his occasional choice of headgear. He still wears his gray hair in a ponytail and has a hint of a goatee on his chin.

Sullivan's room, which he shares with his girlfriend, Hilary Farrell, a former model, was once the home of the French sculptor and painter René Shapshak and his wife, Eugenie. Prior to the start of renovations, Shapshak's bas-relief *The Seven Arts* prominently adorned the fireplace in the hotel's lobby, along with his bust of President Truman, both

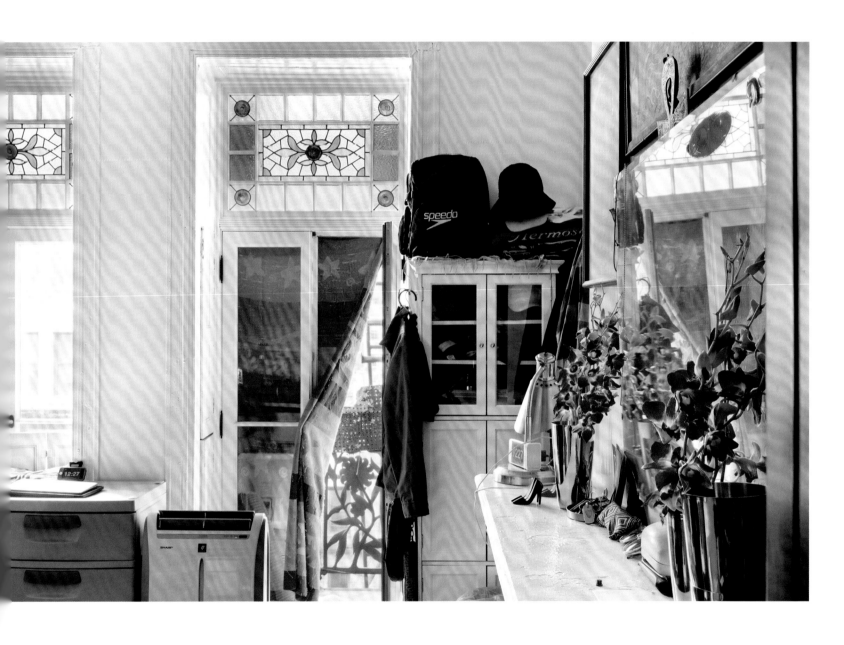

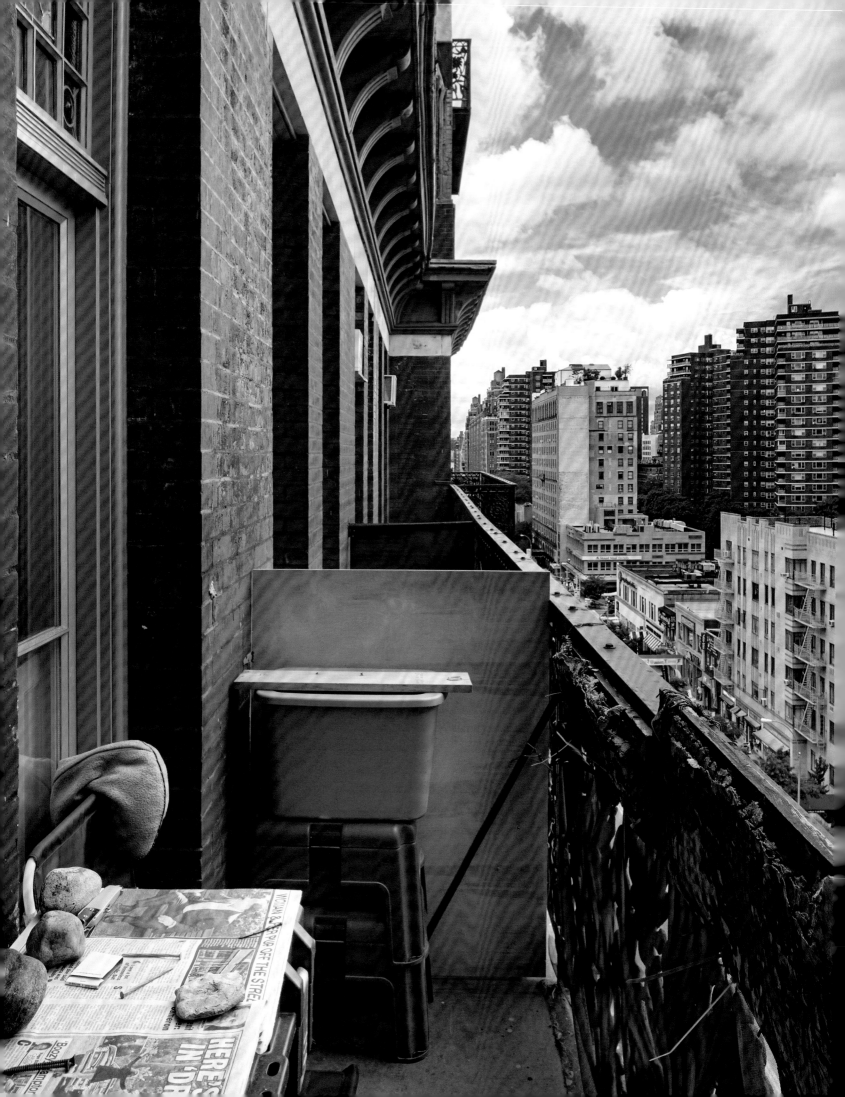

beloved pieces in the building's art inventory. They have since been removed, but traces of the artist's work remain in his old room. Or rather, outside of it. "If you look on my balcony you see where he wiped his paint brushes on the concrete," Sullivan notes.

The apartment, which was renovated as part of Sullivan's agreement with the hotel's owners, is crammed to the gills with personal belongings. A keyboard is centered in front of the fireplace, creating the illusion of an upright piano. A kick drum and a pile of rhythm instruments lie underneath. Two guitars hang from the side of a large rack that towers over the couple's sleeping nook, an amplifier on a dolly serves as a low divider, and memorabilia covers much of the walls. Yet everything is neatly organized. The balcony onto Twenty-Third Street functions as a useful extension of the space, part home office for Farrell and part outdoor living room. One may disagree about the aesthetic merits of the renovation, but it's hard to argue about the benefits of some new features: "I used to use a bathroom down the hall, a shared bathroom. Now I have my own."

With his apartment renovated, Sullivan feels that he is in a secure place to continue making art. He compares his positive outlook on the changes that have befallen the Chelsea to the attitude of one of his upstairs neighbors, the composer Gerald Busby. "We're both extreme artists, we're in love with life," he says. Busby's music forms the soundtrack to a short film Sullivan made, *The Dark Water of the Night*, an experimental portrait of the Chelsea by day and night. The music matches the quick cuts, sped-up takes, and esoteric transitions in the film. Ethereal vocals flow over choppy piano notes and stark organ chords. The guitar store is prominently featured, as is the lobby in its full glory, with Shapshak's *Seven Arts* commanding the space. At one point cops can be seen from above making an arrest. In another scene a group of people dances wildly on the sidewalk in broad daylight. The artist David Combs is shown working on a painting of the hotel's exterior. The energy surrounding the building is palpable. The film feels like a document of a bygone era, yet it was filmed not too long ago, in 2008.

Sullivan is undaunted by the changes that have rocked the Chelsea in the years since he made the film and remains optimistic for its future. "No matter what happens here it will be the right thing, because the Chelsea has a life of its own. It's hard to describe, but it's alive! You're seeing the rebirth. Like anything, it has to go through the cycle."

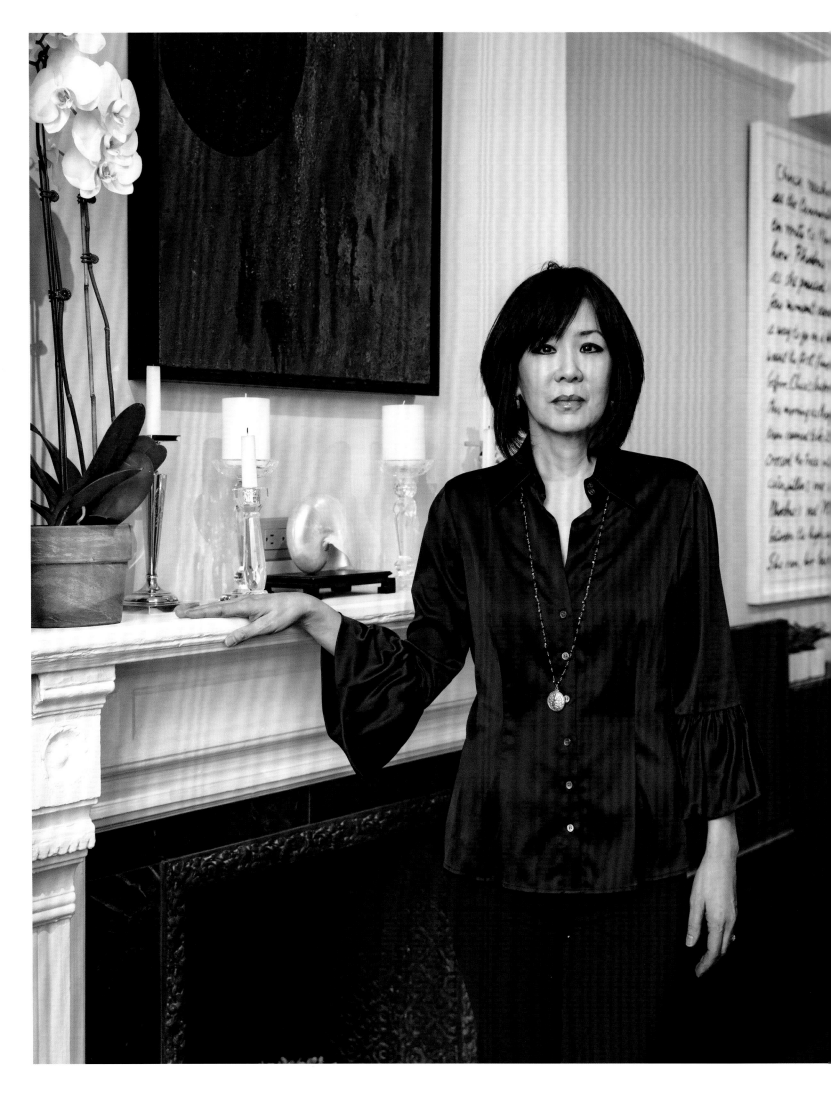

SYBAO CHENG-WILSON

WHEN SYBAO CHENG-WILSON'S OLDER BROTHER, the artist Ching Ho Cheng, died at the age of forty-two in 1989, she was devastated. Cheng-Wilson, who had been raised by their immigrant parents in a quiet neighborhood in Queens, was nine years younger than her brother and looked up to him. As she grew up and began visiting Ching at the Chelsea Hotel, where he rented a room, he became her de facto guardian and role model and once he was gone, she strongly believes, he continued to watch over her. After his death, she noticed that some lights in the bathroom of his former apartment at the Chelsea flickered on December 26, his birthday. When it happened again the next year, Cheng-Wilson knew that it was a sign from him. Her husband and daughter were skeptical, to say the least. "They thought I was crazy," she admits. But the lights flickered again the following year.

Ching's apartment at the Chelsea is now home to Cheng-Wilson and her family. She and her husband, television producer and actor William Wilson III, raised their daughter, Tiana, in the hotel. Today, Cheng-Wilson manages her brother's estate. For years she refused to talk publicly about her life in the Chelsea Hotel, or the crisis that began to brew with Stanley Bard's exit, but the constant flow of curious tourists in front of the hotel made her realize how much interest there was in its preservation, so she decided to speak out. After all, preserving the history of the Chelsea also means safeguarding her brother's legacy.

The Chengs descend from a prominent Chinese family. A great aunt, Soumay Cheng, was China's first female lawyer and judge. Ching Ho Cheng was born in Havana in 1946, where his father, Paifong Cheng, was the Chinese ambassador to Cuba until the Cultural Revolution. Unable to return to China, the family moved to the United States and settled in Kew Garden Hills, Queens, when Ching was five years old. By his own account, he started painting at six years old, and later, as a young man, enrolled at Cooper Union, graduating in 1968.

Ching had little interest in his parent's middle-class lifestyle. The fledgling painter learned about the Chelsea Hotel in the early 1970s after meeting the free-spirited artist and

hotel resident Vali Myers, with whom he had "a whirlwind romance," his sister says—he is the subject of several of Myers's paintings from the period. He was in and out of the hotel for a number of years, until he finally settled into the Chelsea for good in the late 1970s while preparing for a solo show. At the time, the neighborhood was not what it is today. Populated by junkies, prostitutes, and their johns, "it was completely desolate," Cheng-Wilson says. "In my teens, when I wanted to get away from my parents, I would come to the Chelsea Hotel," she remembers, and Ching was protective of her. "He would escort me upstairs and then when it was time to leave he would escort me back downstairs into a taxi." She adds: "My brother and I had a wonderful relationship. We weren't just siblings, we were friends."

Over time, Cheng-Wilson came to understand what the Chelsea represented to her brother: a refuge for creative souls where he could work in peace. "He was extremely disciplined," Cheng-Wilson says. From nine in the morning until five in the afternoon, visitors were greeted by a sign at his door: "Please do not disturb. I'm working." After five, the sign came down and Ching allowed himself to socialize. Stanley Bard always had a room for Ching—who lived in at least three or four different apartments during his time at the Chelsea—and occasionally accepted paintings in lieu of rent, even in later years, when Bard was under pressure to keep raising the rent. He was also unconcerned by Ching's use of toxic substances, including the oxidation bath the artist built in his room. "Stanley is a funny duck," Cheng-Wilson says, but he was good to her brother.

For years Ching struggled, but his work gradually garnered the attention of the art world. He became the first Chinese-American contemporary artist to achieve widespread recognition in the United States and he exhibited frequently in the 1970s and '80s. His work moved through four major stages. Intricate psychedelic paintings were followed by exacting gouache drawings of intently observed everyday objects. For a period he also worked extensively in airbrush. In the early 1980s he embarked on a series of torn-paper collages, which led to the last stage of his work. Inspired by the textures of cave walls he saw when he visited Turkey in 1981, he started to experiment with a complex process by which he oxidized paper covered in metal filings in chemical baths. This method, which he spent years refining, yielded startlingly beautiful colors and textures. Unfortunately, the toxic materials he used also contributed to his early death from chronic lung disease.

Throughout the last stages of his artistic development, Ching sought beauty in simplicity and restraint, even if the process was technically challenging. To Ching, his work reflected both his Chinese heritage and his American upbringing. "I feel very strongly about my Chineseness even though I feel very strongly about my Americanness," he once said. "I feel about my work as a Westerner and a Chinese person and I think it must look that way."

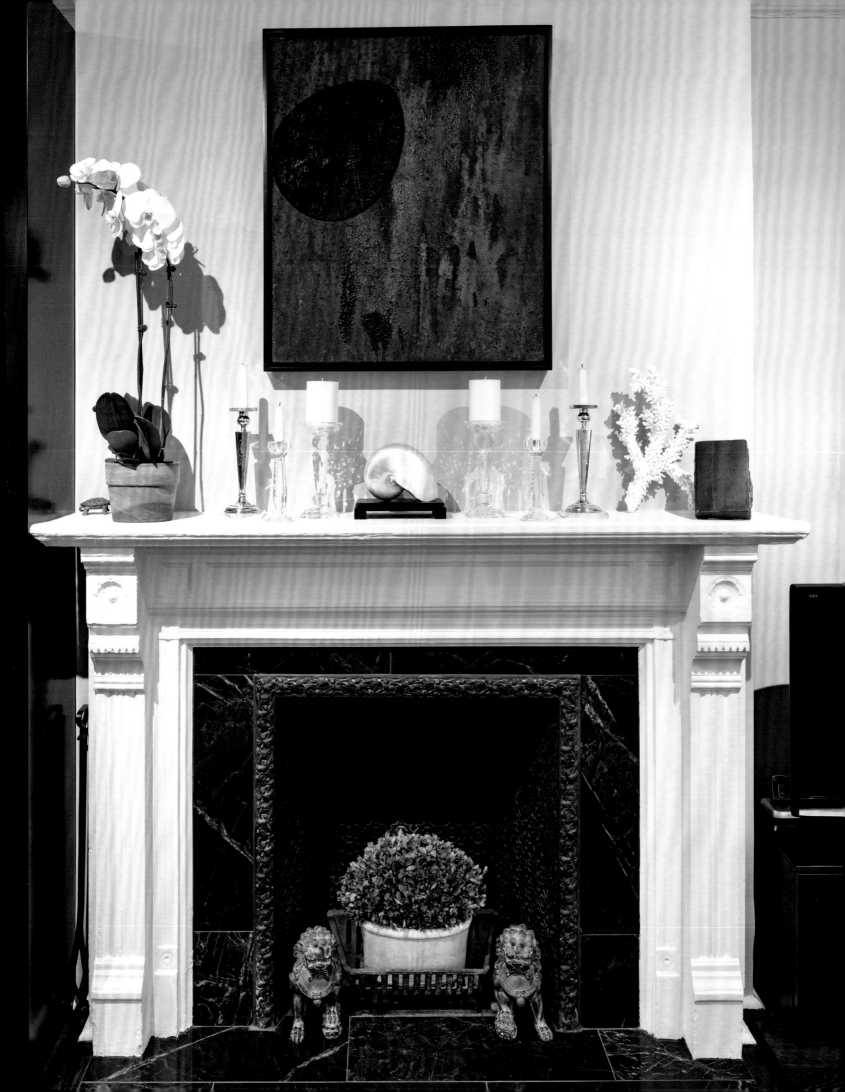

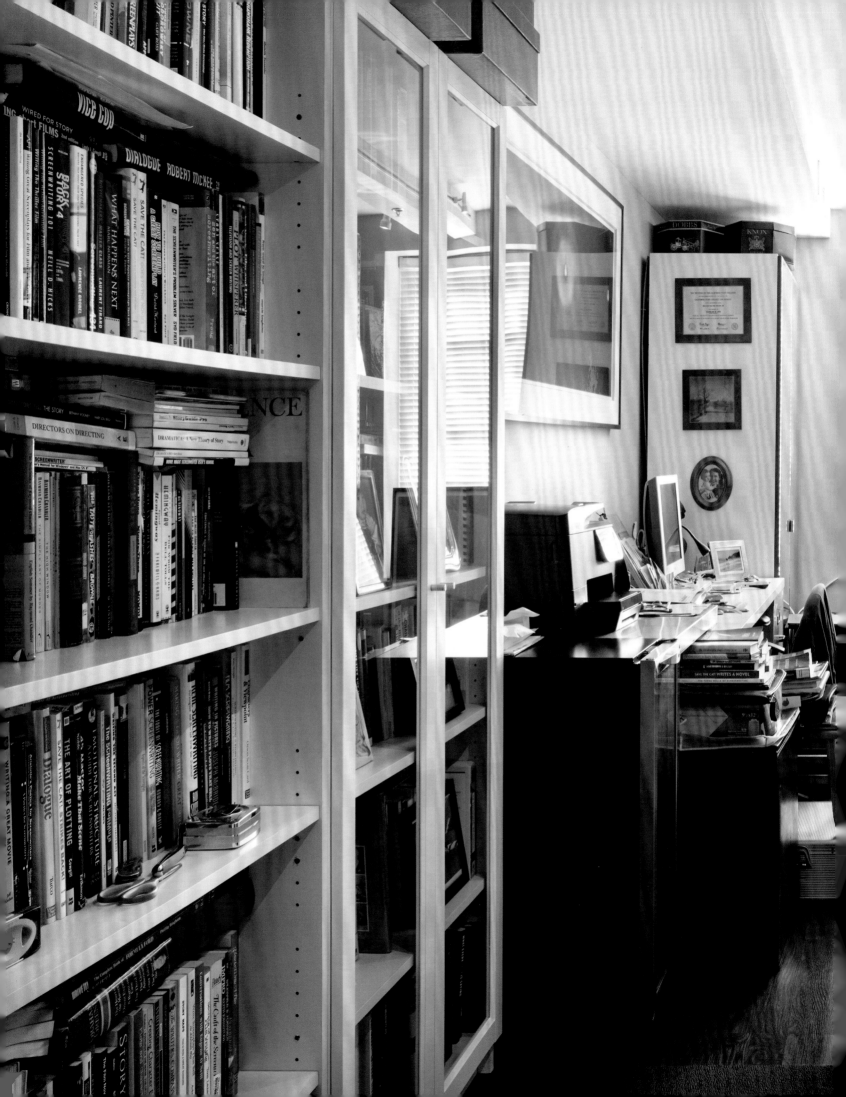

After he passed away, his sister made it her mission to preserve his legacy. In the intervening years, Cheng-Wilson had studied fashion design, worked as a model in Europe, and started her own business importing high-end silk-embroidered blouses from China with the help of her mother. Her brother's illness pulled her back into the orbit of the Chelsea Hotel. "I made a promise to him that I would take care of his estate," she says.

Cheng-Wilson's one-bedroom apartment today bears little resemblance to the space her brother occupied in the 1980s. Ching had loved all of its imperfections. "He painted the cracks and the crevices in his floor," his sister remembers. "He called them the wood grain paintings." He made paintings of the shadows on the floor at sunrise and all the different hues its light produced around him. He also once made a painting of a decrepit, pink Chelsea Hotel bathroom that, Cheng-Wilson says, might be a more authentic representation of the Chelsea than any bathroom currently left in the building. Cheng-Wilson chose to have the apartment fully renovated as part of the deal with the new owners. It is very tidy, in constrast to many of the hotel's other living spaces and to the apartment when Ching Ho Cheng lived there. The walls are a subtle gray and the floors have been redone in walnut. The furniture throughout the apartment was custom-designed or chosen to maximize the space and to reduce clutter, like the eat-in kitchen counter or the large closet in the living room, which hides a Murphy bed. Yet, there is the same fireplace that can be found throughout the hotel, its wood mantel painted white to match the moldings, its front reconstructed with black granite but still featuring the original iron trim. On its mantel sits a resin sculpture by the late Stella Waitzkin, but mostly the apartment is home to Ching Ho Cheng's artwork, including several airbrush paintings in the bedroom, and torn-paper collages and rust pieces in the living room, each placed as if the space and the lighting had been designed around it in order to highlight the colors, shapes, and textures.

Cheng-Wilson shares little about her life at the hotel that isn't related to her late brother. However, as the years went by, the Cheng-Wilsons found a home of their own in the Chelsea. "We were only supposed to come temporarily and then I don't know what happened," Cheng-Wilson shrugs. Like many of the tenants who remained through the renovation, her health suffered as work on her own apartment stretched on for months. As for the hotel, she says, "The Chelsea as we knew it is over." Nonetheless, she is sanguine about the events of recent years, since they brought her closer to other tenants. "Like they say about New Yorkers: when something terrible happens we get very close and we defend each other." If not for the threat of eviction, she suspects, "many of us would just continue our lives not knowing who lives on the other floors."

The hotel's maintenance staff never found an explanation for the flickering light in her bathroom, but eventually it stopped. Cheng-Wilson thinks that her brother no longer visited her because he knew that she was finally at peace with his passing.

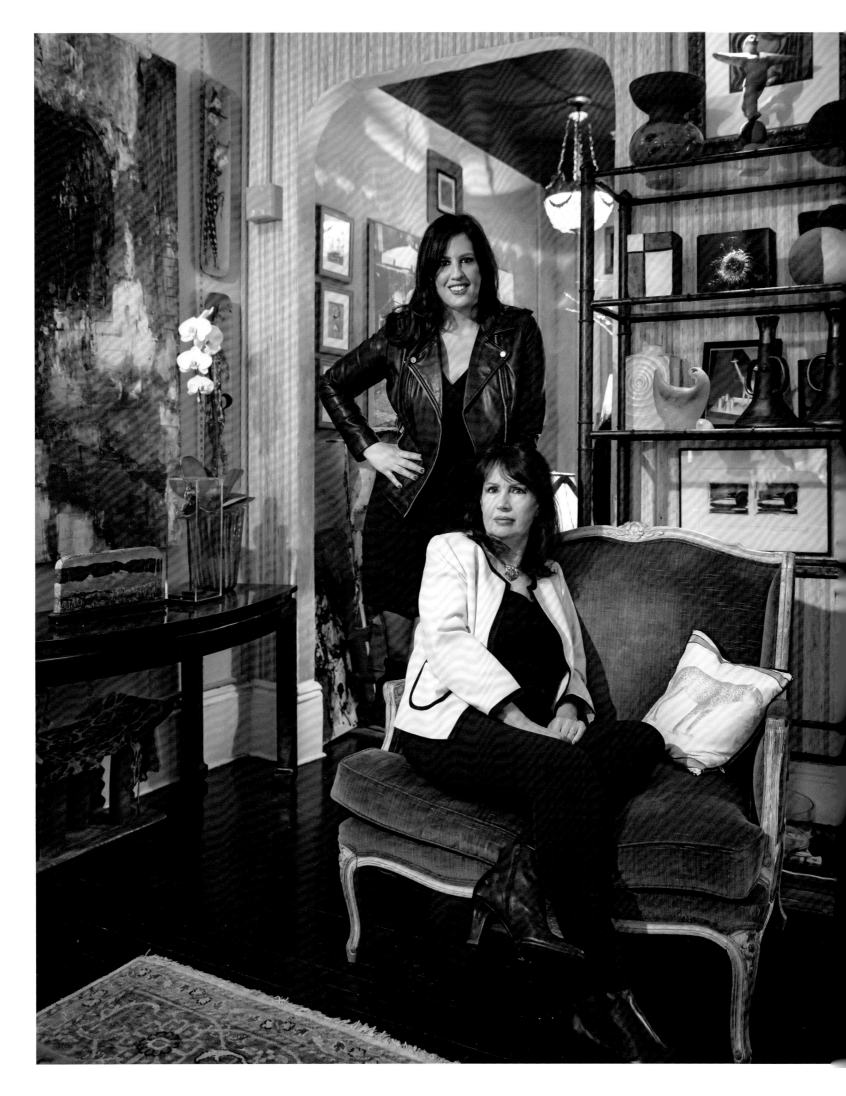

COLLEEN & DAHLIA WEINSTEIN

O NE DAY IN NOVEMBER OF 2011, a rental truck could be seen parked in front of the Hotel Chelsea. Over the course of a few hours, workers filled it with artwork they had removed from the hallways and lobby of the building. An onlooker noticed that the workers didn't seem to be professional art handlers and that the art was poorly protected for transport. Someone snapped a photo of the license plate, but by then it was too late. The truck drove off to an unknown location.

Under Stanley Bard's oversight, it had been common practice at the Chelsea for artists or their estates to loan artwork to the hotel for permanent display in its public spaces alongside the art that Bard acquired from resident artists. When the building was sold to a group of investors led by Joseph Chetrit in 2011, the new owners assumed that they had bought everything in the building, including the art. No one bothered to check with the tenants. The removal of the artwork from the building (for safekeeping during construction, the new owners claimed) ignited yet another firestorm of lawsuits and public outrage at Chetrit. Among the missing works were a piece by current resident Philip Taaffe, a large canvas by Larry Rivers entitled *Dutch Masters* that was on loan from the Larry Rivers Foundation, as well as more than twenty silk screens by the late artist, club owner, and lighting designer Arthur Weinstein, who died of cancer in 2008. It fell upon his widow, Colleen Weinstein, to fight for the return of his artwork.

Arthur Weinstein became infatuated with the Hotel Chelsea when he lived there for several years in the 1970s, in room 611. At the time he was working as a fashion photographer and was just learning how to screen print. In 1976, after a stint in Paris, Weinstein met the interior designer Colleen Mudery. "Tax day, April 15. I always remember, because I was nervous about my taxes," Colleen says. Together, the two became a power couple in New York's fast-moving nightlife industry. A native New Yorker, Weinstein had a knack for uncovering new opportunities. The same year he met Colleen, he opened the club Hurrah, at Broadway and Sixty-Second Street. Featuring elaborate decor, flashy lighting,

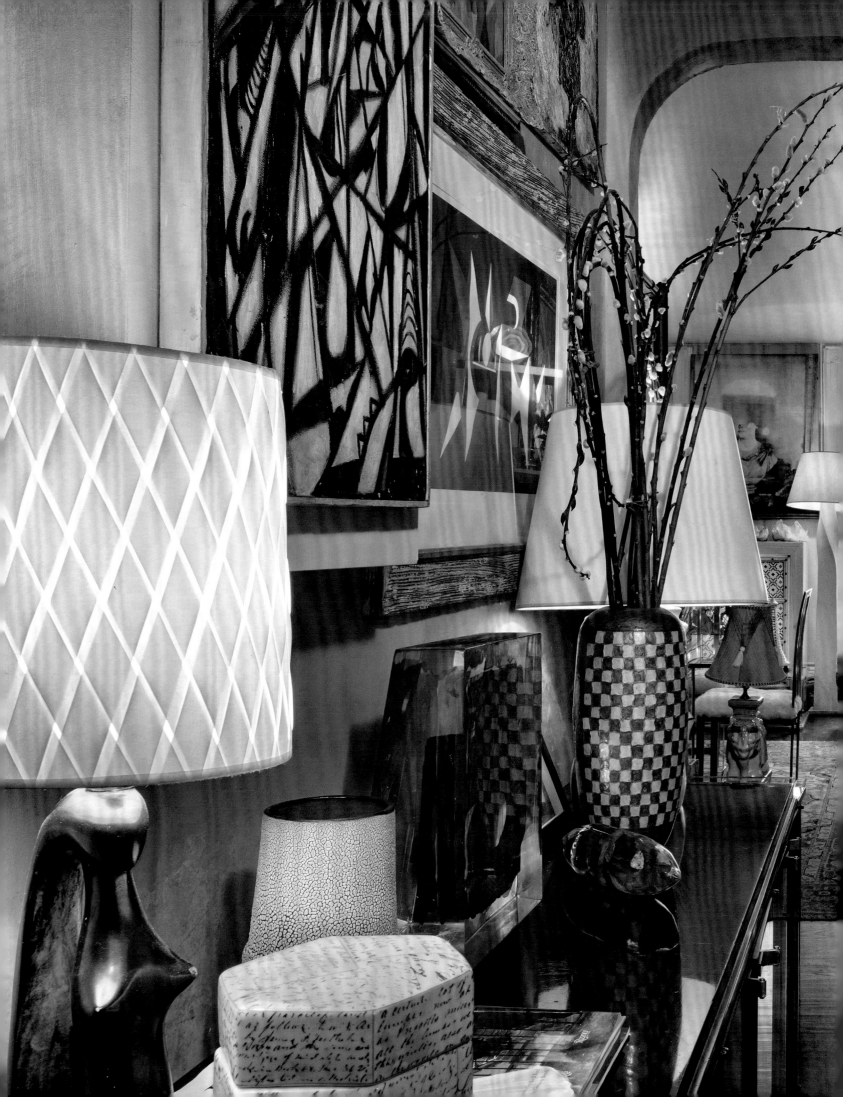

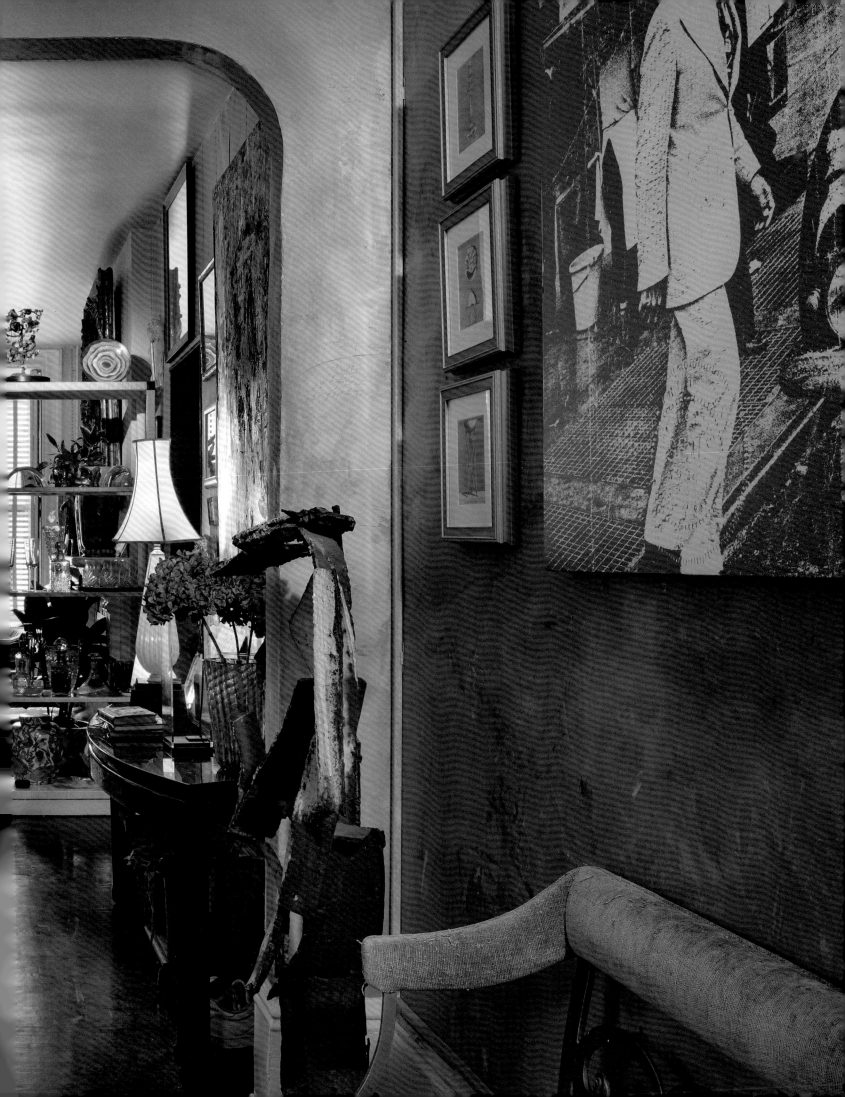

and a private guest list, it was the first large dance club in the city with an emphasis on punk, new wave, and industrial music. By 1980, Hurrah had been upstaged by Studio 54 and closed. Undaunted, Weinstein innovated by flouting local laws and opening New York's first illegal after-hours clubs, the Jefferson and later the Continental. "Then we went legit with The World," recalls Colleen, who worked with him on many of his ventures. The couple also brought their professional expertise in design and lighting to bear on other famed clubs throughout the '80s and '90s, including the Limelight, Studio 54, Palladium, and The Tunnel.

In 1992, the Weinstein family, which now consisted of Arthur, Colleen, and their fourteen-year-old daughter, Dahlia, was forced unexpectedly to look for a new home. Arthur tried hard to talk his wife, who did not share his enthusiasm for the Chelsea Hotel, into staying at the Bohemian enclave while she was scouting new apartments. It was Labor Day weekend when they first walked in together. By chance, the director Sydney Pollack was standing by the door. "Sydney, tell my wife she should stay here for a while!" Arthur said to him. Stanley Bard took a less diplomatic approach. "You're gonna leave here feet first," he told Colleen when they got the keys to their room.

It took a while for her to come around to that idea. The lobby of the building was grungy, the hallways were dark, and their room was a mess. But Arthur did his best to make her comfortable. He whitewashed the walls of their apartment, which consisted of two connected rooms with separate entrances and bathrooms. He installed track lighting and also talked Bard into replacing the old lights in the hallways with new, fluorescent lights. Not long after they moved in, Bard renovated the lobby, uncovering the marble, installing a new front desk and decorating it with flowers. "This is better," Colleen remembers thinking. It also helped that their apartment was in the back of the building. "The back is very quiet. It's like living in the country."

The Weinsteins made friends with Pollack, Arthur Miller, whom Colleen revered, and the poet, playwright, and librettist Arnold Weinstein (no relation). They also became friendly with another unrelated Weinstein, Jerry, who managed the front desk. He was a childhood friend of Bard's with a degree in social work. Sometimes he acted as Dahlia's unofficial guardian when she was hanging out in the lobby. Jerry's daughters received VIP treatment at Arthur's clubs. Jerry was also known to be the voice of reason in the face of Bard's bouts of manic exuberance. "We called it the Stanley and Jerry show," Colleen says, in reference to the intimate give-and-take between the manager and the clerk. Jerry Weinstein died in 2015, at the age of eighty-one.

For Dahlia, who has moved back in with her mother after living on her own for eight years, growing up in the Chelsea as a teenager was a marvelous experience. At first she

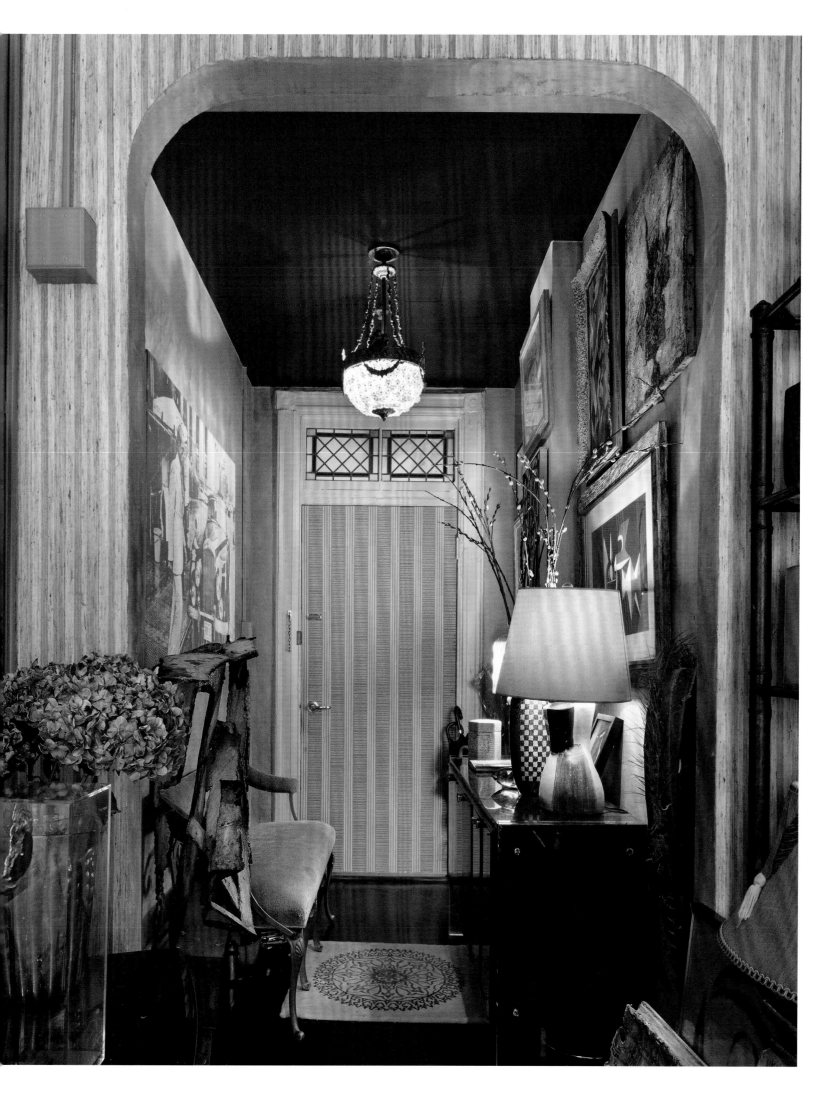

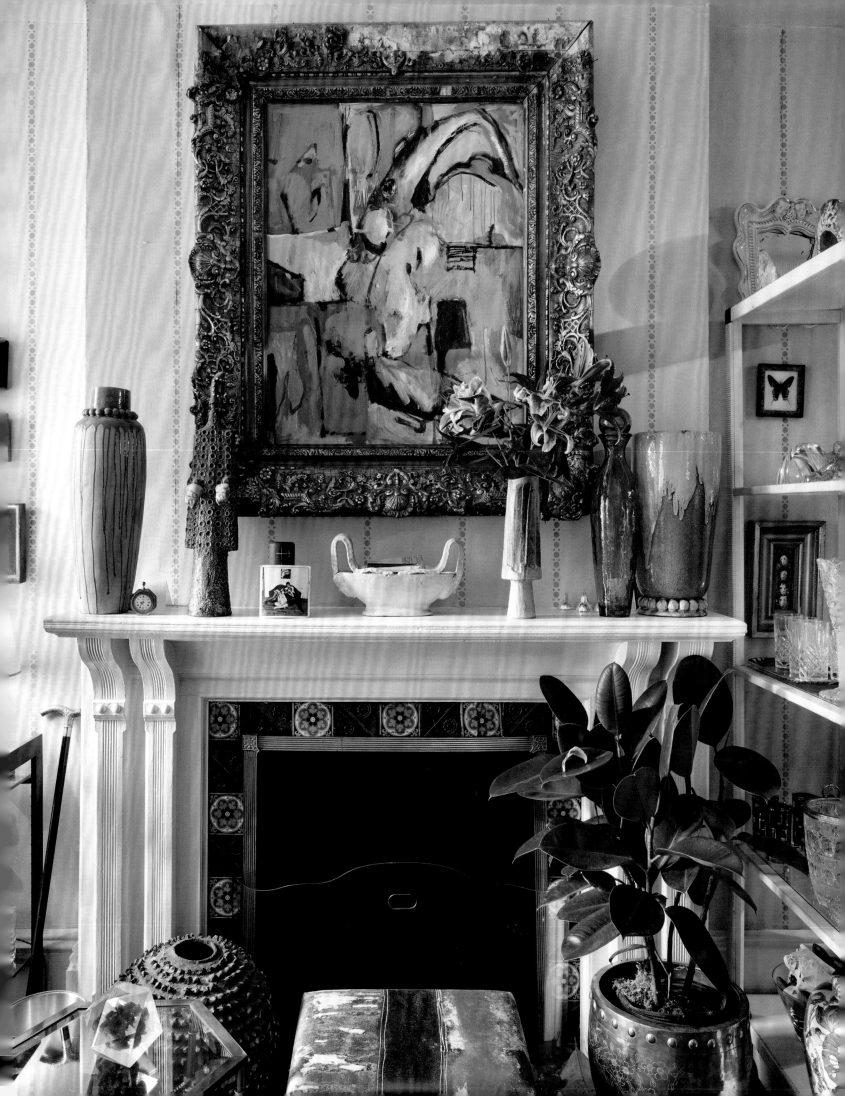

had mixed feelings about living in a hotel. She didn't know much about its history, but she loved hanging out with the actors, musicians, and writers that populated the lobby. "Everyone was so friendly and open about their lives and their careers," she remembers. "As I got older, I appreciated it more." Arnold Weinstein became one of her mentors in the hotel. "He was always there for me if I needed advice." *Interview* magazine cover artist Richard Bernstein, a longtime friend of her father's and the family, also took her under his wing. "He had a huge studio right next to the office downstairs. I would hang out there and learn about photography and art."

She was also inspired by her father's restless ambition as a photographer. "He had tons of energy. I don't know how he did it. He was very passionate about his work," Dahlia says. He taught her to appreciate all of the Chelsea's angles, and the view from its roof. On September 11, 2001, a bright late-summer morning, a friend alerted Arthur to a huge fire downtown, billowing smoke visible for miles around. "Art of course grabbed his camera and went right up to the roof," Colleen remembers. A Swedish film crew happened to be shooting there at the same time and its documentary footage shows Weinstein taking photographs of the burning twin towers.

For Arthur Weinstein, there was no conflict between making the city's nightlife hum and pursuing his creative interests. "He wasn't the kind of guy that needed to sleep for nine hours," Colleen remembers. "He was up at eight in the morning." He picked up screen printing again in the early 2000s, returning to the same workshop where he learned to print in the '70s and using his photographs as the basis for his prints. He also befriended Swiss master printmaker Alexander Heinrici, who had come to New York in 1970 and worked for everyone from Andy Warhol—for whom he made hundreds of prints—to Robert Rauschenberg, Jasper Johns, and Damien Hirst. Dahlia remembers seeing her father stretching his canvases in the hallway if he needed more space, or sneaking into an unoccupied room to work. "Arthur! What, is this your studio now?" Stanley would chide him. "Yeah, what are you gonna do about it?" Arthur would reply.

"He loved my husband," Colleen says of Bard's almost paternal bond with Arthur. "They had a funny relationship," Dahlia adds. One day they would yell "Go fuck yourself!" at each other and the next day they'd politely say, "Oh, how's everything?" Some of their caustic exchanges were recorded by Nicolaia Rips in her book, *Trying to Float*, as a loving tribute to Arthur.

The Weinsteins knew Bard primarily in his role as the gatekeeper of his own private club and vociferous ringmaster of a circus of misfits. "There's a lot of wayward artists here in the city and he gave them homes," Colleen says, but adds, "I don't really know a lot about him as a man." She was upset when Bard was ousted by the hotel's board and

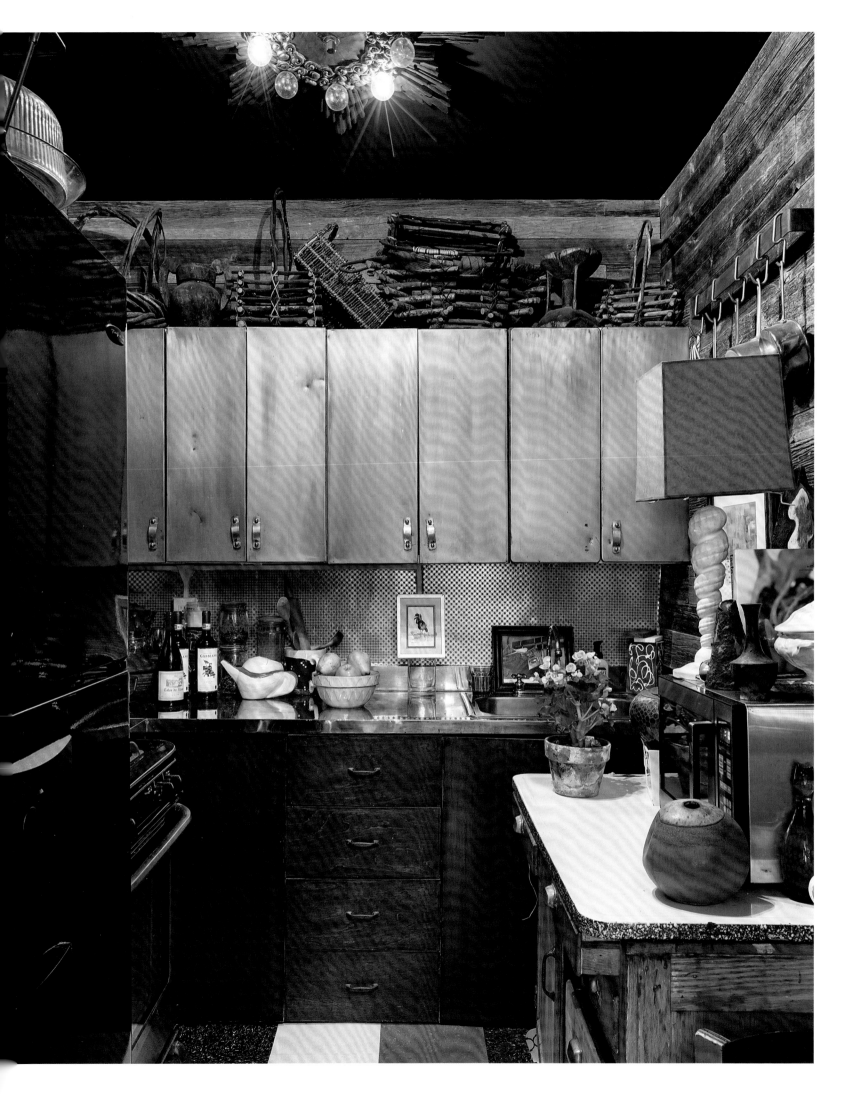

escorted out by security personnel. "Everything from his office was thrown out on the street, boxes and boxes of photographs and playbills. It was very sad."

Colleen herself dug in throughout the ownership changes. She joined the tenant association and eventually worked out a favorable deal with the owners that protected the rent-stabilized status of her apartment. Her home has been renovated to her exact requirements, with the goal of recreating its previous appearance. The Neisha Crosland wallpaper in her living room was steamed off and put back up when she wasn't able to replace it with new rolls of identical paper. The wallpaper in most of the other rooms of the apartment is from Secondhand Rose, the antiques store that was run by her friend and neighbor Suzanne Lipschutz.

Art once again fills most of the apartment's walls. There are numerous prints her husband made, both from his own photos and others', for example, of Klaus Kinski, Mick Jagger, Salvador Dalí, and Roy Cohn, chief counsel to Senator Robert McCarthy during McCarthy's hearings in 1954. Paintings by Chris Davis, a watercolor by mid-century textile designer Angelo Testa, and a dot print by Damien Hirst that was given to Arthur by the artist are mixed in with Arthur's prints throughout the apartment. As for the artwork that was stolen from the hallways, Colleen Weinstein recovered most of it after almost two years of fighting in court thanks to her persistence and meticulous documentation of her ownership claims, with help from Stanley Bard. Addressing Chetrit in his ruling, she said the judge declared, "You didn't buy the art. You bought the problem of the artwork." It set a precedent for everyone else whose art had gone missing. However, her property wasn't returned to her until the subsequent owner, Ed Scheetz, got involved. "Apparently he hired a private detective to track it all down. He got it back to me within a week."

Would she consider lending her art to the hotel for display in the hallways again? Incredibly, Colleen Weinstein says she would—but "an ironclad contract would have to be signed first by all parties." For now, the Weinsteins relish the newfound peace in their restored home. "It's been kind of quiet," Colleen says, and perhaps that's a good thing.

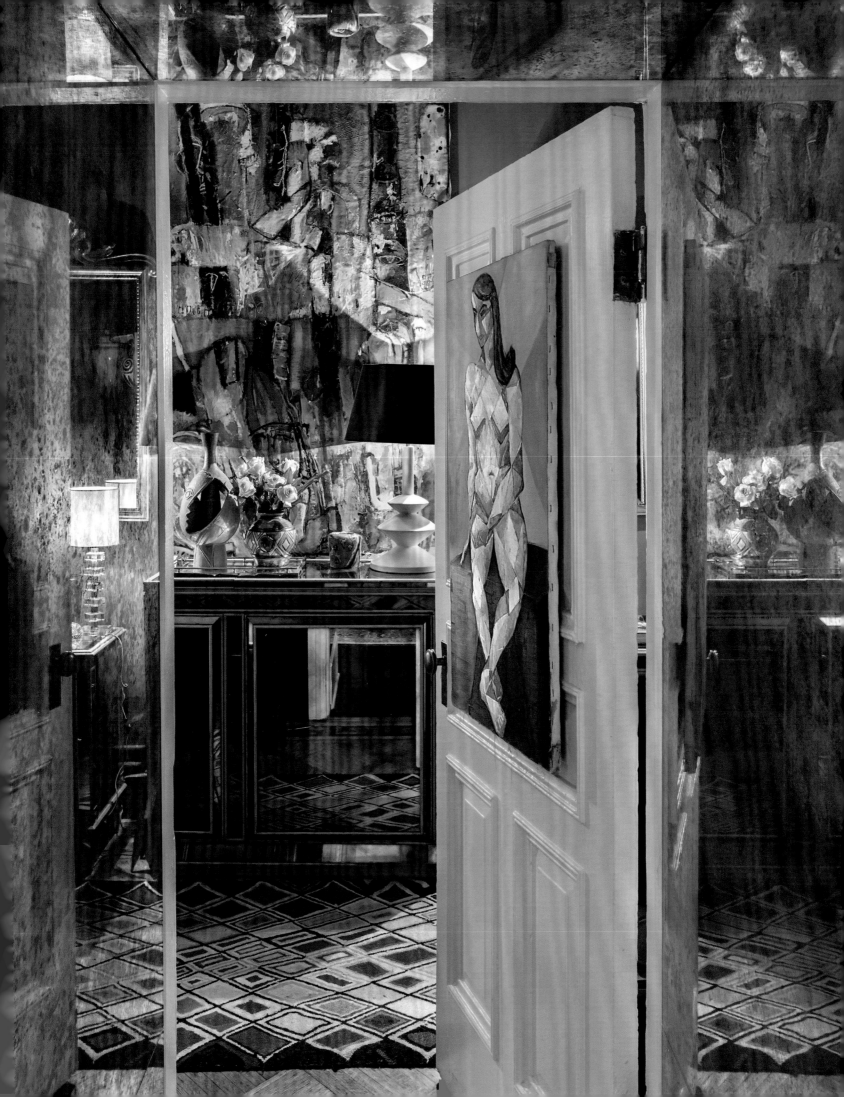

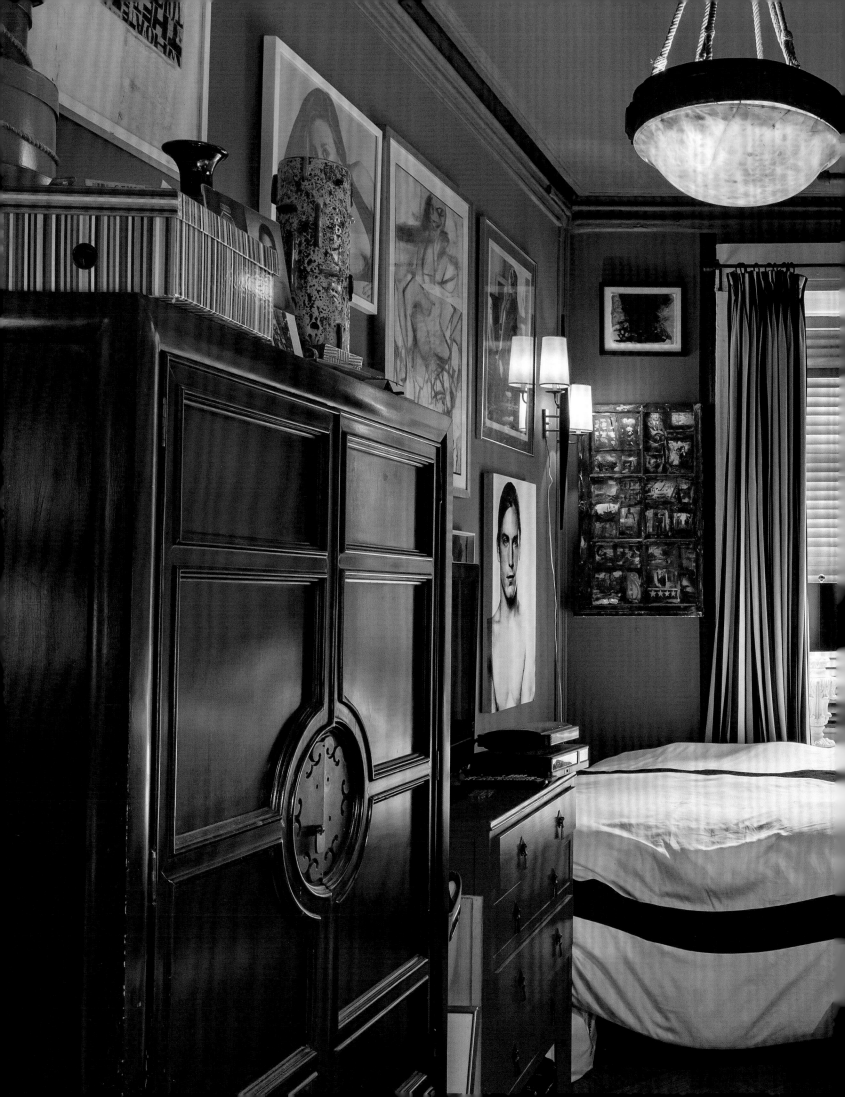

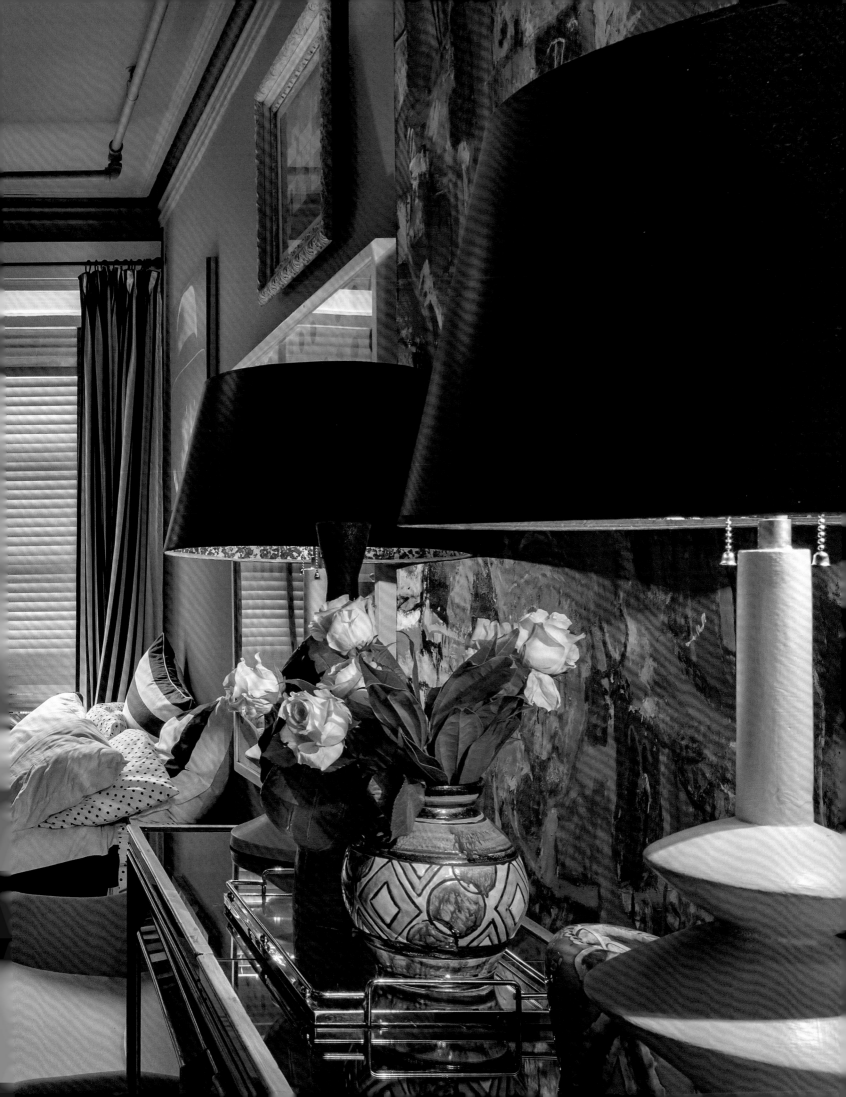

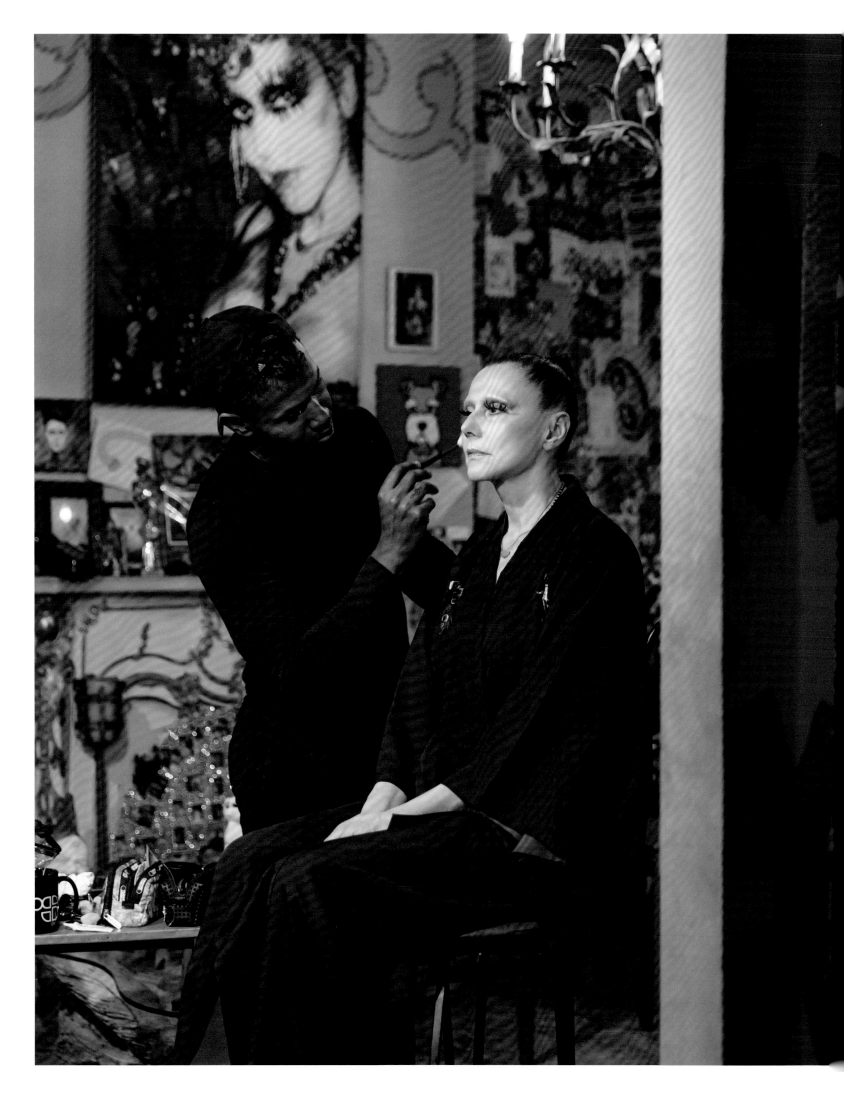

SUSANNE BARTSCH

WHEN SUSANNE BARTSCH GETS READY FOR A NIGHT OUT, her apartment becomes a hive of frantic activity. Her longtime makeup artist, Deney Adam, and her assistant, Brandon Olson, buzz around her, sometimes joined by other helpers, working on her makeup and hair or busying themselves with last-minute assignments in order to create the evening's look, whether it's for Bartsch's weekly cabaret show, *Bartschland Follies*, or a party she's hosting. During those hours of preparation, Bartsch gradually transforms. As she exchanges her designer jeans and sweaters for a robe — and unabashedly flashes visitors — while inspecting the progress in a full-length mirror and giving stern orders to Adam and Olson, there is a palpable change of temperature in the room. Bartsch is in her element. "I get energized when I wear looks," she says. "I enjoy how the transformation comes about. I can be a Marie Antoinette, a Victorian punk, a 1920s screen siren, or a '60s Peggy Moffitt type of a model." The evening is punctuated by a moment of jubilation when Bartsch learns that the feature documentary *Susanne Bartsch: On Top* will be distributed by Netflix. It's the latest achievement in her triumphant return to form.

Bartsch left her native Switzerland for London at twenty-seven. Over the course of thirteen years there, her Swiss accent acquired a British lilt and she befriended emerging designers such as Vivienne Westwood, Stephen Jones, and John Galliano. In 1981, she followed her then-boyfriend, the painter Patrick Hughes, to New York. Hughes, who had been splitting his time between London and New York with his wife, the scandalous novelist Molly Parkin, had a room at the Chelsea hotel. After Hughes and Parkin separated, Bartsch joined him there. She settled in, but missed London's quickly evolving fashions, so she opened a boutique in SoHo and imported outfits by trendy British designers. Her notoriety within the city's fashion and party scenes quickly grew.

The gradual transformation over the decades of Bartsch's apartment at the Chelsea has been a proxy for her personal life. With Hughes, she added a neighboring bedroom and the curved hallway joining the rooms. But the apartment, which also served as Hughes's

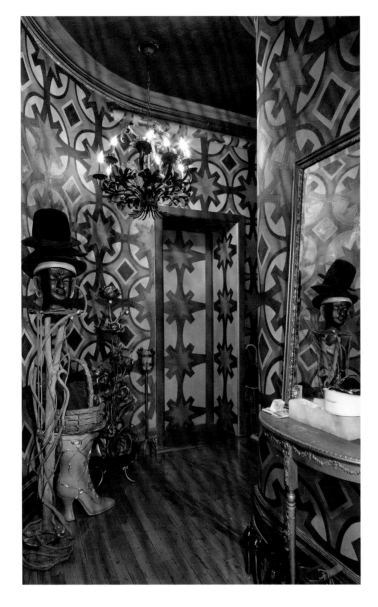

studio, was still plain and functional. "We had a drop cloth on the floor," she remembers. After they broke up and Hughes returned to England, Bartsch took over his lease. Stanley Bard was happy to have her remain at the Chelsea. "He was a big fan and very supportive of me," she says.

The apartment acquired a less conventional look after Bartsch married Ty Bassett, who lived with her at the Chelsea for five years. He had the hallway painted an electric pink, gold, and purple pattern by the artist Joey Horatio as a surprise birthday present for Bartsch. She liked it and the couple decided to do more with their space. Bassett tackled the bathroom next, arranging pieces of mirror in a mosaic that wraps around the walls and ceiling. "After that we painted the bedroom red," Bartsch says, "and then I found this Chinese bed in an auction, really cheap, because people don't have room in New York. I got it for $200." The antique opium bed, with a built-in shelf to hold pipes, dominates the intimate bedroom. It's the most private place in the apartment. "It's almost like a room within the room. When I'm in that bed, it's like meditation to me," Bartsch says. In front of the bed, a Buddha statue that doubles as a hat stand vies for space with a tricked out mannequin and countless trinkets and decorative objects. Religious artifacts — paintings, crucifixes, a small Jesus figure — surround the bed. She enjoys their campy appeal. "I'm spiritual, but I don't subscribe to the dogma of organized religion," she says. There are also several reminders of Bartsch's heritage, such as a Swiss flag made out of drinking straws. "I've always liked being Swiss," she says. "I just didn't like what it represented living there. I knew that I had things to find out about myself and if I stayed in Switzerland, I probably wouldn't." In recent years, she has traveled there often, for the benefit of her son,

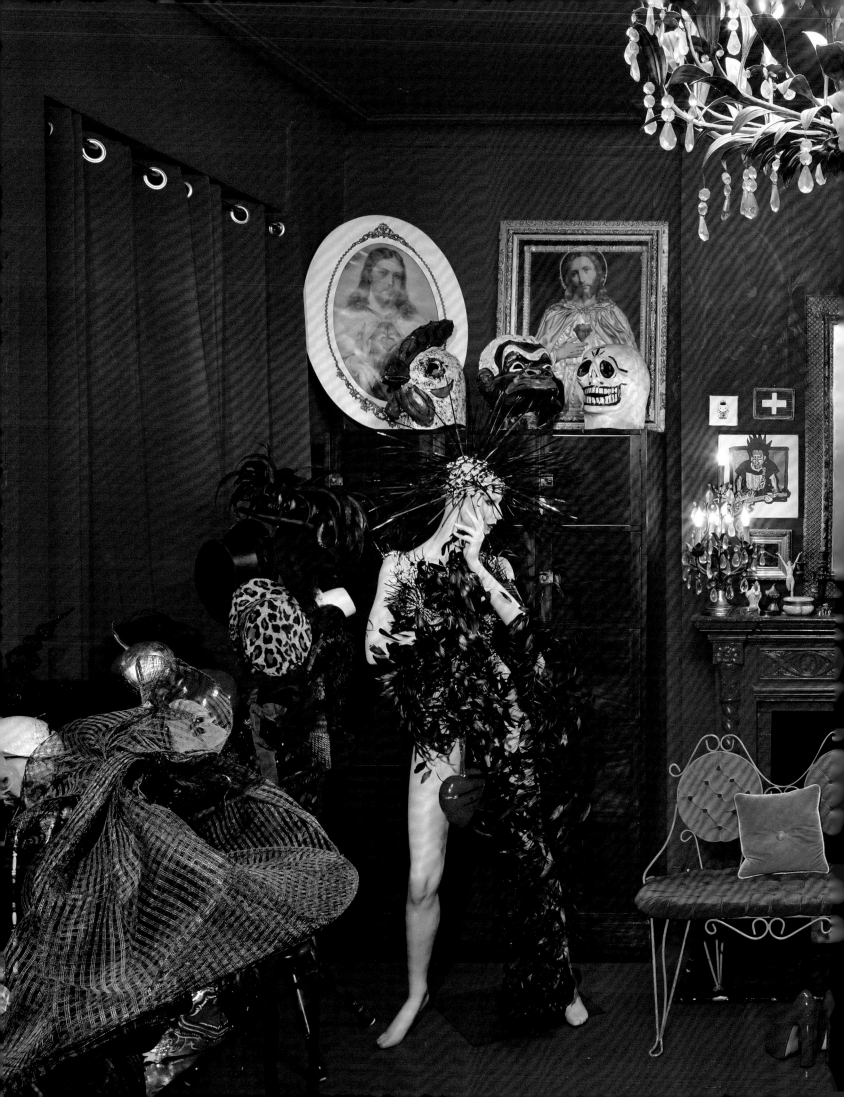

which helped her come to terms with her native country and nationality. "I'm embracing it," she says, rolling the *r* and drawing out the *a*.

By the time she divorced Bassett in 1992, the decor of her two-room apartment — the wall paintings and much of her furnishings — was essentially finished. But she wasn't done expanding.

In the early 1990s, Bartsch met David Barton, a bundle of energy a few years younger than her with an outgoing personality, a ripped body, and big dreams of jump-starting the personal fitness industry. The slender, outrageously dressed Swiss woman and the brawny entrepreneur may not have seemed a natural fit, but they connected on a deep level.

Their relationship also made for great tabloid fodder. By then Bartsch was known as the Queen of New York Nightlife for throwing elaborate events for gay, trans, and nonconformist partygoers. Of her influence on the drag scene, RuPaul Charles has said that she "picked up where Andy Warhol left off." Bartsch was an early champion of RuPaul and many other performance artists, such as Amanda Lepore and Kenny Kenny. Devastated by the loss of many of her friends to AIDS, Bartsch also became an activist and advocate for LGBT rights, and in 1989, she threw her first Love Ball, one of several highly publicized charity events that together raised millions for HIV and AIDS charities. Meanwhile, Barton opened the first in his chain of gyms, in the Chelsea neighborhood, in 1992. With dimly lit interiors and thumping beats from live DJs, David Barton gyms married exercise sciences with club culture. They were known as hook-up spots, and much like Bartsch's events, they attracted celebrities.

When Bartsch became pregnant with their son, Bailey Bartsch Barton, born in 1994, the couple needed more space. Bartsch took over two more adjacent rooms. The most notable previous tenant of the room that became the nursery was the singer Janis Joplin, who apparently once assuaged her neighbor, a nurse who complained about her loud parties, with a set of signed records that were only discovered after the nurse's death. Today the

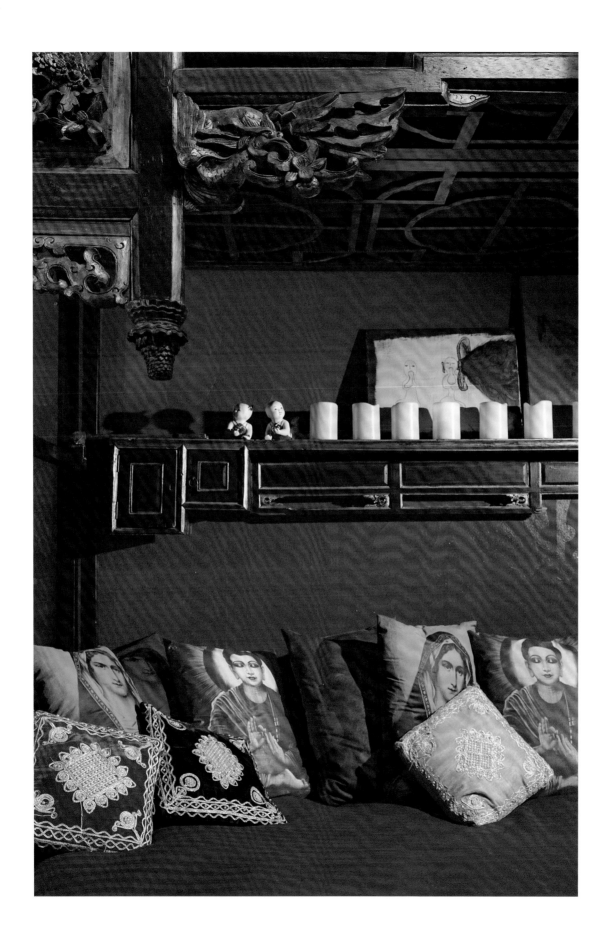

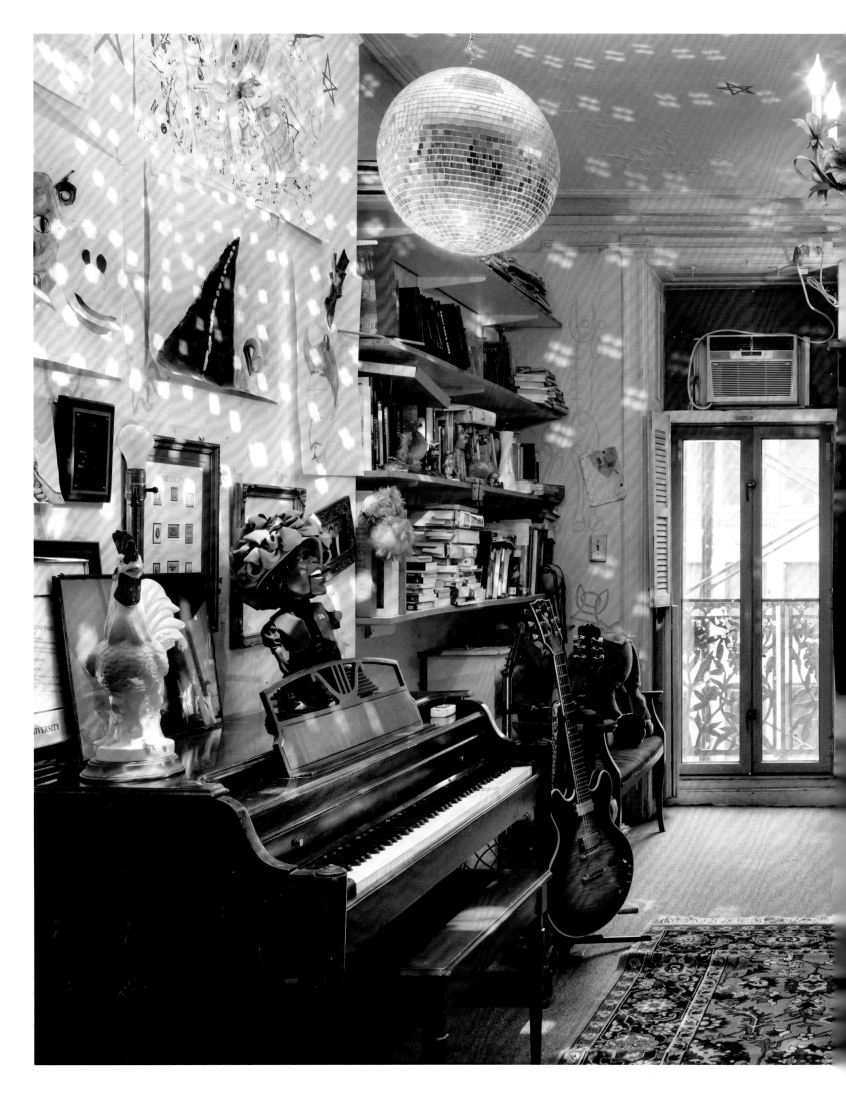

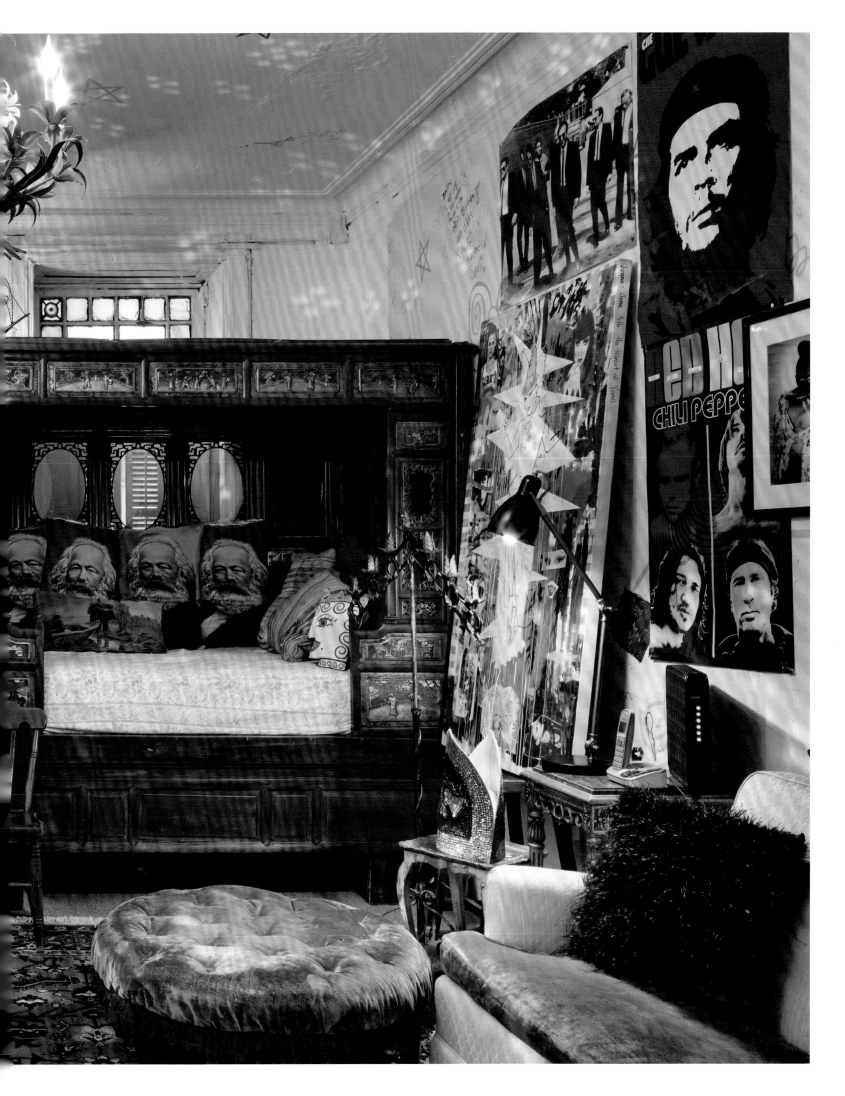

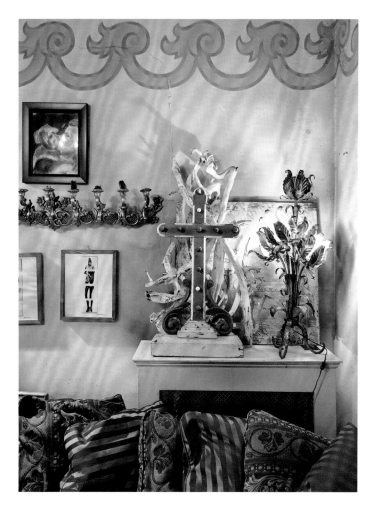

room serves as a living and guest room. A second, even larger and more ornamented Chinese bed sits in front of its window. The austere faces of Karl Marx and Chairman Mao greet visitors from a row of throw pillows aligned at the back of the bed. The room is filled with personal belongings, including books, musical instruments, and memorabilia, such as a photo of Bartsch's old friend from her days in London, Jimmy Page, with a signed dedication to Bailey. A poster of Che Guevara hangs opposite a wall filled with children's drawings. A disco ball dangles from the ceiling innocuously, as if it had always been there. The smell of citrus oil—a scent more commonly encountered in the kind of boutique hotel the Chelsea is trying to become—permeates the room and contrasts with its antique furniture and lived-in earthiness.

Bartsch's marriage to Barton ended and he moved out—"Twice!" she laughs—but stayed close, for their son's sake. Years later, they have yet to finalize their divorce. "Our separation was very grown-up. Bailey never really heard us say a bad thing about each other." Her son, recently returned from college, now occupies the room at the far end of the apartment, which has its own entrance.

While she has mostly kept to herself in the Chelsea, Bartsch had a productive relationship with her former downstairs neighbor, the mononymous designer Zaldy, who lived in the hotel for more than a decade, until the mid-'90s. He started designing her outfits while he was still in college. "His boyfriend Mathu"—Mathu Andersen, who would go on to become a well-known costume designer—"was one of those geniuses who just had limitless talent. Photography and the best makeup ever." A big board plastered with photos and party invitations that leans against one wall in Bartsch's living room features many of Andersen's photos. Zaldy later worked for Cirque du Soleil, designed costumes for Michael

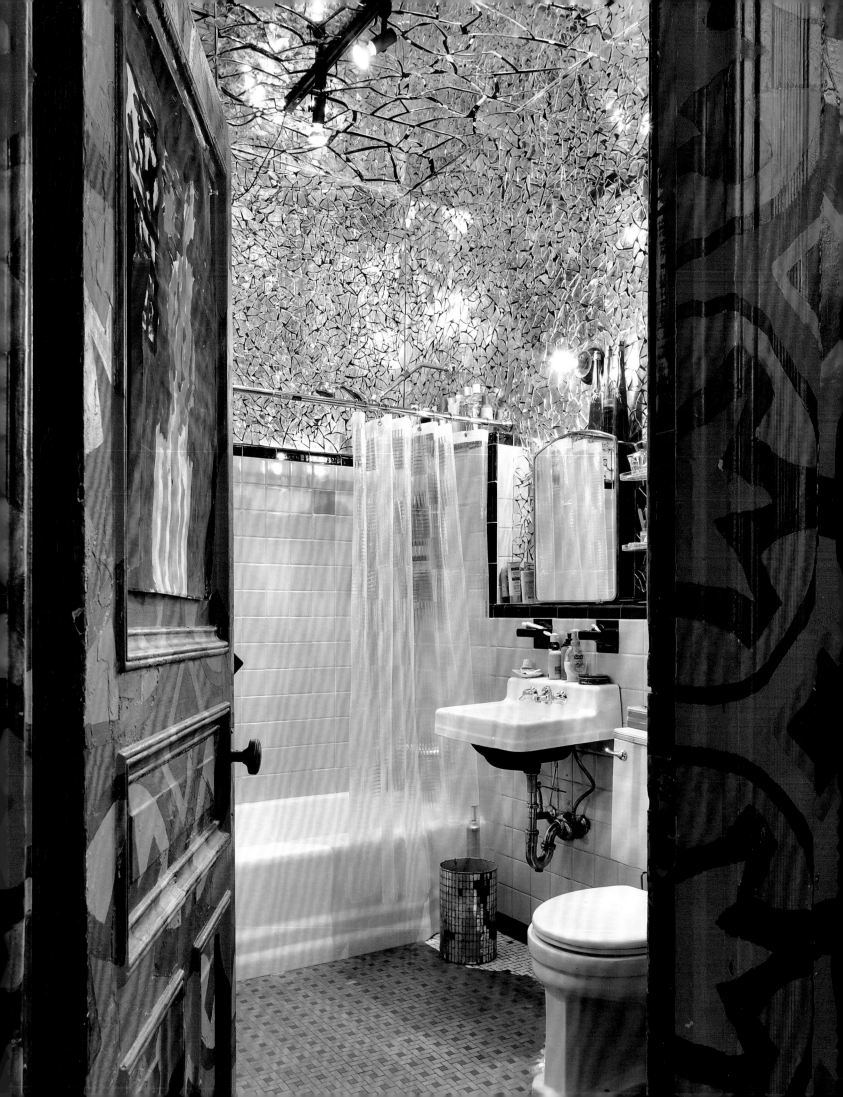

Jackson, Lady Gaga, and Katy Perry, and received multiple Emmy nominations for his work on *RuPaul's Drag Race*. "I can't afford him now," Bartsch says.

The living room—which now doubles as Bartsch's dressing room—was, like the hallway, painted by Joey Horatio, who adorned the walls and ceiling with elaborate murals in pink and baby blue. Bartsch calls the room the heart of the apartment. Today the first thing one notices upon entering is a large portrait of Bartsch in full party mode hanging above the fireplace. It is surrounded by small paintings of dogs, most of them by Barton, and family photos. The fireplace itself, with its gilded ornamentation, is a notable departure from the woodwork more commonly found in the hotel. A landline phone sits on the mantle; it was disconnected when construction in the building started, but is still plugged into the wall. A garden gnome guards her collection of trinkets, candles, and pictures.

"The Chelsea Hotel is a bit like my mom," Bartsch likes to say, because she feels at home and taken care of by the staff. "I love it here." Plus, she says, "It adds a little bit to my mystery, right?" An interior design feature once referred to her apartment as a museum, but, Bartsch says, "It's not that precious." Nonetheless, she is protective of it, for the sake of its historical substance as much as her stake in it, and she has refused all offers to have it renovated. "They wanted to come in and box it in and I didn't want that." Bartsch is not a fan of boxes, in the metaphorical or the physical sense.

Layer by layer, Bartsch's look for the night is nearing completion. Later that evening, in a video posted to social media, she is dancing in the room to Laid Back's 1983 song "Sunshine Reggae," ready to head to the party whose name inspired the title of her documentary, *On Top*. Bartsch's goal for the night is the same as for every night: "Giving joy to people and myself. I love that. That's what I'm about."

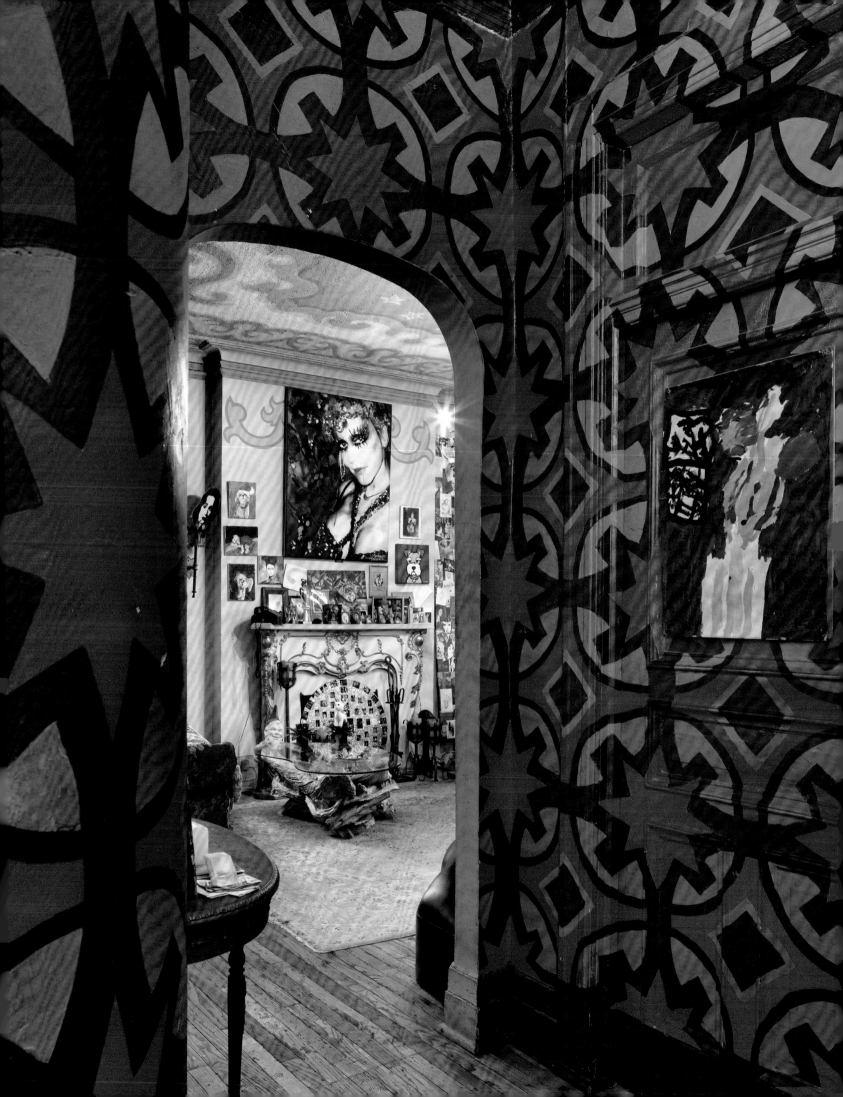

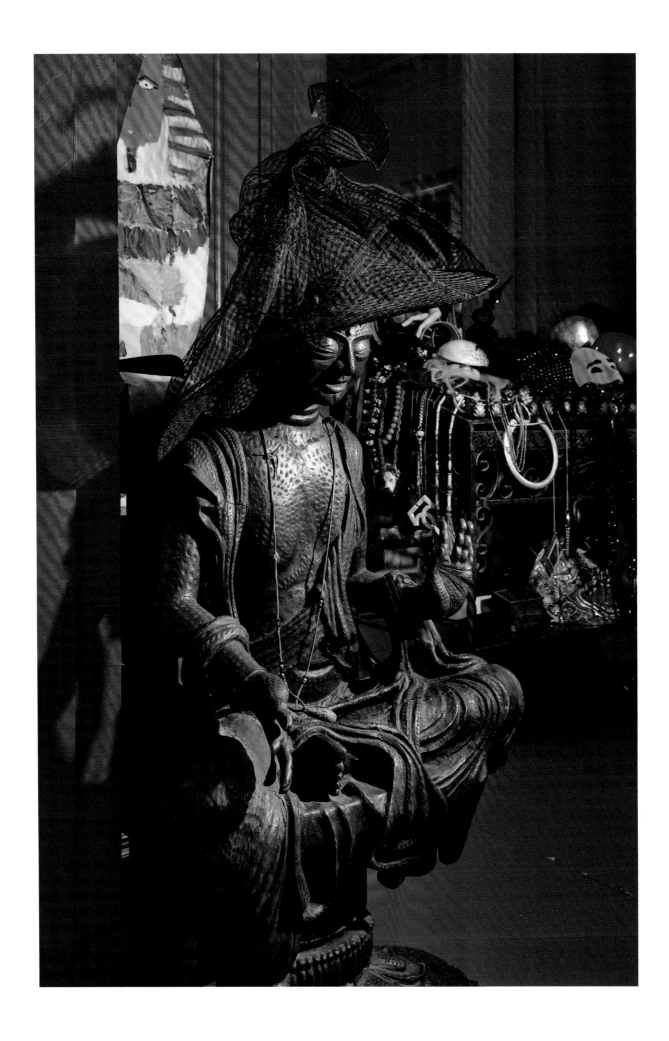

Thou Shalt
Not Whine

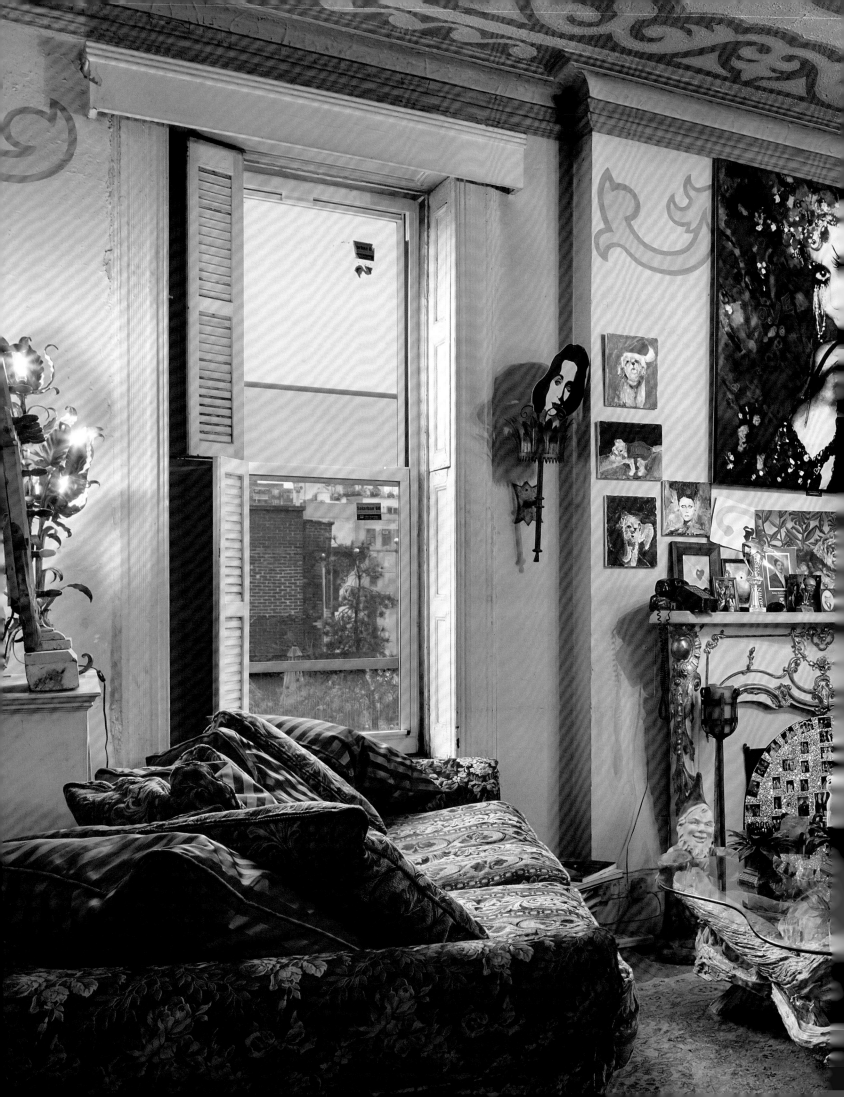

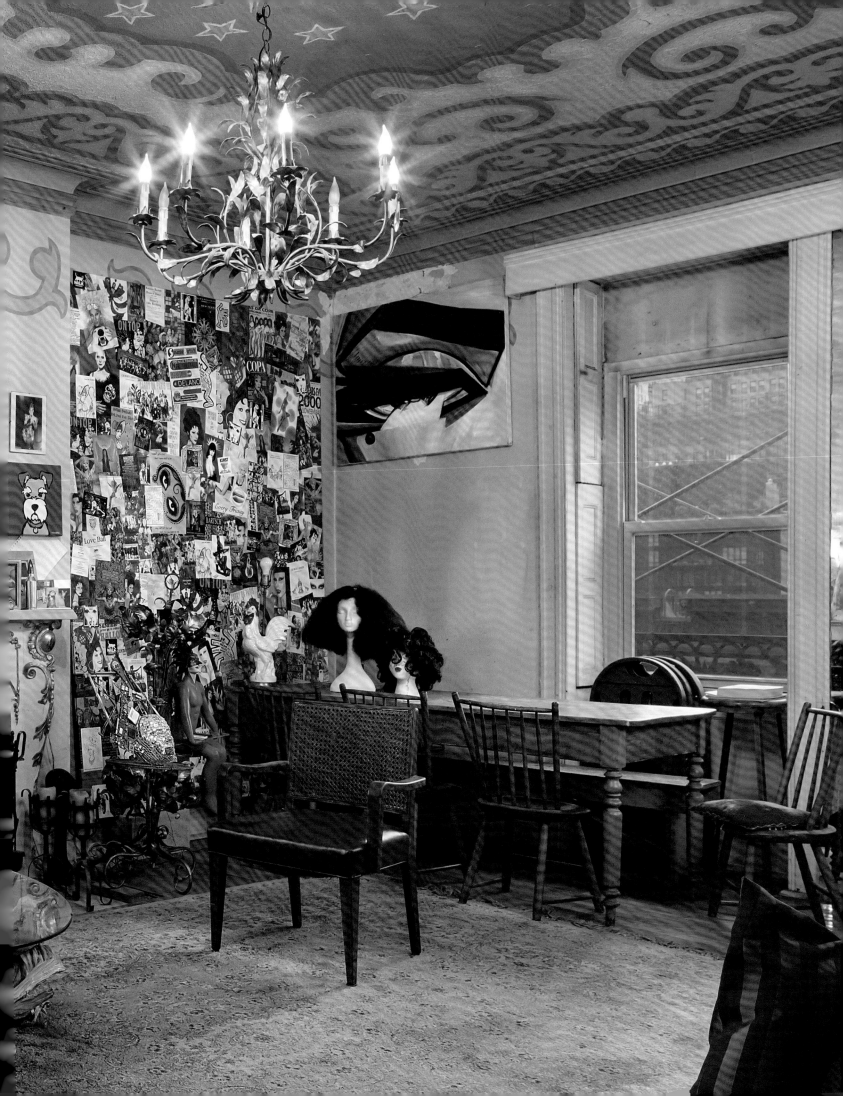

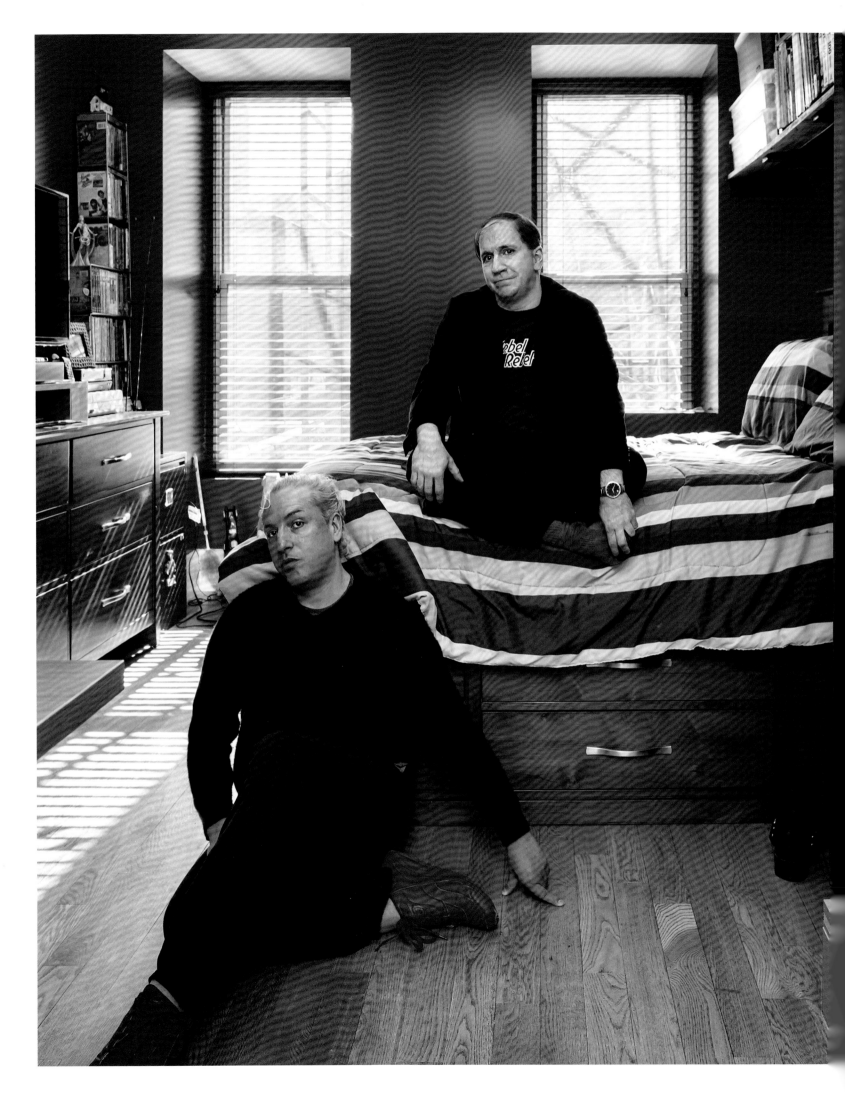

MICKIE ESEMPLARE

MICKIE ESEMPLARE HAS LIVED IN THE HOTEL CHELSEA for less than twenty years, which makes him one of the hotel's newest remaining tenants (with the exception of any children born into the Chelsea more recently). He didn't specifically seek out the Chelsea as a place to live, but the hotel's colorful atmosphere and history appealed to him. Originally, Esemplare lived in a tiny studio without a bathroom on the third floor. "It's small, but just try it for a while," he remembers Stanley Bard telling him when he got the keys. Of course he stayed.

Esemplare works as a paralegal in Times Square, just a short commute from the Chelsea. He has long been an ardent fan of pop music and particularly of the singer Cher, whom he has met many times. "She was a very friendly person, a very real person," he says of his early encounters with the artist. Once she began acting and her career took off, he and a few friends started her fan club. He remembers one time when they met her in a hotel on fan club business and wound up hanging out in her room. "How's the new album going?" Esemplare asked her. She offered to play them some of it. The song they heard was called "Believe." The single from the eponymous 1998 album would go on to sell a record eleven million copies and be Cher's greatest hit.

When the Chelsea Hotel was sold to Joseph Chetrit in 2011, Esemplare was determined to stay put. The first week after the sale was particularly unsettling. New managers came in, groups of people in suits, but they didn't introduce themselves. "No one told us anything." He didn't realize the severity of the threat the tenants faced until he received a letter from City Council Speaker Christine Quinn that expressed concern about the building's new owner. Like everyone else who chose to stay in the building, Esemplare, who lives with his partner, Hugo M. Vilardell, suffered from the ongoing work in the building and the efforts to evict the tenants. He joined the tenant association and, after the building changed hands again in 2013, took advantage of an offer to relocate into a larger studio—with a bathroom—on the first floor. "Right now it's nice because it's quiet," he says, "but I look forward to it being a hotel again, with new people coming in and out."

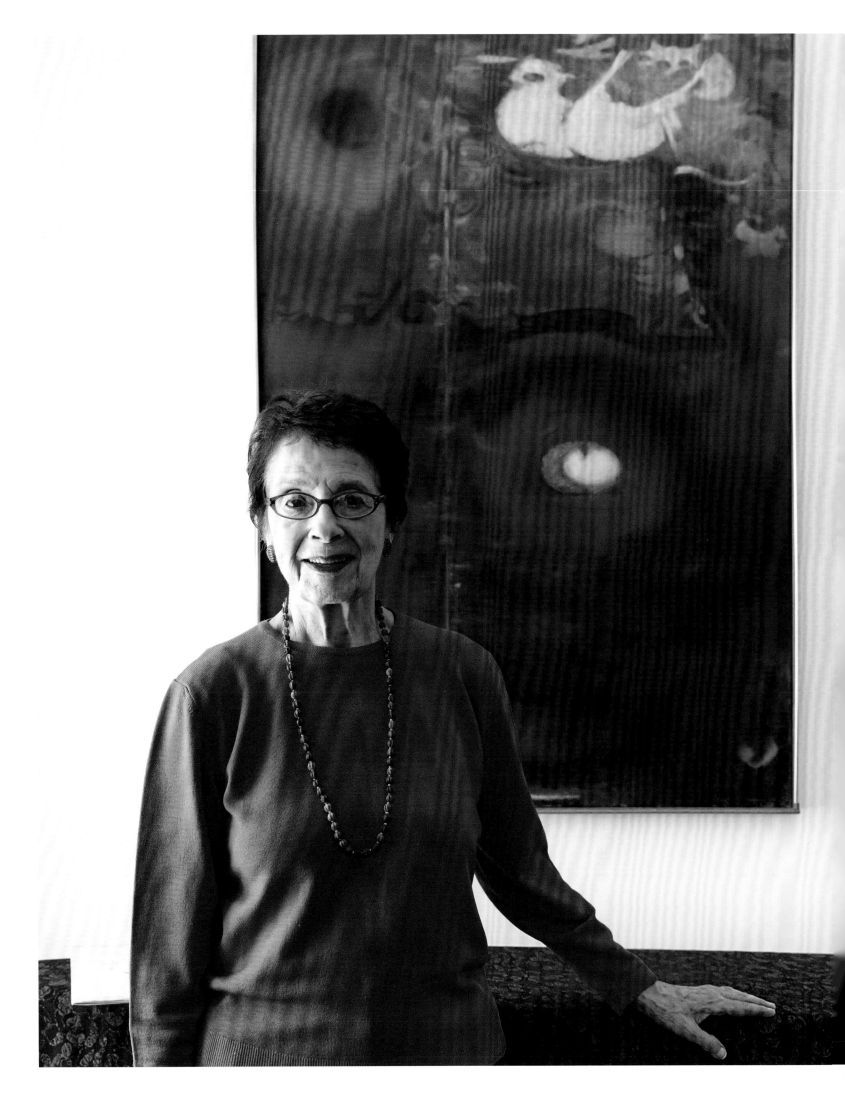

JUDITH CHILDS

THE LATE ARTIST BERNARD CHILDS and his wife, Judith, met thanks to elderly Cretan shepherds with an interest in American politics. You wouldn't know it from his Wikipedia biography, though. The page for Bernard Childs contains an overview of his work and a detailed chronology of his travels and exhibitions, but it makes no mention of his wife, with whom he spent the last twenty years of his life. "No, of course not! I wrote it. No," she says insistently, "because it's about Bernard!" Judith Childs, who dresses simply but elegantly, and always wears lipstick, made managing her husband's estate her life's work after his death at the age of seventy-four in 1985 and avoids making sentimental decisions. "I'm very strict about that."

Bernard Childs was in the Navy during World War II. Stationed in the South Pacific, he survived a kamikaze attack and sustained injuries that required years of intermittent hospitalization. He had a lifelong passion for drawing, but didn't start making art until he was in his early forties. In 1951, aided by the G.I. Bill, he left the United States to pursue his artistic interests, first for Perugia, Italy, and then for Paris. Today he is best known for inventing a technique for engraving metal printing plates with power tools. He left behind an extensive body of work that includes numerous paintings, prints, and printing plates. The plates have frequently been exhibited on their own, another practice Childs pioneered.

The couple met in 1964 in Paris, where both were living and working, she for an American bank on the Place Vendôme, and he as a member of Europe's artistic avant-garde. New York remained an important hub for contemporary artists, and in 1966 the couple rented a room at the Chelsea Hotel, where Bernard Childs had stayed many times during previous visits. They spent the next twelve years commuting between their homes in Paris and New York.

The Chelsea offered the company of other artists, but more importantly, for an aesthetic individualist like Bernard Childs, who never adhered to any movement or group, it offered peace and quiet. Stanley Bard, whom Judith Childs describes as having "his own particular genius," fiercely defended the privacy of his residents and made sure that those

to whom he took a liking stayed. When Childs needed more space to work on a light sculpture for a show — an elaborate composition lit from below — Bard talked them into renting a second studio in the building rather than losing them to a loft in SoHo.

The couple found many kindred spirits in the hotel. Among them were the master printmaker Robert Blackburn, the British painter Frederick Gore, who visited the Chelsea regularly and asked to stay in a different part of the hotel each time — "He finished all of the views of the Chelsea and then he didn't come back," Childs says — and the artist and filmmaker Doris Chase. Later they would also befriend the Belgian tapestry artist Juliette Hamelecourt and the artist Ching Ho Cheng, who lived upstairs. "He and Bernard had a mutual admiration society," Childs says.

In the summer of 1978, while the couple was in New York, Bernard Childs had a stroke. He underwent a slow and painful recovery; his right arm remained paralyzed and the couple's itinerant lifestyle came to an end. A large painting called *The Stroke*, produced in 1981, which now hangs in the living room, tells the story of his survival. Painted in his trademark mix of abstract and figurative styles, Judith Childs likens its symbolism to the terrifying threat of being trapped at the bottom of the sea. "That creature on top was one of his survival creatures," she says. "Bernard was a survivor."

Judith Childs's one-bedroom apartment, the same the couple moved into in 1966, features a representative cross section of her husband's work. A large canvas in striking shades of red, orange, and blue is titled *Blues Record*. "I first saw it when I met Bernard in Paris," Childs remembers. His studio faced a noisy inner courtyard and he told her the painting was inspired by his neighbors, who played the same Mills Brothers song again and again. "I started to laugh and that seems to have been the right reaction.
He had a great sense of humor."

A painting above the bed in her tiny bedroom is an homage to Paris entitled *Paris, A State of Being*, from 1954. Its abstract markings suggest the city. "If you know Paris very well," Childs says, "you'll recognize the shape of the Seine." A smaller painting entitled *Interplanetary Lollipop* and an abstraction called *Coronal* in the hallway testify to Childs's fascination with outer space. "He had been a quartermaster on a destroyer escort, which is a small ship, in the South Pacific, and he spent a lot of time looking at the sky and the sea." Above her dresser hangs an abstract rendition of a nude torso. "That is me," she says matter-of-factly.

After Bernard's death in 1985, Judith Childs began the arduous detective work of piecing together her husband's legacy. She shows us the printing plate for an edition called *Love Apple*, from the early 1960s, which is about the size of a small hand and which hangs

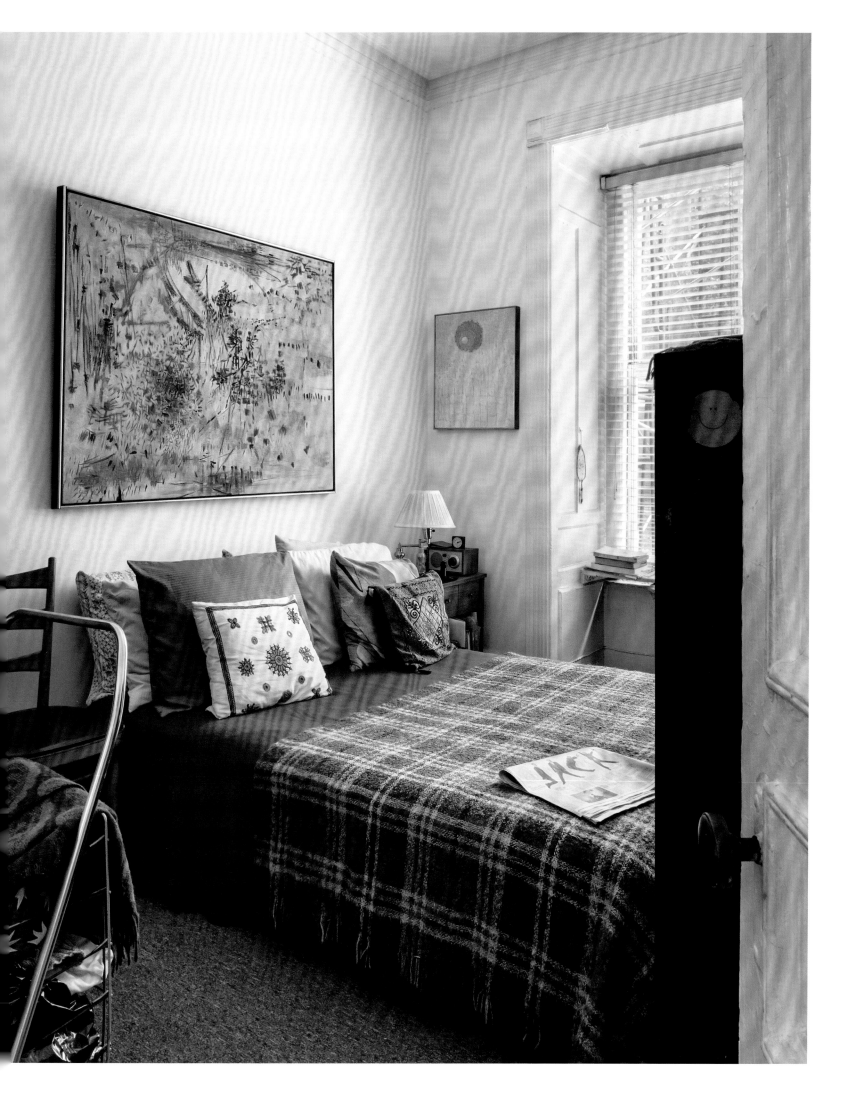

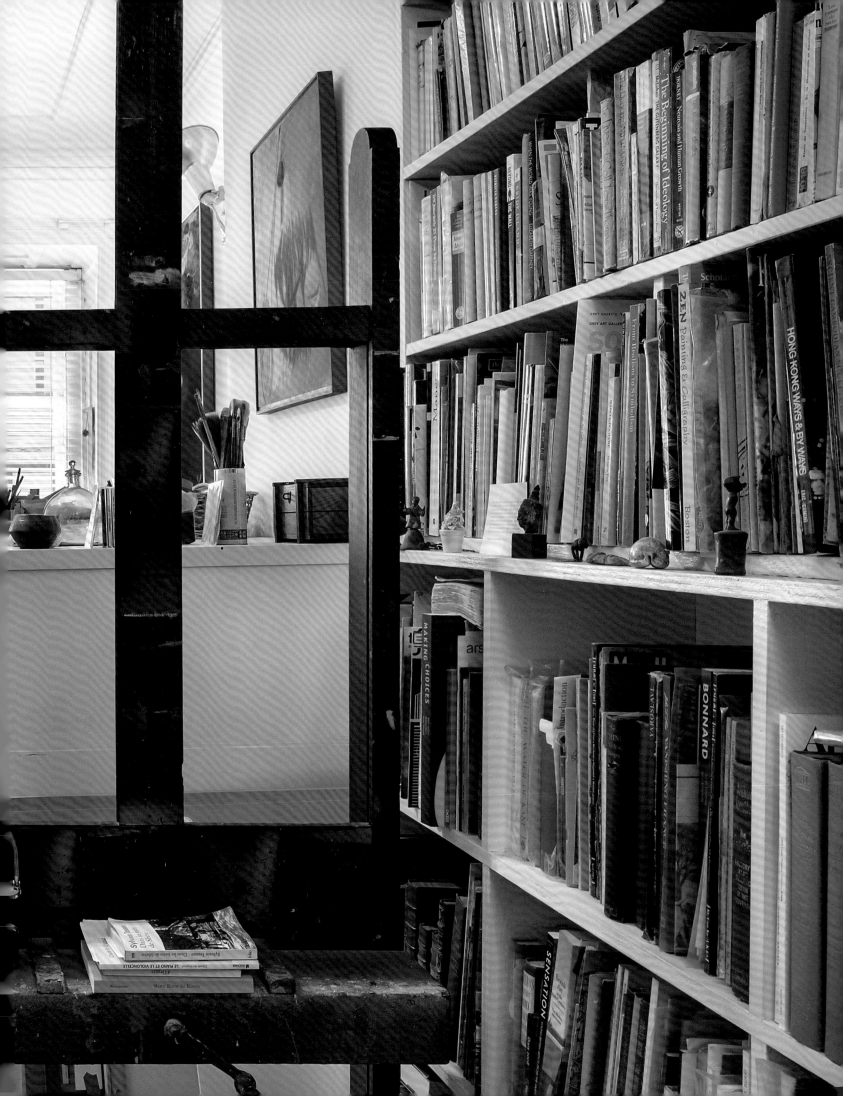

next to her bed, near a photo of Bernard taken not long before he died. She also shows us a receipt for the plate from the 1964 Salon Comparaisons in Paris, which she found after his death buried in income tax files predating their marriage. "They didn't take any impressions from the plate and exhibited it as a sculpture. And this was the receipt for it. That is the first time that I know that happened. Discoveries like this," she says, "are really the fun of what I do."

Childs uses the apartment (as well as her husband's former studio in the Chelsea Hotel, which she also continues to rent) to store much of his work and old tools. It also functions as an office for her never-ending tasks of documenting and archiving notes, correspondence, and news clippings, organizing exhibitions, meeting collectors and fielding inquiries. She says she has compiled the equivalent of seventy-five percent of his catalogue raisonné, and that it might take her another twenty-five years to finish it, so overwhelming is the amount of material.

Following Bernard's death, Judith Childs's friends in the Chelsea helped her deal with her loss. "Everyone was very, very kind," she remembers. Ching Ho Cheng was also grieving for a partner who had died. "We needed to right ourselves. There's a certain off-balance that happens in you." After Cheng himself died in 1989, Childs became close to his sister, Sybao Cheng-Wilson, who manages his estate. In 2011, a knock on her door from

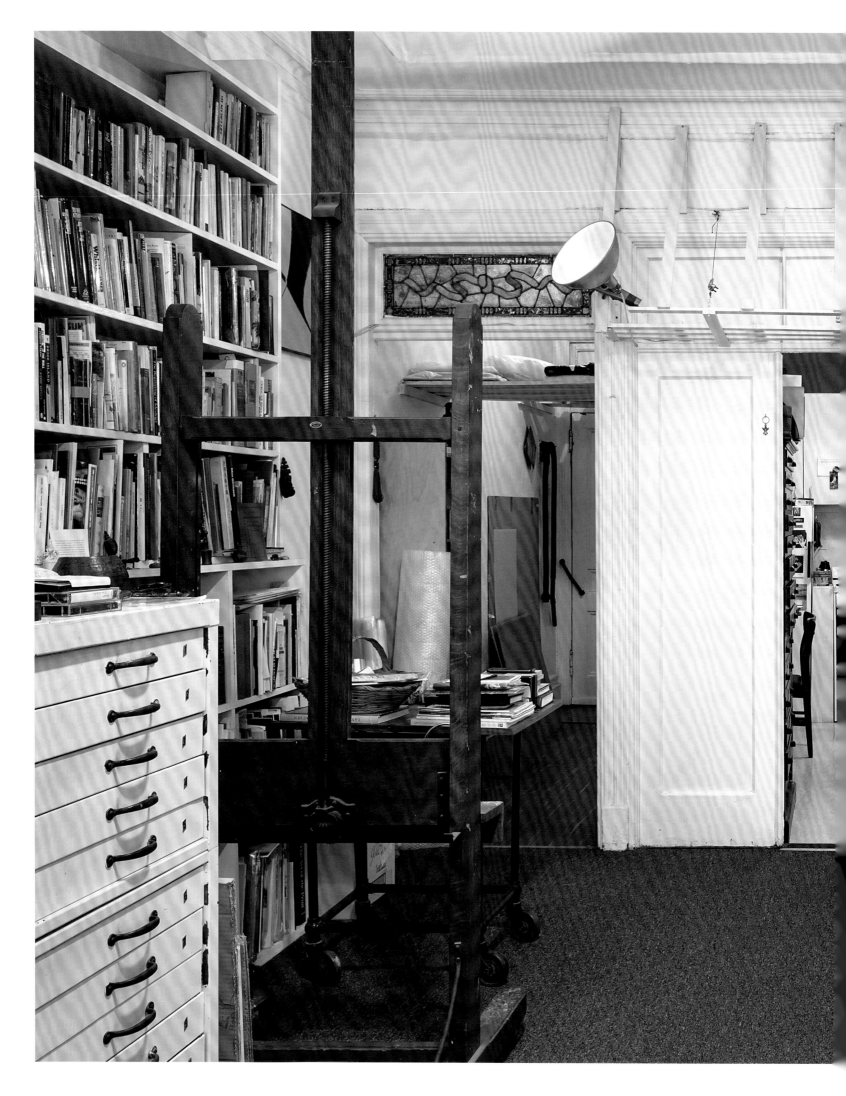

a neighbor, Man-Laï, signaled another abrupt change in her world. The tenants banded together in the rose garden on the roof in the face of mounting threats of eviction from the buyers of the Chelsea. "The garden saved our lives in a way, because it was so sane and beautiful," Childs says. Sadly, it was among the first of the hotel's unique spaces to be destroyed. But amid the crisis, new friendships formed. "We were in survival mode. We still are," Childs laughs.

As for those Cretan shepherds: The year was 1964. Judith, recently divorced, was on vacation in Greece with her cousin. In a village square they encountered a group of shepherds who, unable to speak English, but realizing that the two women were American, raised their arms in bewilderment and said "Goldwater?" Childs picked up the *New York Herald Tribune* upon her return to Athens to catch up on the nomination of the Republican candidate, who was trying to unseat President Lyndon B. Johnson, and learned from the newspaper that an organization called Americans for Johnson had formed in Paris. Back in Paris, she joined the group of expats and, after suggesting that there should be an artists and writers committee, was promptly appointed its chairperson. The problem was, she didn't know many artists or writers. When Judith ran into her former college roommate, Judy Mullen, and her husband, Bob, she shared her dilemma.

Bob Mullen told Judith that there was someone she should really meet.

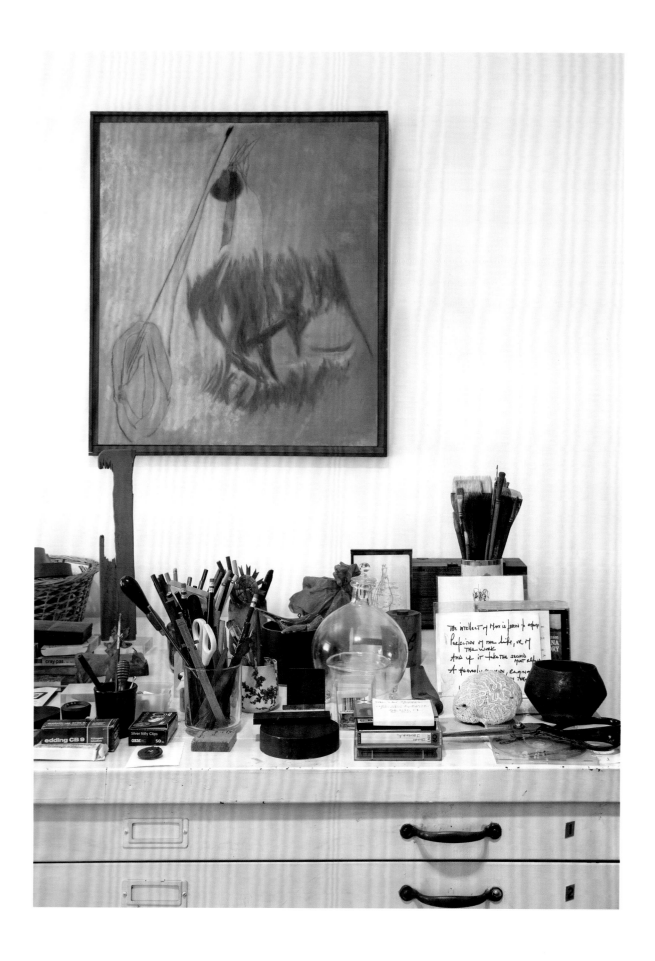

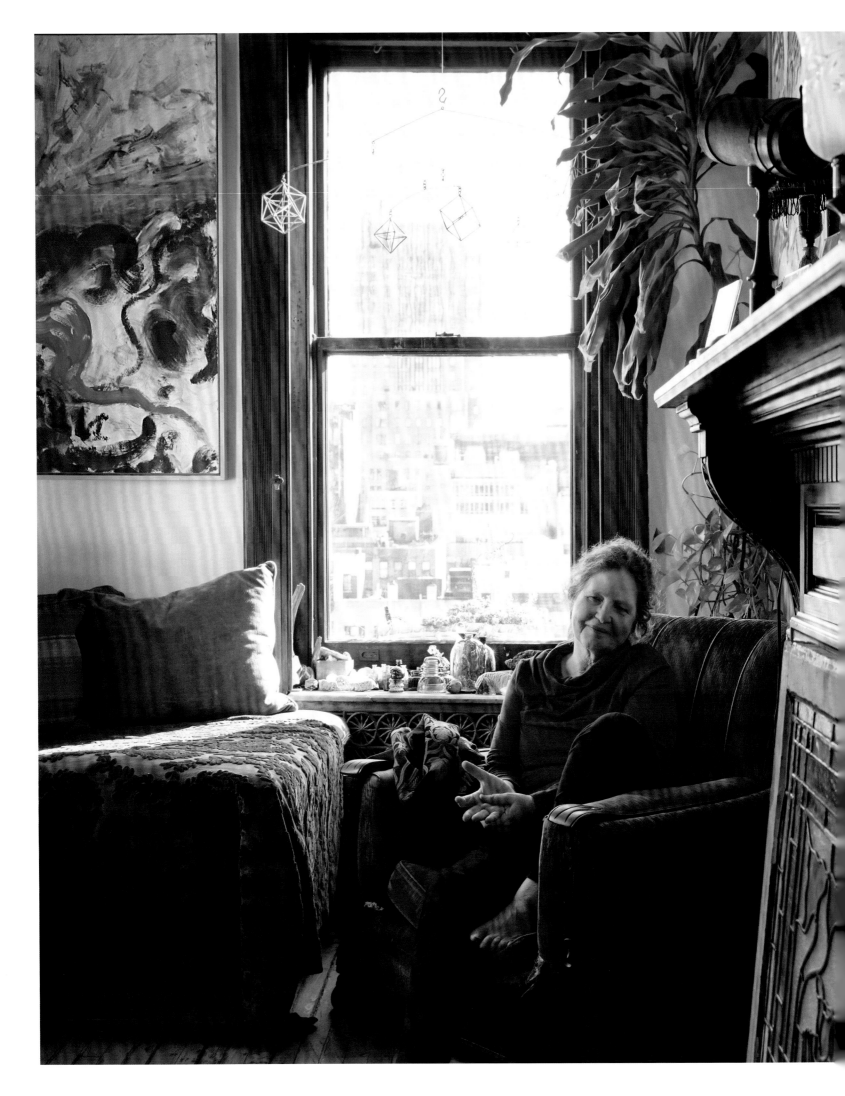

RUTH SHOMRON

DANIEL AND RUTH SHOMRON ARRIVED FROM TEL AVIV in New York in the early 1970s. The two young, free-spirited artists were warmly welcomed at the Chelsea Hotel by Stanley Bard and remained grateful for his help in easing their transition to a new life and for making them feel at home at the Chelsea. They were impressed with how Bard's creativity and genuine love for all people made the hotel an exceptionally artistic community into which they happily fit. Daniel and Ruth had two children in the Chelsea and their family became a grounding fixture in the spirited culture of the hotel. As the family grew, the Shomrons annexed a neighboring hallway and rooms to form a space both maze-like and open, unique, warm and welcoming.

Over the years, the Shomrons lovingly restored the original woodwork in the apartment (which had been home to writer Mark Twain and director Peter Brooks) and augmented it with an eclectic selection of furniture — some of it custom-made and some scavenged from the city's streets. The layout of the three-bedroom apartment hints at the grandeur of the building's early years, before its spacious suites were broken up into smaller hotel rooms. Shelves and vitrines overflowing with books, antique toys, animation cels, and other wondrous objects line the forked hallway that connects the living room and the kitchen to the apartment's bedrooms and bathrooms. A work by the tapestry artist Juliette Hamelecourt that depicts the Chelsea Hotel's exterior hangs next to a massive antique cabinet, on top of which sit several old zoetropes. Around every corner, there is more to discover, yet everything feels harmonious, balancing history and the present, as well as the funky quality of the hotel with the engaging simplicity of the family.

Nowhere are these complex and concordant qualities more striking than in Daniel's paintings, which hang throughout the house and lend light and life to each room. Daniel, who passed away in September of 2013, was an animator and a painter. Several of his more vibrant acrylic and oil paintings fill the walls of the living room. These works are indicative of what the curator and critic Dominique Nahas described as Daniel's authenticity, his

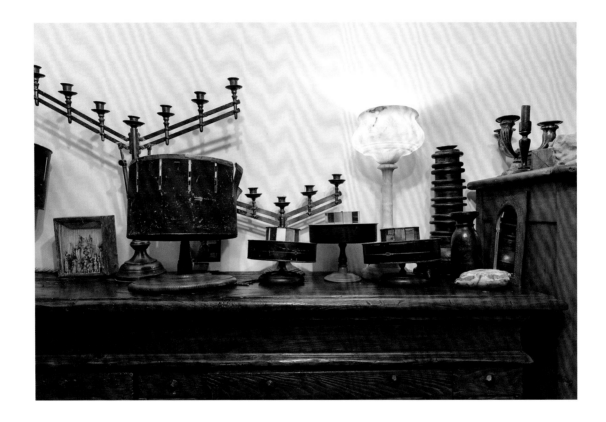

passionate search for the "underlying harmony of nature," and a "rapturous visionary quality made of small and private moments." Daniel's works, such as the radiant landscape painting *Meeting* and the mesmerizing *Oceanic Moon*, express at once what writer Robert C. Morgan called Daniel's "sense of childlike wonderment" and the sobriety of a mature artist.

The timelessness and ebullience that emanate from Daniel's work can be felt throughout the apartment. Ruth is as welcoming to visitors as the Chelsea once was to her and her family. "It is our home," she says about her apartment with a loving urgency, as if no other words were needed to describe it.

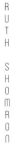

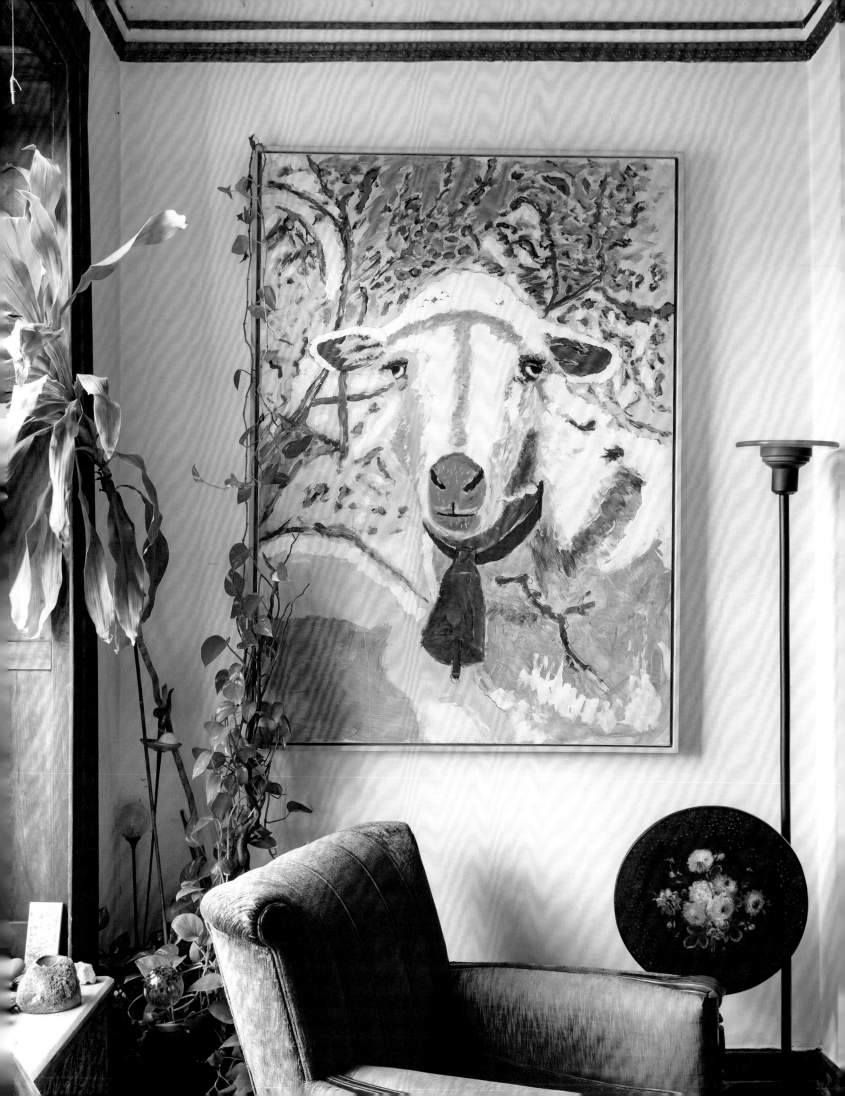

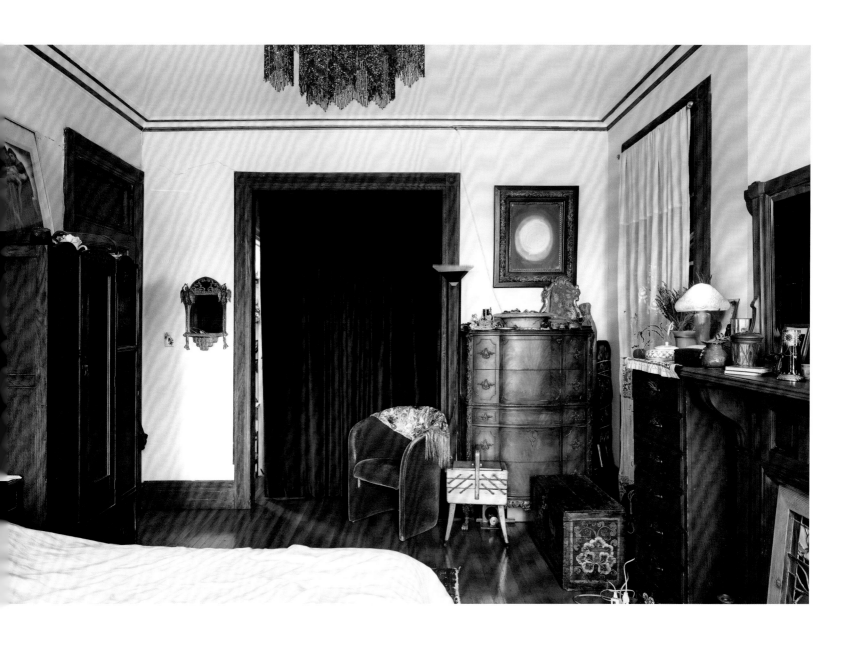

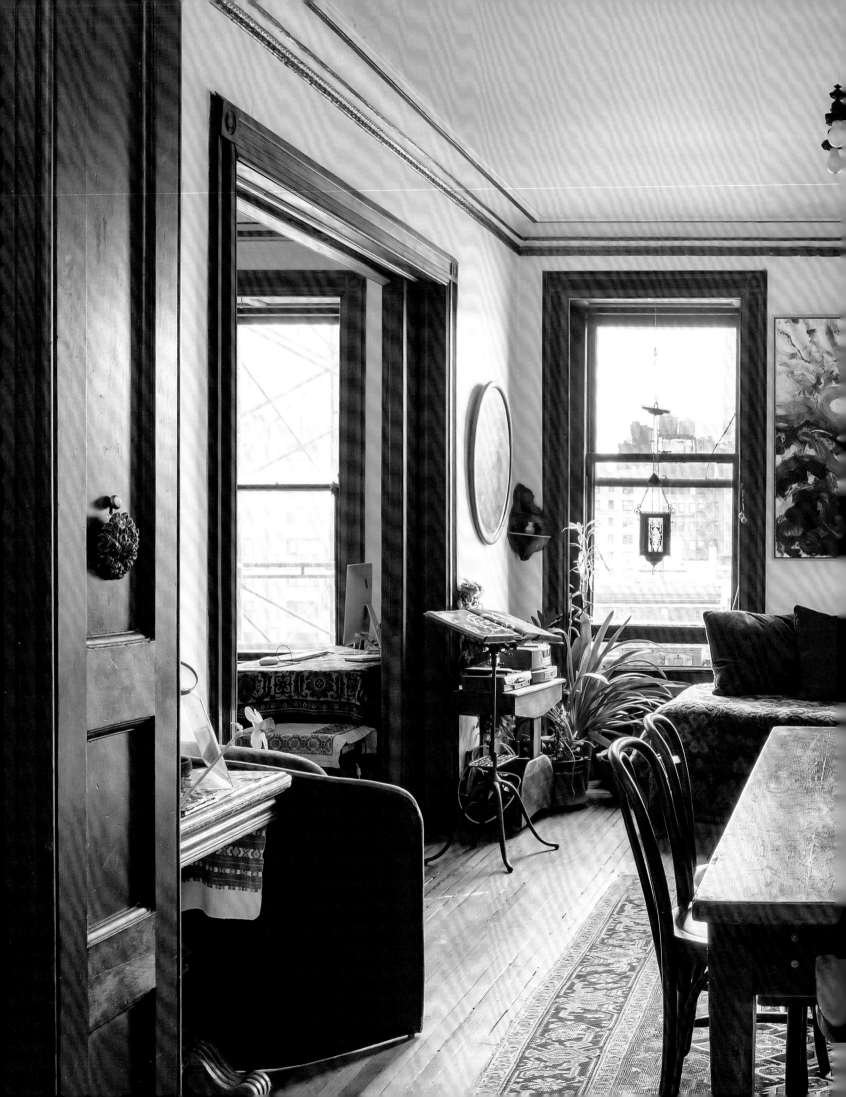

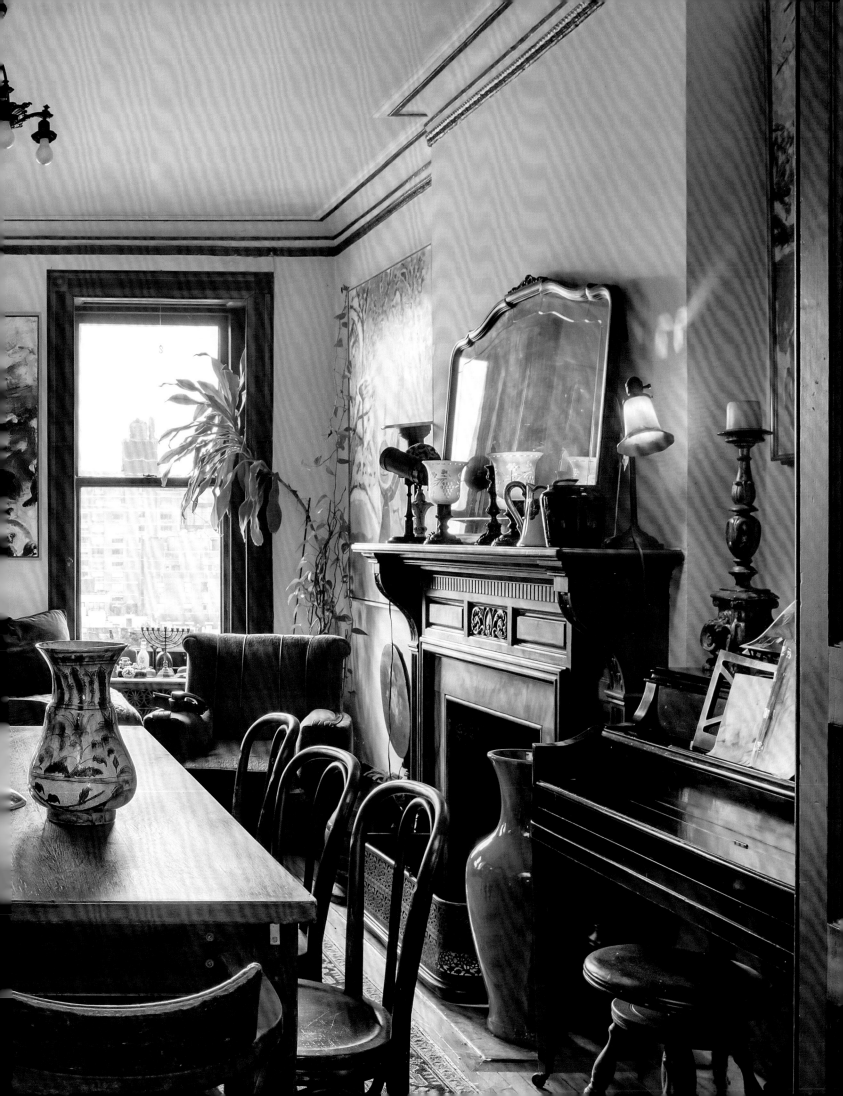

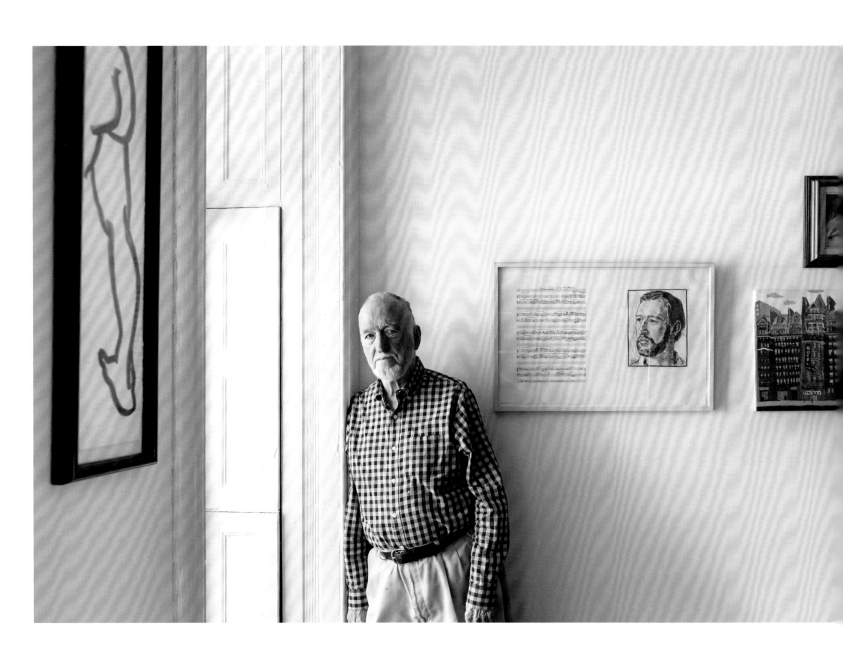

GERALD BUSBY

GERALD BUSBY WARMS QUICKLY TO CONVERSATION. "All problems about who you are and where you are in a sense are solved as soon as you're present and admit that you have no idea," he says between describing his writing on gay snobbery, comparing twentieth-century music pedagogy in America and Europe, discussing tribalism in world politics, and arguing for freedom from aesthetic judgment, among a host of other subjects. Somewhere along the way, we also chatted about his time in the Hotel Chelsea, where he has lived for more than forty years. But, in a way, he had been talking about the Chelsea all along, so deeply has his life been affected by the individuals he's met there and the enormous body of work he's created inside its walls.

Busby was born in Tyler, Texas, and raised a Southern Baptist. He studied at Yale as an undergraduate, first the piano and later philosophy. After college he worked as a traveling textbook salesman for eight years, using school auditoriums and music rooms to continue practicing the piano until he made it to New York, and to his first recital at Town Hall.

He likes to say that he has met five geniuses who have influenced him to varying degrees: the director Robert Altman, who hired Busby to compose the score for his film *3 Women*; the dancer-choreographer Paul Taylor, for whom Busby composed the music accompanying Taylor's *Runes*; the dancer Martha Graham, whom Busby met through Taylor; the composer and conductor Leonard Bernstein, whose daughter he taught to play piano; and Busby's mentor, the composer Virgil Thomson, who had the most profound influence on him. Long after Thomson's death in 1989, the composer's spirit continues to cast ripples in Gerald Busby's life.

To start, it was Thomson who found him a room at the Chelsea. In the early '70s, Busby partly supported himself by working as a cook. At a dinner Busby was catering, the two met and hit it off. "We became friends and I came here to see him a few times," Busby recalls. "That's when things started to break for me." He was commissioned by Taylor and Altman and he acted in a few movies, including Altman's *A Wedding*. When, in 1977, the

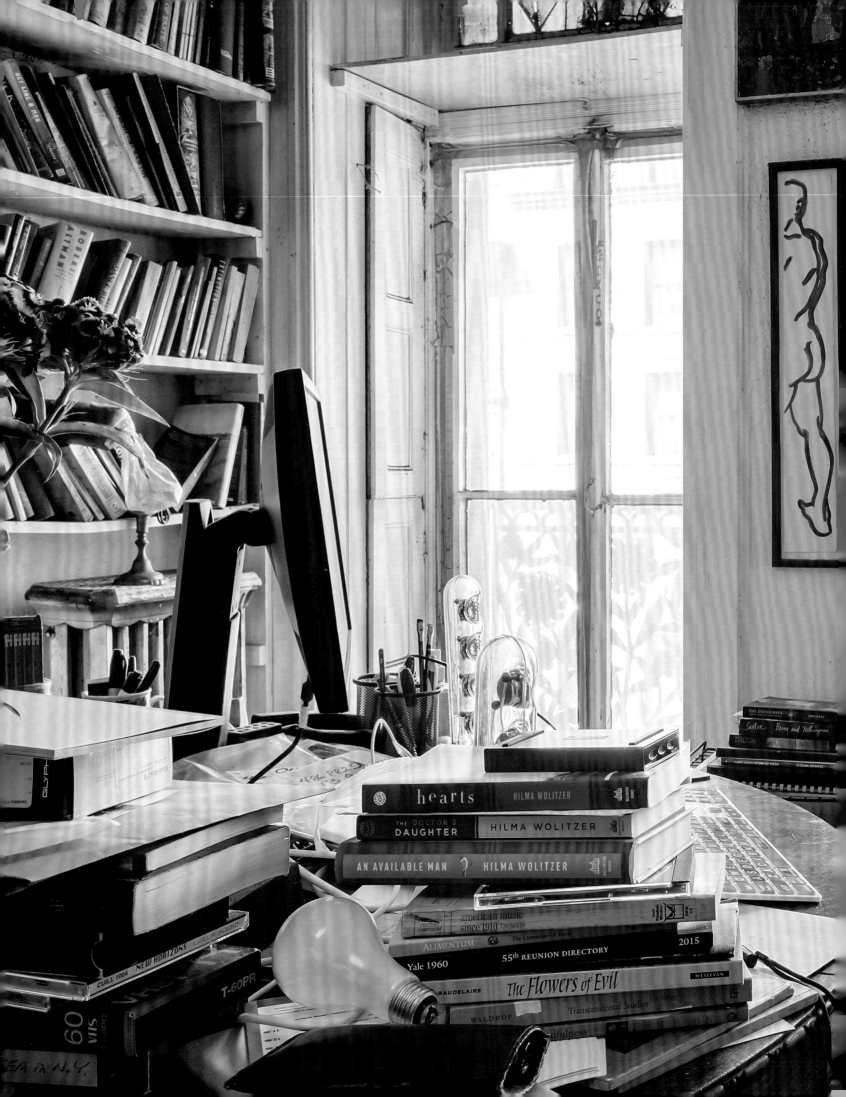

end of a relationship left him homeless, he went to Thomson. "Virgil was a big cheese. He immediately picked up the house phone and called the manager and said"—here Busby imitates Thomson's nasal twang—"'This is the kind of person you're supposed to have here,' and that was that, I was in." He was joined in his new home by a man from Chicago, Sam Byers, who became his boyfriend and later his producer. They would live together in room 510 for the next eighteen years.

In the '70s, Busby remembers, Thomson was a luminary. "Just being around him was electric." Busby became his protégé, preparing meals for Thomson's gatherings, which opened doors to new social connections and exposed him to the aging master's deep well of wisdom. "Although he was my mentor as a composer, I didn't really study composition with him," Busby says. "He was kind of a Buddhist Zen master. You learned just by being with him and observing him and absorbing his taste." Busby says that his awareness of Thomson's kernels of wisdom still grows in him, thirty years after the composer's death. "Every day, I think about him and something he said, I suddenly get."

"He was a genius about the use of energy," Busby says. "For him, the amount of energy you have is the length of time you have to live. He avoided all confrontations. But it wasn't for moral reasons. It's about keeping your energy for your own work. You don't spend it fighting with people." It's a habit that Busby has been trying to practice. "I think I'm so cool until I'm in line at Whole Foods and someone does something I don't like and I'll scream at them," he admits with a mischievous laugh. "Oh my God, what am I doing, I can't be this person! Terrible!"

When it came to music, "Don't be boring!" was the number one rule Thomson impressed upon Busby. "Never mind if you're brilliant or if you've done something unusual. Can you hold our attention?" Busby knew that his own work as a composer was on the right track when Thomson attended a performance of a piece commissioned by Taylor. "He was sitting not too many rows back from the orchestra pit and in a very soft section of the music I heard him say quite distinctly, 'This isn't boring.' It was actually the first time I was sure that I was in with him."

Busby's most vivid memories of Thomson are of cooking with his mentor. "It was about learning how to be intimately involved with a subject and deal with it on its own terms. Cooking was the essence of Virgil's life. His most famous dishes were extremely easy to prepare. That was one thing that he taught me: there are only five ingredients in this and this is how you prepare them and this is how you bring them together. Boom! It all happens very quickly."

Thomson was perhaps the most prominent resident of the Chelsea by the end of the '70s, but he wasn't the only one who left an impression on Busby. A duo of remarkable

women, each of whom forged her own path of independence and success in postwar America, became Busby's patrons and companions: Mildred Baker and Stella Waitzkin.

Busby met Baker, an associate director and then trustee of the Newark Museum, through Thomson. For a while Thomson and Baker were weekly dinner guests at room 510. "She was amazing!" Busby says. "It turned out we had connections: One of her boyfriends, fifty years ago, was a piano teacher I had in Tyler, Texas. That was a big surprise! Her father was a bassoonist in John Philip Sousa's band. He played the premiere of 'Stars and Stripes Forever,' can you imagine that? One of her brothers studied composition with Arnold Schoenberg. She had all this in her life, new music and art." Through Baker, Busby was able to further tap into a leisured social class with a passionate appreciation for art, whether it was musical, visual, or culinary. "She became a close friend of mine, kind of a patron."

Busby also became friendly with another Chelsea Hotel resident, the artist Stella Waitzkin. "She had this Wonder Woman aura about her and she started making plastic sculptures using some concoction that was extremely poisonous and hazardous. . . and she did it in her apartment!" By the time of her death in 2003, her entire apartment had become an installation of her ghostly, polyester resin casts of books, which she called her *Lost Library*. When the art critic and writer Arthur C. Danto visited her apartment, he was astonished by what he saw. "She found meaning in an aesthetic of squalor," he wrote, and "in some way built into her *Lost Library* a monument to the artistic mission of the bohemian ethic of the Chelsea Hotel."

For many years, Busby and his partner enjoyed a life of domesticity with their friends and companions. But in 1985, both Busby and Byers were diagnosed with HIV. After an agonizing fight, Byers died from complications related to AIDS in 1993. "Sam's death was just unbearable," Busby later told the *New York Times*. "He lost his mind and withered away. I was there the whole time with him and taking care of him, so I just went nuts." Deeply depressed, Busby was convinced that he was next. An out-of-control cocaine habit prevented him from working and drove him to the brink of financial ruin.

But Stanley Bard didn't kick Busby out. Instead, in 1997, the manager moved him to a smaller room. The composer was indignant at first. But eventually he sobered up. He also stopped having sex in order to conserve his energy for his work and adopted a monk-like disregard for material possessions. (He says that he has sold or given away everything of value that he once owned.) By the turn of the millennium he began composing again, embarking on a period of productivity that stretches into the present. He reckons that he has written around six hundred pieces of music during his time at the Chelsea, many of them in the last two decades.

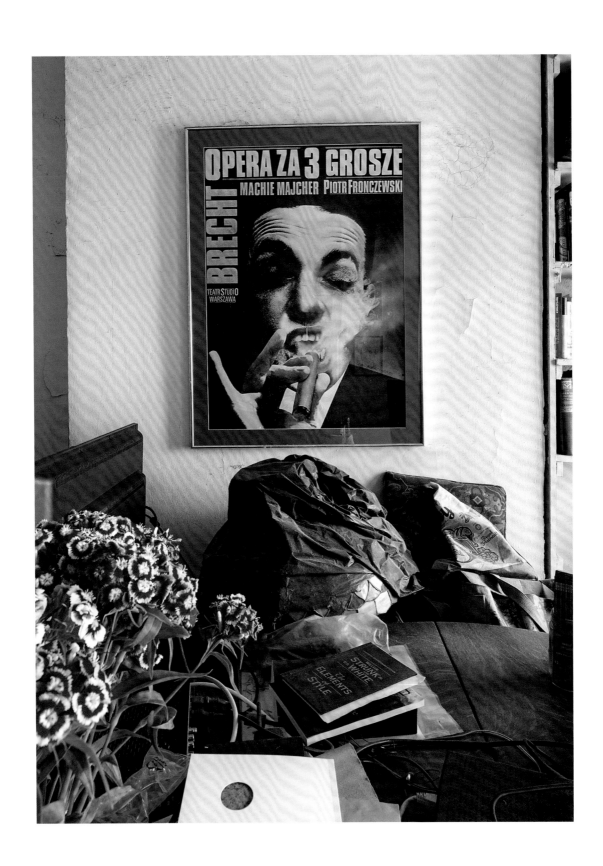

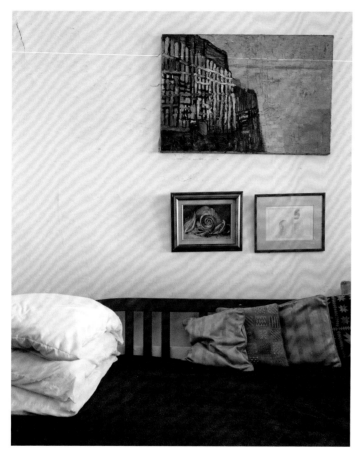

Compared to other apartments, his room is an unremarkable box. "There's a certain cubic space measurement that's perfect for me to write music, and this is it," Busby muses. "It's a hotel room." He recounts how Robert Altman put him up in a luxurious hotel suite in Los Angeles when he was working on the score for *3 Women*. "I couldn't work, I didn't do anything at all there! So I found a dormitory apartment complex near UCLA. Part of me being addicted to the Chelsea Hotel has been that all my work habits have matched with the physical space." He jokes that he lives like a graduate student. "Everything's within arm's reach. It's perfect!"

As one of the more prominent remaining residents, Busby has been asked to talk repeatedly about his life in the Chelsea over the years. Many of his best anecdotes resurface in our conversation, honed to precision from repetition in interviews and undoubtedly many more retellings in private, though they don't come across as practiced or labored. There's the one about his five geniuses. There's Busby's account of his years as a traveling salesman, practicing the piano opportunistically. And there's another about Bard and the actor Viva, which Busby also included in the obituary he wrote for the manager. Viva, Busby says, "was kind of crude and loud and Stanley loved that." "Stanley's thing was, he'd let you get behind in rent and then, as you were stepping off the elevator, the lobby full of people, he would suddenly yell at you, 'When are you gonna pay your rent?!' Most of us would shudder and make excuses. Viva would turn around and say, 'You motherfucker! You don't deserve any rent for that hellhole you've given me to live in!' It was great."

And then there's the one about Thomson's death: "He was ninety-two and he still had his marbles. One day he told Sam and me, 'That's enough.' And he meant living. He said this all totally perfunctory, matter-of-fact. 'Tuesday I'm going to stop eating and Thursday I'm going to stop drinking water and I want to die on Friday so I can be in the

New York Times on Sunday.' And he did exactly that. We would go visit him and he would help plan his own memorial service. He said, 'How's the show going?' I said, 'Well, Phyllis Curtin' — an opera singer who had sung a lot of his music — 'has agreed to take part in the show.' And he said, 'She can't sing anymore!' He was still a critic!"

Busby's stories are anchors for the myths and histories about the Hotel Chelsea that have been perpetuated in countless films, articles, and books. But even if they are not in the least embellished, they don't capture what it means for Busby to sit in his room by himself, day in and day out, working on his compositions. He practices Reiki and engages in philosophical inquiry, but he also practices being in the moment. He likes to play little games with himself that keep him happy, like the platonic crushes on younger men that he nurtures. He recently finished working on an opera, and in the process uncovered memories and emotions from when he was a little boy. "Getting older, I can't remember where I put my toothbrush, but I remember things I did when I was seven years old. I love that, that makes me laugh!" And he does.

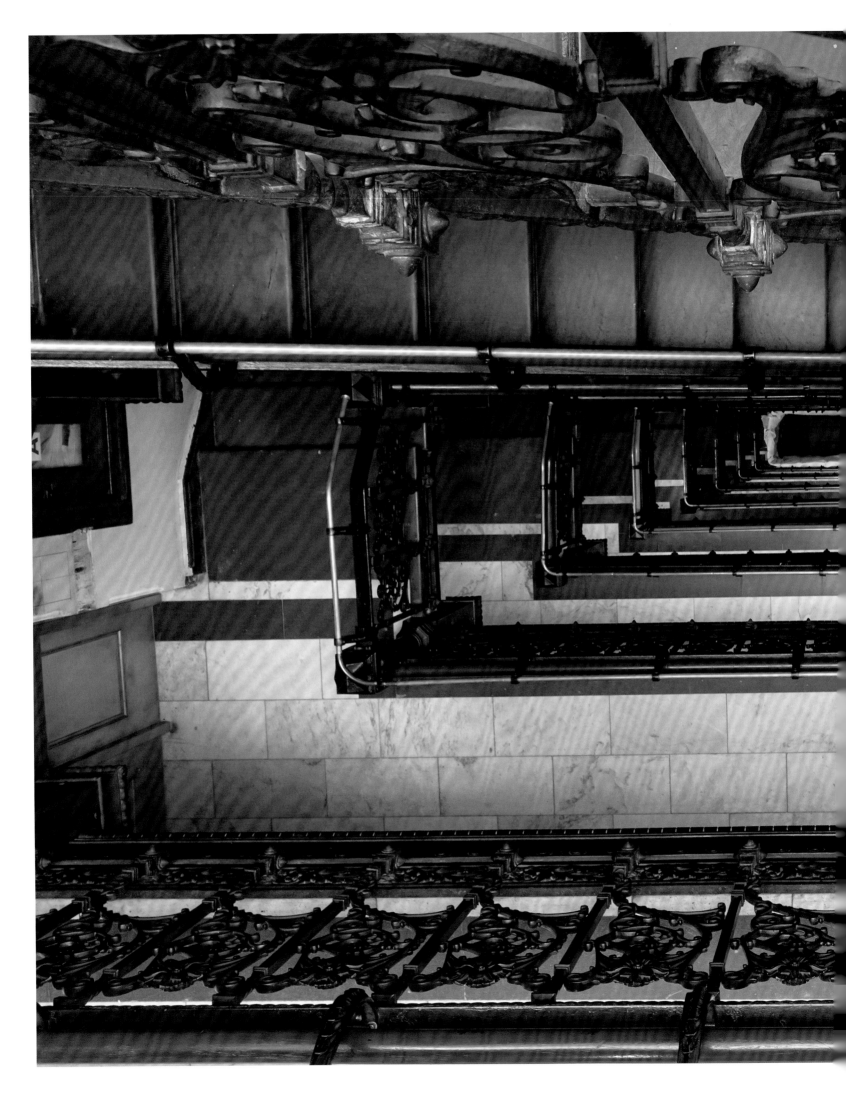

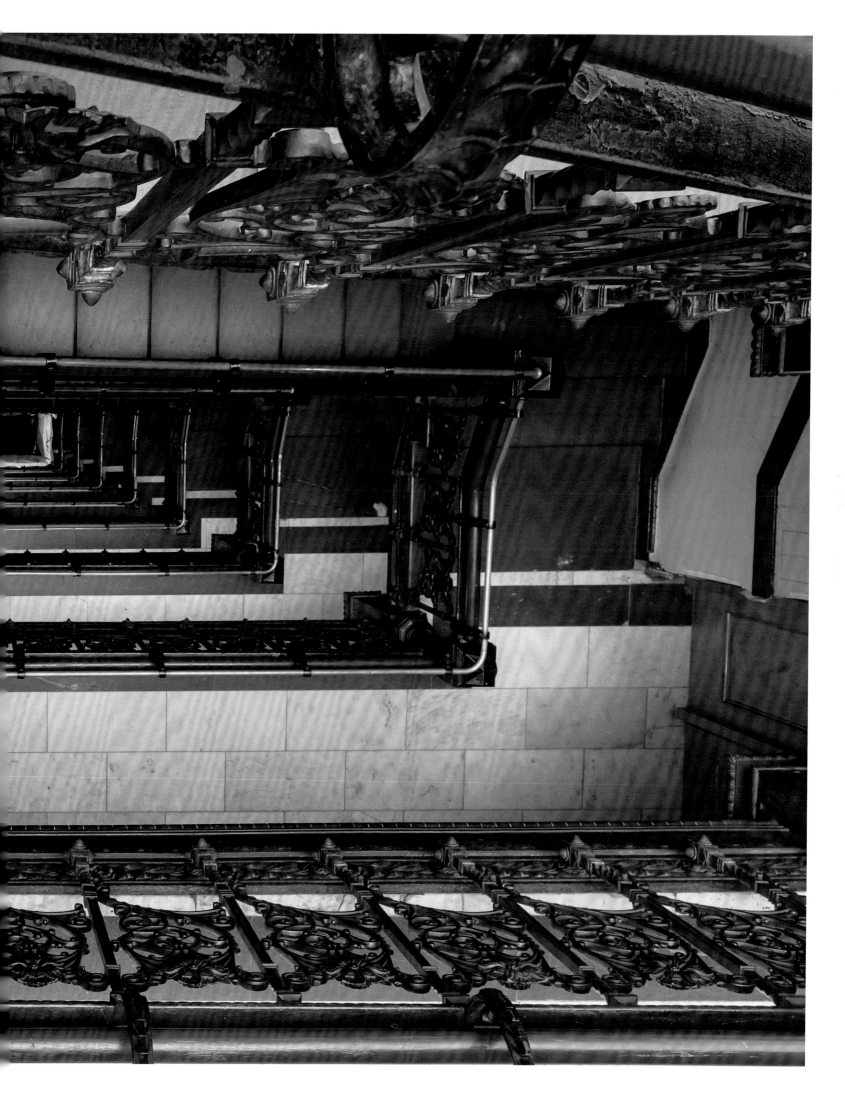

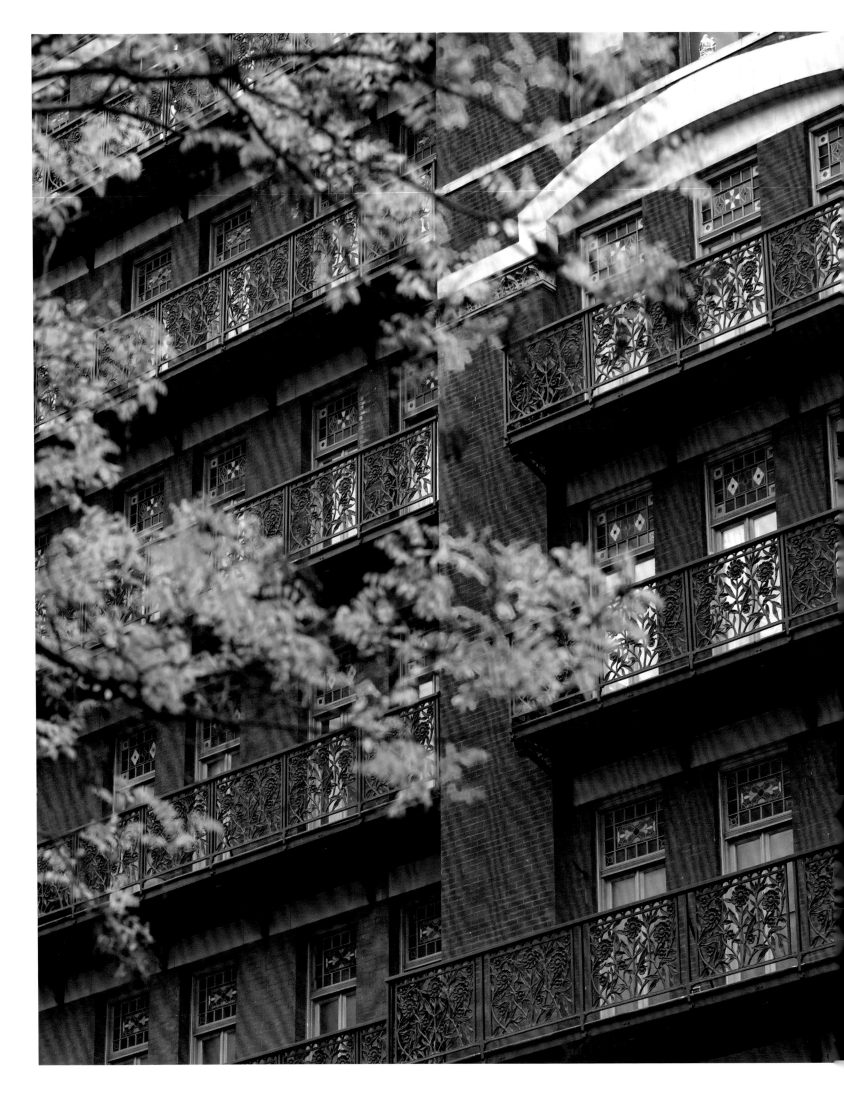

ACKNOWLEDGMENTS

WE ARE ETERNALLY GRATEFUL to the residents of the Hotel Chelsea who invited us into their homes and shared their stories with us, including those who are not featured in this book. We have been humbled time and again by your generosity and hospitality and will always treasure the time we got to spend in the Chelsea.

We would also like to thank our editors at Monacelli Press, Alan Rapp and Jenny Florence, for their patience, diligence, and guidance in bringing this project to fruition, as well as our designer, Phil Kovacevich, for making our vision for this book a reality. Further, we would like to thank Christopher Payne and Albert Vecerka for their sage advice, Jennifer Beal Davis and Allysa Taylor for helping us make crucial connections, Dominique Sindayiganza, Dimitri Mais, and Pavel Bendov for donating their time and expert assistance, and AJ Annunziata, Doug Harry, Erich Fletschinger, and Nat Ward for their encouragement, for lending us their eyes and ears, and for their enduring friendship.

Lastly, we would like to thank our wives, Armineh Moghadasi and Seine Kim, as well as our families, for believing in us, giving us invaluable feedback, and supporting us throughout this journey.

Colin and Ray

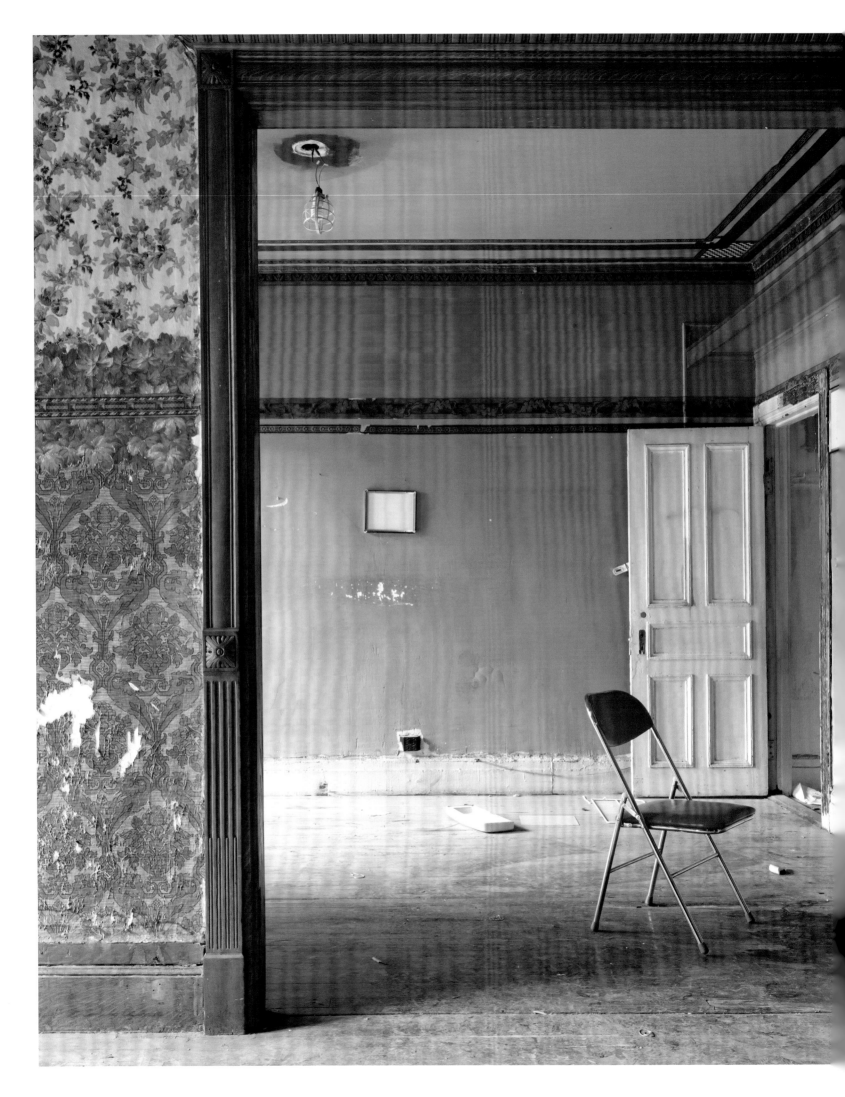

AUTHORS

COLIN MILLER is a photographer based in New York City. His work focuses on the personalization of spaces and what design decisions reveal about the people who inhabit them. He began shooting architecture and interiors with a series of photographs of empty theaters in New England. He recently traveled to Western Sichuan, China, to photograph monasteries in which ornate and colorful decorative paintings cover nearly every surface. Miller's work has been published in a variety of magazines, books, and websites including *Elle Décor*, *Interior Design*, *Architectural Digest*, the *New York Times*, *Town & Country*, *O Magazine*, and *Hamptons Magazine*, among many others. He studied photography at Tisch School of the Arts at New York University.

RAY MOCK is a writer and photographer with an obsessive interest in New York's underground art and music scenes, as well as the city's cultural and architectural history. He is the author of *Banksy in New York* (2014) and has written extensively on graffiti and street art. His photos have been featured in numerous books and magazines and he has published dozens of limited-edition zines and artist collaborations documenting graffiti culture around the world. Mock earned an MBA from New York University and a BA in Social and Historical Studies from Eugene Lang College in New York City. He resides in Brooklyn with his family.

GABY HOFFMANN is a mother, partner, actress, director, and New Yorker.

ALEX AUDER is a performance artist, actress, writer, portrait artist, provocateur, and yoga teacher. Her unique upbringing in the notorious Chelsea Hotel is detailed in a forthcoming memoir. She has appeared in several mainstream and experimental films including Wim Wenders's *The State of Things*, Peggy Ahwesh's *The Star Eaters*, and Rainer Judd's *Remember Back, Remember When*. Auder has acted in and contributed to the productions of world-renowned Hungarian theater group the Squat Theater and performed the one-woman play *Daddy's Girl* at the Kitchen. She is a recurring collaborator in the photographic projects of artist A.L. Steiner, and is a featured character in the HBO series *High Maintenance*. She lives with her family in Philadelphia.

Copyright © 2019 The Monacelli Press

Photographs and Photographer's Note © 2019 Colin Miller

Text © 2019 Ray Mock

All rights reserved. No part of this book may be reproduced, stored in a retrieval system, or transmitted in any form, by any means, including mechanical, electric, photocopying, recording or otherwise, without the prior written permission of the publisher.

Library of Congress Control Number: 2019944575

ISBN 978-1-58093-525-8

10 9 8 7 6 5 4 3 2 1

Printed in China

Design by Phil Kovacevich

The Monacelli Press
6 West 18th Street
New York, New York 10011

www.monacellipress.com